Fauve Painting:
The Making of Cultural Politics

James D. Herbert

Yale University Press
New Haven and London 1992

Designed by Sally Salvesen
Set in Linotron Ehrhardt by Best-set Typesetter Ltd, Hong Kong
Printed in Hong Kong through World Print Ltd.

Library of Congress Cataloging-in-Publication Data

Herbert, James D.
Fauve painting : the making of cultural politics / James D.
Herbert.
p. cm.
Includes bibliographical references and index.
ISBN 0–300–05068–2 (cloth)
1. Fauvism — France. 2. Painting, French. 3. Painting.
Modern — 20th century — France. I. Title.
ND548.5.F3H4 1992
759.4′09′041 — dc20
92–1286
CIP

Of course—I reminded myself on my way home—the idea is not to discover the Templars' secret, but to construct it.

—Umberto Eco, *Foucault's Pendulum*, 1988

ACKNOWLEDGEMENTS

During this project, I have received generous financial support from the Samuel H. Kress Foundation, the Georges Lurcy Trust, the Mellon Fellowships in the Humanities, the Mrs. Giles Whiting Foundation, and the Getty Center for the History of Art and the Humanities. Fellowships from these organizations made possible a year of research in France and the luxury of uninterrupted months to write once I returned to the states. Much of chapter 3 originally appeared in the catalogue accompanying the exhibition entitled *The Fauve Landscape* at the Los Angeles County Museum of Art in 1990; I thank the museum for allowing me to present that material again here.

Roger Benjamin, Nancy Grubb, Anne Coffin Hanson, Anne Higonnet, Jules Prown, and Kenneth E. Silver have given unselfishly of their time and thought in reading parts or all of this manuscript; their suggestions and insights have greatly improved the text. Monique Whiting, my *belle mère*, provided invaluable assistance in deciphering and translating many nuanced passages from the French, while Judi Freeman helped me locate a number of Fauve paintings still in private hands. I thank John Nicoll and Sally Salvesen at Yale University Press for the careful attention they gave to the book.

I owe my greatest intellectual debts to Robert L. Herbert and to Richard Shiff, both of whom read the manuscript painstakingly. Over the years, I have enjoyed many stimulating conversations with Bob and Richard about Fauvism, about French art and culture, and about the processes of representation. Their joint presence can be felt throughout this book: from Bob I learned that pictorial form as well as subject matter has a social history, while Richard has taught me much about how to make a find.

Finally, my special thanks to Cécile Whiting. Many of the ideas in this book were developed in discussion with her, she has always been my editor of first and last resort, and her own work has set high standards of scholarship. I am grateful for her personal support and encouragement that have sustained me over the years.

CONTENTS

Acknowledgements 6

Introduction
The Dialogues of Painting 8

Chapter 1
The North Revisited, Impressionism Revised 15

Chapter 2
Mirroring the Nude 56

Chapter 3
Painters and Tourists in the Classical Landscape 82

Chapter 4
The Golden Age and the French National Heritage 112

Chapter 5
Woman, Cézanne and Africa 146

Conclusion
Figures of Innovation and Tradition 174

Notes 184

Bibliography 213

Index 222

INTRODUCTION
The Dialogues of Painting

The revolution can only be useful and good if it combines itself
with tradition, as everyone now agrees, and the difficulty is to find
the elements and the proportions of that combination.[1]

—Frédéric Paulhan, *L'Esthétique du paysage*, 1913

Donatello chez les fauves, quipped the critic Louis Vauxcelles on seeing a pair of
Italianate sculptures by Albert Marque surrounded by a roomful of paintings by Henri
Matisse, André Derain, Maurice Vlaminck and others at the Salon d'Automne of
1905.[2] The remark, witty enough to christen this group of painters with a name that
has lasted, ostensibly pits classical tradition against the uncivil audacity of wild beasts.
Art historians since 1905 have generally accepted and elaborated on the cultural
antithesis suggested by this interpretation of Vauxcelles's famous phrase, and thus have
considered Fauvism as one more wave of the artistic avant-garde facing its share of
conservative resistance to change.

Yet on a second reading the words of Vauxcelles, who generally approved of the
paintings he saw in the Fauve "cage," may allow something other than this antagonistic
scene. Vauxcelles did not place Donatello "among" (*parmi*) the Fauves; even less
"against" (*contre*) them. The classicizing sculptor Marque was *chez* Matisse and the
others, at home with the wild beasts. From the moment of its first articulation as an
artistic movement, Fauvism potentially enacted a grand reconciliation between the
classical heritage passed down for centuries and the self-consciously modern painting
of recent artists.

Such an artistic reunion—or something quite like it—was clearly the governing
program of the Salon d'Automne. Since its inception in 1903, the Salon d'Automne
had featured retrospective exhibitions of prominent painters recently deceased: Paul
Gauguin in 1903 and Pierre Puvis de Chavannes in 1904. In 1905 when the number
of retrospectives increased to two, the organizers ventured a particularly intriguing
juxtaposition: Jean-Auguste-Dominique Ingres and Edouard Manet. A generation or
even half a generation earlier such a pairing would have been the stuff of polemics:
Ingres versus Manet, tradition versus innovation. At the Salon d'Automne of 1905 the
idea of the organizers, as voiced by the author of the preface Elie Faure, was to recast
the "revolutionary" Manet as the brother of the "classic" Ingres:

The Salon d'Automne has attempted to demonstrate, through these retrospective
exhibitions, the constant legitimacy of the revolutionary effort to rejoin tradition.

The tradition of a people consists in making germinate in its inner nature the fruit of new discoveries in the field of acquisitions that constitute its hereditary patrimony. . . . Like Puvis last year, Ingres and Manet are going to affirm for us quietly that the revolutionary of today is the classic of tomorrow.[3]

Implicitly the virulent young artists exhibiting at the Salon d'Automne, the "revolutionaries of today," would also eventually gain recognition as part of the same "hereditary patrimony" that already included both Ingres and Manet.

The paintings of the Fauves, I will argue, themselves performed the artistic reconciliation of tradition and innovation. In the first decade of the twentieth century, both tradition and innovation were vested in distinct, recognizable pictorial legacies. The "classic" took the form of the French *grande tradition*, that ostensibly unbroken chain of great Latinate and French artists extending from Greek and Roman antiquity through the Italian Renaissance and Nicolas Poussin, to Ingres and Jean-Baptiste Camille Corot. Meanwhile, by the turn of the century an artistic genealogy running from Manet through the Impressionists to those artists whom we now know as the Post-Impressionists stood in the minds of most French observers as an artistic heritage in its own right, a heritage of ongoing innovation. The first large tomes that treated Impressionism as a history were published in these years,[4] and even the official French Salons were crowded with canvases of a mildly Impressionist sort. The Fauves engaged both legacies simultaneously, reiterating themes and compositional principles from the *grande tradition* while adopting Impressionist and Post-Impressionist sites and technical devices as their own.

At the beginning of this century when a cultural heritage could add great weight to a political program in France, each of these artistic legacies possessed a certain valence in the politics of national government. The growing ranks of reactionary nationalists, best personified by the monarchist Charles Maurras, marshaled the *grande tradition* to their cause of promoting the Mediterranean roots of France. That Latin heritage, they maintained, provided the necessary antidote to a republican, Dreyfusard Paris poisoned by modernity and cosmopolitanism. In contrast, many supporters of the Republic claimed the Impressionist lineage as their own. It was precisely in these years that Georges Clemenceau, President of the Republic from 1906 to 1909 as the leader of a solidly establishment center-left coalition, originated the idea of having the French state purchase an entire series of Monet canvases for the glory of France, a project that eventually culminated in the installation of the ensemble of *Water Lilies* in the Orangerie in 1927.[5] The critic Henry Cochin, writing with a hint of nostalgia about Impressionism in the staid *Gazette des beaux-arts* in 1904, remarked that "the anarchist paintings of my youth have become paintings of the center-left."[6] Fauve pictures, bringing these two major artistic traditions together on the same pictorial surface, inevitably played national politics.

The two artistic legacies, and hence the Fauve paintings that engaged them, were enmeshed in numerous other political and social contests as well. Matisse's canvases of the female nude, extending a long history of pictures portraying that theme, cast the viewer as a male and granted him great visual and social powers over the type of women depicted. In London, in the Parisian suburbs, on the Mediterranean shore—all sites previously depicted by earlier French painters—Fauve pictures joined in ter-

ritorial conflicts often heavily laden with issues of class. And Matisse's references to northern Africa, a region the *orientaliste* painters of the nineteenth century had made their specialty, intertwined his works of art with the endeavors of European colonialism.

Fauves pictures "engaged" artistic legacies, they "played" or "were enmeshed in" politics—my verbs up to this point have been purposefully vague. Where, after all, did Fauve paintings stand in relation to the cultural and political entities they encountered? Did these entities exist in some determined form before Fauvism arrived to embrace them? Was Fauvism situated upon some Archimedean point outside culture and politics from which it could act autonomously?

By way of an answer, allow me to return for a moment to Vauxcelles's famous dictum. The phrase *Donatello chez les fauves* actually inverts the relation usually thought to pertain between innovation and tradition. Presumably, tradition sets the stage upon which innovators perform; the wild beasts strike their poses against the backdrop of Donatello. Such an assumption lay behind Faure's argument, which maintained that Manet would shed the spurious label of revolutionary to take his rightful place within a preexisting and immutable classical tradition. Innovators change and are changed— Manet makes new paintings, time transforms him into a classic—while the classic itself remains the same.

I would like to question this priority granted to tradition, and to other stage settings. A tradition certainly exists before an artist emulates its masters or a critic appeals to its authority; nevertheless, each invocation reconstitutes tradition in a new manner. Faure would like to have Manet "rejoin" an immutable Ingres, yet the simple juxtaposition of Ingres in the same sentence—and same exhibition—to Manet, cast the venerated master, and the *grande tradition* he personified, in a new light. The "classic" that excluded Manet in 1865 was not the same "classic" that included him in 1904. In short, traditions—like innovations—are made and remade in the present, although both are constructed in part from remnants appropriated from cultural resources, likewise constructed, in the past.

Through their references and evocations, Fauve paintings reconstituted two traditions, the Latinate *grande tradition* and the Impressionist tradition of innovation, in such a way that they melded into one. Owing largely to the interpretations of Symbolist critics over the preceding two decades, Impressionist and Post-Impressionist styles had come by the beginning of the century to convey the idea that artists employed their refined skills to construct meaning through a laborious and transformative method. Fauve canvases, I will argue, worked to strip Impressionist and Post-Impressionist techniques of the signs of such pictorial construction. These pictures could appear to find their themes and representational means, and to do so naturally. Advocates of the *grande tradition* from the period attributed much this same process of natural discovery to "classic" artists; the Fauves, both by emulating their purportedly natural means and by adopting their pastoral themes, claimed a filiation with the Latinate masters of painting. The classical heritage could consequently appear to unlock itself from the distant past, extending itself through Fauve painting into the modern age. Fauve painting held up neither tradition nor innovation as a stage setting against which to view the other; it modified both to find—or rather, to make—common ground for the two.[7]

But, of course, Fauve canvases as themselves both acts of innovation and extensions of tradition were as caught up in a web of mutual determination with the legacies of

classicism and Impressionism as those legacies, within Fauve paintings, were caught up with each other. While Fauvism reformulated the two dominant artistic traditions of the day, those traditions also reformulated Fauvism. The Fauve artists hardly had final say over the meaning of the Impressionist or Post-Impressionist brush stroke; other custodians of that tradition such as the Symbolist critics insisted they grasped the significance of the stroke, and proceeded to read that significance into Fauve paintings that relied on Impressionist or Post-Impressionist techniques. Likewise, reactionary defenders of Latinism such as Maurras would have resisted the idea that the classical heritage could thrive, through the paintings of the Fauves, in the republican present. Such thinkers, had they commented directly on the canvases of Matisse and Derain, would certainly have dismissed the Fauve evocation of the Mediterranean pastoral as a modernist perversity. Thus even as Fauve painting redefined the two traditions in the process of manipulating their elements, it did not maintain control over the meaning of those elements—and therefore over even its own content. If the stage of tradition was not set before the appearance of Fauvism, neither does Fauvism constitute a constant backdrop against which we can ascertain the meaning of its various artistic references.

Just as Fauvism reconfigured a mutable artistic tradition, art reconfigured politics. Fauve paintings did not merely reflect, reveal, or comment on a preexisting set of political and social affairs. These canvases produced new forms of politics by manipulating political materials and combining them with the attributes of art. The assertion of gendered power in Matisse's pictures of the nude enjoyed the legitimating sanction provided by the aesthetics of high art, as did the territorial claims forwarded by the Fauve landscapes. The Fauve pastorals integrated signs of republicanism and Latin nationalism at a time when no one attempted such a thing within the realm of politics narrowly defined. And Matisse's pictures of African objects played a part in authorizing, in the name of knowledge, further colonial incursions into the massive continent to the south. Over and again, Fauve painting did not find politics; it made them.

Still, the relation between painting and politics, like that between new art and tradition, was always reciprocal. Though the political setting was not engraved in stone before the arrival of the Fauves, neither could Fauve painting make whatever it wanted out of politics, or even control the political significance of its own productions. The meaning of Fauve pictures—as of politics, as of tradition—resulted always from negotiations, from mutual appropriations and transformations. Louis Montrose has discussed this process in literature: "On the one hand, the social is understood to be discursively constructed; and on the other, language-use is understood to be always and necessarily dialogical, to be socially and materially determined and constrained."[8] Painting shaped politics and politics shaped painting; neither took the other as a given. Montrose, in a similar chiastic formulation, insists on the "historicity of texts and the textuality of history."[9] Fauve canvases were not texts set against a context (political or historical) since that "context" itself consisted of a set of constructed texts—including the "texts" of previous works of art. Thus the interaction between Fauvism and its surroundings was always *inter*textual, not *con*textual. Forming alliances or fighting against each other, artistic and political artifacts alike struggled to formulate meanings that could never be other than contingent.

My own relation to Fauvism in this book much resembles that of the Fauves to tradition or of art to politics: I do not find a history, I make it. (No one finds history,

although many historians claim to do so.) Of course, I am myself in turn "determined and constrained" by the artifacts—visual and verbal—I bring under scrutiny. This book thus takes place neither upon the Fauves' stage located in the past, nor upon mine in the present. Dominick LaCapra has written: "The past is not an 'it' in the sense of an objectified entity that may either be neutrally represented in and for itself or projectively reprocessed in terms of our own narrowly 'presentist' interests." The historian, LaCapra believes, should neither "projectively reprocess the past in terms of the present through an ahistorical reading technology nor . . . see the past exclusively in its own putative terms through some kind of total empathetic 'teletransportation.'"[10] I cannot discover the truth of Fauve painting "in its own putative terms," nor am I at liberty to transform these pictures into nothing more than a reflection of my own current concerns; the book consists of an ongoing negotiation between the past of Fauvism and my present.

I am governed not only by my object but also by my audience. In order to convince my readers at the end of the twentieth century about what happened at the beginning of it, I need conform somewhat to established standards of evidence and patterns of argument, even to a certain body of accepted "fact." To express this same idea in a manner that grants me less agency (the degree of my agency is one of the issues under negotiation in this text): I am "determined and constrained" by those rhetorical conventions and established facts. I begin this book, for example, with an anecdote—Vauxcelles's visit to the Fauve "cage"—that countless other books on Fauvism past and future have retold or will retell; we all together accept the currency of this report on the coining of a name. I will finish this book by pointing out my own full participation in an industry of scholarly production only minimally of my own making. Between beginning and end, I will constantly be stretching—without snapping, I hope—the expectations of my readers, reconfiguring fact and rhetoric in order to create a new but still credible explanation of Fauvism and its times. Inevitably my words are subject to the interpretations of those who read them. In writing this book, I enter into dialogues both with Fauvism and with you.[11]

My approach renounces the possibility of ever locating, once and for all, the meaning of Fauve painting. The significance of these canvases lies not in themselves, an immanent truth waiting to be discovered by those who have the tenacity to uncover it. Nor do the intentions of the artists—however we might know of such things—carry a determining weight. These painters may well have seen themselves as working through a set of strictly artistic problems. Even had they wished to produce paintings that advanced their own political and social values—which, in fact, varied widely from Matisse's rather staid bourgeois respectability to Vlaminck's pseudo-anarchism—there is no guarantee that their paintings would have had the desired effects. No artist enjoys the luxury of controlling the present and future uses—artistic, political or otherwise—of his or her images. To avoid ascribing and assessing intent and to maintain an analytic focus upon the cultural products rather than upon their producers, I will tend to treat paintings, rather than artists, as the historical actors in this story. The Fauves themselves may not have intended, or even have been aware of, the meanings their paintings assumed or the ideological tasks these canvases performed once they entered contexts other than the artist's own mind.

"Contexts" of whatever variety, however, also cannot serve as courts of final appeal

since, by my lights, contexts don't exist as such. At times I may seem to situate the meaning of Fauve pictures in the eyes of their contemporary audience, yet I use this tactic as a rhetorical device, and recognize that it raises as many issues as it settles. How can we know the thoughts of an audience, any more than we can the content of a painting or the intentions of an artist? Which audience?—for often there were several. What of paintings, certainly replete with meaning, that were never shown before a public audience? Nevertheless, I find it convenient to describe, or at times to imply the existence of, audiences contemporary with the Fauves—often contesting one another—in order to remind us all that my interpretations are not entirely imposed from my present but are also cobbled together from vestiges from the past, the products of a negotiation across time. The meaning of Fauve painting, in short, is not to be found, immutable and determined, in any one location: painting or artist, context or audience. Rather it is constructed in the interstices between locations, constructed initially at the turn of the century when a set of paintings entered an arena of reception, and constructed again today in the writing and reading of this book.

And what meaning will here be made? Perhaps paradoxically, I will make the case that much of the significance of Fauve painting, much of its political efficacy, derived from its presentation of itself as an art of finding. The manner of painting that came to be known as Fauve style constituted a new form of naturalism based on tactile rather than visual correspondences between pictures and depicted objects. Formulated early on in Matisse's paintings of the female nude, Fauve style matched method to theme: the canvas appeared to render the nude, to find the female form, as directly and naturally as men ostensibly looked at women (in fact, a highly mediated and enculturated act of viewing). When that style of painting was applied to landscape, the countryside likewise seemed to fall, naturally and without mediation, into the purview of the observer's gaze. Nowhere did this operation assume greater moment than in the south of France. There, Fauve painting devised a manner of finding the Mediterranean landscape that contributed in crucial ways to one of the major cultural and political shifts of the early twentieth century when the French nation turned away from cosmopolitan northern Europe and ostensibly rediscovered its natural roots in the Latin heritage. By affecting to find its themes, Fauve painting presented its formulations about gender, about land, and about the national heritage as self-evident truths above the contingencies of politics and beyond the vagaries of history. Such acts of dissimulation, I will maintain throughout this book, were profoundly political and historical. Fauve finding, and the natural control over the depicted object that that finding implied, only foundered when applied at the end of the Fauve period to the depiction of Africa; and even here the failure of apprehending Africa through painting proved productive for the larger French project of attempting to know the mysterious continent beyond the Latin basin of the Mediterranean.

My approach will be thematic, and I will not account for all of the Fauve artists, let alone all Fauve canvases and painting campaigns. Only works by Matisse, Derain, and Vlaminck receive anything resembling intensive scrutiny.[12] Chapter 1 explores two instances where the Fauves, beginning in 1905, self-consciously took up the Impressionist legacy in theme and style: Derain, in emulation of the aging Claude Monet, traveled to London to portray the English capital, while Vlaminck depicted the same suburbs along the Seine that had been treated by Pierre-Auguste Renoir.

Chapter 2 takes a short step back in time to the period 1903–05 in order to examine two canvases by Matisse that depict the female nude posed in the artist's studio. Here I wish both to establish the nude as an important Fauve motif and to explore the aesthetic dissimulation of interest in the female body.

Chapters 3 and 4 travel with Matisse and Derain—along with a new generation of tourists—to seemingly untouched fishing ports on the Mediterranean shore. Chapter 3 examines how Fauve painting and tourist practices together generated a new aesthetic attitude toward the southern landscape. The south was also the land of the *grande tradition*, and in chapter 4 I focus on the manner in which Matisse's well-known pastoral paintings, *Luxe, calme et volupté* (fig. 55) and *Bonheur de vivre* (fig. 56), along with similar works by Derain, came to terms with that Latin legacy.

Chapter 5 chronicles the shift, thematic and stylistic, undertaken by the Fauve artists around 1907. Rendering the nude now with a pronounced Cézannean facture, Matisse and to a lesser extent Derain ventured beyond the boundaries of Europe to exploit the artistic resources of Africa. Finally in the conclusion I describe how the rise of the figure Pablo Picasso, perceived as a new actor both inside and outside French culture, paradoxically both brought Fauvism to an end and gave the movement—and its political formulations—new life in the form of a modernist tradition.

This book, in short, recounts a set of dialogues both cooperative and antagonistic undertaken by a certain body of painting: dialogues between the *grande tradition* and Impressionism, between reactionary nationalism and republicanism, between genders, between classes, between Europe and Africa, between the Fauves and Picasso. Through such contests and collaborations meanings were forged. I too enter into exchange with Fauve pictures, and invite you the reader, in turn, to enter into a dialogue with me. Since you will consider texts and images from the turn of the century in making your assessment of my argument, your reading, like my writing, will represent neither truth imbedded in the past nor interpretation locked in the present. You will, as you read further, inevitably negotiate with me as well as with historical artifacts over how best to make meaning out of the paintings of the Fauves.

CHAPTER 1

The North Revisited, Impressionism Revised

London and Chatou were hardly sites untouched by French painters when Derain and Vlaminck adopted them for major pictorial campaigns of their own. The Impressionists, towering figures in the world of French art, had recently preceded the Fauves at both locations. Derain's canvases of London from 1905 and 1906 were conceived as an emulation and rebuttal of Monet's highly successful series of views of the English capital, which were exhibited in Paris at the Galeries Durand-Ruel in the spring of 1904. Ambroise Vollard, the established dealer who had recently added Derain to his stable, dispatched the young artist to England in the hopes of cashing in on the lucrative market for London scenes opened up by Monet and Durand-Ruel. Whereas Derain crossed the English Channel to come to terms with the legacy of Monet, Vlaminck had but to step out of his front door at Chatou to engage yet another theme dear to the Impressionists: life and leisure along the Seine. Virtually every landscape Vlaminck produced during his Fauve years depicts a view on or near the bend of the Seine that arcs past the communities of Chatou, Bougival and Marly-le-Roi several meanders downstream of Paris. This same stretch of river had served Renoir as a model around 1880 for a series of pictures that included the large *Luncheon of the Boating Party* (fig. 2), which hung prominently at the Salon d'Automne of 1904 and figured as a touchstone painting in many contemporary writings on Renoir.[1] Within French artistic circles in 1905, London was largely defined by Monet's vision of it, and Chatou assumed the character of Renoir's renditions. Fauve paintings of the two locations could not have helped but enter into a dialogue with their illustrious predecessors on how such northern sites should be portrayed in paint.[2]

Monet's and Renoir's paintings, claimed contemporaries, transcended mere worldly matters to enter into the realm of essential and durable truths. Those "contemporaries" who formulated such arguments were, for the most part, art critics. Critics, with their own set of issues to raise and interests to defend, provide only one of a great number of possible contemporary and retrospective interpretations of paintings from the period. Nevertheless, in France at the turn of the century this cadre of highly professional writers enjoyed a virtual monopoly over the public articulation of the meaning of art. Even as we acknowledge the historical contingency of their evaluations and the possibility of meanings not articulated in their public forum, the manner in which these critics attributed the attainment of essential truths to late Impressionist painting undoubtedly carried a great deal of rhetorical weight in their historical moment. Paintings by the Fauves, I will argue, systematically countered the late

Impressionist pictorial devices that signaled transcendence to these professional viewers—and presumably to the many others who read their words. Manifesting new naturalist strategies, works by Derain and Vlaminck made assertions about the mundane realities of London and Chatou.[3]

If few challenged the critics' authority for speaking the verities of art, conflict raged in France over how to describe London and Chatou as they supposedly existed in the here and now. Fauve canvases viewed as naturalist pictures joined with and pitted themselves against many other cultural artifacts—descriptive books, illustrations, prints, photographs—in the often explicitly political exercise of describing the physical reality of these places. From the self-distancing perspective of late Impressionist painting and criticism, most of these secular accounts were beside the point of art: painterly expression and daily life took place in two different realms. Fauve canvases, in contrast, staked out positions within both discursive fields, merging them, at least partially, into one. Just as Derain's and Vlaminck's pictures engaged the mundane reality attributed to specific sites in order to challenge the transcendental character of painting, they brought certain properties ascribed to painting to bear on their descriptions of the material nature of London and Chatou.

1

Monet's *Charing Cross Bridge (Overcast Day)* (fig. 1), dated 1900 but reworked by Monet until its exhibition in 1904, insists on the difficulty of its own construction. Layer upon layer of stippling, troweling, and highly crafted brush strokes—especially in those passages where light strikes water or haze—bear witness to the multiple painting sessions Monet must have used to modulate tone and texture. That Monet had not been in London since 1901 only confirmed the fact that most of the revisions had been made in the artist's studio far from the motif; in 1905 the English critic Desmond Fitzgerald, who visited Monet at Giverny as the artist was repainting these London canvases, dubbed them the "Studio Series."[4] These images offered no illusion, as did early Impressionist pictures, of the notational sketch executed as rapidly as the moment it portrayed.[5]

Such painstaking technique served as the visual representation of the artist's transformative powers. The critic and writer Camille Mauclair, a staunch defender of Impressionism writing in 1904, found much of Monet in the labored surfaces of the artist's late canvases: "With this intense faculty of synthesis, nature, simplified in detail and contemplated in its general lines, truly becomes a living dream. . . . The vision of nature by Claude Monet is a psychological operation, an absolute transposition, a synthesis."[6] Similar psychological terms—*rêve, imagination, émotion*—pepper many critical accounts of Monet's series, locating the object of the paintings less in the landscape of London than in the mind of Monet. For viewers in 1904, meaning underwent a spatial displacement from site to artist; the picture, in other words, appeared to transcend the depicted scene.

Monet's choice of motifs in London contributed greatly to this impression of transcendence. The 37 canvases exhibited at Durand-Ruel illustrated only three views—Charing Cross Bridge, Waterloo Bridge, and the Houses of Parliament—each from a perch high above the water overlooking the Thames. In these pictures filled

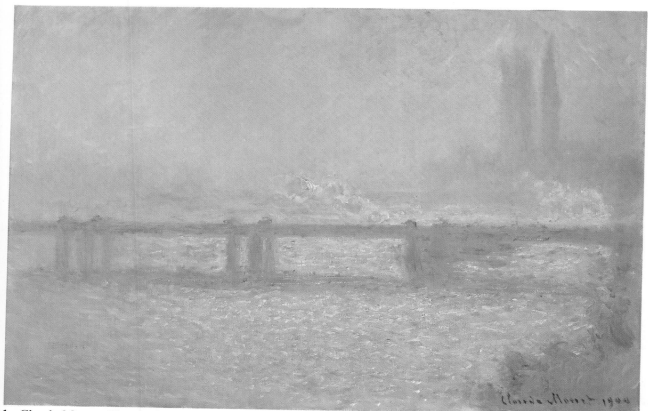

1. Claude Monet. *Charing Cross Bridge (Overcast Day)*. Boston: Museum of Fine Arts. 1900.

with wisps of vapors, only atmosphere and light vary within each set. Emphasis shifts from the distant events on the streets of London to the envelope surrounding them. "No episode," rhapsodized the Symbolist poet Gustave Kahn about Monet's pictures of London in 1904, "distracts the spectator from the enchantments that [light] plays with its partners, fog and smoke."[7] The vagaries of atmosphere altered the phenomenon as it traveled from object to the painter's eye and this alteration had a corollary in the artistic process itself: Monet's rendition of the object on canvas translated the image a second time before it reached the viewer. Contemporary critics of Monet's paintings frequently invoked the metaphoric similarity between the transformative powers of atmosphere and the visual mediation of the artist: the depiction of atmospheric effects became a representation of the artist's interpretive capacities.[8]

As manifested on canvas that interpretive capacity, Monet's artistic procedure, remained quite inscrutable. His multiple reworkings inevitably covered over the myriad *pentimenti* that formed the textural foundations of each painting, hiding the early stages of the picture's construction from view. Monet and Pissarro, pointed out the critic Félicien Fagus in 1901 "are definitively abandoning the technique of rigorously juxtaposing minute spots of paint that made their procedure really too obvious."[9] Opaque technique shrouded in mystery the personality it represented. Monet's vision, like that of a priest performing his spiritual duties, appeared unfathomable. Critics pioneered the simile between the priest and Monet—the image would have currency for decades—in response to Monet's series depicting the façade of Rouen Cathedral,

exhibited in 1895. In his laudatory review published in 1898 the anti-clerical Léon Bazalgette, for instance, described the artist as a pantheist able to express a vital "*cosmic* meaning of the stones" in place of the "*biblical* meaning of the stones" dished out by an obsolete Catholicism.[10]

Paradoxically here in the realm of inexplicable spirit, site and artist could reunite: the artist-priest, claimed critics, revealed the eternal essences of things. The critic Joseph Guérin marveled in 1904 about the London canvases: "It is incredible that the analytic work of an Impressionist in this way translates, by imitating the most super-ficial and fugitive appearances, the permanent and general character of things. Claude Monet has pushed his intense observation of details so far that he has encountered the profound truth where they unite."[11] Monet's Impressionism, added the artist's friend and critic Gustave Geffroy in 1904 about the London canvases, "is a synthesis of universal existence"; this artist, "at the greatest depths of the mystery of substance," miraculously negotiated the distance between "beauty of the moment and of eternity."[12] According to such an interpretive line, London did not drag the artist down to its mundane level. Instead, Monet lifted the city into the transcendental domain of universal truths, discovered and explored by the artist using his privileged sensibilities.

Technical sophistication and transcendence took somewhat different forms in Renoir's paintings of Chatou. At first, Renoir's *Luncheon of the Boating Party* of 1880–81 (fig. 2) hardly appears transcendent at all, for unlike Monet's London canvases this picture is quite attentive to the people and activities along the stretch of river it portrays. Details mattered to Renoir as he produced this image of contem-porary Sunday boaters feasting at the Restaurant Fournaise in Chatou. Distinct physiognomies allow for the identification by name of most of Renoir's sitters,[13] and types of clothing distinguish social class: informal summer dresses or elegant bonnet and gloves among the women, a top-hat and bowlers or less genteel straw boaters and sleeveless shirts among the men. Renoir's view is not distant and disengaged; indeed a place along the front edge of the table marked by an unclaimed aperitif glass and a bunch of golden grapes beckons the viewer to join in the festivities. Addressed to the appetites, the painting exerts a sensual appeal.

Neither dissension nor unhappiness clouds these *bons vivants* as they relish good wine, good food and the pleasures of flirtation. The top-hatted gentleman chats amicably with a man wearing a rather out-moded mariner's cap, someone below him in elegance and perhaps in social station.[14] In the group of three in the right foreground and again in a second trio directly behind the first, Renoir's painting treats women as common property to be exchanged freely, like words, among men of different dress and, by implication, class.[15] Though viewers at the turn of the century could discern "clerks" and "working girls" in *Luncheon of the Boating Party*,[16] no one here suffers the burdens of work, and all lord with equal authority over the riverscape beyond the terrace.

An aura of idyllic fulfillment pervades *Luncheon of the Boating Party*, and precisely because of that the picture began to loose its semblance of present-day veracity. Regardless of whether Renoir's vision of social harmony and easy access to the land at Chatou would have passed muster as real in the days when the painting was created—and a significant body of art-historical research would indicate that it would not[17]—by the first decade of the twentieth century the picture definitely seemed pure

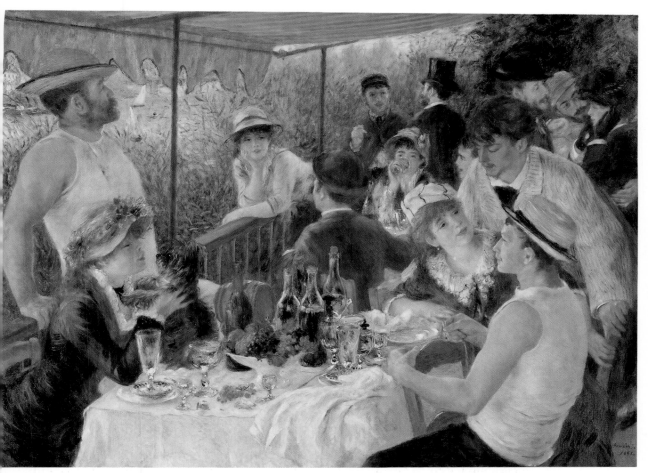

2. Pierre-Auguste Renoir. *Luncheon of the Boating Party*. Washington: Phillips Collection. 1880–81.

fantasy. As we shall see, many French observers at the beginning of this century described the suburbs of the Seine as the site of work, social struggle, and disputes over the land; by contrast *Luncheon of the Boating Party* seemed nostalgic, yearning for a lost era when the countryside was not rent by conflict. The critic Georges Lecomte, writing in 1907, named the historical period associated with such a vision of harmony evoked at the time by Renoir's painting: "Renoir seems . . . the modern continuator of the French masters of the eighteenth century. . . . Representing boaters with their pretty girlfriends on the terraces of river taverns through the arches of which one can discern the Seine illuminated, . . . he appears as the painter of modern and popular *fêtes galantes*."[18] Depicting commonplace revelers of the modern suburbs, Renoir's fanciful scene nonetheless resuscitated the world of Watteau in which gallants and their ladies enacted the rites of love within uncontested pastoral settings.[19]

Renoir's style even more than his treatment of theme pointed the way toward the eighteenth century. If the aging Monet had abandoned the "too transparent" procedure of early Impressionism, so also, by 1880, had Renoir. His new technique—like Monet's, clearly labored in the studio—appeared a self-conscious emulation of the masters of the eighteenth century. One critic after another during the first decade of the twentieth century found affiliations between Renoir's technique and the paintings

of Rococo artists. Mauclair, who considered the Rococo to be the true French national painting style and declared Watteau's *Embarkation for Cythera* to be an Impressionist painting, ecstatically included Renoir in his pantheon of great French artists: "It is through the magnificence of color, through the opulence of thick paint, through the mastery of execution, through pictorial charm that the modernist scene elevates itself to the rank of painting in the grand manner [*la grande peinture*]. . . . No one has painted anything more free, more natural, more French!"[20] Many aspects of Renoir's painterly execution in *Luncheon of the Boating Party*—the pastel colors, the brush strokes either buttery or feathered, the sparkling highlights—would indeed be perfectly at home in canvases by Boucher or Fragonard. Whereas Monet's complex procedure in his late works signaled spatial transcendence through a shift of significance from landscape to artist, Renoir's Rococo technique performed a temporal transcendence of Chatou, lifting his happy gathering out of the present and into a seemingly happier age.

Where Renoir's *Luncheon of the Boating Party* offers a suburban world of perfect leisure, work intrudes upon Vlaminck's banks of the Seine. The chestnut gatherers in *Chestnut Trees at Chatou* (fig. 3),[21] aproned women stooping beneath the trees that provide their livelihood, fill but one role in Vlaminck's large and varied cast of country

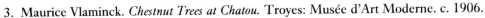

3. Maurice Vlaminck. *Chestnut Trees at Chatou.* Troyes: Musée d'Art Moderne. c. 1906.

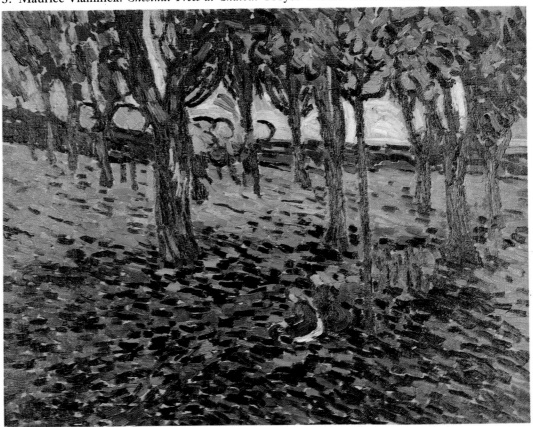

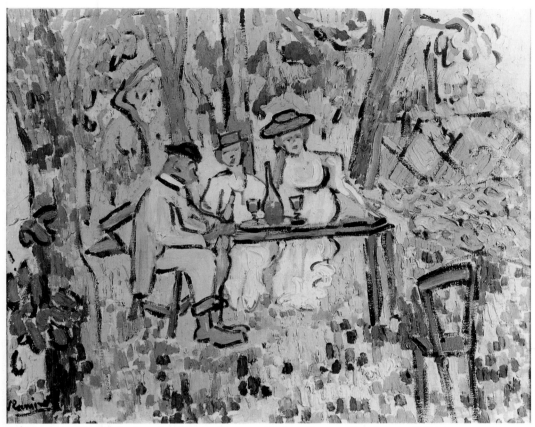

4. Maurice Vlaminck. *Luncheon in the Country*. Paris: private collection. c. 1906.

laborers struggling for their daily bread. Bargemen or stevedores loading boats, a pilot in the wheelhouse of his tug, market gardeners tending their fields of vegetables; such figures of toil populate many of Vlaminck's paintings. Their presence makes Vlaminck's Chatou a site of ordinary weekday employment, rather than of continuous holiday as it is in Renoir's enchanted vision.

Even where Vlaminck took up the theme of leisure, he steered clear of the idealizations of his illustrious predecessor. *Luncheon in the Country* (fig. 4) tells a comic tale: a Parisian bourgeois with stiff white collar and bowler and his two female companions, presumably out from the capital for a Sunday outing, down a bottle of wine or two in a rustic outdoor café. This proper fellow suffers his collar and fastidiously cuffs his pants to avoid muddying his suit, and Vlaminck showed no mercy for he gave the man the face of a lout. With the French title *Déjeuner champêtre*, Vlaminck's painting parodies the genre of the *fête champêtre* no less than its sends up the bourgeoisie. Not only do Vlaminck's weekend tipplers, like his daily laborers, not inhabit Renoir's faultless world; after Vlaminck's treatment, any elegant idyll in the suburbs becomes a laughable prospect. Vlaminck's Chatou, placed along side Renoir idealized version, smacks of the sorry realities of contemporary life.

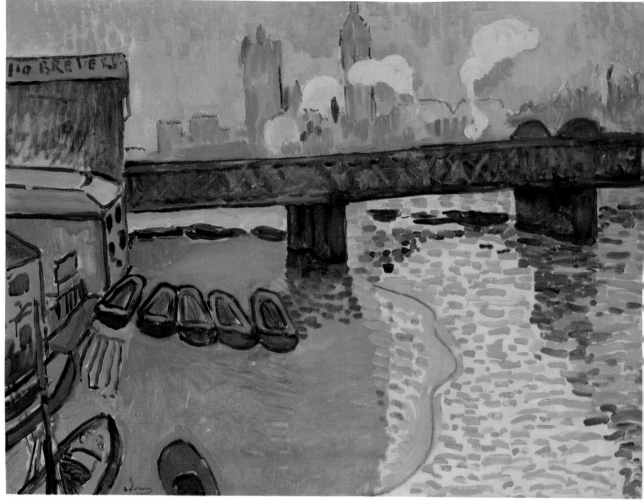

5. André Derain. *Charing Cross Bridge, London.* Washington: National Gallery of Art. 1905–06.

If Vlaminck's humble subject matter dispels from Chatou any ambiance of the eighteenth century, Derain purged London of its atmosphere. The bridge, boats and buildings in *Charing Cross Bridge, London* (fig. 5)[22] body forth crystal clear and sharply outlined. Derain's bold colors speak of corporeal objects in full sunlight, not of the meteorological "effects" evoked by Monet's subtle blues and grays. In Derain's picture, even the few puffs of smoke emanating from trains passing on the trestle, rather than creating a transparent gauze through which we view the background, stand out solidly as palpable objects in their own right. It is a rare passage in Derain's paintings when vapors or light obscure or distort our vision of the London. The great cascade of brush strokes that make up sky and water in *Waterloo Bridge* (fig. 6) stops abruptly when it reaches the substantial structures of London that cut across the middle of the picture; only at the extreme left edge of the picture does a veil of raking light in the form of multicolored paint dabs descend in front of the buildings. All of Derain's paintings with touches of cloud and light effects, in any case, cluster around the sites of Parliament, Waterloo Bridge, and Charing Cross Bridge, all associated

directly with Monet. When Derain moved downstream or left the river completely—as in *The Pool of London* (fig. 16) or *Regent Street* (fig. 8)—atmospheric effects more or less disappear. Derain's paintings cut off at its iconographic source the metaphoric link, so important to the interpretation of Monet's canvases, between atmosphere and artistic interpretation.

Fauve technique, even more than choice of theme, frustrated the transcendental message of late Impressionism. Application of paint throughout Derain's and Vlaminck's northern canvases remains patently simple. The waves on the right side of Derain's *Charing Cross Bridge* (fig. 5), compared to Monet's encrusted surfaces, appear the hasty work of an inexperienced amateur. Heavy strokes of paint, each the product of a single jab at the canvas, stand out clearly, isolated in small groups against large stretches of untouched priming. Even where paint is more plentiful, technique is no less rudimentary: around the moored boats further left, for instance, Derain encircled each blue craft with a crude halo of the same red paint used to depict the surrounding water. All the physical objects in the painting, formed by rough outlines and thick brush strokes with nary a trace of chiaroscuro modeling, display a similar naïveté of drawing. Color in *Charing Cross Bridge* likewise suggests the lack of sophistication. The painted surface consists almost entirely of bright primary and secondary hues straight from the tube, and pigments mix in only a handful of passages. Virtually unmodulated

6. André Derain. *Waterloo Bridge*. Lugano: Collection Thyssen-Bornemisza. 1905–06.

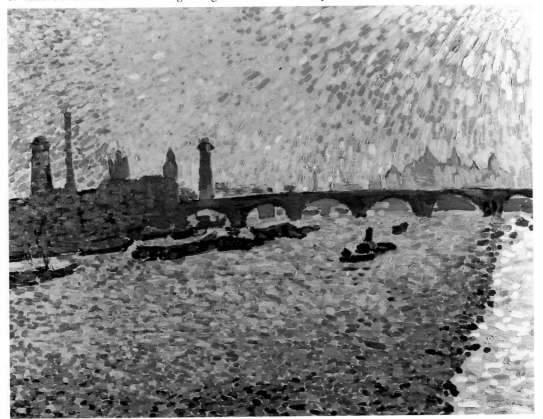

expanses of color—red to the left, yellows in the center, blues along the right edge—cover most of the lower two-thirds of the canvas. All this is not to say that Derain was a technical incompetent; in 1905, it may well have required more skill to look naïve than to emulate obediently the established master Monet.

Derain, in any case, avoided any manipulation of paint that might seem the work of a trained hand. Monet the man emerged from his London canvases in the guise of complex procedure; a recognizable signature style served to represent the excess of his artistic personality over the depicted site. The simplicity of Derain's technique could never similarly suggest the interventions of a skilled and painstaking artist. Where Monet's pictures show the signs of his reflection in the studio—a ponderation that mirrored back the artist on the surface depicting the site—Derain's paintings look slap-dash and quick, as if they were executed without deliberation.

Fauve paintings are so simple in execution that they bare their means of fabrication. In *The "Restaurant de la Machine" at Bougival* (fig. 7), Vlaminck left abundant clues indicating how he executed the canvas. He began, it would appear, with an *ébauche* laying down the basic compositional outlines—edges of the road, frames of buildings, trunks of the trees serving as *repoussoirs* left and right—in an aqua blue pigment. Next followed dabs of saturated, unmixed paints to depict the paving or, in a passage relatively rare in Vlaminck's oeuvre, flat color planes defining the walls of the buildings. Around virtually all of these colored strokes, even along the more densely painted tree trunks, bits of priming peek through, making clear the short distance Vlaminck had progressed from a clean canvas. Even the final touch of the blue letters spelling "RESTAURANT" Vlaminck painted wet into wet, making them less a new and obscuring layer of paint than an integral component of the last one, melded firmly into their bed of red pigment. All here—and in virtually all paintings by Vlaminck and Derain—is obvious: no underpainting, little layering; nothing hidden from view.

Technical inscrutability in Monet's works signaled spirituality: Monet supposedly captured the cosmic essence of London. To search for a similar transformation in Derain's views of the London or Vlaminck's of Chatou would yield meager results, for the demystification of technique, its reduction to conspicuous simplicity, shut off the late-Impressionist route to spiritual ascendance. Without complexity to connote artistic deliberation, without unfathomable technique to indicate essence, Fauve paintings refused to reenact the late-Impressionist spatial displacement of meaning from depicted site to the figure of the artist.

Nor did Fauve style, like Renoir's, conjure up the eighteenth century. While Vlaminck worked his canvas with brush strokes as richly unctuous and as generously thick as those of Renoir, *Chestnut Trees at Chatou* (fig. 3) spurns anything resembling Renoir's ornate Rococo touch. Gone are the sparkle of crystal and the sensual appeal of fruit and flesh. Gone are the delicately feathered transitions from green foliage to blue-green river. Vlaminck abandoned Renoir's light touch and carefully modulated pastels for ostensibly crude brushwork and a palette of highly saturated pigments—reds, yellows, greens—juxtaposed against the browns and blacks of tree trunks and foreground undergrowth. The Fauves' manner of painting, quite removed from the aristocratic refinements of Boucher and Fragonard, seemed manifestly plebeian. Just as the Fauves' simple technique forestalled a spatial shift from site to skilled artist,

7. Maurice Vlaminck. *The "Restaurant de la Machine" at Bougival.* Paris: Musée d'Orsay. c. 1906.

their coarse style thwarted a temporal displacement of contemporary scenes into the elegant, aristocratic past.

The Fauves' elimination of refinement—Monet's finesse as well as Renoir's evocations of the Rococo—was more than a project of negation, more than the refusal of late-Impressionist transcendence. It also promised a renewal of art. By the first decade of the twentieth century, the history of Impressionism already stretched back more than thirty years, and as an eminently sophisticated manner of painting it could be seen as the culmination of centuries of artistic evolution—such, for instance, had been Mauclair's claim about Renoir. However, the gap between conceiving of style as highly advanced and condemning it as overly developed was not wide, and more than one commentator on late Impressionism was willing to make the leap. The critic J.-C. Holl, commenting in 1910 on the artists exhibiting in the official Salons at the beginning of the twentieth century who derived their manner of painting from the Impressionists, lamented: "With the [current] decadence appeared insipid, affected art; puerile ingenuity; subtleties; pale, diluted colors; anemia of tones and half-tones; and the dull languor of washed-out nuances."[23] Impressionist brushwork, no less than its color, could be faulted for its bloodless delicacy. Looking retrospectively over the legacy of Impressionism in 1913, the artist and critic Charles Moreau-Vauthier detected

among the Impressionists of his day a "mania for facture and . . . virtuosities of the brush," which he labeled a form of "art of decadence" with great appeal to cultured dilettantes.[24] Late paintings by Monet and Renoir, chromatically subtle and deftly executed, could not have remained untainted by these charges of cultural degeneration. Monet's brand of Impressionism, in the words of the conservative historian of French landscape Georges Lanoë writing in 1905, "is extremely civilized painting, very decadent, very degenerate."[25]

Where daintiness was the disease, crudity was the obvious cure. To escape from the official Salons and "venture amid the effervescence of the young," argued Holl, was to rediscover health: "Violent tones, the virgin sensibility of pure colors appeared, as if the artists were trying to regenerate themselves through contact with primitive sensations. For [these artists], decadence was the source of a generous revolt of their youth against an art that they guessed was deadly."[26] Similarly, Moreau-Vauthier detected a reaction against Impressionist virtuosity among contemporary artists: "[One group] has claimed to prove themselves naïve and awkward. This taste for false naïveté has yielded for us, over the past number of years, manners of painting that defy all method. Applied awkwardness here triumphs with a feigned candor."[27]

Neither Holl nor Moreau-Vauthier, writing in general terms, mentioned Derain or Vlaminck by name when they penned their words about the recent return to rude color and simplified technique. Nevertheless, the Fauves, with their thick, quick strokes of pigment straight from the tube, undoubtedly exemplified the trend. Such was the essence of Vauxcelles's crucial assessment of the Fauve "cage" at the Salon d'Automne of 1905. His formulation *Donatello chez les fauves* highlighted the distance this critic posited between the "delicate science" of the Marque sculptures and the "ultra-bright gallery of daredevils, of risk takers" that surrounded them. Wild beasts, "shocking and virulent," were anything but the feeble citizens of a civilization past its prime.[28]

For viewers versed in the principles of late Impressionism—supporters as well as detractors—Derain's paintings of London and Vlaminck's of Chatou would have suggested endings: the end of transcendence, the end of highly civilized art. But these works would also have augured a beginning, a coming age when art paraded a rude new vitality. Whether one regarded that rudeness as necessary, of course, depended on one's beliefs about the health or degeneracy of Impressionism. The terms of the debate, in any case, were quite clear. Used in paintings depicting sites previously selected by the Impressionist masters, the Fauves' simple, bold streaks of pigment constituted either a needless exercise in artistic vulgarity or the resuscitation of an timeworn Impressionist heritage.

2

The rejuvenation of a sophisticated but aging artistic lineage through the means of seemingly unschooled technique involved a paradox. To signal that which was in need of new life, the younger generation of painters needed to make visual reference to the Impressionist heritage—Derain and Vlaminck did so, in part, by returning to favored Impressionist sites. Yet by that very reference, these artists tainted their standing of being truly naïve by demonstrating an awareness of their technically proficient

predecessors. The Impressionists had to be invoked and disavowed at the same time. Moreau-Vauthier, with his talk of "false naïveté" and "feigned candor," captured the gist of the dilemma. The act of renewal, in short, found itself in direct conflict with its representation.

As they served to revitalize late Impressionism, Derain's and Vlaminck's pictures did not—indeed could not—escape this paradox. Yet while the Fauves may not have achieved technical innocence once they engaged the Impressionist heritage, they could nonetheless represent it. This, I will contend, their pictures could be seen to do through two distinct pictorial means, one borrowed and one new.[29]

Vincent van Gogh and Paul Gauguin had emerged by the first decade of the twentieth century as the artists within the Impressionist heritage who best exemplified naïveté. A large body of critics, known as Symbolists owing to their various associations and debts to the literary movement, championed the two artists in part on these grounds—by extension Van Gogh and Gauguin came to be known as Symbolist artists.[30] By incorporating the styles of Van Gogh and Gauguin into their paintings the Fauves had a relatively certain manner for conveying to an extended and established contemporary audience the idea that their own canvases were produced without benefit of artistic skills inherited from an advanced and perhaps degenerating culture.[31]

Traces of Van Gogh are ubiquitous in Derain's canvases from London. Although Derain left much more priming exposed than did his Dutch predecessor, in the right foreground of *Charing Cross Bridge* (fig. 5) the unctuous brush strokes themselves recall Van Gogh's technique. Derain's *Waterloo Bridge* (fig. 6), while clearly also indebted to the late works of the Neo-Impressionists, evokes Van Gogh through its dense mosaic of thick strokes and its dynamically active sky.[32] Here too the palette of bright red, oranges and yellows used to depict the emanations from the sun as well as the sun glade running down the right edge of the canvas had as its precedent countless depictions by Van Gogh of sun-drenched Arles and Saint-Rémy. Vlaminck's choppy, tightly packed application of paint and his glistening oils—the brightly colored foreground paving in *The "Restaurant de la Machine" at Bougival* (fig. 7) and virtually the entire surface of *Chestnut Trees at Chatou* (fig. 3)—also often bear a striking resemblance to Van Gogh's canvases. Indeed Vlaminck may well have depended on the lessons of Van Gogh to a greater degree than any other Fauve before 1907 relied on a single artistic predecessor. The filiation was not lost on at least one perceptive critic. In his review of the Salon des Independants of 1907, Vauxcelles declared: "M. de Vlaminck is a virulent image-maker who drives bourgeois spectators to fury and confusion; a singular temperament that recalls Van Gogh, with a slighter accent no doubt."[33]

Van Gogh's vigorous application of paint and his use of strong color, coupled with the fact that he received no proper French artistic instruction, had by the first decade of the twentieth century made him the epitome to Symbolists and non-Symbolists alike of a certain type of rustic vitality.[34] The association of Van Gogh with what were perceived as the simple folk of the countryside was based partially on his favored themes: Van Gogh confined himself almost exclusively to depictions of the people of the land. "It was only plebeians [*gens du peuple*] that he took pleasure in representing," wrote the senior art critic Théodore Duret in 1916; "one finds in his oeuvre no person belonging to the upper classes."[35] Yet it was also Van Gogh's style of painting—

described variously as *brut, rude, fruste, gauche, maladroit, naïf, violent, grossier,* and *rustique*—that caused contemporary viewers to link his works to the perceived vitality of the lower classes; François Monod even compared Van Gogh's colors to the bright but mottled finish with which boatmen coated their barks.[36] As the antithesis of upper bourgeois sophistication, Van Gogh represented a return to untutored painting.

Derain, to a greater extent than Vlaminck, relied on aspects of Gauguin's technique as well. The large flat areas of highly-saturated but internally undifferentiated color in Derain's paintings—the left foreground of *Charing Cross Bridge* (fig. 5), for example, but also the color fields predominant in the foreground of *The Pool of London* (fig. 16)—owe a direct debt to the recently deceased artist. Like the works of Van Gogh, Gauguin's paintings were considered robust: the same type of adjectives that had been used to describe Van Gogh's technique—*brusque, fruste, rude, sauvage, gauche, grossier*—crop up as well in critical accounts of Gauguin's manner of painting.[37] Gauguin offered Derain what the French imagined to be a different source of un-refined vitality, the "primitive" cultures of Brittany and the islands of the South Pacific. As the critic Marius-Ary Leblond phrased it in 1904:

> According to Gauguin, all that is European—deviant, shriveled, anemic, niggardly calculated—is inferior to that which is savage, to the spontaneous and unconscious manifestations of primitive instinct.
>
> Art itself, the last thing that opponents and detractors of civilization hold against it, European art is only the domestication, poisoning, and castration of our most natural and primordial instincts: it is no longer "direct."[38]

Here was an artist who, according to Vauxcelles in 1906, "rejected [*vomissait*] all civilization."[39]

If the late works by the Impressionists could be accused of civilized overrefinement, those by Van Gogh and Gauguin were not: their paintings spoke to virtually all viewers around the turn of the century of rudimentary sensibilities outside the evolution of fine art. The Fauves grafted this machinery for representing fresh vision wholesale onto their pictures of London and Chatou; Vauxcelles, for one, accepted the Fauve claim to a lack of artistic sophistication. To adopt a recognizable method for looking unschooled is obviously a stratagem mired in contradiction. Perhaps all routes through the paradox of rejuvenation, including this one negotiated by the Fauves, must by their very nature involve such an inconsistency. It should thus come as little surprise that Vlaminck both repeatedly proclaimed himself an autodidact and acknowledged that he loved Van Gogh like a father.[40]

To throw one's lot in with Van Gogh and Gauguin, however, was to run the risk of engaging not only connotations of rustic classes and "primitive" cultures but also other meanings associated with their paintings. While Symbolist advocates of Van Gogh and Gauguin distanced these artists from the refinements of late Impressionism, they ascribed to them a similar transcendence of the mundane word into the realm of eternal truths. Indeed, the description of Monet as an artist-priest owed much to the spiritual interpretation of Van Gogh and Gauguin formulated by the Symbolist critics in the early 1890s.[41]

The Symbolist treatment of Van Gogh began with the only article published on the artist during his lifetime, an influential essay entitled "Les Isolés: Vincent van Gogh"

authored by the Symbolist writer and critic G.-Albert Aurier in 1890. Van Gogh, wrote Aurier,

> is very conscious of pigment [*matière*], of its importance and beauty, but also, more often, he only considers this bewitching pigment as a kind of marvelous language destined to translate the Idea. He is almost always a symbolist.... a symbolist who feels the constant necessity to clothe his ideas in precise ponderable, tangible forms, in intensely corporeal and material envelopes. In almost all his canvases, beneath this morphic envelope, beneath this very fleshly flesh, beneath this very material matter, there lies, for the spirit that knows now to see it there, a thought, an Idea, and this Idea, the essential substratum of the work is, at the same time, its efficient and final cause. As for the brilliant and dazzling symphonies of color and lines, whatever their importance be for the painter, they are in his work only simple expressive *means*, simple *processes* of symbolization.[42]

According to Aurier, Van Gogh may have manipulated the material substance of his paints, but only as a means of expressing immutable Platonic ideals through the double mediation of pure form and the artist's mind.

By the turn of the century, Aurier's had become the standard critical line for both Van Gogh and Gauguin. Félicien Fagus in 1902 lionized "the extraordinary Van Gogh [who,] . . . extract[ing color] with violence from all of nature, from light, from the sun itself, molded for himself from it an unknown language to express universal and identical life."[43] And in 1903 Armand Seguin declared Gauguin's painting to be about "Love and Beauty, condensation of life, harmony of lines, colors and values, that signify to him the expression of facts and ideas. It is because Paul Gauguin was symbolic that the school of Pont-Aven will retain his influence."[44]

By appropriating the stylistic traits of Van Gogh and Gauguin to signal a robust lack of refinement, the Fauves invited a Symbolist assessment of their paintings, and the Symbolist critics, frequently and often quite eloquently, took advantage of that opportunity.[45] The comments by the anonymous "Foski" writing in 1906 about Matisse's *Bonheur de vivre* of 1905–06 (fig. 56), another Fauve painting that borrowed heavily from the Symbolist painters, would have applied equally well to Derain's London pictures and Vlaminck's canvases from Chatou: "It is [an] absolute quest of pure intellectuality . . . The idea of that conception must be, although a little confused, elevated and interesting . . . The symbolist poem or a book on metaphysics would seem wholly appropriate."[46] From the beginning of the century until this day, a number of critics and art historians have worked to assimilate the Fauves into the Platonic project of Symbolism.

Nevertheless, in crucial respects Derain's and Vlaminck's paintings swim upstream against the Symbolist flood of connotated transcendence. Just as these works repudiated the devices that in the late-Impressionist paintings suggested displacement away from the depicted scene, they also countered the stylistic ciphers of mystical insight operating in the pictures of Van Gogh and Gauguin.

For Van Gogh's and Gauguin's pictures to embody Symbolist painting, artistic personality had to take a distinct visual form since the persona of the painter, within the Symbolist scheme, was responsible for translating universal essences into paint on canvas. "[Gauguin] must have . . . found insufficient the process that consists of sub-

ordinating oneself to the fugitive aspects of nature," claimed Guérin in 1903. "To express on canvas his decorative interpretations, it was necessary for him to provide himself with a doubly personal manner in that it emanated in large part from him alone and, in addition, that it translated the conceptions of a very particular personality."[47] Viewers had little difficulty in distinguishing those stylistic attributes—broad planes of bright color in the case of Gauguin, great swirls of pasty strokes in the case of Van Gogh—that marked Van Gogh's and Gauguin's canvases as uniquely their own. Such features constituted for each a recognizable signature style, a guarantee of the artist's personal intervention.

Yet while such a personal style had to be readily discernable, it also had to resist rational explanation. According to the Symbolists, style and the personality it represented could never be reducible to a set of rules derived from experience in the material world if it were to make the leap out of that world and into the realm of ideas. Van Gogh and Gauguin filled the role of Symbolist artist perfectly since their sensibilities were always described as somewhat inexplicable. By attributing the cause of Van Gogh's technique to his mental illness—a practice so frequent, then as today, as to verge on platitude—critics could regard that style as both highly irrational and unique to Van Gogh.[48] Gauguin's exotic subject matter and his reputed Peruvian bloodline insured that his manner of painting would not lose its mystery to contemporaries: Gauguin's technique appeared in virtually all French accounts as the product of a fundamentally foreign mind.

The self-explanatory character of Fauve pictorial construction, as we have seen, resisted enigma. Even had Van Gogh or Gauguin utilized the type of preliminary blue outlines so routinely visible in Fauve pictures, such *ébauches* would long since have been covered over by subsequent layers of obscuring pigment. Derain's habitual practice of leaving priming exposed, or Vlaminck's almost childlike procedure along the upper edge of *The "Restaurant de la Machine" at Bougival* (fig. 7) of drawing a loop of blue and filling the space with a globule of yellow to define leaves, have no place in the more worked surfaces of Van Gogh and Gauguin. All is manifest in Fauve paintings, for technique is demystified; there is no suggestion here of the unintelligible forces ostensibly seething within the Symbolist artists.

More crucially, Derain and Vlaminck frustrated the representation, if not of personality itself, then of the uniqueness of artistic persona. Derain's *Charing Cross Bridge* (fig. 5) has no real style to call its own. The application of paint in the right foreground, reminiscent of Van Gogh, bears little resemblance to Gauguinesque passages in the left foreground, and neither area matches the technique of the background sky. Although viewers including ourselves may be able to identify a certain amalgam of stylistic traits as characteristic of this artist's method—the paintings from London are recognizably "Derains"—the constant mixture of techniques throughout the series make it impossible to isolate any single style as the distinguishing mark of Derain's own mind, as opposed to a cipher of his borrowings from others.

Even a consistent Symbolist style, when borrowed, did not represent personality as it did in its source paintings. Vlaminck relied, more or less constantly, on Van Gogh alone; the flat planes of color in the manner of Gauguin that form the buildings in *The "Restaurant de la Machine" at Bougival* (fig. 7) have few counterparts in Vlaminck's other paintings. Yet the fact that Vlaminck borrowed his manner of painting from such

a well-known artist cut off much of the reference to his own personality. A Van Gogh brush stroke in a picture by Van Gogh could be regarded as directly caused by the artist's highly pitched temperament. Transposed into a canvas bearing Vlaminck's signature (or Derain's), such a recognizable stroke recorded neither Van Gogh's sensibility, since he didn't paint it, nor the Fauve's, since the style was not his own. Much of the Symbolist traffic between the material world and the spiritual realm— attributed to Monet's late works as well as to the pictures of Van Gogh and Gauguin— came to a halt in Fauve paintings before it began since these canvases failed to indicate the presence of an individuated and enigmatic artist capable of embarking on the mystical journey.

Given Derain's and Vlaminck's clear reliance on Van Gogh and Gauguin coupled with their refusal to signal transcendence in the fashion of their predecessors, the Symbolist script on Fauvism was practically written before critics put pen to paper. This was painting highly legible to Symbolist eyes; to them, the visual lexicon from which Derain and Vlaminck drew the terms of their painting was absolutely familiar. Yet if Fauvism spoke the Symbolist language, it did not live up to Symbolist goals: for virtually all of the Symbolist critics the movement thus came to exemplify failure, the inability to attain Platonic ideals.

Consider the extended critique of the "school of Matisse" composed by the influential critic Maurice Denis, himself a painter of a rival group who came of age in Gauguin's circle at Pont-Aven. These were Denis's words about the infamous Fauve room, which included Derain and Vlaminck, at the Salon d'Automne of 1905:

> As soon as one enters the gallery consecrated to [the school of Matisse], . . . one feels fully in the domain of abstraction. No doubt, as in the most ardent divagations of Van Gogh, something subsists of the initial emotion of nature. But that which one finds above all, in particular with Matisse, is artificiality; . . . it is painting beyond all contingency, painting in itself, the pure act of painting. All the qualities of the picture other than those of the contrast of tones and lines, all that has not been determined by the intellect of the painter, all that comes from our instinct and from nature, in short all the qualities of representation and sensibility are excluded from the work of art.[49]

The fatal shortcoming of Fauve canvases, according to Denis, was not that they could be read as set of "contrast[s] of tones and lines"; the same could be said of Van Gogh or Gauguin. Rather, fault lay in the inability of these paintings to lift themselves beyond a merely mechanical concern with such formal qualities and, through the means of mystical sensibility, enter into the realm of Symbolist truth.

It was not that personality, that key mediator of essences, was missing from Fauve painting. "It is precisely the search for the absolute," continued Denis; "and yet— curious contradiction—that absolute is limited by that which is the most relative in the world: individual emotion."[50] Here personality, instead of transporting art beyond the boundaries of the physical properties of paint, constrained it further; subjectivity operated entirely on this side of spirituality. What the Fauves lacked, rather, was that crucial ingredient that allowed personality to transcend the mundane: enigma. The Symbolist critics—denying these painters, in passing, even the spontaneity of "wild beasts" found in their works by Vauxcelles—accused Matisse and his followers of

reducing all to cold artistic reason, leaving no space for the mystery of spiritual transformation. "You are only satisfied when all the elements of your work are intelligible to you," Denis chastised Matisse. "It is necessary to resign oneself: all is not intelligible. One must renounce the reconstruction of a wholly new art with our reason alone. One must trust sensibility, instinct more."[51] Without such inexplicable instinct, the Fauves were mere pusher of paints, not mystical seekers of Platonic ideas. "Everything here can be deduced, explained; intuition has nothing to do with it," concluded André Gide, a close friend of Denis much taken with his ideas, about the Fauves at the Salon d'Automne of 1905. "How far from the lyric excess of a Van Gogh!"[52]

Colors and lines, as in Van Gogh and Gauguin, but colors and lines that lead nowhere. "It is the excessive use of theories," argued Charles Morice, the house critic of the Symbolist *Mercure de France*, in 1906, "the far too exclusive concern with the means of expression."[53] The Symbolist critics dismissed the Fauves for lacking the ability to transcend their pictorial means, the mundane world of physical pigment. Artistic mediation had not disappeared, yet that which Fauvism mediated, according to the Symbolists, was rather pedestrian stuff: this was painting that provided insight not into Platonic ideas or even pantheistic nature but simply into the mere mechanical processes of painting.

That the Symbolists condemned the Fauves hardly invalidates their reading of the movement. These critics did not miss the point of Fauvism (for there can be no such single locus of meaning situated beyond the constellation of interpretations mobilized in history); rather they made a point—a strong one—about it. By the standards of Symbolist aesthetics—a measure the Fauves themselves encouraged with their explicit borrowings from Van Gogh and Gauguin—Denis and his colleagues evaluated Fauve paintings with precision and care. Indeed, the Fauves served the Symbolists well, for the "school of Matisse" quickly became the Symbolists' prime incarnation, by counter example, of the principle that line and color must transcend the mundane. The Symbolists, like any number of critics, could simply have ignored the Fauves; they did not. Throughout the middle years of the decade, Denis devoted enormous attention to Matisse and his followers, and Gide finished his relatively short review of the Salon d'Automne of 1905—a mere eleven pages—with a three-page discussion of the Fauves. For the Symbolists, the type of painting practiced by Derain in London and by Vlaminck in Chatou exemplified well both which artistic resources to exploit, and what not to do with them.

3

A certain excess marks the Symbolist critique of Fauvism. Denis, in characterizing Matisse's "pure act of painting," regretted the absence not only of "all that comes from our instinct," but also of "all that comes . . . from nature." Surely, from a strictly Symbolist perspective, this second lament was superfluous. If the true "nature" of a depicted scene was identical to its essence disclosed by artistic sensibility, the omission of the painter's instinct *ipso facto* excluded the representation of nature as well. The Symbolist refrain that Fauvism was only cold theory voiced over and again the double failure—the paintings were about *neither* Platonic ideals *nor* nature—that these critics attributed to Matisse and his followers.

This critical overkill, more than a mere redundancy, flags an anxiety lying at the heart of the Symbolist account of Matisse and his followers. The Fauves tried to achieve transcendence and failed; fine and good. But what if these paintings refused the Symbolist Platonic program altogether? What if they dared offer a means of perceiving reality that did not involve lifting either themselves or the mundane world into higher realms? This was a possibility the Symbolist critics could not explicitly acknowledge without raising doubts about the self-evidence of their own project. And yet they addressed it, obliquely, in their insistence that Fauvism no more touched nature than it did ideals. Their claims were, in Bakhtin's sense of the word, dialogic, referring not only to the Fauve movement itself but also to "someone else's speech" on that subject.[54]

Let us take it that this implicit defense of the Symbolist enterprise was called for, that the second voice represented by the Symbolist critical excess existed. An alternative assessment of Fauvism, accordingly, must have been possible in these years, an interpretation in which these paintings were granted the power to record the physical world directly, without spiritual mediation. The canvases of Derain and Vlaminck allow, even solicit, such an approach.

The sheer variety of scenes portrayed by Vlaminck at Chatou and Derain in London promotes the importance of the sites themselves. Vlaminck trekked up and down the Seine, staying close to the river and moving into the hinterland, to present a seemingly comprehensive view of life in and around Chatou. His vision cast itself as a roving reportorial eye, capturing all types of landscape, of people, of activities, in the Parisian suburbs. These things, Vlaminck's paintings insist, are worth taking the trouble to observe.

Derain's vignettes of London take us on a small tour of the sights of the city. In addition to presenting views of the Houses of Parliament and the upstream bridges as did Monet, Derain's canvases take us inland to Hyde Park and Regent Street, as well as downstream to a great number of bridges ignored by Monet, and finally to the Pool of London. Derain, moreover, did not for the most part repeat his motifs: views of the city, not vapor and light, vary in Derain's series.

Just as he surveyed sites, Derain catalogued people. Forsaking the lofty perches from which Monet communed with fog and cloud, Derain set his easel up on the embankments and on the streets, making himself a witness of the passing Londoners. From his vantage point at the curb line in *Regent Street* (fig. 8), Derain methodically presented the diversity of pedestrians in London. Along the sidewalk a natty chap in a bowler swaggers alongside his well-dressed lady, other female shoppers populate the sidewalk behind them, and at the far left a sandwich man—a uniquely Londonian character that French tourists were advised to keep an eye out for[55]—braves the street. Here, too, Derain offered a compendium of English vehicles: several cabs and a horse-drawn bus, a two-wheeled cart with its cargo of ornately bonneted women, a bicyclist bearing down to avoid thundering hoofs, and even, perhaps, a newfangled automobile venturing into traffic in the far left lane. Derain's care in classifying and recording life in London would seem to bestow pictorial significance to everyday people and things.

New themes, it would seem, called for new means. To capture this abundance of local detail, Vlaminck and Derain forged a non-visual link between depicted scene and painterly rendition. Their pictures of Chatou and London play down iconic visual

8. André Derain. *Regent Street*. New York: Metropolitan Museum of Art. 1905–06.

resemblance in favor of the seeming directness of the indexical physical imprint, as if the depicted site pressed its characteristics into the rugged surface of the painted canvas. In the place of visual impression the Fauves offered physical impress. Between the sites of Chatou and London and their paintings, Vlaminck and Derain formulated a tactile rhyme.

Vlaminck's canvases are filled with passages where the artist matched the texture of his paints to material characteristics of the objects he portrayed. In *Chestnut Trees at Chatou* (fig. 3), palpable pigments mimic the staccato confusion of the undergrowth, the corrugation of tree trunks, the sinuosity of the branches, and the flow of the clothing and hair of the chestnut gatherers. Similarly in *The "Restaurant de la Machine" at Bougival* (fig. 7), the paints copy the surface qualities of that which they depict: walls are flat, the street is pebbled, foreground grass is choppy and the tree trunk has its gnarls. "What I wanted to paint," claimed Vlaminck many years later, "was the object itself, with its weight, its density, as if I had represented it with the very material of which it was made."[56]

Comparable passages abound in Derain's London paintings: the flat surfaces of the sandwich sign in *Regent Street* (fig. 8), for instance, or the choppy brush strokes depicting waves in *Waterloo Bridge* (fig. 6) and *Charing Cross Bridge* (fig. 5). But Derain did more: he mutated optical effects into tactile qualities. The view in *Charing Cross*

Bridge looks toward the sun, and rays of sunlight bounce off the surface of the Thames as they pass beneath the span in the distance. Three distinct zones result: water in shadow on the left, illuminated water on the right, and the glaring light of the sun glade between the two. To each, Derain assigned its own surface texture so that the visual phenomenon of shadow takes on the physical characteristic of smoothness and bright light becomes asperity. "Relations of volumes can express a certain light or a joining of lights," wrote Derain to Vlaminck from London.[57] Light, no longer an elusive visual effect as it was in Monet's pictures, assumes the volumetric palpability of thick paint on canvas.

Still, Derain did not purge visual variations from his canvases. Just as each of the three zones in the lower half of *Charing Cross Bridge* has its own surface texture, it possesses its own discrete, saturated hue: red, yellow and blue from left to right across the canvas. Color here, like texture, hardly mimics effect visually; shadows are no more red than is bright light choppy. Hue seems, rather, the attribute of pigment itself, squeezed straight from the tube. But this is simply to say that the visual phenomena radiating from the depicted scene assume the guise, once again, of the physical properties of paint on canvas. The pure cadmium of Derain's pigment, not a certain shade of yellow, renders the sun glade in *Charing Cross Bridge*; cobalt rather than the color blue represents less illuminated waters. Any tonal modulation of pure pigments, any mixing of paints, would suggest an attempt to replicate a visual stimulus iconically, but Derain made few such gestures. By treating even chromatic variation as an attribute of the paints used to render light rather than of light itself, Derain allowed color—even where it translated visual phenomena—to pretend to the same direct accessibility as the tactile brush strokes on his canvas.

Through these two mechanisms—textural variation and the chromatic difference of actual pigment—Derain's paintings systematically reformulated in physical terms virtually all the established painterly conventions for treating permutations of light. Chiaroscuro modeling, the depiction through gradual tonal variation of light falling across rounded surfaces, has no place in Derain's chromatically saturated canvases. In *Charing Cross Bridge*, nevertheless, well-laden brush strokes, though uniformly blue, impart a strong sense of corporeality to the depicted boats by tracing their contours. The minute corrugations inscribed by the hairs of the brush reconstruct the curves of these craft, plank by bowed plank. And in *The Pool of London* (fig. 16), a bright swatch of blue and another of red suffice to delineate the circular smokestack half sunlit and half in shadow; the central mast likewise splits between pink and yellow along its terminator line.

Atmospheric perspective, too, can take a material turn in Derain's pictures. In *The Mountains, Collioure* of 1905 (fig. 9), a painting Derain executed in the south of France around the time of his two trips to London, color does not mellow toward softened tones of blue as it approaches the horizon; rather, intense oranges and blues clash among the background mountains. The suggestion of recession into depth depends instead in this work on permutations of texture. Tightly-packed, short and explosive brush strokes offer the gritty detail of proximate things, while longer, smoother strokes fill middleground, and flat planes of color instill the sweep of distance.

Hence in Fauve pictures an entire range of visual sensations pose as the physical properties of painting itself. This, however, was no simple substitution of one grounds

9. André Derain. *The Mountains, Collioure*. Washington: National Gallery of Art. 1905.

of representation in the place of another, for Fauve technique claimed a greater immediacy to the objects it portrayed. Vision and touch, during the first decade of the twentieth century, implied radically differing manners of knowing the world. In an age when late-Impressionist and Symbolist expectations reigned and virtually all viewers were fluent in a vocabulary of *impression* and *effet*, any vision of an object stood over and against the object itself, a phenomenon against its noumenon. And since that phenomenon represented a mediation between world and viewer, invoking the very process of vision could not help but activate the metaphor, in the fashion of the late works of Monet, that equated intervening *effet* to both interpretive painter and labored canvas. Tactility, on the contrary, promised perceptual immediacy, an escape from mediation. Wrote the aesthetician Lucien Bray in 1902: "Taste, touch and smell are the *senses of contact* . . . ; the eye and the ear are adapted to perceive *at a distance*." Where the former produced "visceral" reactions, the latter appealed to "our mental state."[58]

The Fauves, by recording vision as well as matter in the *substance* of their oil medium, worked in a manner that proposed to cut the mental and artistic interventions implied by sight out of the process of representation altogether. The fact that the Fauves' paints and the solid objects of London or Chatou shared a common materiality, moreover, elided the difference between painting and subject matter by conflating each brush stroke's status as representation and as object. The extreme simplicity of Derain's and Vlaminck's technique made it nearly impossible to differentiate those aspects of the picture that represented physical London or Chatou from those that existed as autonomous formal properties of actual paint. In a late canvas by Monet, by contrast, careful viewers could recognize the depicted image of a boat or a cloud, then subsequently move in closer to discover the individual small brush strokes that, each taken on their own, were entirely non-mimetic. Portrayal of the site and formal play occurred on two different registers of perception. Not so with the Fauves: this dab of yellow, this line of blue referred simultaneously both to the crest of a sunlit wave or the

gunwale of a boat and to their own qualities as paint. No level of technical nuance existed below these patently obvious masses of pigment and medium; the corpulent streak that incarnated the materiality of paint could not be divorced from the descriptive passage that evoked London or Chatou, for the two were one and the same.

London and Chatou issue forth as if no less proximate to the viewer than the surface of the canvas. The gap of iconic resemblance—that property of looking alike, but not being the same thing—had ostensibly been closed. We apprehend tactile differences in Fauve paintings with our eyes, of course, not with our fingers. No matter; the mediations that operated within the late-Impressionist and Symbolist programs had here lost their visual foundations. Embodiment replaces resemblance; the death mask pretends to be the living face.

Read in this way, Fauvism constitutes a naturalist manner of painting; to distinguish the Fauves from earlier naturalist movements, I will label this tactile means of rendition "neo-naturalism." As I coin this term, let me be explicit about how I mean to use it. "Naturalism," neo- or otherwise, is a product of rhetoric, not of the real. The degree of a painting's naturalism cannot be determined by evaluating in an absolute sense how closely that image corresponds with some pre-existent "nature"—how well, for example Derain's pictures match up with the "real" London or Vlaminck's with Chatou. Such an approach begs all questions since it fails to identify both that which constitutes nature and on which grounds a correspondence between picture and nature should be sought. In practice, conventions—more precisely, conventions of representation—specify both what counts as nature and when images should be considered to coincide with that nature. Naturalism, in short, is always conventional, and nature always fashioned by representation. Paradoxically, naturalism typically effaces its status as convention by insisting that the nature it captures is self-evident (not selected by convention) and that the correspondence between image and nature is so close as be natural (not conventional).

As I label Fauve painting neo-naturalist, then, I mean to suggest that these paintings formulated new conventions for naming "nature" and also for establishing the "natural" correspondence of images with that entity. The nature that was London and Chatou, according to Derain's and Vlaminck's paintings, took the form of the physical substances of these places, not the light rays those substances reflected. And the Fauve paintings could appear to correspond quite closely to that nature since they matched the materiality of their own pigments to the physical substances of London and Chatou. That matching, moreover, seemingly enjoyed the "natural" visceral immediacy to which the sense of touch laid claim.

Early Impressionist paintings had, of course, also formulated a certain kind of naturalism, basing their correspondence with nature on an ostensibly accurate visual rendition of "atmosphere." However, the conventions of naturalism change with time, and they were not the same in 1905 as they were in 1870. In 1870 the depiction of atmospheric effects, along with the choice of a theme from modern life, had strong connotations of naturalism. By 1905 atmosphere contributed more or less exclusively to the construction of Symbolist and pantheistic readings of art, in the manner of Monet's late works. Ironically any portrayal of the visual effects of vapors and light in 1905, no matter how devoted to meteorological accuracy, turned a picture into an essay on spiritual transcendence where paint corresponded, in a supernatural way, to more

than simply the nature of the site. In contrast Fauve canvases, simple, quick and viscerally tactile, could sanction the belief that painting transcribed nature naturally, free from both the distancing mediation of vision and the openly acknowledged artifice of sustained artistic intercession.

A contemporary critic or two, in passing, hint at this interpretative approach to Fauve painting. André Pératé found verity in Vlaminck's pictures at the Salon d'Automne of 1907 by conflating in his description the stirring up of water and the swirling of paints: "The barbaric brutality [of M. Vlaminck] knows how to condense the essential traits of a landscape; his *Boats* dig eddies into the Seine that twirl and twist with a power surprising in its truthfulness."[59] This passage formulates a perfect match between painted image and real world—a match where one becomes indistinguishable from the other—for here it is Vlaminck's picture entitled *Bateaux*, not some (non-italicized) boats, that churns the waters of the Seine. Paul Gsell's assessment of the Fauves from 1909 credited the movement with the eradication of mental mediation: "Concerned above all with material exactitude, they seem to distrust thought and sentiment."[60] A productive ambiguity authorized this claim: Gsell did not specify whether he thought the Fauves concerned themselves with the materiality of painting or with that of the object.

Comments such as Pératé's and Gsell's on the Fauves, it is true, are rare and elliptical; most critics in the first decade of the twentieth century opted for the Symbolist line. Yet the institution of criticism may have had its own interests at stake in embracing the Symbolist logic of mystical artistic mediation. The very practice of criticism depended on the existence of enigmatic artistic interpretation since paintings executed in such a recondite manner required in turn a reinterpretation by the critic in order to be made available to the viewing public. In a revealing discussion from 1908 of his own critical role, Mauclair, the champion of late Impressionism, assigned himself and other critics the same quasi-religious function of mediation usually reserved for artists:

> [The critic] is the intermediary, which Socrates more frankly called the mediator, of minds [*esprits*] . . . Assimilating and recomposing a whole series of ideas and emotions that have lead to the creation of an oeuvre, he converts them into accessible and clear formulas on which the public will be able to nourish itself. From whom does he take his mandate? From his conviction, from his sympathy, from his altruism, like the priest explaining God to his brothers in humanity. . . . Criticism is an ideological vocation, and an art, that as well, but above all an apostolate. . . .
> One will sense that he serves neither more nor less than the artist himself.[61]

To treat Fauvism as failed Symbolism reaffirmed the mediating role of the critic between painting and the public. The paucity of critical accounts that describe Fauvism as direct tactile transcription does not mean that such an interpretation of the paintings was impossible at the time, but simply that critics were not in the business of providing it. The defensive excess in Symbolist writing about the Fauves indicates, in fact, that critics were in the business of warding it off.[62]

The neo-naturalist interpretation disowned the idea that meaning needed to be articulated in words at all. Obviously this reading of Fauve painting, reticent about its own program, proves somewhat elusive to our historical investigation. In the place of

explicit formulations, however, we can rely on distinct traces—the redundancy in the Symbolist attack, the elliptical comments of a handful of critics—to indicate the currency of the neo-naturalist reading, along side the Symbolist one, during the early years of this century. Further instances of this interpretation, added resonances to the concept, will accumulate in the chapters to come. In many ways, the remainder of this book will be devoted to discerning the nature of the neo-naturalist assessment of Fauvism and exploring the transactions involved in its establishment.

<div align="center">4</div>

Painting that renounced spiritual transcendence was painting married to the mundane reality of its subject matter. Fauve canvases—read as neo-naturalist works, as I will be doing in the following pages—fused artistic expression and the passing moments of life into one. What happened in the streets of London or on the riverbanks of the Seine, it would appear, was what these pictures were all about.

If few cultural artifacts had the pretension to speak of the eternal essences of places, many claimed to record the activities of daily life. Fauve pictures, in leaving behind the lofty recesses of late-Impressionist and Symbolist painting, plunged themselves into a sea of representations—books, polemical pamphlets, prints, postcards, and even personal experience of the sites—all of which asserted that they revealed the truth about mundane London and Chatou. Indeed, the "real" London or Chatou consisted, in each contemporary mind, of nothing other than a composite image of each place pieced together from these many accounts, negotiated out of their competing and complementary claims. Derain's and Vlaminck's neo-naturalist paintings, by speaking of the material world, inevitably participated in this traffic of representations.

French descriptions of London, visual and verbal, tended to conform to one of two general interpretive regimes: the polemic of social reform or the ostensibly less motivated vision of the tourist. Explicitly or implicitly, each regime asserted its capacity to render London accurately, to reveal the city's true character. Yet in so doing each interpretive practice also inevitably excluded from its attentions aspects of London stressed by the other.

At first it may seem that Derain's paintings exclude little. Derain, as we have seen, had encyclopedic inclinations during his London campaigns. He hopped from merchant port to riverscape to shopping street; he catalogued urban types ranging from dock workers to sandwich men to dapper gents. His series laid claim to providing a complete record of London, a comprehensive survey of the English capital.

To French social reformers, however, Derain's canvases would have seemed to leave an enormous gap in the typology of Londoners. Within the pages of reformist texts a special cast of characters, invisible in Derain's paintings, comes to light: the poor, the beggars, the ruffians; in a word, the dispossessed. In 1900 Edouard Deiss, a French visitor who championed the works of the Salvation Army in England, recounted seeing along the sidewalks of London "beings, born of women like themselves, in rags and dirty."[63] The presence of such lost souls, in these accounts, turned London into a city of extreme social contrast. Commencing in an ironic tone, Deiss expounded:

England is the country blessed with jarring opposition. The teeming crowd in the

10. *Nocturnal Attack by Two Hooligans*. Drawing. Published in W[illiam] H. Dumont & Ed[ward] Suger, *Londres et les Anglais* (Paris, 1908), 203.

City is, to the utmost degree, characterized by this duality. Few classes of people: the rich or those who appear to be rich and the wretched in sordid clothing.

. . . The spectacle is unique. London presents that opposition of things, unknown in Paris and in the majority of our French cities: the spectacle of the greatest opulence and the most extreme misery.[64]

Radical social disparity could obviously be seen as detrimental to the lower classes; many pages of Deiss's book and other reformist texts devoted themselves to documenting the hardships of the poor. But even the well-to-do could suffer its consequences— as an illustration in William E. Dumont's and Edward Suger's book *Londres et les Anglais* of 1908 made frighteningly clear (fig. 10). For continental readers—these reformist books and articles, after all, were destined for the French—social bifurcation in London could have varied meaning. To some, these texts sounded the clarion for social justice at home; any similar poverty, the argument ran, must be eradicated from French streets. To others, they provided the comforting assurance that ruinous poverty was a foreign affair, "unknown in Paris." And perhaps to all, reformist tracts must have served notice of the dangers inherent in venturing to London, a land where merely sporting a well-tailored coat could make one fall victim to the notorious "hooligans."

Derain's pictures do not, like Monet's canvases, simply sidestep this vision of London; they actively work to erase the signs of social conflict. The curbside viewpoint in *Regent Street* (fig. 8) promises to capture the full spectrum of street life in the posh West End of London, and the variety of social types depicted in this work seems to deliver. Yet for those who wished to find them here, the dispossessed could be spotted among the wealthy shoppers. "One encounters in this street," claimed Dumont and Suger about Oxford Street, which intersects Regent Street and forms part of the same shopping district, "all of the types of London, from the little street urchin to the grand lady opulently dressed."[65] The diversity of social types presented by Derain's painting extends no further down the social scale than to the sandwich man, a worker productively engaged in the machinery of commerce. Derain, like many a neophyte traveler, was fascinated by wealth: fancy stores and well-dressed customers. His pictures exercised a type of blindness ascribed by French reformers to the English upper

classes themselves. Bemoaned Deiss after describing the daily confrontation of rich and poor: "I would not be far from believing the Englishman endowed with a sixth sense that permits him not to see those things capable of upsetting his temper."[66]

Perhaps the best place in London from which to expunge the traces of class conflict was not inland but along the banks of the Thames, Derain's favored location for painting. Economic disparity, in descriptions of London written by Frenchmen, was quite frequently figured geographically as the juxtaposition of the poor east to the rich west of the city.[67] The river, in contrast, belonged to no one class in particular. The destitute may have daily invaded the fine streets of the west, but this was not considered their territory; only along the Thames could workers from the east legitimately penetrate the west without stepping foot on soil foreign to their class. The travel writer Louis Bourgouin-Malchante, standing on Westminster Bridge, exclaimed in 1909 about the sheer variety of craft—and classes—passing below him:

> I see immense processions of large boats, of barges full to the gunwales and riding low in the water.
>
> Here is one that a single man alone nonetheless maneuvers. Here also are steamers towing yet more overloaded barges. And all these boats cross paths without running foul of each other.
>
> Pleasure boats dash assuredly around in the middle of all this. Chartered boats, boats providing regular connections to Kew.[68]

On the river, classes could mix "without running foul of each other." It helped, of course, that any lower-class man steaming or rowing his way upstream on a boat was gainfully employed as a riverman and thus, to use Louis Chevalier's famous phrase, part of the *classes labourieuses* rather than of the *classes dangereuses*. No muggings occurred on the Thames; here there were no vivid contrasts between scruffy ruffians and opulent ladies. On the river, boats steered a course of class harmony.

Derain's many pictures from near the Thames help spin this tale of class accord. In the *Houses of Parliament, London* (fig. 11) commercial vessels with their smokestacks, low horizontal masses with occasional vertical protrusions, echo the structure of the buildings and towers of Parliament. Boats and buildings here are metonyms for the two great classes of London; workers and *dirigeants*, the leaders of the nation, live together in symbiosis.[69] The parity of physical London and the substance of paint posited by Derain's technique reinforced this sense of harmony. The relationship between site and paint, after all, was reciprocal. If physical pigment could pass itself off as the material of London, London could take on the guise of thick paints. The coordination of paint textures and hue achieved by matching pasty blue barge to pasty blue Parliament thereby enacted, on canvas, the concordance of class. Countless pictures by Derain similarly integrate working craft on the river with surrounding edifices and bridges on the western side of the city.

At points, Derain's views of the Thames appear to tip the balance of class decidedly in favor of the river workers, placing us in their shoes. Of all of Derain's canvases, ironically, these pictures serve most effectively to deny that separate classes experience the city in different ways. The vertiginous perspective taken by Derain in *The Two Barges* (fig. 13) at first appears to lower the viewer into the boats passing below.[70] The drop is arrested midway, however, before we actually find ourselves rubbing elbows

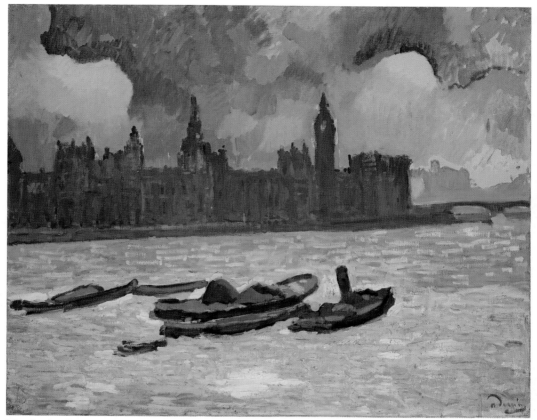

11. André Derain. *Houses of Parliament, London*. New York: Metropolitan Museum of Art.
1905–06.

with the working-class boatmen. Tucked between the hulls of the two vessels in which they labor sits the base of a pier that assures our foothold on a stable bridge. Moreover, at the top of the picture what appears to be the tip of Victoria Tower, part of Parliament, reflects off the surface of the water; we are probably upstream in Westminster. The two vertical bookends of pier and reflection establish that the perspective in *The Two Barges* is not a proletarian one. Yet the initial confusion conflates the workers' view from the river with that of the stroller on the bridges of the western side. Just as class lines do not divide society in Derain's pictures, they create no rifts in vision.

A handful of Derain's paintings actually do venture into the proletarian east. The expansive deck of an ocean-going steamer fills much of the foreground of *The Pool of London* (fig. 16), and we the viewers can witness the activities of its industrious crew. Derain has brought us to the Pool of London, the heart of the English shipping trade. This is the world of dirty hands and hard work, far from the comforts enjoyed by the *dirigeants* in the west. Here at last it seems Derain may have created the working-class counterpart to his views of Regent's Street and the western, upstream reaches of the Thames.

Yet *The Pool of London* converts this potentially working-class theme into a safe image of the east, perfectly compatible with Derain's upstream depictions of London. In *The Pool of London*, much as in *The Two Barges*, Derain propped the viewer safely above the many boats below. A large red base of a pier juts up from the bottom edge

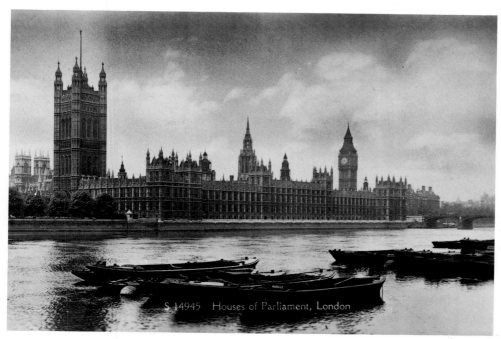

12. *Houses of Parliament, London*. Postcard photograph. Undated.

13. André Derain. *The Two Barges*. Paris: Musée National d'Art Moderne. 1905–06.

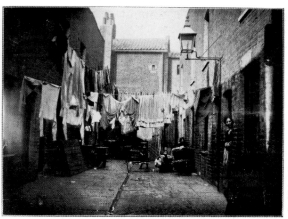

14. *Blind Alley in the Slums, Shoreditch*.
Photograph. Published in F. de Bernhardt, *Londres et la Vie à Londres* (Paris, 1906), 225.

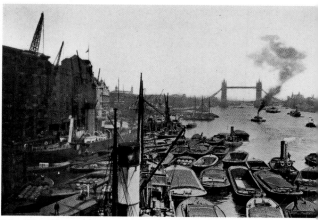

15. *The Thames Near the Docks*. Photograph. Published in Joseph Aynard, *Londres, Hampton Court et Windsor* (Paris, 1912), 7.

of the canvas: we are planted on a firm structure, elevated above the deck of even the largest steamer on view. Not all of Derain's pictures of the Pool of London—there are at least four others—include this pier, but all are painted from a standpoint distinctly above any boats depicted directly below. This is the perspective not of a boatman but that of an observer on a tour of the eastern half of the city to witness the world-renowned activities of English maritime commerce. Just as wealth enthralled Derain in *Regent Street*, here the modernity of large steam ships and industrial dock equipment attracted his attention.

The Pool of London does more than just observe: it also assures its viewers that the east, despite all those rumors of poverty and hooliganism, was essentially the same as the west. Except for the sheer size of the steamer, life on the river in *The Pool of London* is identical to that portrayed by Derain in his upstream pictures: these are gainfully employed and active workers, busily contributing their part to the great English economic machine. Tower Bridge, looming in the background of *The Pool of London*, greatly strengthens this message of the equivalence of east and west. The bridge was—fortuitously, to be sure—one of the most prominent monuments in the social geography of London: standing at the boundary that divided east and west, its great height possessed the dual advantages of being visible from most of central London and of appearing exactly the same from both directions. To include Tower Bridge in a picture of the east of London was to declare that the east was no more than a mirror image of the western half of the city.

If the conflations executed by Derain's paintings—of rich and poor, of west and east, of one class's vision and another's—distanced these pictures from the reformists' program, it brought them quite closely in line with the other prevalent manner of viewing the city: the tourist's perspective. Undoubtedly more French citizens visited the English capital with a tourist's disposition than with a reformer's. That frame of mind was programed and transcribed in an extensive collection of guidebooks and postcards, words and pictures that both lead and followed tourists to the sites of London. Like Derain, tourists gawked at Regent Street, "London's center of commerce in luxury goods."[71] Nevertheless, the tourist, like Derain, preferred the view from the river: "The Thames with its docks and its vessels is the first image that one has of London, and it is the most accurate," exclaimed the travel writer Joseph Aynard in 1912. "The Thames is indeed the principal trait of London's scenery and beauty. It

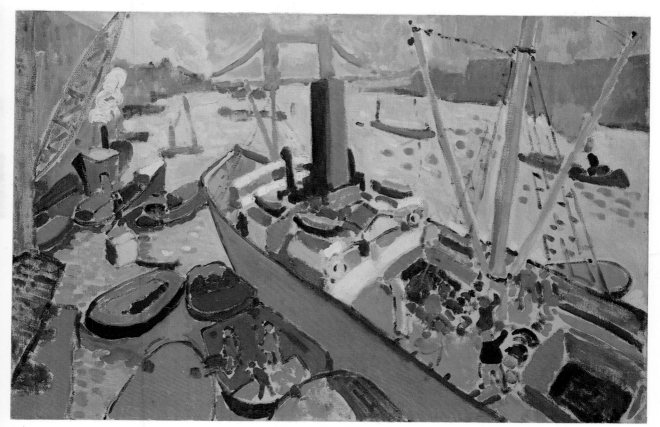

16. André Derain. *The Pool of London*. London: Tate Gallery. 1905–06.

is from the Thames and its bridges that one must see London."[72] And if tourists journeyed east, they, again like Derain, did so but briefly and kept close to the docks. Bourgouin-Malchante, whose trip to London lasted almost two months, spent but just one day in the east, while the Baedeker guide in French devoted only six and a half of its over two hundred pages on London to that side of the city, and more than half of that space to the commercial embankments.[73]

Photographers who supplied tourist guides and postcard publishers framed the city much as did Derain. For virtually every painting there exists a postcard or guidebook photograph with a homologous view; *Houses of Parliament, London* (fig. 11), finds its double in a contemporaneous postcard (fig. 12), while *The Pool of London* (fig. 16) and a photographic illustration in Aynard's book (fig. 15) echo each other. Like Derain, tourist photographers made few forays into the east side and produced images in which no hooligans or beggars spoil the prospect. These photographs and paintings deploy the same pictorial strategies for the denial of class difference. The blindness that the reformer Deiss attributed to the English upper classes describes not just Derain's viewpoint but the tourist's perspective as well.

That blindness, however, was less a failure to see than a different mode of sight. The tourist's view—and Derain's—adopted a passive stance, ostensibly recording that which the cityscape yielded forth on its own accord. "What is the illustrated postcard?," the editors of *Figaro illustré* asked rhetorically in 1904, "it is the infinite kaleidoscope in which can be reflected as many views as Nature and Humanity

present, have presented, and will present to it."[74] Vision here was mere reflection; it pretended not to search or select—though in so doing, of course, it recorded not some objective version of London but rather that which had already been given up to sight by previous tourists and painters.

The reformer's vision, in contrast, claimed to probe actively into parts of the city as yet unseen. Consider, for instance, the barriers confronted by F. de Bernhardt—the photograph entitled *Blind Alley in the Slums, Shoreditch* (fig. 14) is from his book *Londres et la Vie à Londres* of 1906—as he sought to explore the inland tenements of the East End:

> To arrive [at the dwellings of the poor], it is necessary to penetrate into the building courtyards, saturated with poisonous and nauseating gases emitted from piles of garbage and stagnant puddles. Never does a ray of sunshine penetrate in these courtyards; nor, for that matter, does a whiff of fresh air enter. One climbs a rotting staircase that threatens to collapse at every step. What am I saying?—in certain spots it has already happened and the outsider who ventures in these passages encounters patch-job repairs where he risks breaking his neck a hundred times. One next passes through gloomy, filthy corridors where vermin swarm. Finally, if one has not been repelled by the appalling stenches that fill the atmosphere, one penetrates into those hovels where thousands of human beings are heaped one upon another.[75]

Bernhardt's text and photographs present not just the misery of the east, but also the author's struggle to perceive it. To be sure, Bernhardt was not the first French visitor to penetrate the slums, but the rhetoric of his prose casts him as an explorer in uncharted and often dangerous territory. His eventual triumph over obscurity figures both his personal enlightenment and the success of the active vision of social reform in creating new knowledge about its object. Nothing could be further from the tourist's apparently reiterative experience of the established monuments of the city.

Though they may have differed in much else, the late paintings of Monet and reformist vision thus shared the project of forging new meaning—spiritual essences in one case, a recognition of injustice in the other—out of the site of London. Derain's selection of motifs, meanwhile, seemed to hand over to London the active role of reflecting itself in the artist's images; like his neo-naturalist technique, his treatment of themes effaced the artist's mediations. In their apparent passivity, these paintings and tourist accounts alike took the lack of class tension in London as given—which is to say, rather, that they had the effect of positing social harmony as truth by disowning their own role in producing that image. Derain, bringing the practices of painting to the project, added his voice to a large chorus of French visitors to the English capital who saw no conflict in London, and presumed no struggle in that act of seeing.[76]

5

Chatou, even more than London, was hotly contested territory in the first decade of the twentieth century. Contested in a double sense, as a large number of cultural artifacts competed with each other to define, each in their own way, the nature of the social conflicts buffeting the area. Rather than a simple bifurcation between rich and

JOURNAL AMUSANT

JOURNAL ILLUSTRÉ.

Journal d'images, journal comique, critique, satirique, etc.

AUX CHAMPS. — par A. Grévin.

La régate dans le bassin de Rueil
ou le contenant et le contenu.

17. Alfred Grévin. *In the Fields.* Wood engraving. Published in *Le Journal amusant*, 7 August 1875.

18. *The Regatta in the Basin of Rueil, or the Container and the Contained.* Drawing. Published in Georges P. Thierry, *A travers un siècle de notre yachting de course à voile* (Paris, 1948), 219.

poor, lines of division in these years cut across the social landscape of Chatou in a variety of directions.

In Renoir's day, Parisians of varied social rank, attracted by the region's aquatic and convivial recreations, disputed suburban turf with the locals and with each other.[77] The contrasts between Sunday visitors and permanent residents could be made the stuff of satire, such as in the wood engraving entitled *In the Fields* by Alfred Grévin, which appeared as the cover of *Le Journal amusant* in 1875 (fig. 17).[78] Clashes of this sort continued into the twentieth century, but to a lesser extent. The Seine at Chatou, as seen through the eyes of the weekend visitor or guidebook writer from Paris, had lost some of its power to draw boaters and other excursionists to its shores. Octave Beauchamp, describing Chatou in 1910, lamented: "boating is flourishing much less than in former times on the river," and the guidebook published in 1912 by Hachette acknowledged that Bougival, neighboring Chatou, was a "site formerly famous and much frequented by painters and boaters."[79] Riverside cafés were in serious decline. The renowned Grenoullière had by 1900 earned a scurrilous reputation and by 1914 would be closed for good; other restaurants, including Renoir's Restaurant Fournaise, would soon suffer the same fate.[80]

New conflicts displaced the old. Commentators from Paris claimed that the increasing demands placed on the river by nautical commerce, as the ever greater number of tugs and barges making their way to or from the ports of Paris bottlenecked at the heavily navigated locks of Bougival,[81] drove recreational boaters away. Owners of pleasure craft could have retreated to the dead waters of the smaller, undredged channel that ran parallel to the main channel behind a line of islands running from Carrières-Saint-Denis (now Carrières-sur-Seine) to Saint-Germain-en-Laye; Ardouin-Dumazet commented in 1907 on this alternative in his guidebook.[82] Given

the rapid decline of the area around Chatou as a recreational center, presumably sailors and rowers considered this an unsatisfactory solution. An illustration in Georges P. Thierry's history of sailing in France (fig. 18) expressed the attitude of despairing recreational boaters toward the river; eventually Thierry's beloved Cercle Nautique de Chatou, established in Chatou in 1902, found conditions on the river there unbearable and moved their craft *en masse* downstream to Meulan, adopting the new and more general name "Yacht Club de l'Ile-de-France."[83] Traffic on the water, not crowds on the shore, had become the Sunday visitor's chief adversary.

The view from land, as articulated by anarchist sympathizers of agrarian workers, had changed as well.[84] The plight of the small-scale market gardeners in the suburbs was an obvious cause for the anarchists to adopt as their own since a number of anarchist writers, unlike racial polemicists more preoccupied with the plight of the urban proletariat, emphasized the need in the countryside for control of the small-scale means of production and for free access to the land.[85] In the anarchist press, the small tracts of agricultural land in the suburbs were treated as bastions under siege in the class war.

In František Kupka's lithograph *How Long Until the Allotment of Air Space?* of 1906 (fig. 19), typical of the many political prints published in the anarchist weekly *Les Temps nouveaux*, a strong and proud agrarian worker stands squarely on a plot of land. Bordered by a river and a small grove of trees evocative of the landscape in the Ile-de-France, this territory is most likely meant to be the suburbs outside Paris. The

19. František Kupka. *How Long Until the Allotment of Air Space?* Lithograph. Published in *Les Temps nouveaux*, 24 February 1906.

..... *A quand le lotissement de l'espace ?*

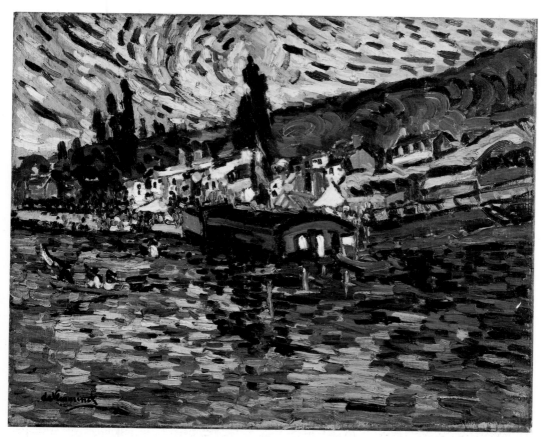

20. Maurice Vlaminck. *Regattas at Bougival*. New York: Richard L. Feigen & Co. c. 1906.

worker's pose declares that the earth he occupies should be placed at his disposal, but a forest of pickets that spell out legal prohibitions—"Private Property," "Land Belonging to the State," even "Fishing Prohibited"—restrict his access.[86] The whoring state, personified by a grotesque nude wearing a military bicorn and sitting astride a building flying the tricolor, oversees the allotment of the terrain, while a crowd of bourgeois in their top hats and bowlers line up to reap the spoils she distributes only to those able to pay her price.

Kupka's print suggests that the parceling out and selling of land to the bourgeoisie rather than the weekly trespasses of Sunday boatmen constituted the greatest danger to rural agriculture. The anarchists were not alone in remarking an invasion of new landowners from the capital: urban crowding in Paris and new rail lines into the surrounding region made attractive the practice—all too familiar to us today—of commuting daily from suburban residences into the city. Around Chatou, new houses and even apartment blocks displaced river taverns and market gardens alike.[87] The conversion was not complete in the first decade of the twentieth century—in 1907 Ardouin-Dumazet could still declare the carrot, a popular crop of market gardeners, to be king of the domains around Le Vésinet inland from Chatou[88]—but the battle lines were clearly drawn.

Where all these verbal and visual accounts detected social antagonism in the suburbs, Vlaminck's paintings found virtually none. Vlaminck's pictures name no enemies. The bourgeois drinkers in *Luncheon in the Country* (fig. 4) may be a bit ridiculous but they do not bear the mark of evil or of abusive power as do the bourgeoisie and the state in anarchist illustrations. And not the slightest hint of condemnation falls upon any of the other actors—Sunday boaters, proletarian boatmen, rural workers—that assume a place in Vlaminck's world.

There are no villains in Vlaminck's suburbs for there is no real competition for space. To be sure, the various groups who frequent these canvases do not intermingle as they did in Renoir's utopia, but they do manage to share the land and river without displacing their cohabitants. Whereas from the perspective of the sailing enthusiasts not enough space existed on the river for both sailboats and commercial vessels, Vlaminck found room for both. In *Regattas at Bougival* (fig. 20), a race between skiffs enjoys plenty of open water despite the large enclosed barge along the shore; Vlaminck, unlike the boaters described by Ardouin-Dumazet, felt no need to segregate traffic into separate channels of the river. Vivid and gay colors add to the air of relaxed festivity. Sailors and rowers have no reason to abandon Vlaminck's joyous world, and they do not; these canvases are filled with sailing craft and rowing boats in addition to barges and tugs, all plying the waters of the Seine.

Vlaminck's pictures similarly grant agricultural workers all the terrain they need. Women gather chestnuts unhampered in *Chestnut Trees at Chatou* (fig. 3), and in *The Wheat Farm with the Red House* (fig. 21), a farmer tends to his crop of grain or vegetables, perhaps in the rich flatland soils near Le Vésinet. These figures belong on the land, argue Vlaminck's images; they form part of the landscape. Choppy brush strokes dissolve the chestnut gatherers into their sun-dappled setting. The stooping laborer works his small plot of land that is but one piece of terrain well integrated into a patchwork of grain fields and vegetable patches. Buildings in the background, more likely village houses and light-industrial buildings than new bourgeois residences, do not impinge on the activities of agrarian life. The contented folk in these pictures are far from the victims of privations presented by the anarchist press. In Vlaminck's world, the interests and needs of one class never rub against those of another, and the friction of class conflict never generates the spark of social discontent.

Although Vlaminck's paintings of the suburbs diverged from the thematic emphasis of anarchist prints, there was an alternative manner in which these canvases could be seen as contributing to the anarchist cause. Anarchist political theory and pictorial practice postulated a two-pronged program for revolutionary change. In addition to prodding society onward with the stick of present injustice, anarchists offered the carrot of a better world to come. And, according to Jean Grave, anarchist theorist and editor of *Les Temps nouveaux* writing in 1895, the artist more than any other figure exemplified the type of unfettered individuality awaiting everyone after the revolution:

Free art, as we understand it, will make the artist his own and sole master. He will be able to give free reign to his imagination, to the caprices of his fantasy; he will execute the work of art as he will have conceived it, animate it with his inspiration, make it live with his enthusiasm.

... As a deranged person, who in this was right, phrased it: *Art, that supreme*

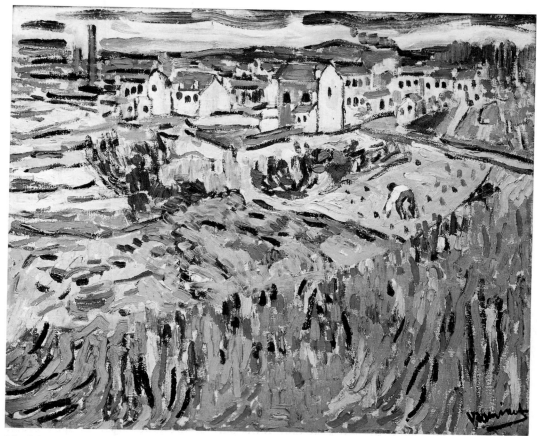

21. Maurice Vlaminck. *The Wheat Farm with the Red House.* Shizuoka: Prefectural Museum of Art. c. 1906.

manifestation of individualism, will contribute to the delight and the extension of the individual.[89]

At times it would seem that Vlaminck, a self-professed anarchist who published articles in the movement's press as early as 1900,[90] imagined his paintings fulfilling this second anarchist role. Vlaminck would write years later of his Fauve period in his autobiography *Tournant dangereux* of 1929:

My ardor allowed me complete audacity and shamelessness for neglecting the conventions of the craft [*métier*] of painting. I wanted to provoke a revolution in customs and habits, in everyday life, to show nature in liberty, to liberate it from the bygone theories of classicism, whose authority I hated as much as that of generals and colonels. I felt neither jealously nor hate, but rather a passion to recreate a new world, the world that my eyes saw, a world for myself alone.[91]

Certainly Vlaminck's simple, seemingly naïve technique constituted a rejection of the tired lessons of academic classicism. And to the degree that his forceful brush strokes and arbitrary colors could be read, along the lines of Van Gogh, as signs of artistic caprice, his individuality did declare itself liberated into an unconstrained world of its own making. Generations of art historians have been lead by Vlaminck's own

statements—and perhaps also by their own desire to link ostensibly progressive art with seemingly progressive politics—to conclude that these paintings embody the spirit of anarchism.[92]

To the extent that these pictures were about liberated individuality, however, they were not about mundane Chatou, at least as it was perceived by the anarchists. Complete freedom for the inhabitants of the suburbs, everyone within the anarchist camp could agree, was a promise not a fact. To express that promise required leaving the reality of the site—according to the anarchists, agrarian workers struggling for their bread—behind. But this was only to restate the Symbolist program in slightly modified terms: art must transcend the actualities of the moment to reach some greater ideal. In those moments when he spoke of recreating a new world for himself, Vlaminck clearly thought his works capable of such transcendence. Symbolist critics, insisting on enigma, did not. The organized anarchist press—while we need not necessarily grant it final say over what constituted anarchist art—preferred the pictorial solutions offered by Signac and the Neo-Impressionists.[93]

In another sense, however, individuality, no matter how pronounced it may have been by Vlaminck's technique, needed not be read as transcending Chatou as it existed in the present. The words of Vlaminck himself suggests such a reading, for the passage from *Tournant dangereux* in which he claimed to remake the world for himself paradoxically continued: "And I had no other requirement than to discover with the help of new means the profound ties that connected me to the earth itself."[94] Strong personality, yes; but personality empathically tethered to the place it calls home. The neo-naturalist equation of depicted site and physical paints expanded to include the third, coequal term of artistic persona. A particularly vivid and chromatically arbitrary passage—say, the tree trunks of unmodulated bright reds and blues in *The "Restaurant de la Machine" at Bougival* (fig. 7), or the veritable kaleidoscope of pure primary and secondary hues making up the cobblestones and grass of road and roadside in the same painting—could simultaneously point visually toward Vlaminck and physically toward Chatou. And in so doing, the passage hinted that the two, transitively, were one and the same.

Whose social position at Chatou did this notion of strong personality tied to the land represent? Stripped of the transcendental promise of anarchism, extreme individuality such as that exemplified by Vlaminck did not remain a neutral political concept. Others also claimed the concept of individuality as their own, and even Grave had to admit that the key phrase in his definition of anarchist art as "the supreme manifestation of individualism," had first been spoken by someone "deranged," presumably a political opponent. The bourgeois class, in particular, put the principle of individuality to its own use, and the values embodied by Vlaminck's painting, despite the artist's personal animosity to the middle classes, could easily slip out of the anarchist camp and into that of the bourgeoisie. The artist ran a special risk of having his anarchist beliefs turned to the expression of bourgeois values since he personified creative genius, the cultural category into which bourgeois liberalism ghettoized the concept of un-restrained personal freedom. As Michel Melot, in a path-breaking article discussing the anarchism of Camille Pissarro, has argued: "Ideal liberty is precisely that which the bourgeoisie requires the artist—but the artist alone—to represent. . . . a super-imposition [occurred] of the libertarian practice of art as the perfect flowering *of every*

individual and the liberal conception of art as a symbolic activity *reserved for certain individuals...*"[95] Vlaminck, artist of the earth, could embody the bourgeois conception of individuality no less effectively—and perhaps more so—than he did the anarchist version.

In a rare instance of humility in *Tournant dangereux*, Vlaminck recognized that his activity as a painter might well have realigned his own class affiliations:

August, the grain is ripe....

I stop. A team of reapers is forming sheafs. The sun beats down strongly, the people are sweating. The women cover their heads with kerchiefs and the men roll up their sleeves to their shoulders. I am uncomfortable. The reapers, as I stop, respectfully greet me: "Bonjour, monsieur." Face-to-face with them, I am ashamed of myself. My paint box and my canvas in hand, they have respect for the gentleman [*monsieur*] that I represent. I am ashamed not to work, not to grow the grain that I eat....

I try to find excuses for myself, to find valid reasons. I can only come up with hypocritical lies. The fact is there: art, painting, seem to me to be trickery...In front of them I am a dishonest man...

This is not the first time...[96]

For a moment Vlaminck regretted the fact that his chosen profession had irrevocably placed distance between himself and the workers in the fields. The laborer's "Bonjour, monsieur" cut to the quick for it marked the artist as a bourgeois—although Vlaminck himself only admitted to "represent" a bourgeois, not to be one.

Yet the Vlaminck of *Tournant dangereux*—winner of every fist fight, coiner of every devastating rejoinder, innovator of every modern artistic movement worth its salt—was not to be kept down for long, even by his own self-imposed shame. Within several pages he found the justification to paint that was more than a "hypocritical lie":

A path in the forest, the road, the bank of a river, a reflection of a house in the water, the profile of a boat, the sky with black clouds, the sky with pink clouds.

Using a rich palette is futile: you cannot come into profound contact with things by looking at a landscape through the door of an automobile like a tourist, or by spending your vacations in a corner of the countryside. You don't flirt with nature, you possess it.[97]

Landscape painting was a legitimate activity to the extent that the resulting canvas captured the reality the site. This required more than a passing commitment by the artist to the location, and Vlaminck chose a revealing metaphor to make the point: to paint a landscape is tantamount to "possessing" the land. Following directly after the verb "flirt," Vlaminck's "possess" carries a full load of sexual innuendo—his words suggest a particularly intimate, even invasive, form of access. Nonetheless the euphemism of possession reveals more than a politics of gender, for it also demonstrates how easily a discussion of landscape painting in the first decade of the twentieth century could find use for metaphors of property.[98]

The equation between representing land and owning it is age-old. It was certainly not unique to Vlaminck even in his own epoch: during these very years Monet was in the process of turning the equivalence of painting and possessing land into an

obsession at Giverny. Activated in relation to the suburbs on the Seine, however, the concept had special resonance. Vlaminck suggested that his relation as an artist to the area around Chatou resembled that of the people who owned the land there. And in the years that Vlaminck painted his pictures, those people were increasingly the new residential bourgeoisie who were constructing their homes on land once tilled for carrots and turnips. Vlaminck's paintings of the suburbs, certainly unintentionally, may well express the interests of the one class they do not portray. Indeed, the omission of the new bourgeois class from Vlaminck's paintings should not be surprising: either literally or figuratively a picture, to portray a particular view, need not include within its frame the ground upon which the artist stands. Vlaminck rendered the suburbs much as they must have appeared to the recent purchaser of a suburban home, who would have focused his attention more on the remaining signs of rusticity than on his compatriots from the city. Within the fictional world of Vlaminck's paintings, it is true, all classes enjoy the same rights to the land that the new bourgeois landowners themselves claimed: farmers, merry-makers and bargemen all seem at home on the land and waters around Chatou. But, again, this should be expected: displacement, like exploitation, exists only in the eyes of its victims and their sympathizers. If the reality of the area around Chatou as posited by the anarchists was rife with class conflict over the land, if the passing generation of boaters felt chased from the waters of the Seine, suburban reality from the perspective of Vlaminck and the newly arriving bourgeoisie alike was perfectly harmonious.

Ultimately, by this reading, all the characters who inhabited the suburbs may be beside the point in Vlaminck's canvases. Perhaps these figures, often minute, are mere *staffage* to the central object of these works, that which the bourgeoisie had left Paris to claim as its own: the landscape itself. Many of Vlaminck's views of the suburbs lack any human actors whatsoever. Interpreted purely as the physical record of a site, *The "Restaurant de la Machine" at Bougival* (fig. 7) resembles an empty stage set, waiting for the arrival of an unnamed protagonist to fill its space. We known now the name of the class that was in the process of occupying such suburban spaces in the years that Vlaminck painted his canvases. In another sense, however, the street depicted in *The "Restaurant de la Machine" at Bougival* is filled to capacity with the corpulent brush strokes and bright primary colors of Vlaminck's paints. In *Bank of the Seine at Chatou* (fig. 22), even more so, the illusion of vacant space along a riverside path is fleeting at best as Vlaminck's abundant brush strokes jump to the surface in constant defiance of spatial recession. Plenitude of style counters thematic emptiness. Such seemingly abstract passages, as we have seen, could represent something: an autonomous personality that declared through art its possession of the land. Vlaminck, in the name of artistic individuality, formulated in his Fauve canvases a means by which the gradual occupation of the suburbs by the new residential bourgeoisie could be represented on canvas without the class itself showing its face.

Vlaminck in Chatou, like Derain in London, had devised a manner of producing pictures that explicitly engaged the activity of oil painting in the daily events of the material world. For advocates of late Impressionism, for Symbolist critics, and perhaps for an idealist strain of anarchist thought, these canvases must have seemed painfully limited, a mortgaging of art to the constraints of physical reality. To be a naturalist,

22. Maurice Vlaminck. *Bank of the Seine at Chatou*. Paris: Musée d'Art Moderne de la Ville de Paris. c. 1906.

their arguments might have run, was to sacrifice the ability of art to forge new meaning. Yet for the Fauves to replace the pretense of transcendence with the pretense to naturalism in no way diminished the ideological power of their paintings to shape the meaning of a particular site. The Fauves' physical technique, though it claimed unity with material reality, was not enslaved by the physical objects it depicted. Nor was the Fauves' interpretation of the sites they portrayed, despite appearances, a simple reiteration of the tourist's attitude toward London or of the landowner's view of Chatou. Rather, these paintings were themselves the means by which such class-based perceptions could be formulated, and their efficacy was all the greater for presenting their vision as free from the distortions of mystical artistic interpretation. It was no mean feat—then as now—to make the radical economic disparities within a major metropolitan area or a contested countryside dissolve away, transfigured into a seemingly objective image of social and pictorial harmony. Neo-naturalism as practiced in Fauve painting, far from being a neutral or innocent manner of making a picture, constituted a powerful tool for constructing the hegemonic manner of viewing the world.

CHAPTER 2
Mirroring the Nude

"You don't flirt with nature, you possess it."[1] In staking the claim of the landscape artist (and, by extension, of the landowner) over the suburban countryside, Vlaminck invoked a sexual metaphor: one conquers the land like one conquers a woman. The parallel at the turn of the century was virtually a cliché; yet therein may have lain the efficacy of the formulation. The euphemism of "possession," a term from the politics of gender, provided the foundation for an assertion of control in the politics of land—without much attention being drawn to the turning of the trope.[2]

It will be my contention that much of the politics of Fauve landscape painting—not just Vlaminck's hackneyed dictum—grounded itself thus in the politics of gender. A "natural" way of looking at the female nude served as the (unheralded) model for a "natural" way of looking at the countryside. Many of the formal devices in Derain's and Vlaminck's paintings from around 1905 and 1906 that I have labeled "neo-naturalist" were in fact pioneered earlier, in a handful of paintings executed by Matisse between 1903 and 1905 that depict the female nude posed in the studio.

By concentrating closely on two of these early nudes by Matisse, I wish in this chapter to show how—and how easily—a technology of gendered "possession" came to present itself as natural. Matisse and the other Fauves, of course, hardly abandoned landscape for the nude during the Fauve years to come; eventually in their pastoral paintings they merged the two pictorial themes into one. Following their lead, I will in subsequent chapters examine how the technology of "possession" formulated in Matisse's pictures of the female nude crossed over, all but transparently, into Fauve paintings of the landscape and of the pastoral. In short, rather than taking the clichés actuated by Fauve painting for granted I would like disassemble their mechanisms and scrutinize the parts.

1

Whom does Matisse's *Carmelina* of 1903 (fig. 23) address? What was the audience this painting posited for itself in the first decade of the century? There may be an unexpected—and ultimately unviable—answer to these questions: the pictorial organization of the picture suggests the possibility of a spectatorial position for women. The central figure, which virtually fills the foreground, faces squarely out from the fictional space of the picture. Her countenance is as frontal as the rest of her body; this model, unlike innumerable nudes painted around the turn of the century, does not discretely

23. Henri Matisse. *Carmelina*. Boston: Museum of Fine Arts. 1903.

avert her gaze. She confronts her viewers, seemingly their equal.[3] Or perhaps, she is not so much an equal as a likeness. Contemporary spectators presented with this perspective onto face and body must have been struck—as we still are today—by its directness, for it is a view matched in its sense of forthright immediacy only by the image in a mirror. Since the figure is clearly female, Matisse's picture may have proposed that woman viewers could see on its surface a reflection of a member of their own sex.

"The traditional view of a mirror," writes Jane Gallop in her study of the French psychoanalyst Jacques Lacan, "is that it reflects a self, that it produces a secondary, more or less faithful likeness, an imitation, a translation of an already constituted original self. But Lacan posits that the mirror constructs the self, that the self as organized entity is actually an imitation of the cohesiveness of the mirror image."[4] If we accept that such a mechanism operated in *Carmelina* in 1903, then the body in the foreground of this painting produced a viewing position figured as female, a position from which an inferred women spectator could assume the role of the subject of sight.[5]

Undoubtedly in 1903 the position for the female spectator before *Carmelina* was riddled with contradictions, specifically those of class. The person Matisse portrayed was a model from the working classes, while the type of women who might have encountered an oil painting such as this in a gallery or Salon at the beginning of the century belonged, for the most part, to the bourgeoisie. Unabashed nudity, moreover, was not something to be expected of bourgeois French women in 1903,[6] and *Carmelina* could hardly rely on such grounds for identification. Matisse's painting required its inferred female spectator, in order to derive a sense of reflected subjectivity from the image, to suspend differences of class.

Difficulties for the female subject looking at *Carmelina* were yet greater still. The frontal female figure presents only half the story of the canvas. Behind the model on a table rests a mirror, and in that mirror appears, with the back of the woman, the artist himself, the bearded Matisse. Actually, the model on her own constitutes no story at all since only with the inclusion of the second actor does the painting generate a clear sense of narrative development.[7] In one possible tale, the reflected image introduces the cast of characters: Matisse, facing away from the model with his arms raised in work, is in the process of painting a nude. The product of his labors is the canvas that now stands before our eyes. Reading from left to right, making gives way to viewing, a progression culminating in the small framed print propped up on the mantelpiece. The recounting by *Carmelina* of its own production finds resolution in this object, unequivocally an image, that, like the body of the nude herself, is positioned perfectly parallel to the picture plane.

Appropriately the middle of this diegesis, its development sited in the central foreground, builds up a certain dramatic tension. This patch of canvas presents itself as both what Matisse saw in 1903, a nude sitting on a table, and what all spectators see at their various moments of viewing, the painted image of the model. The foreground scene thus enacts—it does not merely capture—the crux of this particular story: the transformation of a woman into her artistic representation. Through that process, also, the artist and viewer merge into one. The spot and moment once filled by Matisse in front of the canvas becomes indistinguishable from that occupied by all subsequent

24. Edouard Manet. *A Bar at the Folies-Bergère*. London: Courtauld Institute Galleries. 1881–82.

viewers. Spectators find themselves in Matisse's shoes: they are invited to identify with the artist who scrutinizes the model.

The viewer figured by this narrative structure of *Carmelina* is as distinctly male as the mirrored subjectivity set up by the isolated foreground figure was female. Asked to join with the artist in the enjoyment of the spectacle of the female nude, viewers find themselves aligned by erotic sight with that vision's male subject over and against its female object.[8] The gaze defines man as the opposite of woman, the seer rather than the seen. In an offhand quip in 1894, the essayist on contemporary habits and morals Octave Uzanne positioned the sexes in basically this same differential manner. "In a word," he wrote about woman to his implied male reader, "does she not appear to us as the plaything of our vanity, of our image of ourselves [*notre représentation*], of our egoism, and of our debauchery?"[9]

The spectator empathically linked to the artist assumed the role of male not only by indulging in the erotic contemplation of the female form but also by becoming the hero who drives the narrative forward. The film maker and theorist Laura Mulvey describes the process in cinema: "As the spectator identifies with the main male protagonist, he projects his look onto that of his like, his screen surrogate, so that the power of the male protagonist as he controls events coincides with the active power of the erotic look, both giving a satisfying sense of omnipotence."[10] When *Carmelina* is regarded as the exposition of Matisse's creation of the picture, man emerges as the subject of the story, and woman as the object of his gaze.

There are other possible tales told by the picture. Consider, for example, that the composition of *Carmelina* unquestionably invokes Manet's *Bar at the Folies-Bergère* of 1881–82 (fig. 24), a painting Matisse and many of his contemporaries would have seen at the Exposition Universelle in 1900. Matisse's canvas, although lacking some of the spatial and psychological complexity of Manet's *Bar at the Folies-Bergère* and retreating from its public setting into the studio, is basically the mirrored reversal of the earlier work; Matisse even echoed Manet's subtle difference between a stiffly frontal woman and her slightly inclined and thus seemingly more amenable reflected image. Once knowledge of this precedent is added to the scenario of *Carmelina*—few informed viewers at the beginning of the century would have missed it, and neither would most art historians today—dramatic tension and development also flows from Matisse's apparent venture to stake out his position as an artist, and *Carmelina*'s as a painting, against the renowned Manet and his well-known canvas of a barmaid.[11] Spectators could identify with the hero of this second story, experiencing through empathy the perils of the artistic endeavor, as readily as they did with the protagonist of the first tale.

Ultimately, in terms of gender, the two narratives may be much the same. The film theorist Teresa de Lauretis argues that the structure of narrative itself casts all readers into one of two sexually differentiated roles: either as the subject who faces difficulties and acts—the "male-hero-human"—or as the object that poses difficulties and is acted upon—the "purely symbolic other" of "female-object-boundary-space."[12] Accordingly, the artist of *Carmelina* and the spectators identified with him obtain the same standing as male subjects by confronting Manet's legacy—a difficulty to be overcome—as they do by pursuing and capturing the spectacle of the nude. "The drama," concludes de Lauretis, "has the movement of a passage, a crossing, an actively experienced transformation of the human being into—man."[13]

These interpretations of *Carmelina*, actuating the powers of narrative, do not invalidate the non-diegetic reading based on the mirroring of the female figure; they subsume it. Enticed by the reflection to recognize themselves in the painting, female viewers find woman instead the object of someone else's vision and action. The promise of female subjectivity transmogrifies into the choice forced on actual female viewers either to cast themselves as the model who is spectacle or to identify across gender lines with the active artist and spectator, both figured by the narrative as male.[14] Since one option sacrifices the status of subject and the other her standing as female, the diegetic *Carmelina* divests the female viewer of the coherence of a single entry into the picture.

Crucially, that which woman loses here, man gains. The male subject sees in the female object a lack of volition and integrity against which he can articulate his own coherence and will.[15] Through the differential mechanism of gender, *Carmelina* manufactures the fiction that the active male artist and viewer enjoy control in a way that women do not. Such a belief in the unproblematic agency of the male artists was, at the turn of the century, commonplace. The novelist and playwright Auguste Germain claimed in 1908, in the pages of the lavishly illustrated series entitled *Le Nu au Salon*, that to paint the female form "permits the artist to affirm his personality. Each painter can thus demonstrate his originality, his special comprehension of a model and, by means that are his own, translate the artistic emotion that he experienced with it. . . . Every artist impresses on his work a distinctive sign, by which the talent [*génie*]

that he has to see and to paint people and things manifests itself."[16] In *Carmelina*, as in the works discussed by Germain, the male subject acquires the attribute of coherence, his "genius," precisely by confronting and overcoming the challenges of painting the female nude.[17]

If *Carmelina* positions its viewers as male subjects, it also fashions the female object of its—and their—vision. This is, above all else, a woman accessible to sight. Face, clavicles, breasts and belly radiate outward from the sternum along lines formed by a crude chiaroscuro. No part of her body twists, with a baroque flourish, out of view. The mirror in the left background, by bringing the model's back into view, insures that both sides of the woman are exposed to sight. That in this reflection Matisse modeled the sitter's scapula like a breast may even assure spectators that her back matches her front—*verso* repeats *recto*—and thus woman, even when unaccompanied by a mirror, hides virtually nothing from vision.[18]

It is tempting to equate this nearly total visual access to the image with the uncontested social control over the person; tempting but hasty. Matisse's representation of a woman on canvas is not the same thing as the living woman whose very existence beyond the picture frame is implied by that representation—let me call her Carmelina (non-italicized) for the sake of distinguishing her from *Carmelina* (italicized), the name of the painting. In order for Matisse's painting to exert control over "woman" (a social category) rather then simply "the nude" (an artistic one) the person needed somehow to be encompassed by the image; otherwise the image could not make claims about things that surpassed the artistic sphere. Containing women within a representation, Carmelina within *Carmelina*, did not follow automatically from painting a picture; that operation, a feat of social engineering, had to be performed.

Certainly at the beginning of this century the fact that Carmelina was a woman greatly facilitated her containment within an image. "The likeness of a man, in effect, is always *social*," asserted the critic Camille Mauclair in 1906, "but one paints a woman for her own sake." Mauclair continued:

> There is . . . in the representation of a woman something that is passive, a stable element. The portrait of a man seems to come to the viewer, to impose a will on him: the portrait of a woman waits for him to come to her. It is an impersonal form, the object of a desire, a motif of lines, of tonalities, of ornaments. . . . [In the portrait of a woman], the artist has not pursued the investigation of an idea, but rather of the secrets of form.[19]

If the truth of woman consisted in her physical form rather than some intellectual essence unobservable to the eye, painting could well aspire to capture all of her in its web of visuality.

It did not always succeed, however. Manet's notorious *Olympia* of 1863 (fig. 25), as analyzed by the art historian T. J. Clark, provides the troubling counter example. The female body in Manet's painting is nearly as exposed as is Carmelina's, and the picture overflows with the sort of items—maid, flowers, cat, the unequivocal signs of prostitution—from which stories can be built. There is potential here, clearly, to set up a male subject as the driver of the apparatus of scopic pleasure and narrative development. And yet the naked woman on the bed refused, at least at the time of the painting's initial exhibition, to become the complacent object of that apparatus. No one

25. Edouard Manet. *Olympia*. Paris: Musée d'Orsay. 1863.

in 1865 could say who this woman was supposed to be. "Manet's picture," writes Clark, "was . . . marked . . . by a shifting inconsequential circuit of signs—all of them apparently clues to its subject's [*i.e.* object's] identity, sexual and social, but too few of them adding up."[20] The figure of Olympia, everyone at the time could agree, was a prostitute, and the French had ways of thinking about such women; "the category *courtisane*," explains Clark, "was what could be *represented* of prostitution."[21] Manet's painting, however, failed to map the prostitute it portrayed into a safe and stable category such as the *courtisane*—Clark undertakes a careful analysis of the physical placement of the woman, the way in which her body is drawn, and the treatment of hand and hair to show how she failed to conform to established artistic and social categories for women.

Viewers of Manet's canvas simply could not answer all the questions raised about the implied social being, the prostitute, by looking at the image, the nude. Olympia the person, it appeared, exceeded *Olympia* the representation; Manet—again, Clark— "displace[d] . . . the spectator from his accustomed imaginary possession of the work."[22] Viewers were denied the satisfying sense of being able to bring all of the inferred woman under the purview of their gaze at the painting.[23]

Where *Olympia* posited a being that resisted easy social classification, *Carmelina* (fig. 23) most emphatically did not. Matisse specified with remarkable clarity exactly where to place Carmelina in the social scheme of things. This woman was a model. Her dark features and her Hispanic name, moreover, indicate a precise class identity. In 1905 Victor Nadal, poet and man of letters who scribed the lofty prose accompaniment to the annual issues of *Le Nu au Salon* during the mid-decade, described the presumed

social origins of such women. "As models, the studios possess two types, the professional model who usually comes to us from Italy, has set up camp in the place Pigalle and waits for the chance engagement and her daily bread. . . . There are, as well, models chosen by the heart, and they are not always the least ideal."[24] Though Spanish rather than Italian, Carmelina's southern European attributes mark her as one of the first type, a professional. Even if we assume an amorous interest on Matisse's part—and certainly hiring a model implied at the time the potential of gaining sexual access to her body[25]—Carmelina is first and foremost a model, unlike Nadal's second type of nude selected "by the heart." The painting *Carmelina* consistently and un-ambiguously places this woman within the established social category "model," in contrast to *Olympia* where the signs never "add up" to *courtisane*.

In depicting a professional model, the artist gained enormous control over his sitter. The academic artist Jules Laurens, in penning his memoirs in 1901, recalled the following incident that illustrates the dangers inherent in not hiring a professional. Alexandre Cabanel was having great difficulty finding a suitable Sextus Tarquinius to pose for his *Lucretia*. When Laurens discovered a young lawyer who filled Cabanel's needs precisely, the master exclaimed: "Damn! . . . damn! . . . A proper gentlemen, too proper. I would rather, I would definitely prefer, that he were a poor devil, a professional model, any individual whatsoever: people that I pay, people that are at my disposal without reciprocal discomfort nor, above all, promised results."[26] A man as a model—"always social," in Mauclair's words—had the potential to possess a will and resistances of his own; that Lauren's overly "proper" fellow was a well-placed lawyer realized that potential. In the end the sitting did not work out, not least because the attorney took some offense at being told he resembled the evil Tarquinius.

In *Carmelina*, the model, a professional and a woman, is at Matisse's "disposal" in the manner that Cabanel would have wished. She complies with his desire to turn her into an image; that is, in fact, her job. If the category *courtisane* existed for the purpose of safely converting prostitution into a stable representation, the social function of a model such as Carmelina was from the start exclusively to become a picture.

The painting *Carmelina*, moreover, literally strips its model of any accoutrements that might suggest an existence for her beyond the task of posing, here and now, for Matisse. The setting is not a model's own haunt in the place Pigalle, much less Olympia's fancy boudoir; it is Matisse's studio, equipped with pictures, mirrors and a table that serves as an improvised posing dais. With the exception of a small blue hair ribbon (which in any case elaborates more on the model's hair than on her body), Matisse excluded from his picture any scrap of clothing; there is nothing here to indicate that Carmelina ever was dressed or came in from elsewhere. Even the towel she holds before her sex, like the drapery on which she sits, surely belongs to the artist in whose studio she poses. *Carmelina* argues that this model is nothing other, nothing more, than her image. That image—to be precise, it belongs not to the woman but to the artist—entirely conveys the social category "model"; the former adequately represents the latter. The painting smoothly executes the transformation of the social being, embodied by the foreground figure, into the equivalent of the small framed picture depicted in the right background. Model and framed picture alike offer themselves up for visual scrutiny undistorted—in the figuratively social as well as the literal sense—by foreshortening or anamorphism.

26. Henri-Georges Morisset. *The Model*.
Location unknown. c. 1905.

Carmelina thus assigned to the subject position, which it created and figured as male, unfettered control through the medium of the image over the female social being set up as the object of vision and action. With social autonomy from her representation denied to the model by the argument of the picture, Matisse's canvas brought the entirety of the sitter's existence under the purview of the controlling gaze. By equating the male spectator with the artist and the woman with her image, this picture transforms the seemingly innocent proposition "the artist views the image" into the political assertion "man controls woman."

Matisse's painting performed much the same operation that Nadal, writing in 1905, read into Henri-Georges Morisset's *The Model* (fig. 26), a painting of a young model peering into a hand mirror:

> Nothing is more natural and more gracious than this svelte adolescent who, while waiting for the artist who must immortalize her, looks in her mirror to assure herself that she is worthy to charm those who will suit her, or to appear in the next Salon. Under the aegis of Morisset, she appears there [in the next Salon] brilliantly, for the little model has transformed herself into a little masterpiece [*chef-d'œuvre*].[27]

Like Morisset's adolescent who sees herself through the artist's eyes, the woman who gazed into Matisse's *Carmelina* found the female body there to be the object of male vision. And, like Morisset's "little model," that body undergoes a transformation—literally, "transforms itself"—into nothing more than the artistic image, the *œuvre* of the *chef*, the "work" of the "master." In terms of gender, Matisse's painting proved a powerful mirror indeed, for it promised that the entire drama of the sexes could be played out within the safe confines of the picture frame.

2

Carmelina, however, is not just a picture; it is a painting. The likeness of a woman, and with it the model's implied social being, filtered through the category "painting" before reaching its viewers, and that passage left its mark. Matisse's model acquired the attribute of being not just an object of vision, but also an object of high art. It is likely that the viewers of this painting in the first decade of the twentieth century, above all its first viewer Matisse, would staunchly have resisted the imputation of political motives, concerning gender or anything else, to their artistic activities of painting and contemplation. Art, their claim would probably have been, is above issues of power. This assertion—for an assertion it was, taken for granted without need for the persuasion of argument—was hardly an absolute truth but rather an ideological construct. The unexamined principle of the purity of art hid interest in the female nude—political, sexual, whatever—behind a screen of supposedly higher, disinterested aesthetic values. This concept of aesthetic disinterest can be traced back to Immanuel Kant's *Critique of Judgment* of 1790: "*Taste* is the faculty of judging of an object or a method or representing it by an *entirely disinterested* satisfaction or dissatisfaction."[28] Under the auspices of the aesthetic, the naked became the nude.[29]

Painting seemingly engaged the properties of the aesthetic so automatically that the principle of disinterestedness as it applied to the nude hardly needed to be articulated in relation to the practice of this medium; for the most part it went without saying. Pictorial mechanisms, often quite subtle, extended the status of the aesthetic across the narrow gap separating painting as a practice from the nudes it depicted. In photography, a medium whose stake in the territory of the aesthetic was barely established at the turn of the century, these pictorial devices by necessity appear in greater relief. Then as now an "artistic" photograph of the nude ran the constant danger of collapsing back into the category of pornography, that is, of being considered an image that treated the woman it depicted as an object of prurient interest. As a result books of nude photographs were conspicuously filled with explicit signposts that either visually exemplified or verbally expounded the means by which photography allegedly aestheticized the bodies standing before the lens.

By far the most common mechanism employed by photographers in an attempt to establish the aesthetic character of the female nude was to mythologize her. *Bacchic Joy* (fig. 27), a photograph appearing in Edouard Daelen's *La Moralité du nu* of 1905, certainly maintained that it depicted a living model: the publisher even went to the trouble and expense of touching up her body with flesh tones in this black-and-white photograph. Yet at the same time the picture transports its model out of doors where she can seek to commune with the classical aura emanating from a replica of a Greek urn on a pedestal. The classic promised to lift the model out of her existence as a real and thus sexual individual onto the higher plane of ideal beauty, and this woman literally embraces that promise. The gesture is hardly convincing to us, and may not have been at the time judging from the fact that the Bibliothèque Nationale in Paris often consigned books such as Daelen's to its restricted section named *Enfer*, or "Hell"; nonetheless the program of legitimation here is clear. Despite the title, the model is cast less as a licentious bacchante than as a sculptural water bearer of the sort one might expect to see as a background *repoussoir* to a foreground bacchanalian fete.

Joie bachique.

27. *Bacchic Joy*. Hand-tinted photograph. Published in Edouard Daelen, *La Moralité du nu* (Paris, [1905]), 47.

C. Klary in his book *La Photographie du nu* of 1902 regarded such chaste classical statues as the ideal that all artists, including photographers, should strive to attain: "What man has ever sensed obscene ideas roused in him when looking at antique statues, so true and yet so human? It is that in these representations, supreme accomplishments of art, reality is sanctified and, so to speak, consecrated by beauty."[30]

In photographs such as *Bacchic Joy*, nature likewise promised to purify the nude. Emile Bayard, the author of the prefaces for a serialized collection of photographs published under the title *Le Nu esthétique* in 1905–06, described the miraculous transformation of low-class Parisian models that occurred when they arrived on the banks of the Marne for a photographic session *en plein air*. After the women had undressed and begun to pose, he recounted,

> an incredible thing happened. Our models, who a moment before had been chatting and laughing immodestly, fell silent suddenly. A sensation of grandeur and of the unknown disturbed them abruptly, and the women that they were on arrival became nymphs; we no longer recognized our friendly working girls [*faubouriennes*], in our eyes they had exalted themselves! A singular metamorphosis, that, and what a perfect lesson of Nature imposing itself on its creatures and bestowing on them a modesty beyond that of the human sort.[31]

Nymphs beyond the contingencies of human sexuality, Bayard's models had entered the realm of myth—and of art.

A number of photographers, instead of appealing to the classic or to nature, grafted the aesthetic onto their images by associating them with the already aestheticized

28. H. L. v. Jan. *The Studio*. Hand-tinted photograph. Published in Bruno Meyer, *La Grâce féminine* (Paris, 1904–05), 247.

practice of painting. H. L. v. Jan's photograph *The Studio* (fig. 28), appearing in Bruno Meyer's book *La Grâce féminine* published serially in 1904–05, is a particularly elaborate staging of this charade. Jan's three models strike their wooden poses to form what appears to be an allegory of music ready to be recorded in paint. To our eyes, over eight decades after the fact, the leap from real-life models—like the figure in *Bacchic Joy*, hand-tinted in the published photograph—to allegorical *tableau vivant* may seem disconcertingly, if not comically, ambitious. It was probably so for contemporaries as well, for the picture takes recourse in several rather obvious devices to buttress its all-too-precarious initial thesis. The models appear in a veritable amphitheater of already completed paintings. By looking beyond these flesh-and-blood figures to the background, the viewer places them within the fictional settings that appear behind them on canvas. The two nudes on the left in particular join a romantic wisp of a woman in her painted forest glade. More important, Jan included in the foreground of the photograph a painter seen from behind; much as in *Carmelina*, the viewer can identify with the artist at work. Indeed, like him we are stationed in front of a canvas: behind his back and facing toward us rests an unframed picture in a rack. The empathic bond established here between painter and viewer crosses the boundary of medium: Jan's image equates viewing a photograph to making a painting. According to the fiction of the photograph, the viewer scrutinizes the nudes with the disinterest of a painter, not the appetite of a voyeur.

Artistic vision, insisted the writers of texts accompanying photographs of the nude, was beyond moral reproach. "A difference" existed, Daelen claimed in *Le Moralité du nu*, "between the vulgar instinct and the total purity of aesthetic contemplation."[32]

29. Henri Gervex. *Birth of Venus*. Paris: Petit Palais. 1907.

To represent the nude, he explained: "requires not only a complete mastery, but a character free of all baseness, a spotless, noble character. In a word, the essential condition for artistic ethics [in painting] the nude is 'idealized vision [*vision élevée*].'"[33] Purchasers of such books were invited to partake in such lofty artistic vision. Although probably only a handful of their readers were active painters, Klary assured his audience that the photographs he provided were intended for impecunious artists who could not afford living models, and Daelen's and Meyer's volumes appeared under the legitimating imprint of "Librairie d'art technique."[34]

Serious artists did not take prurient interest in their models, the argument ran, because they regarded them not as female bodies but as a collection of lines and forms. Paul Bergon and René Le Bègue, in their book of nude photographs entitled *Le Nu et le Drapé en plein air* of 1898, explained: "Beauty imposes itself on every artistic eye, without regard for any notion of morality or of modesty, by the happy accord of lines, of the medium, and of values; and the closer that harmonious ensemble approaches ideal perfection, the more every idea of sensual animality disappears."[35] Meyer voiced a similar sentiment in a phrase from *La Grâce féminine*, revealing in its emphatic redundancy: the nude should be "considered uniquely from the formal point of view as forms."[36] Judging from the strong thematic insistence on chastity in most photographs of the nude, few practitioners of this medium trusted the dissimulation of prurience to formalism alone. Nevertheless the publisher of *Bacchic Joy* (fig. 27) discovered a clever—if somewhat overt—means of suggesting a formal reading. By cropping the photograph into the shape of a fan, the image appears as a decorative object—presumably intended for a woman, moreover—for which a formal pattern rather than a representational image served as the norm.

For the most part, painting was spared the frantic hand-waving required of photography to indicate the aesthetic character of its subject matter. Yet many of the same aestheticizing devices used by photographers also appeared within paintings of the nude. To treat the nude as a classical goddess was a tried-and-true device of academic painting, and Ingres and Bouguereau had plenty of progeny filling the Salons with Venuses and Dianas for the turn-of-the-century crowd. For example, Henri Gervex's *Birth of Venus* (fig. 29), shown at the Salon de la Société Nationale des Beaux-Arts in

1907, relies on a timeless title and setting to transform the nude into a mythical entity ostensibly untainted by contemporary society or prurient appeal.

Other painters turned their nudes into creatures of art—Matisse was hardly the first French artist to paint his female model as a studio nude. For painters who were resistant to academic practice and participated in the various realist movements dating from the mid-nineteenth century, the studio nude was perhaps the most accessible motif for depicting a naked woman while dissimulating sexual interest in her. Since painting was firmly established as an artistic practice, these artists had the luxury of using more subtle and varied devices than did photographers to aestheticize the studio nude. Major paintings by Gustave Courbet and Georges Seurat exemplify the greater finesse allowed at the time to the practice of painting.

Courbet was not an artist who disguised female sexuality in a great number of his paintings,[37] but he did so, it could be argued, in the central grouping of *The Painter's Studio: A Real Allegory Summing Up Seven Years of My Artistic Life* of 1855 (fig. 30). The pile of clothing at the feet of the female nude in this group, it is true, marks her as a real woman, less chaste than the eternally unclothed figures of classical myth. It might seem at first that the role of model likewise fails to sanction her nakedness since the artist within the picture seems not to portray her: it is a landscape without figures on his easel. Yet on further examination this painter may indeed seem, in his manner, to be capturing her image. As Michael Fried points out, the model's head, cocked oddly to the side, has as its homologue the thicket of leaning trees within the depicted

30. Gustave Courbet. *The Painter's Studio: A Real Allegory Summing Up Seven Years of My Artistic Life* [detail]. Paris: Musée d'Orsay. 1855.

canvas, and the foamy waterfall near the bottom of the landscape echoes the cascade of her fallen skirts.[38] In other words, the woman inspires the depicted artist to paint the landscape. The painter of *The Painter's Studio* transformed the real model in the painting into that mythical character peculiar to the arts, the muse. Courbet presented the female nude not as an object of sexual desire, nor even as an object of painting; rather she has become the embodiment of painting itself. *The Painter's Studio* brings the female nude under the auspices of the aesthetic by making her its allegorical representation.[39]

The nudes in Seurat's painting *The Models* of 1886–88 (fig. 31) are, like Courbet's muse, surrounded by contemporary garments; indeed two of them are in a state of only semi-undress. Yet these Parisian women, again like the model in *The Painter's Studio*, are also transformed into an artistic myth. Seurat's posing of the three figures to compose a systematic survey of the feminine form—back, front and profile—evokes the tale, related by Pliny, of the Greek painter Zeuxis who combined his studies of various body parts from five beautiful but imperfect models to create his representation of a single perfect Aphrodite.[40] At first it may appear, owing simply to the multiplicity of figures, that Seurat depicted the models and not the Zeuxian ideal. Yet these three models are, in fact, a single model depicted thrice across the same canvas: the hair, face and body are always the same. No real figure, no professional earning her daily

31. Georges Seurat. *The Models*. Merion, Penn.: Barnes Foundation. 1886–88. Photograph © 1992 by The Barnes Foundation.

32. Louis Galliac. *In the Studio*. Location unknown. c. 1905.

bread, could so fill the space of Seurat's painting without doing irreparable damage to the assumptions of verisimilitude upon which any such realistic interpretation of the image would necessarily be based. It is the ideal form of woman seen from various perspectives that appears in *The Models*. That Zeuxian ideal is ostensibly a purely aesthetic entity, ultimately no more real in the fiction of *The Models* than the figures painted on the surface of Seurat's large canvas *A Sunday Afternoon on the Island of La Grande Jatte* that hangs in the background on the studio wall.

Courbet and Seurat invented subtle devices for dissimulating sexual interest, mechanisms deeply and intricately embedded in the fictional and formal structures of their paintings. Most of Matisse's contemporaries who painted studio nudes—and plenty of these paintings made their way to the official Salons—used simpler means. The most common device used by these painters to feign disinterest was to include in the picture males who, quite literally, show no interest in the nude female models in their midst. In Louis Galliac's *In the Studio* of around 1905 (fig. 32) a highlighted nude stands in the center of the canvas. We know she is a model since the sandals with classical leggings wrapped up her calves are appropriate attire for the mythical figure pictured in the nearly completed painting—is it a Diana with a bow?—at the left edge of Galliac's canvas. Yet she is not posing: this is the interlude between sessions and she has assumed the domestic chore of serving tea. And once she has been dethroned from her dais (curiously missing from Galliac's picture), once she has become mere woman and not an object of art, all men in the room ignore her.

Dessin de WEILUG

« Artiste peintre demande jeune
et jolie femme (du monde de préfé-
rence), belle poitrine... S'adresser
etc., etc... »

TRUC BOURGEOIS
— Et à part ça, t'es peintre ?

33. Weilug. *Bourgeois Behavior*. Drawing.
Published in *L'Assiette au buerre*, 8 May
1909, 947.

Nadal provided an ornate *ekphrasis* for this painting in 1905: "The body of a woman . . . dominates the scene, which she warms like a ray of sunlight. But around her, and as if to pay homage to her victorious attractions, three artists embellish a musical theme that absorbs her. . . . A woman serves tea to these devotees of chamber music and to the zealot of fine painting who listens only to the harmonies of a sublime paintbrush."[41] The musician at the picture's right edge epitomizes this shift in attention since that which he fingers, that which he holds between his legs, is his shapely cello in the place of the nude. Nadal, writing about Raoul Baligant's thematically kindred painting *The Repose of the Model* of 1905, continued in a similar vein: "The colleague whose elegant studio the artist reproduces for us pays no attention to the charms displayed so close to him. Entirely caught up in his work, he ask himself if his hand has realized his idea well. What do the radiant body, the divine bust, the superb legs of his model matter to him? He wants to succeed at the Salon, and ambition for him prevails over pleasure."[42] The glories and immortality of the arts, not passing sensual pleasures, attract the attention of these men.

Galliac himself hardly ignored his domestically engaged model: her carefully rendered backside forms the focal point of the canvas in front of us. There is a marked division between the ogling Galliac on the one hand and the seemingly indifferent painter and his musical colleagues on the other. Any representation of a painter working within a painting, nevertheless, verges on self-portraiture since both actual artist and his depicted counterpart share the activity of making pictures. And as the two artists merge into one the viewer identifies with both. The conflation of the two

attitudes held toward the model occurs quite smoothly since the diligent artists depicted in the painting pursue their calling with the nude in full view before them "as if to pay homage to her victorious attractions." While they ignore the woman they see the muse. There is no need for the sexual interests of viewer and actual artist to vanish from the picture when they can be sublimated and thereby legitimated by the aesthetic activities of the high-minded men in the picture.

Cumulatively, then, these pictures—the photographs *Bacchic Joy* and *The Studio*, the paintings by Courbet and Seurat, Gervex and Galliac—give some sense of the established repertoire of techniques in Matisse's day for the visual dissimulation of gendered interest. The efficacy of these aestheticizing mechanisms appears most clearly, perhaps, at its moment of collapse in satire. A drawing by Weilug published in the Parisian humor magazine *L'Assiette au buerre* in 1909 (fig. 33) shows a model and her artist dressing after an amorous encounter. She, not he, speaks the witty words: "Other than that, you're a painter?"[43] Having sacrificed the Olympian distance of aesthetic disinterest, the lustful artist becomes the object of the model's wish to categorize *his* social being. An omniscient voice answers her query, providing the definitive classification for his unseemly conduct: "Bourgeois behavior."[44]

It's just a joke, of course, and humor sanctions the transgression. But, like many jokes, Weilug's cartoon draws a laugh by inverting a relationship that has otherwise come to be taken for granted. Weilug's drawing was funny in the precise degree to which images such as Jan's, Galliac's and the rest succeeded in establishing a normative order that authorized the operation of the gendered gaze while dissimulating its interested character.

3

Matisse's *Carmelina* (fig. 23) shuns virtually all the usual iconographic signposts of aesthetic disinterest used by photographers and other painters of the day. Carmelina is no Venus or Diana. Moreover, nothing in the picture proposes her as an allegory of art, whether in the form of the inspiring muse or the perfected Zeuxian ideal. She is a model, to be sure, but her rigid, symmetrical posture is less a pose in any artistic sense of the word than a refusal of one. Her inscrutable face and unfinished hands and feet, mere rudimentary clubs, defy interpretation as the expression of human emotion or moral value. Nothing could be further from the artistic language of gesture codified over centuries by academic practice. Perhaps Carmelina is meant to be shown during the interval between sessions, resting cramped muscles before resuming her assigned position. But then the reflected Matisse, turning away from the easel we presume to stand beyond the left edge of the mirror and looking instead toward the woman, would appear—unlike Galliac's dutiful painter—more interested in the body than absorbed by the art.

What iconography did not accomplish, however, style could achieve. Writers about photographs had hoped their nudes could be read as pure form—"considered uniquely from the formal point of view as forms," in the words of Meyer—but in practice works in that medium invariably supplemented style with a thematic program in order to sustain their aesthetic pretense. For painting, in contrast, an interpretive strategy capable of treating a painting depicting practically any subject matter

in rigorously formal terms was already firmly established in France by the turn of the century. That school of critics we have encountered before: the Symbolists. Maurice Denis, whom we have heard on the subject of the Fauve paintings at the Salon d'Automne, offered the following (oft-quoted) definition of painting in 1890: "Remember that a painting—before being a war horse, a nude woman, or some anecdote—is essentially a flat surface covered by colors in a certain assembled order."[45] This was the pictorial logic of Van Gogh and Gauguin, of Monet the pantheist priest. Much as Derain's pictures of London and Vlaminck's of Chatou were subject to a Symbolist reading, so too Symbolism could turn Matisse's "nude woman" into a "flat surface covered by colors."

Carmelina invites such a formalist assessment. Consider, for example, the modeling of the woman—or rather the lack of it. Although the stark highlights on breasts, belly and thighs certainly endow Carmelina with a fully developed female body, she never emerges entirely from the surface of the canvas to assume the well-rounded corporeality attainable through *trompe-l'œil* illusionism in the manner of, say, Bouguereau or Gervex. Matisse constructed her breasts as if they were a pair of Cézannean apples, juxtaposing a limited number of discrete planes each consistent in tone and value.[46] The thigh on the left is yet simpler, four tonal planes lined up next to each other with the contrast between lightest and darkest at the crest dramatically unmodulated. Moreover, the radical separation of line from form at the forearm to the left—we can actually discern the edges of the background mirror and table between the thick black outline at the arm's edge and the ochres of the flesh—defies any strictly anatomical interpretation. The apparent coarseness of Matisse's execution insured that a great number of his brush strokes could be regarded as non-mimetic colors and lines.

The strength and prevalence of Symbolist readings of the nude by the beginning of the twentieth century registers most clearly, perhaps, in the evolving fortunes of *Olympia* (fig. 25). In 1863, judging from the reactions to Manet's infamous painting, simplified modeling alone proved an insufficient means to hide away the confusing and contradictory signs of the model's social and sexual character. Forty years later the legacy of the Impressionist and Post-Impressionist movements in painting and criticism empowered Symbolists to venerate this same canvas on formal grounds when, in 1907, *Olympia* entered the Louvre. An anonymous writer in the conservative journal *Rénovation esthétique* declared on that occasion that owing to "its frank and bold *method*, its appositions of black and white," Manet's work avoided "a realism that, very fortunately, it does not have." The critic continued: "*Olympia* is above all a work of a master painter; its parts are built up by thick paints during long working sessions, and as if caressed with love. . . . Manet was intentionally abstracting the modeling in order to preserve only the general contrast of successively colored lights and darks."[47] Manet "caressed with love" not the nude but his painting, for it is the picture and not the model whose parts the critic is discussing. This is dissimulation at its finest, a monument to the political powers of formal analysis in the first decade of the twentieth century.[48]

Since *Carmelina* (fig. 23) displays even less refined modeling and representational articulation than *Olympia*, Matisse's painting would certainly have solicited the same sort of formalist treatment that *Olympia* received. Style on its own could proclaim the disengagement of art from gender, its disinterest in such interested affairs. Indeed, it

34. Henri Matisse. *Nude in the Studio (Marquet Painting in Manguin's Studio).* Paris: Musée National d'Art Moderne. 1904–05.

still does so today. If many of the iconographic tools employed at the turn of the century by photographers and painters to aestheticize the nude appear foolish to virtually everyone now, many writers still take the legitimating imprimatur of formalist aesthetics quite seriously, discussing even nude photographs—think of Stieglitz or Weston—as essays in pure form. Such formalizing strategies are far from timeless; they date, in fact, from precisely the era of early Matisse.

More than a year later during the winter of 1904–05, Matisse returned to the theme of the studio nude. *Nude in the Studio (Marquet Painting in Manguin's Studio)* (fig. 34)[49] reactivates many of the same devices that in *Carmelina* inscribed the roles of male subject and female object. The model, though no longer facing the picture plane as if a reflection of the viewer, still fills the foreground space with her nude body exposed to the interested erotic gaze. The studio setting and the artist in the background—almost certainly a depiction of Albert Marquet—provide all the props and actors necessary to play out a narrative about the painting of a nude. Treatment of theme here, in fact, endows the portrayed action with the sanction of high art to a greater extent than it did in *Carmelina*. Standing in *contraposto*, the model obviously poses, and does so in a conventional, even classical manner. It is not impossible—as it would be with Matisse's earlier work—to imagine the artist in the background laboring away on a study of a nymph or an attendant to a goddess.

Style, too, could furnish the legitimating cover for desire in *Nude in the Studio*. If anything, Matisse's canvases in the years following 1903 facilitated formal readings to an ever greater extent than did *Carmelina*. His colors became intensely vivid, his application of paint abbreviated yet varied and bold; in short, he, like Derain and Vlaminck, began to paint in that manner we now identify as the Fauve style. The non-mimetic strokes of paint that typified a handful of passages in *Carmelina*—forearm and hip, hands and feet—are the norm in *Nude in the Studio*. The dark blue lines of the *ébauche*, visible throughout the figure as discrete and apparently hasty brush strokes, form an armature that buckles beneath the slightest demands for verisimilitude. The rough-edged planes of color and swarms of paint spots that hang themselves loosely on that armature distract more than contribute to the effect of visual resemblance. Which of the cluster of paint spots appearing on the side of the model's head, for example, can we read as parts of an ear? And what to do with the remainder?

Fauve paintings of this abbreviated sort, as we have seen in the case of Derain's and Vlaminck's landscapes, provided ripe material for Symbolist viewers wishing to read pictures as the accumulation of lines and colors. The studied examination of *Nude in the Studio* stroke by stroke, the type of reading contemporary Symbolist critics could have produced effortlessly, dissolves Matisse's nude away into a sea of seemingly arbitrary clusters of pigment. If Fauve canvases were, in Denis's words from his review of the Salon d'Automne of 1905 nothing but "painting beyond all contingency, painting in itself, the pure act of painting," these works could hardly be censured for thematic prurience.[50] Hence no need to allegorize, no need for classical urns or musicians in the background. No need for iconographic distractions from the serious business of scopophilic pleasure and the narrative assignment of gender roles. Style on its own, in a Symbolist reading of *Nude in the Studio*, could proclaim the disengagement of art from politics, its disinterest in such interested affairs.

None of this alters the fact that Fauve paintings sorely disappointed many Symbolist

critics. "The qualities . . . of sensibility" along with those "of representation" were, according to Denis, "excluded from the work[s] of art" produced by Matisse and his school. *Nude in the Studio*, like Derain's and Vlaminck's Fauve pictures, lacked the basic stylistic attributes, complexity and enigma, from which Symbolist critics built their case for artistic transcendence. The dark blue streaks of the *ébauche* outlining Matisse's nude, as well as the patches of brown shading and the dots of bright color that fill in the figure, are quick and crude. Behind and below her body the application of paint is more basic still: single lines and dabs of paint lie isolated against a vast area of exposed priming. Matisse's technique, moreover, lays the picture's means of construction open for scrutiny. Outlining, coarse modeling, bright highlights; Matisse in *Nude in the Studio*—like Derain and Vlaminck in their landscapes—covered over none of his various painting stages. Here technique, stripped bare like the woman it depicted, reveals all. Perhaps the labored, Cézannesque surface of *Carmelina* could have suggested to Symbolist viewers the type of sustained engagement of a unique and mystical artistic personality that they found in the paintings of Van Gogh and Gauguin and the late works of Monet. Style in *Nude in the Studio* could not.

Yet Fauve paintings read formally—not in spite of, but because of their failure to attain Platonic ideals—succeeded remarkably well in dissimulating the politics of gender. Denis, in making his adamant case against Matisse and his followers, insisted that their paintings referred neither upward toward essences nor downward toward contingent reality; this was "pure painting" concerned with nothing outside itself. Fauve canvases, by the standards of the Symbolists, were all about aborted transcendence—they affirmed in their failure the need for others to prevail—and consequently they were not about such mundane trivialities as sex and power.

In a passage from *La Photographie du nu* in which he wrote of the photographer as if he were a painter, Klary considered the artist's complete control of his model a necessary consequence of his concern with formal values:

> It is from a knowledge of the laws of his art that the photographer-artist obtains the combinations of light and shadow, the contrasts of forms of movement, and all the other means of expression. But all his facility will disappear if at the moment of execution he does not succeed in awakening in his models the feeling for the situation and the subject for the sake of which he has devoted so many calculations. . . .
>
> If the artist is not absolute master of his model, if he does not possess it, he lacks the theory or the practice of his art. It is for him to suggest at the desired moment the ideas that should give him the expression that he has observed and chosen.[51]

For the sake of chiaroscuro and the balancing of forms, the artist received license to possess his model. If, during the first decade of the twentieth century, this was the photographer's dream of legitimacy, the institution of formalist reading, established by the Symbolists and marshaled against canvases such as *Nude in the Studio*, made it the reality of the painter's practice.

4

Nude in the Studio is not a canvas uniform in its technical execution. The application of paint across most of its surface is remarkably simple, seemingly the product of a few

hasty stabs of the brush by an untrained amateur. Matisse, a painter who had spent years in the studios of the Ecole des Beaux-Arts, painted as if he had learned nothing from his predecessors in painting. (Which does not mean—to repeat the point I made earlier about Derain—that Matisse was inept; undoubtedly a great deal of skill was required to create this naïve effect.) We see more exposed priming, perhaps, than pigment. *Nude in the Studio* lacks the expanses of labored encrustations that cover the full surface of *Carmelina*.

Art—if by that we mean a developed and sustained method, the sort of thing Symbolist critics expected—really only manifests itself in the upper right corner of *Nude in the Studio*, where Matisse positioned the depicted Marquet at his easel. Especially around Marquet's head, great masses of highly saturated paint dabs, smaller and more precise than those further left, swarm over the lines of the *ébauche* and obscure from sight virtually all the original priming. Contemporaries could easily recognize this manner of painting, for it closely resembled the late procedure of the Neo-Impressionists such as Signac, whose pointillist dots, since 1894, had grown mutantly large. *Luxe, calme et volupté* (fig. 55), which Matisse completed during the same winter that he painted *Nude in the Studio*, displays a technique quite similar to the upper right quadrant of the figure study. When in 1905 Denis declared this large pastoral "the schema of a theory," the theory to which he alluded was that of Neo-Impressionism, considered by many the most rationally codified artistic method of the day.[52]

Overwhelmed by Neo-Impressionist dabs, the depicted Marquet appears trapped in the claustrophobic world of complex artistic technique. Moreover, he is surrounded by the artifacts of art, squeezed between two rectangular images, the mirror above the fireplace and the canvas on an easel before him. A smaller canvas, its stretcher facing outward, leans against the base of the easel, boxing Marquet yet further into the realm of art.

If *Nude in the Studio* casts Marquet as a creature of painting, the nude, in contrast, emerges the stuff of reality. Within the frame of the depicted mirror, the reflected Marquet—we see his hat and head in its lower corner—is but an image against which Matisse's model, blocking our view of the left side of the reflective surface, bodies forth as real. This woman, the picture suggests, can be apprehended directly, without the mediations of the practices of painting.

The manner in which Matisse rendered the foreground nude, utilizing a technique more Fauve than Neo-Impressionist, reinforced the impression of this body's corporeal presence. Just as Derain and Vlaminck recast the material objects of London and Chatou as the physical properties of paint, so too Matisse formulated between his female model and her rendition on canvas a tactile correspondence.[53] The painting of the figure in *Nude in the Studio* frequently echoes the actual physical body of the model: an erratic loop of paint captures the sensation of a loose hair escaping from her bun, while thick brush strokes at the hands and feet replicate her fingers and toes, one lump of paint for each digit. More generally, the sheer accumulation of palpable substance, as Matisse constructed his figure with corpulent brush strokes upon flat exposed priming, rhymes the material nature of this painted nude within the empty surface of the canvas to the corporeality of the actual model within the empty space of the studio.

Like his Fauve compatriots, Matisse additionally transformed the visual phenomena emanating from objects he portrayed into the physical attributes of his paints. Consider the few faceted planes—very few—that create a fleeting impression of contour around the model's hip. Two contrasting patches of unmodulated pigment, a mustard yellow at the front of the thigh and a muddy brown at its center, produce the effect of light flowing in from the right to strike the front of the model. A third tone, the streak of tan which defines the crest of the buttock, undercuts the chiaroscuro of the first two since its value is too light to coincide with the impression of raking light from the right. This swatch is a result not of an application of pigment but of its opposite: the light tan priming, visible in large areas of the canvas below and to the left of the model, here shows through the model's body. Matisse represented this section of the model's anatomy less through visual tonal difference than through the physical presence or absence of paint.

Nude in the Studio offered a sense of material correspondence in the place of visual semblance. As in Derain's and Vlaminck's canvases, this tactile linkage implied a visceral immediacy. That ostensible immediacy, I have argued, authorized an account of Fauve painting that stood as an alternative to Symbolism: the neo-naturalist interpretation.[54] Once *Nude in the Studio* banishes the visual art of painting and the artistic mediation it implied to its upper right corner, the nude in Matisse's canvas assumes a physical presence of its own capable of evoking directly the inferred living woman. The depicted Marquet ponders a visual representation; we seemingly apprehend a material nude.

Nowhere in *Nude in the Studio* is the elision of the process of painting more manifest than in the construction of the narrative around the foreground figure. If the art of painting has been relegated to the corner, what do we make of the story of the process of painting of the nude—the transformation, that is, of the artist's view of the woman into the spectator's view of the canvas?

In Galliac's *In the Studio* (fig. 32), those two gazes are kept distinct. The depicted artist looks disinterestedly at Diana; we look interestedly on the woman serving tea. The first legitimates the second only through the general metaphor, not articulated by the painting itself, equating all "artistic" views of the female form. The process of painting, likewise, is represented twice: first by theme—the enthusiast of painting busily at work on his canvas to the left—and second by technique—the visible signs on the actual canvas of Galliac's competence as a painter in rendering the vignette in oils. A loose metaphor, once again, links the two: this oil painting must have been fabricated by a disinterested artist, just like that one.

In *Carmelina* (fig. 23) the woman that the depicted Matisse uses as his model and the woman in the foreground, if we trust the veracity of the mirror, are one and the same. As in the classic cinematic practice of splicing shot to reverse shot, we see Matisse seeing, then what he sees (the order, as in film, can easily be inverted). The device of juxtaposing shot and reverse shot, argues the film semiotician Kaja Silverman, "sutures" the nominatively male viewer of the woman into the depicted action by providing him with both an object for his attentions and a surrogate subject inside the picture with whom he can identify.[55] Yet even as *Carmelina* enmeshed the spectator's position with that of Matisse in this proto-cinematic manner, the process of painting remains on display.[56] It reads laterally across the canvas like a sentence:

Matisse works (left side) on a canvas (center and whole) to produce an image (right side). The much labored pigments covering the canvas serve as traces of that concerted effort to turn material woman into visual image.

Nude in the Studio (fig. 34) projects all that process into the background. Not only does the spectator ostensibly see exactly what Matisse saw, what they see together— what we all see—is presumably both the scene in the studio and the scene on the canvas. Standing before *Carmelina*, spectators knew that the artist with whom they identified had to turn his head back and forth to compare the living model with his painterly rendition of her—we can all but see him doing so in the reflection. That implied head turning registers the distance between woman and representation. In *Nude in the Studio*, the depicted Marquet must similarly move his head, but then he is still a creature of art. For the author of the canvas in front of us, in contrast, we are given no sign of a similar rotation of the head back and forth. We the spectators cannot determine which of two objects present in the studio in 1904–05 we are presumed to be looking at now: the model who stood before the artist or her painted representation mounted on the inferred easel. This painted surface before our eyes pretends to be simultaneously the actual nude and Matisse's rendition of her. In the fiction of the painting, nothing distinguishes the one from the other.

This absence of difference between the nude and her painted rendition, crucially, does not exile the author Matisse from *Nude in the Studio*. Brush strokes on the surface of *Nude in the Studio* that evoke the living woman can simultaneously be read as the trace of Matisse's presence, much as Vlaminck's technique in his paintings of Chatou gave visual form to that artist's personality. Yet since the perception of the nude and the paint on the canvas ostensibly matched each other precisely, since no gap of difference waiting to be ascribed to the mediations of the painter appeared to exist between woman and representation, artistic intervention between the two assumed the role of faithful transcription. Just as Vlaminck's personality seemed derived from the suburban sites he portrayed, so in *Nude in the Studio* the persona of Matisse served to guarantee the identity of paint and perception by ostensibly conforming perfectly to both. In that process, remarkably, the same collection of brush strokes perform both the shot and reverse shot of the suture. Matisse's pigments on the surface of *Nude in the Studio* simultaneously index the surrogate subject formally and represent the perceived object tactilely as the painting weaves the viewer into the fiction of the scene.

Nude in the Studio thus tells the story of the emergence of the subject out of art and its mediations into the direct apprehension of woman. The tale relates how Matisse and the viewer together escape from the world of representational art into a domain where painting and the nude are one. And if we juxtapose *Nude in the Studio* to *Carmelina*, much as we viewed *Carmelina* against Manet's *Bar at the Folies-Bergère* (fig. 24), an additional narrative ensues. *Nude in the Studio* recounts Matisse's development out of his own painterly past, when he produced artistic images of the nude in the manner of the depicted Marquet, into the present of Fauve direct apprehension.

This neo-naturalist account of *Nude in the Studio*, far from diminishing the efficacy of the painting as an agent in the politics of gender, enhanced it. Regardless of its neo-naturalist aspects, Matisse's picture was nonetheless an oil painting that enjoyed the sanction of the aesthetic. In other paintings the aesthetic took a variety of forms: the myths of Diana and Zeuxis and of the painter's muse, the pantheist imperatives of

Symbolism, the theories of Neo-Impressionism. In the neo-naturalist *Nude in the Studio* the established category of painting on its own transformed the political drama of male subject and female object into an ostensibly disinterested affair. Those other dissimulating devices, however, all presented themselves unabashedly as the products of human civilization, passed down through millennia or recently developed by advanced culture. The aesthetic in the neo-naturalist *Nude in the Studio* assumed none of these civilized guises. It could, in contrast, appear the simple consequence of immediate nature. Since Matisse's technique and composition posited no essential difference between perceiving a female in her natural state and viewing a canvas, by necessity painting shed its cultured artfulness. To present aesthetic disinterest in this manner was to declare it free from the mediations of either contemporary society or its cultural past.

Paradoxically the Symbolist and neo-naturalist interpretations of Matisse's painting, while logically in contradiction, functioned ideologically as complements in this process of legitimating and then naturalizing the politics of gender. To see *Nude in the Studio*, as Denis might have done, as a pure act of painting firmly fastened the principle of the aesthetic onto the picture. To see the work simultaneously—even if inconsistently—as neo-naturalist rendition disowned the active agency of that cultural category. Taken alone a Symbolist reading—"a picture, *before* being a nude woman . . . is essentially a flat surface covered with colors" (my emphasis)—posited a temporal displacement of interested vision, a gap in time between "picture" and "woman" filled by the mediations of the artist. Symbolism and neo-naturalism taken in conjunction dispensed with that deferral: the canvas could appear as pure form and real woman at one and the same moment. The two together might even suggest a disinterested formalism now trained not on the visual art object but rather directly on the corporeality of the female body.

Neo-naturalism thereby authorized *Nude in the Studio* to present the entire political technology of painting—the relative positioning of male and female, the aesthetic transformation of interest into disinterest—to be as innocent as the image in the mirror, that paradigm of unmediated and temporally immediate representation. The picture, read in this manner, pretended to reflect back to its contemporaries a natural vision of the aestheticized relation between genders. If paintings in general dissimulated gendered interest as aesthetic disinterest, Matisse in turn dissimulated that dissimulation as mere reflection. What you see, asserted *Nude in the Studio*, is how things naturally are; society has not constructed this condition, nor has art, nor has Matisse.

Louis Althusser has written: "What . . . is . . . ideology if not simply the 'familiar,' 'well known,' transparent myths in which a society or an age can recognize itself (but not know itself), the mirror it looks into for self-recognition, precisely the mirror it must break if it is to know itself?"[57] Matisse's paintings of the nude, by implementing without articulating a certain politics of gender, manufactured an ideology in precisely this sense of the word. I have not broken Matisse's mirror in these pages, but I hope to have offered some notion of how it worked—and, more to the point, how it was made.

CHAPTER 3

Painters and Tourists in the Classical Landscape

The Sirens of the sunny Mediterranean beckoned, and virtually all the Fauves heeded their call. (Once again I begin my chapter with a sentence, this time my own, that calls attention to the ease of the metaphorical slippage between woman and landscape.) Around mid-decade, these painters—all save Vlaminck—migrated nearly every summer away from Paris to the beaches of France, where they painted the local seascapes. Increasingly they chose the Mediterranean coast, rather than the Channel shore favored by many French artists of preceding generations, for their sojourns. In terms of sheer numbers, more Fauve canvases depict scenes of the south than all other sites combined. In the Fauve "cage" at the Salon d'Automne of 1905, for example, 25 of the approximately 30 landscapes whose sites can be identified by their titles were produced on the Mediterranean shore. And with the exception of a single painting by Derain of London shown at the Salon d'Automne of 1906, it would seem that Derain and Matisse displayed landscapes only of the south in all the Salons des Indépendants and the Salons d'Automne from the fall of 1905 through the end of 1907. Despite Derain's two painting campaigns in London and despite Vlaminck's constant flow of depictions of the Parisian suburbs, the typical Fauve landscape portrayed the sun-drenched south of France.

Matisse summered at Saint-Tropez on the Riviera in 1904 and, with Derain, in Collioure near the Spanish border in 1905. As they depicted these sites, Matisse and Derain developed many of the distinctive painting techniques and treatments of theme that were to become hallmarks of the Fauve movement. The towns portrayed by Matisse and Derain were still sleepy fishing ports rather than the chic international resort or the French vacation center that Saint-Tropez and Collioure, respectively, have become today. In ever increasing numbers, however, tourists were beginning to discover such quaint Mediterranean locales during the same years that Matisse and Derain frequented them. These travelers adopted attitudes toward the sites they visited that differed markedly from those of the previous generation of French tourists, who had favored bathing establishments along the English Channel. The new breed of tourists discarded the habits of urbanity that visitors to the Channel had brought with them from Paris and attempted instead to integrate themselves into seemingly untouched fishing ports and the surrounding countryside.

The simultaneous development of new manners of painting and of touring in the south of France was hardly happenstance. The taste—artistic and touristic—for such

35. Henri Matisse. *View of Saint-Tropez*. Bagnols-sur-Cèze: Musée de Bagnols-sur-Cèze. 1904.

sites as Saint-Tropez and Collioure had to be invented, and the activities of these painters and tourists in tandem produced a new standard by which to assess the landscape.

<div align="center">1</div>

Almost without exception, Matisse's and Derain's paintings from the south present a vision of town and landscape harmoniously intertwined. In Matisse's *View of Saint-Tropez* (fig. 35), the town occupies the comfortable middle ground of the picture. Topography limits the expanse of human habitation, for these buildings are surrounded by rolling hills and nestle on a moderate promontory extending into the calm waters of the bay. Yet nature here never overwhelms Saint-Tropez nor renders human presence superfluous. Since the near and far shores are all but bisected by the bay, their integrity as a single coastline within the picture relies heavily on the visual bridge provided by the man-made tower of the village church. Fishing port and landscape commingle, neither complete without the other.

Often color as well as composition blend town and setting. In Derain's *Collioure* (fig. 37), the bright colors—orange, pink, blue—that define the walls and roofs of the town recur in the foreground land and the distant waters and hills. It is difficult to determine where the foreground terrain ends and buildings begin, or even where man-made

36. Claude Lorrain
(Claude Gellée). *Ariadne
and Bacchus on Naxos*.
Elmira, N.Y.: Arnot Art
Museum. 1656.

37. André Derain.
Collioure. Private collection.
1905.

structures give way to the bay. All mixes together, a collection of highly saturated brush strokes depicting a cozy fishing port basking beneath the hot southern sun.

Fauve paintings of the south not only unite buildings and settings, they also stake out claims for Matisse and Derain over the harmonious townscapes portrayed. Matisse's *By the Sea (Gulf of Saint-Tropez)* (fig. 38), appropriates the site for the artist indirectly, through an act of substitution. Here a woman—her clothes and her leisure mark her as a tourist—assumes within the same setting a place quite similar to that of the town in *View of Saint-Tropez* (fig. 35). And, like the town, she is posed so that the contours of her body echo the line of the coast: she too appears at one with nature. A second figure, a boy—barely discernable, sitting in front of the woman—is even more

38. Henri Matisse. *By the Sea (Gulf of Saint-Tropez)*. Düsseldorf: Kunstsammlung Nordrhein-Westfalen. 1904.

39. André Derain. *Return of the Fishing Boats*. Paris: private collection. 1905.

integrated into his surroundings for he all but dissolves into the outcrops of rock around him. Absorbed into the setting, equated with Saint-Tropez by serving as its replacement, this woman and child intermingle with the site as harmoniously as the town and landscape intertwine in *View of Saint-Tropez*.

A mother, a child . . . and a father. The artist himself—likewise a tourist, likewise having taken up a place along the beach of Saint-Tropez—implicitly joins the happy family circle. The woman posing for *By the Sea* was, in fact, Matisse's wife Amélie, and the boy his son Pierre. This family, the artist's own, provided Matisse with his link to Saint-Tropez.[1] In *By the Sea*, the politics of domesticity extend beyond the woman and child to encompass nature and town, with which they are, respectively, integrated and equated. The painting credits the artist with the same relationship to the site of Saint-Tropez that a bourgeois male at the turn of the century presumably enjoyed within his own family: intimacy coupled with paternal authority.

Alternatively, Derain's *Return of the Fishing Boats* (fig. 39), makes Collioure appear the artist's home by seemingly positioning the artist on native soil. To paint this work, Derain must have stood on one of Collioure's two sandy beaches where the local fishermen moored their craft. No architectural elements, similar to the bridge pier in Derain's *Two Barges* (fig. 13) from London, differentiate the footing of the artist from that of the people portrayed. Adopting the perspective of the men he depicted, Derain surveyed those things—shore and dock, boats and water—that undoubtedly made up

many of the daily concerns of these fishing types. To scan the picture repeatedly from side to side is to shift one's footing from land on the left to shipboard on the right and back again, replicating the action of the depicted fishermen, who pass back and forth along the pier between the beach and their boats.

Derain's painting claims for the artist full access to the world of these locals. Such fishermen, moreover, would have appeared to most of Derain's viewers as "naturally" part of Collioure: the aesthetician Frédéric Paulhan voiced a truism of the day when he declared in 1913: "Villagers and peasants, those who do not come to the countryside as tourists but who live their lives there, working the soil, are in some sense part of nature."[2] Derain's proximity to these locals ostensibly placed him in similarly close contact with Collioure itself. Matisse and Derain appeared to belong, then, in these small fishing ports seemingly unsullied by civilization—and, conversely, these sites belonged to them.

It was a rustic theme for high art, and, as if in accordance, Matisse and Derain painted their southern scenes in a style that declared itself to be simple. These pictures, actually, wrested out simplicity from the relative complexity of Neo-Impressionist technique. Ever since Paul Signac had first sailed his yacht into the port of Saint-Tropez in 1892 and established a residence and studio there shortly thereafter, his paintings had set the standard for how this site, and other Mediterranean landscapes like it, should be portrayed. Signac's pictures such as *Saint-Tropez in the Setting Sun* of 1896 (fig. 40) capture views of Saint-Tropez using points or dabs of bright-hued pigment. Matisse first visited Saint-Tropez in 1904 on Signac's invitation, and at times he, like many of Signac's numerous guests, emulated his host's artistic practices. Matisse's *View of Saint-Tropez* (fig. 35), though offering a different prospect of the fishing port, follows the same basic compositional scheme as Signac's *Saint-Tropez in the Setting Sun*: both pictures cradle the town between the near shore and water and have the tower of the church bridge the bay. *Luxe, calme et volupté* of 1904–05 (fig. 55), Matisse's culminating and most ambitious canvas from the sojourn in Saint-Tropez, reiterates yet again this same format, for while nudes replace the town and a boat's

40. Paul Signac. *Saint-Tropez in the Setting Sun*. Saint-Tropez: Musée de l'Annonciade. 1896.

mast now links the shores, Matisse based this work on the identical stretch of coastline that he depicted in *View of Saint-Tropez*. In this large work, moreover, Matisse's mosaic of saturated paint dabs made clear his debt to his pointillist predecessors.

Even as he engaged Signac's legacy, however, Matisse modified pointillism in such a way as to purge his canvases of the essence of Neo-Impressionist technique. In *Luxe, calme et volupté*, dots become large dashes of pure pigment, a far cry from the microscopic points of paint typical of most pictures by Seurat and by Signac through the 1890s. With each brush stroke clearly visible even from a distance, there was no chance to emulate the Neo-Impressionist principle of optical mixing whereby the light rays reflected from two dots of pure color were meant to conjoin optically to produce a compound third. Matisse did not even try to produce the illusion. For the most part he laid out his dashes of pigment in large monochromatic fields, or at the most in fields of closely related hues. An expanse of yellow dabs here, an area of blue or red dabs there, but virtually no suggestion that light reflecting off contiguous blue and yellow dots might combine, according to Ogden Rood's influential theories, to create white.[3] In a handful of passages Matisse did retain some semblance of the pointillist principle of simultaneous contrast whereby dots of complementary color encircling an object of bright hue was thought to capture its chromatic afterglow. A violet aura, for instance, surrounds a cigar-shaped yellow cloud in the upper left of *Luxe, calme et volupté*. Yet even here the contrast of hue is so radical as to repudiate completely the Neo-Impressionist pretense to scientific optical verisimilitude. In classic pointillist painting, colors and contrasts were built step-by-step and (reputedly) founded upon the rational laws of science; in the Matisse's canvas they appeared anything but constructed. Matisse made his dabs of pigment boldly self-evident, straight from the tube and large as life.[4]

Neo-Impressionists working in the south, including Signac, in fact took much the same route as Matisse would half a decade later as they entered the twentieth century. The paint dots of Signac and his followers were to expand in size to become buttery dabs, shattering forever the illusion of optical mixing. Nevertheless, few canvases produced by Signac and his circle simplified pointillism to the extent that did *Luxe, calme et volupté*, where individual paint dabs often lie isolated against visible white priming.[5] And in most of his pictures from Saint-Tropez, Matisse avoided even the reference to Neo-Impressionist technique. *View of Saint-Tropez* (fig. 35), though preceding *Luxe, calme et volupté* in time, suggests the direction Matisse would take in future years. Here full brush strokes, not short dabs, of bright color define the contours of town and landscape. Throughout the foreground, the tan of priming peeks out from between Matisse's rudimentary patches of paint.

It was in Collioure, however, that technical simplicity in both Matisse's and Derain's paintings came into its own. The predominant color in Derain's *Port of Collioure, the White Horse* (fig. 41), is white, but what we are seeing is untouched primed canvas. Against this white surface lie Derain's large and unctuous brush strokes and swatches of color, for the most part detached one from another. The treatment of the horse that gives the work its title typifies the whole: the animal is carved out of the priming only by the handful of lines that define its harness and the shadowed edges of its belly and legs. The passage is so abbreviated, in fact, that we cannot be sure that Derain has not reversed the beast and put the cart before the horse.

41. André Derain. *Port of Collioure, the White Horse.* Troyes: Musée d'Art Moderne. 1905.

Matisse's *View of Collioure with the Church* (fig. 42) and Derain's (mistitled) *Lighthouse at Collioure* (fig. 43), both depicting the small church at the port, are more rudimentary still. The academically trained Matisse did not even bother to prime his coarse burlap canvas before smearing on the handful of strokes that must suffice to define the tower. Likewise, the dark tan of Derain's rough unprimed support stands out between the isolated orange brush strokes depicting the rough-hewn stones of the church. All here seems patently obvious: no underpainting, little layering; nothing hidden from view, nothing to suggest artistic finesse.

Such abbreviated technique we have seen before: Matisse's *Nude in the Studio* (fig. 34) was headed in this direction in 1904–05, and Derain's paintings of London—and, to a lesser extent, Vlaminck's of Chatou—were to rely on the procedure in the months and years to come. This manner of painting, subsequently known as the Fauve style, reached its first fruition—and perhaps its fullest realization—in the paintings Matisse and Derain executed in Collioure in the summer of 1905. Unembellished painting of this sort provoked the ire of Symbolist critics; Matisse's and Derain's

42. Henri Matisse. *View of Collioure with the Church*. Location unknown. 1905.

43. André Derain. *Lighthouse at Collioure*. Paris: Musée d'Art Moderne de la Ville de Paris. 1905.

canvases of Collioure, after all, filled the Fauve "cage" against which Denis launched his attack against the "school of Matisse."[6] To produce paintings so lacking in complexity or enigma exemplified, for the Symbolists, the failure to attain Platonic or pantheistic transcendence along the lines of Van Gogh, Gauguin or Monet in his late works. Certainly nothing could have been further from the recondite encrustations of Monet's Rouen Cathedrals than Matisse's and Derain's depictions, coarse and quick, of the humble fishermen's chapel at Collioure.

If extreme technical simplicity made these pictures prime candidates for Symbolist condemnation, it also greatly enhanced the neo-naturalist character of Matisse's and Derain's paintings.[7] In the small fishing ports of the Mediterranean coast, far from the urban sophistications of Paris, artlessness had a strong thematic basis. Accordingly, technique in Matisse's and Derain's southern landscapes could appear the product of the very rustic sites and people it was used to portray.

The palette used by the Fauves for their paintings in Collioure was strikingly rudimentary. Little mixing and no modeling dilute these paints straight from the tube. Primary hues abound. The small sailboat in the upper right corner of Derain's *Port of Collioure, the White Horse* (fig. 41) is archetypal: an elementary color wheel of the three most basic hues—yellow, red, blue. We have already seen how such pure color could speak of the physical properties of pigment itself, physical properties that echoed the materiality of the site. For some viewers, such highly saturated color also evoked the unrefined tastes of "primitive" races and classes. "If the savage, if the peasant prefer vivid colors," argued the writer Paul Adam in 1907, "it is because their optic is not sufficiently refined. At a village ball, green and red attire, ruthlessly blue hats, and white lace collars are in abundance."[8] Purged of the nuances of color that Adam and others associated with the fine art of painting, canvases by Matisse and Derain could well have suggested instead the chromatic forthrightness of the ostensibly plain, natural folk they depicted.

Similarly, the seemingly crude application of paint made the artists appear as unsophisticated as the locals in front of them. Factoring the residents out of the equation altogether, Derain's *Lighthouse at Collioure* (fig. 43) went so far as to assert

that the vision of Collioure it provided was indistinguishable from the site itself. In the ultimate tactile rhyme, the sail of a fishing boat at the right edge of the picture consists entirely of exposed canvas, a clever matching of the rugged fabric of the painting's support to the coarse sailcloth of the fishing craft. The object portrayed by the painting appears as tangibly physical and as immediately present to the viewer as the unpainted surface. In like fashion Derain's brush strokes in *Lighthouse at Collioure* often emulate the physical characteristics of that which they depict: one well-laden stroke for each massive building block of the church; one long, continuous streak for the railing in the left foreground. In these passages the site is evoked less by visual resemblance than by direct, tactile correspondence: Derain's ''bricks'' of pigment are set into place like so many rough-hewn stones at Collioure. Pictures by both Derain and Matisse are filled with such visual puns that turn on the shared substantiality of paint and depicted object. This is neo-naturalist painting in its purest form. Iconic representation, with the gap it always implies between image and reality, collapses into material similitude: to examine the physical object that is the painting seems tantamount to beholding the actual portrayed scene.

Even here, certainly, the practice of painting always and inevitably mediates the view. The conflation of picture and seascape is a fiction manufactured by the artist's effacement of skilled technique. Because the interventions of style in Matisse's and Derain's pictures are hidden by their mimicking of rustic scenes, the resulting views onto the Mediterranean shore appear direct and authentic, unencumbered by the artifices of art. Pictorial means seem as guileless as pictorial theme. The practice, as we have seen, proved effective among Parisian critics, for it earned these artists the label *les fauves*, "wild beasts" presumably as at home in nature as were the fishermen of Collioure.[9]

Paris, seemingly, had been left behind. Matisse and Derain presented themselves as natives of the Mediterranean shore. They painted Collioure as if out of the material, and with the sensibility, of the site itself; no scientific or artistic technologies of the late- or Neo-Impressionist varieties need be applied from afar. Here, even more than in London or Chatou, that which was depicted and the means by which it was portrayed appeared one and the same. Painters and natives, paint and landscape; all became part of the same rustic and integral whole.

2

To this direct rendition of the harmonious Mediterranean landscape corresponded a new manner of touring, likewise developed in the south of France in the first decade of the twentieth century. Although their numbers were not yet legion, a new breed of traveler was beginning to search out small Mediterranean villages and ports where natural setting, human settlement and visiting tourist could merge together in common accord. The paraphernalia of organized travel—guidebooks and postcards—prescribed and recorded how these new excursionists experienced the landscape around them.

At Saint-Tropez, according to the author of guidebooks Ardouin-Dumazet writing in 1898, the tourist discovered a gentle prospect: "The gulf is a marvel of grace with its rounded contours, the hills wooded with parasol pines, the long trunks of palm trees, . . . the old and picturesque fishermen's quarter."[10] In 1904, Ardouin-Dumazet found that Collioure offered much the same. "In a bend of the coastline, at the outlet of a valley, scattered around the forts, gardens, and coves in a picturesque manner, . . . here is the pleasant town of Collioure. The prospect is charming."[11] The villages themselves, fully integrated into their landscapes, contributed as much as the surrounding hills and water to the picturesque appeal of the sites. A postcard of Saint-Tropez (fig. 44), purchased and sent by a tourist during the first decade of the twentieth century, similarly posited a peaceful harmony between human habitation and the surrounding scenery. The photograph—need it be said?—composes the scene in a fashion virtually identical to Matisse's *View of Saint-Tropez* (fig. 35).

Vacationers who traveled to such Mediterranean villages strove, like Matisse and Derain, to submerge themselves in their natural surroundings. To abandon the international resort city of Nice for nearby Cimiez, maintained the travelogue writer Georges Fontaines in 1897, was to leave "society" behind in favor of "a delightful simplicity." In this small town, Fontaines continued, it was "up to each [visitor] . . . to search out such peaceful and sunny spots where he will be able to savor at his leisure

44. Saint-Tropez: General View. Postcard photograph. Before 1903.

the thousand treasures of nature, in the midst of an infinite mixture of continuously renewing and diverting pleasures."[12] Displacing oneself physically into the gentle embrace of nature implied a corresponding mental shift from civilized sentiments to natural ones. Albert Dauzat, the author in 1911 of a book entitled *Pour qu'on voyage* whose subtitle declared the volume to be an "Essay on the Art of Traveling Well," encouraged his readers away from heavily frequented locales with the following enticement: "For a time, one recovers for oneself a primitive mentality that, by contrast, demonstrates that the needs created by refined civilization are, in the end, artificial and relative. One learns better to appreciate those things that appear completely natural and on which we have never taken the trouble to reflect."[13]

Fraternizing with the local inhabitants proved a reliable manner for tourists to shed metropolitan habits and make themselves a part of the natural scene. Dauzat advised: "To know a country and its inhabitants, it is necessary to make contact with the natives and penetrate as much as possible the local settings."[14] This preference for indigenous company determined not just where the new tourist ventured in the south, but also when. If an earlier generation of refined and international traveler descended on the *hôtels de luxe* of Nice and Monaco exclusively during the winter "season," hearty French tourists of the new era sought out small villages during the hot summer months. M. Tournesac, a fictional character created by Henri Boland in the pages of a humorous travelogue of 1910, professed:

The Midi [the South of France] is not known, or is not known very well. The snobs—who are legion—go there during the winter and catch cold. . . . [During the summer,] they go and catch cold on the beaches of the Channel or of the North Sea.

Me, I hate catching cold . . . and I go to the Midi when the cosmopolitans have left it and no one remains there but the folk of the region, the Meridionals.[15]

The summertime south, Boland's words suggest, promised the tourist not only native setting and community, but also robust health. Shunning the sophisticated winter crowd, it would seem, provided prophylaxis against those twin infirmities of refined civilization, snobbery and the common cold. How much better to count as one's companions the "sun-bronzed and sun-scorched fisherman" that travelogue writer Victor Dujardin admired in Collioure. "It is the tanning of the wind, of the sun, of the open salt air," declared Dujardin in 1890, "that makes the sailors so strong, and give to their complexion those warm, ardent tones."[16] By identifying with such stalwart locals, the new tourist aspired to a sound physical constitution.

And indeed, vacationers in the south exposed themselves to the same natural elements that Dujardin claimed rendered the natives hearty. Quite literally, they entered nature, swimming in its waters, absorbing its rays. Whereas previous generations of tourists took care to shield themselves from the light of the sun, a reversal in medical opinion accompanied the growth of tourism in the south, and sun bathing was declared beneficial. Dr. Adolphe Monteuuis, writing to the French in his book *L'Usage chez soi des bains d'air, de lumière et de soleil* of 1911, proclaimed: "The regenerating action of the sun is so profound that it produces (the word is not an exaggeration) veritable resurrections . . . Sun baths, baths of light and of fresh air, have a considerable influence on the health and vigor of the individual as well as that of the race . . . They are a necessary condition for vital energy."[17] Swimming in the open waters of the Mediterranean also had its advocates—and practitioners. Mme Léonide Votez, touring near Eze in 1907, recounted: "Wading in the water, I am struck by a diabolical idea: what if I went for a swim?" She did, in fact, take the plunge, her minor contribution to the gradual transformation of an act virtually unimaginable in the nineteenth century into commonplace behavior of today. "The ardent sun that burns my face, in the end, persuades me," explained Votez; "the first impression is disagreeable enough, but in the end I get used to it and soon the chill is followed by an extraordinary sensation of well-being."[18]

Perceived as a means for revitalizing both the individual and the race, tourism in the new manner played a part in a larger campaign around the turn of the century directed toward the physical rejuvenation of the nation. A growing number of the French, fueled by concerns over a feeble national birthrate and the military defeat at the hands of Germany in 1871, hoped to reinvigorate the French population through a regimen of physical exercise and sport; the modern Olympics and the institutionalization of physical education in French schools were but two products of their efforts.[19] Traveling constituted one of the most important manifestations of this new emphasis on physical vigor. "Tourism," argued E. de Morsier in the pages of *La Revue* in 1905, "truly has become a national school of initiative, of activity, of composure, of good will, of virile ardor, of noble and healthy ambition. It contributes to the development of the noble human animal toward beauty and goodness."[20] Georges Casella, author of *Le Sport et L'Avenir* of 1910, devoted sections of his book to "Tourism" and "On the Taste for Traveling" as well as to "The Air and the Sun."[21] The polemical cover of this volume, designed by Pierre Falize (fig. 45), made clear the choice Casella believed

45. Pierre Falize. Lithograph. Cover for Georges Casella, *Le Sport et l'Avenir* (Paris, 1910).

confronted France: the decrepitude of an aging civilization or the physical vigor of the natural body. Tourists traveling south at the turn of the century faced much the same decision, opting between the refined winter crowd at Nice or the robust natives of summertime villages.

Ultimately, the return to natural vigor represented by sport and the new form of tourism promised cultural as well as physical rejuvenation. Casella quoted the writer Albert Surier:

Contemporary art . . . lingers forever over the mannered forms of yesteryear; "the natural sense of harmony" that in reality sportsmen possess takes fright at the unaesthetic caprices of the new art [*art nouveau*] . . .

That art that we will like, in fact, does not yet exist. It would be of very sober conception, of the harmonious line with simplicity; it would magnify human beauty, the splendor of the nude, the imperishable joy of healthy flesh; it would exalt the happiness of life [*le bonheur de vivre*], the serenity of the strong, the nobility of natural pleasures.[22]

An art that rejected the tired formulas inherited from an anemic civilization in favor of "natural" artistic sensibility, an art that celebrated the nude and the good life of strong beings; Surier may have worried that no such art existed, but his could well have served as a description of the Fauves. Fauve technique, as we have seen, repudiated the sophistications of late Impressionism as well as the rational constructions of Neo-Impressionism. Nudes and sturdy fisherman crop up regularly in Fauve canvases from the south: Matisse even relied on the same words as Surier—fortuitously, to be sure—for the title of one of his most important paintings from Collioure, *Bonheur de vivre* of 1905–06 (fig. 56).[23]

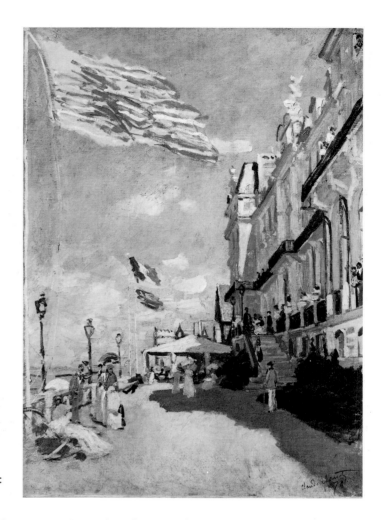

46. Claude Monet. *Hôtel des Roches Noires, Trouville*. Paris: Musée d'Orsay. 1870.

 Just as, in the minds of writers on travel and sport, the new generation of tourists reinvigorated the French body, so Matisse and Derain, their advocates could contend, gave new life to French culture. The south, "rough and savage" in the words of Boland, must have appeared a natural habitat for Vauxcelles's "shocking and virulent" Fauves.[24] The vitality of both Frenchmen and French art, it seemed, depended on a bracing dose of nature, and no place offered a better setting for their joint renascence than the untrammeled Mediterranean shore.

<div align="center">3</div>

Touring and painting at the French seaside had not always been such an informal, ostensibly natural affair. Although we have seen traces of civilized vacationing in wintertime Nice, the French actually pioneered this mode of touring during the second half of the nineteenth century along the Channel coast, where it flourished in resort cities such as Trouville and Deauville. And if Matisse and Derain joined the trek to small southern ports and villages at the beginning of this century, in 1870 the young Monet, traveling with his new bride on their honeymoon, made the pilgrimage to Trouville.

For his *Hôtel des Roches Noires, Trouville* (fig. 46), Monet set up his easel on the terrace of the liberally ornamented hotel, which was then the jewel of the luxurious establishments along the Channel. The painting invites its viewers to partake in the swirl of activities at this pinnacle of holiday society at Trouville. The expansive terrace, almost exactly as wide as the canvas itself, opens before our eyes. To enter the pictorial space of the painting, to follow the path laid out by the commanding orthogonals commencing in the lower two corners of the canvas, is to join in the mingling of the well-dressed sophisticates situated on Monet's social stage. Above, an assortment of flags proclaims the international character of the clientele. And what of nature? Here it seems all but beside the point. The ocean may lie beyond the railing at the left of the picture and a sea breeze may flutter the flags, but these people—and Monet—seem oblivious to the natural attractions of the place. Enacting cosmopolitan rituals with fellow tourists is occupation enough at Trouville. Monet's airy technique, its swirls echoing the baroque ornateness of the statue at the peak of the façade and its light pastels capturing the crisp freshness of chiffons and linen, seems to play the elegant game over again in paint. The *Guide Diamant* declared of Trouville in 1873: "It is Paris, transported for two or three months to the seashore, with its qualities, it frivolities and its vices."[25]

Three and a half decades later, visitors to the north still experienced Trouville as an urban place. A hand-tinted postcard from around 1904 (fig. 47) features the same urban crowds, flamboyant façades, international flags—and indifference to nature—as Monet's painting. This stretch of sand, proclaimed the Baedeker's guide to the northwest of France in 1908, "is the summer boulevard of Paris."[26]

Raoul Dufy—in Vauxcelles's words, a "Fauve follower"[27]—sojourned and painted in Trouville as he traveled through Normandy in 1906 with his friend and painting companion Albert Marquet. The scene depicted in his *Posters at Trouville* (fig. 48) scarcely divulges the fact that the artist was working within sight of the water. The large hotels in the background hint that this human thoroughfare may be near the beach, but nothing indicates whether the picture portrays the row of façades fronting the ocean or that facing inland toward the access street. Only a matching painting by Marquet, which includes two beach tents in front of the same wall of billboards, establishes with certainty that Dufy's vantage point was from the boardwalk. Dufy's painting, on its own, could well seem the view of a large boulevard within any major city. Crowds rush by, a street lamp stands at attention, a park bench offers rest for the weary or leisurely—there are no takers—and, of course, a profusion of billboards blare forth their advertising messages. Even more than Monet in 1870, Dufy in 1906 portrayed the seaside Trouville indelibly marked with the attributes of urban life.

The mass-market appeal made by the loud billboards in Dufy's picture suggest that in 1906 the clientele at Trouville no longer consisted only of a financial and social elite. Certainly all witnesses could agree that during the intervening three and a half decades since 1870 the classes able to afford the time and expense of vacation travel had expanded greatly in France. Jacques Lux, a regular contributor of social commentary to the solidly mainstream *Revue Bleue*, wrote in 1907: "The practice of staying in the country or traveling, accepted only by the aristocracy a half century ago, is now prized by the lower bourgeoisie."[28] Even the exclusive Trouville, where a man of limited means such as Monet must have been in a distinct minority in 1870, could be

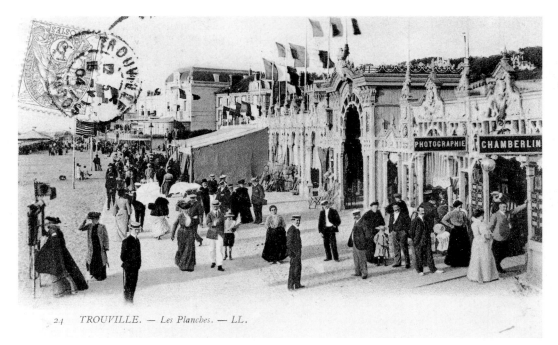

24 TROUVILLE. — Les Planches. — LL.

47. *Trouville: The Boardwalk.* Hand-tinted postcard photograph. Before 1905.

perceived as having made place for the new tourist crowds. Paul Gruyer, author of the Guide Joanne for 1913, observed that "Trouville brings together the most diverse groups, from high and rich society . . . to a popular clientele."[29]

The bold primary colors and forceful brush strokes with which Dufy executed *Posters at Trouville* speak of the ostensibly unrefined artistic sensibilities of the lower classes recently admitted to this northern tourist center. Like Derain's renditions of London boatmen and Vlaminck's pictures of suburban agrarian workers, like Matisse's and Derain's canvases of simple fishermen from the south, Dufy's work correlates a coarse manner of painting with plebeian characters and site. And, indeed, the members of the crowd passing in *Posters at Trouville* lack the aristocratic bearing of Monet's elite on the terrace of the Hôtel des Roches Noires. While the canvas does not provide an incontrovertible iconographic sign of the presence of the middle or lower classes— we cannot be certain that the ill-defined blue costume of the foremost figure in Dufy's picture is a worker's smock—the slouches that bow the shoulders of many of these strollers signal their status as commoners, lacking the type of grace typically associated with the aristocracy.

In his paintings of Trouville, of course, Dufy was hardly forced to replicate the demographic trends articulated by Lux and Gruyer. He, following in the footsteps of Monet, could have ignored billboards and common crowd, painting instead only the elite frequenting the still thriving and exclusive Hôtel des Roches Noires. Nevertheless throughout Normandy, Dufy chose motifs from a wide social spectrum, and rendered them all in his version of the brazen Fauve style.

Yet while Dufy may have opened the gates of Trouville to the common classes, he found no more place for the natural attractions of the coast, for sea and sand, than had Monet in *Hôtel des Roches Noires, Trouville.* In Trouville, more often than not, Dufy turned his back to the water and regarded the crowd. Moreover, just as nature does

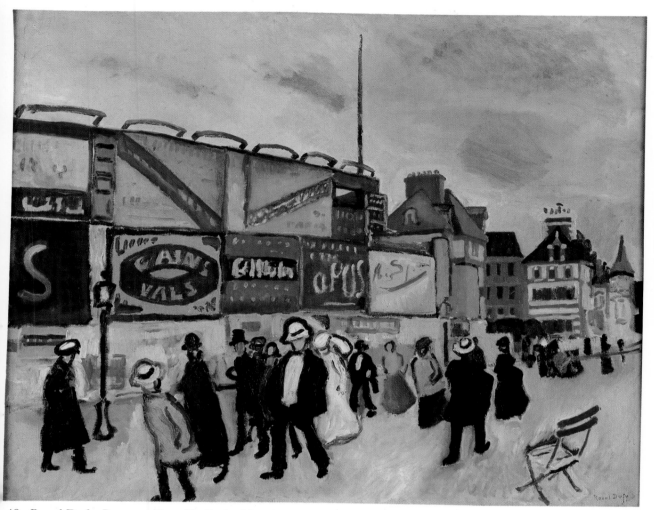

48. Raoul Dufy. *Posters at Trouville*. Paris: Musée National d'Art Moderne. 1906.

not figure prominently in these canvases, Dufy seldom painted with the neo-naturalist simplicity of his better-known Fauve associates. The neutral-colored walkway in *Posters at Trouville* is not priming, halos of reworked paint surround many of Dufy's figures, and the numerous layers of pigment overlap to form the billboards. Color and execution may be aggressive, yet Dufy's style is far from the self-explicating and seemingly natural rendering of, say, Derain's rustic *Lighthouse at Collioure* (fig. 43). Even had Dufy's style aspired to naturalness in the manner of Matisse and Derain, the object with which technique would here have rhymed itself would have been the sign board, an archetype of visual communication within advanced civilization. Dufy's style and subject matter may have claimed affiliation with the lower rather than the higher social strata, they may even have offered a healthy dose of robustness as a cure to the anemia of overrefinement, but they nevertheless appeared the product of human society, not of nature.

Thus in Trouville at the beginning of the century, while the cast of players may have altered somewhat, the drama of tourism as it was recorded in painting and by the written word had remained essentially the same. Although Parisians traveling to the

49. Claude Monet. *Cliffs of Petites Dalles*. Boston: Museum of Fine Arts. 1880.

Channel resorts left the city itself behind, they willingly brought with them urbanity and its concomitant mechanisms of visual expression. Tourists and painters replicated along the Channel coast many of the social and visual practices they knew from the capital.

Monet's and Dufy's depictions of Trouville certainly do not exhaust the range of paintings produced on the Channel coast. Nature could also be the object of art in the north. Forsaking cosmopolitan Trouville after 1870, Monet ventured several times in subsequent decades to the dramatic rock formations of Etretat and other sites along the Normandy coast. His *Cliffs of Petites Dalles* of 1880 (fig. 49) belittles humanity: an expanse of violent sea and the soaring heights of distant cliffs dwarf several small figures in the middle distance. This is nature not encompassed by civilized life but opposing it, contrary to human society.

In a word, this is the sublime.[30] French audiences at the turn of the century would undoubtedly have conceived of the sublime in terms derived from Edmund Burke and Immanuel Kant since the aesthetic theories of these two eighteenth-century philosophers had percolated through virtually all nineteenth-century texts on landscape, including those written in France. It could be said that Monet formulated a Burkean conception of the sublime in *Cliffs of Petites Dalles*. In *A Philosophical Enquiry into the Origin of our Ideas of the Sublime and Beautiful* of 1757, Burke claimed that the sublime consisted of those things "vast in dimension," "terrible," and evocative of "pain and danger." And when Burke wrote: "The passion caused by the great and sublime in *nature . . .* is Astonishment" and "Whatever excites this delight, I call *sublime,*" it is clear that he situated the sublime in nature, independent of human cognition.[31] Monet's juxtaposition of minute humans against the soaring cliffs at Petites Dalles reiterates this same Burkean principle: the terrible sublime exists in nature, beyond the human realm.

This contrast between humans and cliffs, far from contradicting an appreciation of the refined life at the luxurious resorts, stood as its complement. For nature to surpass

the measure of society reinforced the sense that humanity existed only within the framework of civilized life. Monet's representations of the cliffs at Petites Dalles, like pictures of Trouville by him and Dufy, placed civilization on one side of a conceptual divide and nature on the other.

Yet where mere mortals could not go, the artist dared to tread. In *The Manneporte, Etretat II* of 1886 (fig. 50) and many other like canvases, Monet pitted himself alone—there are no *staffage* figures—against the soaring rock face. The artist claimed special powers in relation to the sublime: he could interpret it. If "the sublime is the manifestation of a power that surpasses us, the expression of an infinite activity," argued the Arch-priest of the Cathedral of Nantes, l'abbé Gaborit in 1871 in his religiously charged discussion of the beautiful in nature, "man, through literature or through painting, through music assisted by poetry, can translate for us the spectacles in which we see the sublime."[32]

Viewers of Monet's canvases could discover ample pictorial evidence of such artistic mediation; Monet, in other words, offered a representation of his privileged status as the interpreter of sublime nature. In *The Manneporte, Etretat II*, the skillfully worked and thickly encrusted surface catalogues many of the intricate technical devices that Monet had developed over two decades as a painter. Complexity mystifies technique— it is exceedingly difficult to discern exactly how Monet put this picture together—and thus late-Impressionist style conveniently becomes the sign for the artist's special

50. Claude Monet. *The Manneporte, Etretat II*. New York: Metropolitan Museum of Art. 1886.

51. André Derain. *Port of Collioure*. Paris: Musée National d'Art Moderne. 1905.

vision. Once the artistic dynamic had been culled down to this atomic pairing of artist and natural motif, the entire critical mechanism that emerged alongside Monet's late paintings—it had its origins in the 1880s and we have seen it operating at peak performance in regards to Monet's paintings of London in the first decade of the twentieth century—could come into play: Monet the pantheist, Monet the secular priest captured the hidden essences of his natural objects.[33] Unlike the rest of us, the argument ran, the artist comprehends sublime nature because he possesses his seemingly magical artistic skills, and *vice versa*.

This affinity between the artist and terrible nature reiterated, in place of Burke's ideas, the account of the sublime penned by Kant. Kant argued in the *Critique of Judgment* of 1790 that aesthetic categories were purely mental constructs: "We express ourselves incorrectly if we call any *object of nature* sublime . . . true sublimity must be sought only in the mind of the [subject] judging, not in the natural Object the judgement upon which occasions this state."[34] Kantian aesthetics, by treating the sublime as a cognitive rather than an ontological category, granted fantastic powers to those who could perceive nature using the mental construct of the sublime. If nature seemed threatening, if humans feared for their safety before its mightiness, humanity could use the concept of the sublime to tame dangerous nature, to bring it down to human scale. "In our mind," Kant argued, "we find a superiority to nature even in its immensity."[35]

From a Kantian perspective the category of the sublime, far from marking inhuman nature off-limits to human experience, functioned as the very device by which such nature could be brought under control once again, contained within an aesthetic created by human minds. The sublime allowed society, through the offices of the artist, to have nature both ways: both infinitely powerful and bounded by human sensibilities. Terry Eagleton has commented on this seeming paradox:

> There is . . . that about the particular ideology of the bourgeois class—its restless, dynamic self-distancing from Nature—which enters into potentially tragic conflict with one of the requirements of ruling orders in general: the need to see themselves consolingly reflected in a world of their own creation. The aesthetic accordingly steps in to unify, for a precious, precarious moment, a subject and object ripped rudely apart by common social practice. . . . Lest we grow complacent in contemplating the image of our own powers in the mirror of reality, there is always the shattering, destabilizing inruption of the sublime to remind the bourgeoisie that its forces are infinitely expandible, that its true home is eternity.[36]

In France at the turn of the century, the sublime served as an "aesthetic" in Eagleton's sense of the word, for it "step[ped] in to unify" a certain bourgeois class, Monet's audience, with awe-inspiring and eternal nature, Monet's theme. The privileged, mystical artist Monet facilitated the claim by a finite social class to have control over the infinity of the natural.

4

In their paintings from the south Matisse and Derain systematically rejected this vision of nature formulated in the north. These two painters expunged from their southern canvases virtually any natural feature that might have suggested the terrifying scale of the sublime. In Saint-Tropez Matisse found a suitable object for portraying a gentle landscape since, although the Maures region in general is quite mountainous, the peninsula on which this port is situated consists only of rolling hills. Even the mountains visible across the bay from Saint-Tropez appear quite moderate in height and slope; nothing abrupt interrupts the smooth flow of the landscape. To avoid the sublime in paintings such as *View of Saint-Tropez* (fig. 35) required no special selection of prospect or editing out of details on Matisse's part.

Collioure was quite a different matter. Almost immediately behind Collioure rise the steep foothills of the Pyrenees, and ruins of ancient fortresses cap many of the immediately surrounding peaks. As monuments to the impermanence of human existence in face of the dramatic forces of nature, these ruins begged for sublime treatment. In virtually all their depictions of Collioure, however, Matisse and Derain turned their backs on this spectacle. They looked instead outward toward the calm Mediterranean, perhaps including some of the gentler bluffs just skirting the water's edge. Only very occasionally did Derain, positioning himself in the section of town closest to the sea, look back toward the bay and the hills beyond. In *Port of Collioure* (fig. 51), the verdant slope appearing along the upper edge of the canvas depicts the lowest section of a hill on whose summit sit ancient fortifications in ruins. Derain, however, cropped the scene in such a way as to eliminate the fort, indeed to eliminate

52. André Derain. *View of Collioure*. Essen: Folkwang Museum. 1905.

practically all of the hill. The daubs of green paint that define this small portion of the hill give little sense of rise, and the few touches of orange and reddish-brown pigments dotting this passage, as a result of the similarity of their hues and values to the patches of exposed dark prime that appear throughout the canvas, do little to reinforce the illusion that we are looking here at solid earth rather than at a horizon. Most of the canvas, in any case, draws our attention away from the surrounding landscape and focuses it on the lazy afternoon activities of the port, as fishermen, resting between their morning and evening fishing runs, busy themselves with the maintenance of their boats, sails and nets.[37]

Nature in Fauve canvases from Saint-Tropez and Collioure remains calm and harmoniously intertwined with human society. Matisse and Derain, moreover, disavowed the privileged status of the skilled artist: none of Monet's layered and recondite reworkings here. Yet the Fauves did contain the landscape within an alternative aesthetic category. Fauve paintings of the tranquil Mediterranean south conformed to, and thus helped to perpetuate, a convention of painting that I will refer to as the classical landscape.[38] At the beginning of this century in France the compositional standard that defined the classical landscape was set above all by artists of the French *grande tradition*, that seemingly unbroken chain of great Latinate and French artists extending from antiquity to modern times. The artworks in 1905 most widely considered to exemplify the *grande tradition* were beyond a doubt the landscapes by the seventeenth-century masters Nicolas Poussin and Claude Lorrain, a manner of painting perpetuated into the nineteenth century by the early Italian landscapes of—in the words of the historian of landscape Raymond Bouyer—the "grandson of Claude," Jean-Baptiste Camille Corot.[39]

Over and again as they shunned sublime elements in their paintings of the Mediterranean coast, Matisse and Derain produced canvases that conformed to the contemporary standards of the classical landscape. Except for its vertical format, Matisse's *By the Sea* (fig. 38) echoes the pictorial organization of Claude's *Ariadne and*

53. Jean-Baptiste Camille Corot. *Papigno, Buildings in the Valley*. Private collection. 1826.

Bacchus on Naxos of 1656 (fig. 36): a tree as *repoussoir* along the right edge, secondary massing on the left, gradual spatial recession articulated by the diagonal of the shore line, and even *staffage* figures in the foreground. Moreover, Matisse's colors, despite their saturation, actually set up a rudimentary atmospheric perspective similar to Claude's: warm tones in the foreground, cool blues in the distance. Derain also often followed the norms of the classical landscape. He bracketed the scene in *Port of Collioure, the White Horse* (fig. 41) with trees positioned as primary and secondary *repoussoirs*. And in *View of Collioure* (fig. 52), the artist nestled the village in the comfortable middleground among rolling hills, much in the manner of Corot's early Italian landscape *Papigno, Buildings in the Valley* of 1826 (fig. 53).

This is not to suggest a direct "influence": Matisse and Derain did not systematically copy Claude, Poussin or Corot.[40] Such obvious and self-conscious borrowing was, for the most part, unnecessary: even the most elementary artistic training in France at the turn of the century would have instilled in painters a way of thinking about the countryside that would have made the devices of the classical landscape immediately available for use. No need for reflection, no need for specific prototypes. Similarly, viewers at the turn of the century—as today—may well not have consciously recognized a filiation between the Fauves and the artists of the *grande tradition*. Nevertheless, conditioned by exposure to countless paintings of the *grande tradition*, that audience would have marshaled the artistic category of the classical landscape to the task of viewing these Fauve landscapes with such rapidity and ease that the classification would have felt like an unconscious act of intuition.

Thus in their Mediterranean landscapes, Matisse and Derain—without first positing nature as a monster to be tamed, as had the artists of the sublime—likewise suggested that nature fell within the bounds of human aesthetics.[41] Both the sublime and the classical landscape, however, concerned more than simply the manner of painting a picture. As we have seen, the two aesthetic principles corresponded to two different modes of touring. Yet the two types of painting did not follow meekly in the

wake of tourism, recording the sensibilities of tourists in a servile fashion. If anything, the opposite was true. To make sense of the natural scenery around them, tourists turned to the visual precedents furnished by landscape painters. The Comte d'Ussel, like Dauzat a writer counseling readers on how to travel correctly, advised in 1907: "To understand the landscape well, and as preparation for a voyage in a country of landscapes, it would be good to have drawn or painted oneself, or—failing that—to have looked attentively at many paintings: the lessons of painting are better than those of nature itself contemplated directly."[42] Tourists self-consciously viewed the landscape, analyzed it, and registered it in memory, utilizing categories already provided by painting.

It was thus not by chance that painters and writers pioneered the tourist sites of Saint-Tropez and Collioure—and, in an earlier age, of Etretat and even Trouville—for in doing so they brought a set of aesthetic principles to bear on the sites that subsequently served as models for other tourists following in their paths. When Ardouin-Dumazet wrote in 1904 of the setting and attractions of Collioure, "all of this forms one of the most picturesque, most animated, and most colorful pictures [*tableaux*] of the Mediterranean, where beautiful sites are abundant," he revealed just as much, if not more, about his own predilection for ferreting an artistic image out of a tourist site as about the Mediterranean port in front of him.[43] Without the guidelines laid out by painting, many a tourist would have made no sense, or at least a very different sense, of the views before their eyes.

Picture postcards, the commerce in which enjoyed a boom parallel and related to the rapid expansion of tourism at the beginning of the century,[44] reiterated the lessons of landscape painting since photographers often modeled their work on canvases by the masters of oil painting. It easy to imagine the creator of our postcard from Saint-Tropez (fig. 44) subscribing to the opinions of Frédéric Dillaye, author of a manual from 1899 on how to make artistic photographs of the landscape:

> Corot . . . said: "Me, I take a walk, I go, and then when I find a picture [*tableau*] or a part of nature that *seizes me*, I set up my easel and I work." When we [photographers] see a part of nature that *seizes* us, we will set up our tripod, we will place our camera on top of it and we will try to photograph it to the best of our abilities. That act of reading the ensemble is a purely psychological act: it is called *simultaneity*.
>
> We have that simultaneity as much as the painters do, as much as any artist who wishes to make a representation of nature.[45]

Photographers cast themselves as artists by emulating the practices of their painting brethren. The postcard photograph of Saint-Tropez, much like Matisse's *View of Saint-Tropez* (fig. 35), does indeed follow the principles of composition, the "reading of the ensemble," laid down by artists such as Corot. Tourists embarking for the south, prepared for their travels as much by a flood of postcards received from their precursors as by visits to galleries and museums, could not have helped but view the Mediterranean shore through the inherited lenses of the *grande tradition*.

Fine art provided more than a set of epistemological categories with which to view the countryside. Just as artists used the sublime and the classical landscape to colonize nature for human contemplation, so tourists could use their travels to assert a similar

control over the land. As the novelist Henry Bordeaux, in a remarkably forthright passage, declared in 1906: "To travel is to conquer new lands with one's eyes, to annex emotions and images onto one's sensibility like a conquerer adds territories to his nation."[46] Tourists, at least initially, did not claim actual ownership of the regions they visited; rather, they asserted that the landscape that fell beneath their gaze belonged within the purview of their cultural experience. "I intend," the collector of postcards Maurice Brousse wrote to the *Revue Illustré de la carte postale* in 1905, "to make with [postcards of] cities as well as [those of] historical events, that is, to compile for myself a geography of France."[47] In a conceptual sense, the landscape belonged to such travelers and collectors. Bordeaux's proved a prescient observation, for in the years to come the rapid growth of tourism in villages such as Saint-Tropez and Collioure was effectively to integrate these previously isolated and semi-autonomous sections of the Mediterranean coast into the mainstream of French national cultural and political life.[48]

Bordeaux's formulation is remarkable for its time only in its explicitness. For even as artists and tourists asserted their interests in the Mediterranean landscape, even as they colonized these sites using the categories of the sublime and the classical landscape, more often than not they dissimulated their claims on the land behind another Kantian principle, that of aesthetic disinterestedness.[49] In a particularly Kantian formulation, the essayist Paul Gaultier in an commentary of 1909 entitled "Le Sentiment de la nature dans les beaux-arts," described the attitude that he felt artists should take as they stood within nature: "It is important to have rid oneself, as much as possible, of the prejudices, biases, interests, concerns and conventions that in ordinary life interpose themselves between nature and ourselves to such a degree as to mask the view. . . . It is necessary to have . . . a thoroughly disinterested sensibility."[50]

In viewing the landscape using the aesthetic categories provided by artists, tourists adopted this apparently disinterested attitude as their own. The fact that their claim consisted of a conceptual appropriation of the site rather than actual ownership of the land only reinforced the pretense of disinterestedness. In 1905 there was little question as to which class possessed the legitimating powers of this Kantian aesthetic, and did so absolutely: the educated bourgeoisie on vacation, not the practical peasantry. In *Pour qu'on voyage*, Dauzat invented the following typical exchange between tourist and local inhabitant to make the point. It is an anecdote told from a position of such unequivocal class self-assurance that nothing restrained the author from indulging in caricature of those he considered beneath him.

Has it never happened, during a journey when before a landscape of the sea, forest or mountains, that you have expressed your admiration to a passerby—fisherman, plowman or woodcutter—exclaiming before him:
"What beautiful country!"
But the man has not understood you, and invariably you elicit one of the following responses:
"Yes, it's good land; crops grows well," or "the fishing is good," or "the oak wood sells at a profit."
Or more frequently:
"Oh, no! It's bad country; nothing grows well," or "you can't catch fish anymore," or "you work to death to earn a miserable living."

But if, to your companion, you try to extol the beauty of the lines of the mountain, the coloring of the ocean, or of the forest or of the clouds at sunset, the worthy fellow will shrug his shoulders with a smile of disdain, not understanding how one can loiter over such nonsense. It is useless to insist; you would waste your time and your eloquence: *he does not feel.* . . .

[The feeling for nature] is promoted by the culture of the mind [*esprit*], the degree of civilization. . . . It does not exist for simple and primitive souls, for the child, for the peasant who both only appreciate the sensible world to the extent to which it is capable of satisfying their pleasures, their needs, their interests. The feeling for nature supposes, on the contrary, a disinterested contemplation; it is a form of artistic enjoyment.[51]

The argument behind the story is uncompromising: only those endowed with the gift of aesthetic contemplation, and not those burdened with practical concerns, truly understand the landscape. This "beautiful country" must belong to the aesthetically inclined, for no one else can even see it.

In a much more sophisticated way—certainly without having to resort to the overt disparagement of the lower classes—the Fauves performed much this same dissimulating function. Beyond a doubt, Fauve pictures grant the power of vision to only certain viewers. While (as I argued earlier) Matisse's *By the Sea* (fig. 38) and Derain's *Return of the Fishing Boats* (fig. 39) posit an intimate proximity between painter and site, the painters themselves, or their social and gender equivalents, never appear in Fauve canvases. Women and children, fishermen and landscapes are the objects of vision in these paintings, and artists and tourists the controlling subjects of the interested gaze. Yet such scenes, when depicted in paint, receive the sanction of disinterested aesthetics. In the hands of Matisse, Saint-Tropez and Collioure become classical landscapes, entities of art. And, to be precise, Derain in *Return of the Fishing Boats*, though he rubs elbows with the local residents, is not fishing (and thus personally concerned with the success of the catch). He is painting. The claim exerted over the Mediterranean south—by the Fauves, by those who viewed the landscape through their eyes—disguised itself, legitimated itself, as art.

All this should sound quite familiar, for it is much the same relationship between artistic viewer and aestheticized object that we have seen in pictures of female nudes by Matisse and other artists of the nineteenth and early twentieth centuries. Just as aesthetic disinterestedness dissimulated the masculine subject's social and sexual interest in the female object, it hid the tourists' interest in exerting control over the sites they visited behind the veil of higher values. The integration of previously isolated sections of the nation into the political and cultural realm of France was accomplished with the same pretense toward objectivity above the fray of interested politics as characterized the control of women through their images.

The ideological tool provided by aesthetics could be applied with equal efficacy to both women and land in part since woman and land, in the contemporary mind, were like quantities. As Michel Epuy, in his essay *Le Sentiment de la nature* of 1913, expounded: "Woman perceives between herself and nature a very profound analogy. . . . There is something more supple, easier, a sort of more penetrating mutual comprehension in the relations of these two lives: woman . . . loves to let herself be dominated by the exterior world, to give herself to something outside herself."[52] In

practice, nature, like women, often "gave itself" to the dominating "exterior world" of man first by relinquishing its image to artistic representation, for within painting the aesthetic stood always ready to legitimate the resulting political act of control. Just as an artistic appreciation of the nude depended on the pretense of a suppression of sexual interest in the object, contemporary aestheticians posited a similar suppression of the passions in the contemplation of the landscape. Paulhan wrote: "A well-ordered landscape is like a human soul that is master of itself, where the passions are contained, where reason dominates, where the force of life translates itself—not by impetuosity, by transport—but by equilibrium and calm. The landscapes of Poussin have in this manner a noble, proud, and solemn soul, serene in its force."[53] The appreciation of the classical landscape, like that of the studio nude, ostensibly aspired to a chaste contemplation guided by the principles of artistic sensibility rather than the base desire for possession.

Yet the Fauves—and here lies the special power of their version of aesthetic disinterest—masked the overt presence of art in their paintings. Just as Matisse's *Nude in the Studio* (fig. 34) could make gendered vision appear the simple consequence of nature rather than the product of culture,[54] the canvases by Matisse and Derain from Saint-Tropez and Collioure turned the appropriation of land through art into a natural affair. Matisse's and Derain's adherence to the pictorial standards of the classical landscape was oblique enough—and the material from the *grande tradition* on which they relied so elementary—that the reference did not call attention to itself. Certainly critics hardly commented on the connection. And the Fauves pretended to an intimacy with their Mediterranean sites and the local residents that seemed to cast aside the sophistication—social and artistic—of Paris.

Most important, Fauve canvases of the Mediterranean south, like Matisse's *Nude in the Studio*, are stripped clean of any signs of the skilled artist's mediation; they are neo-naturalist paintings. Highly noticeable in the pictures from Saint-Tropez and Collioure are all the technical devices that declare this manner of painting to be so simple as not to constitute recondite art—visible priming, crude brushwork—and to be derived directly from the objects portrayed—the bright colors favored by the locals, the conflation of sailcloth and canvas. Artistic procedure in such works as Matisse's and Derain's pictures of the church at Collioure appears so completely exposed and simple as to refuse to suggest culturally inherited skills on the part of the painter; the canvases appear as self-evident as the objects they depict. Fauve landscapes of the Mediterranean south, like Matisse's version of the nude, performed a double dissimulation: politics posed as art, which in turn posed as the direct rendition of nature.

Such an aesthetic paved the way for the new generation of tourists not only by supplying the aesthetic sanction but also by suggesting a way to hide that cultural imprimatur from view. These excursionists sought to shed all civilized trappings and merge into their natural surroundings, much as Matisse and Derain painted in an apparently untrained manner and integrated themselves and their paintings into the life at Saint-Tropez or Collioure. In the first decade of this century, the artifice of art and the practices of tourism alike aspired to conceal their social character and attain a natural state. It was audacious ideological work that artists and tourists, each in their own way, performed: the most recent artistic and social forms were to appear as natural as the untrammeled shores of the Mediterranean.

5

The political operation performed by Fauve paintings of the Mediterranean shore at the beginning of this century is perhaps difficult for us to recognize precisely because it continues unabated to this day. When we travel to visit tourist sites we still, more often than not, organize our expectations, sensations, and recollections according to the aesthetic principles of the harmonious classical landscape. Today's traveler amassing souvenir snapshots or the professional photographer of postcards often compose—consciously or unconsciously—their views of the scenic tourist site alone such lines. A typical amateur photograph recently taken from the hill above Saint-Tropez (fig. 54) shares its basic pictorial organization with literally millions of like images—and with Matisse's *View of Saint-Tropez* (fig. 35). (I must admit to some disingenuousness here: the posing of this photograph of me was hardly uninformed by the ideas and paintings I've explored in this chapter. Nevertheless, I was far from alone standing on that hill above Saint-Tropez, and many other tourists were simultaneously having themselves photographically inscribed into the same classically composed landscape.) Moreover the photograph, the medium now popularly regarded as free of the taint of mediation, prescribes and records the perceptions of tourists in an ostensibly direct and natural way.

Touring, like all human activity, is an interested affair: we benefit from our travels, we lay claim to the sites we visit. We Americans who today pose for the camera before Saint-Tropez or buy postcards of Collioure can regard ourselves as "worldly," and in a cultural sense we assert Europe to be our own. These are political propositions, for they lay out positions of authority and power over those Americans who have not traveled, and over Europeans whose land and culture we claim. Yet for the most part we, like the French tourists along the Mediterranean at the turn of the century, consider touring to be disinterested, a comforting idea that legitimates our peregrinations. That belief is an ideological construct, produced by artists such as Matisse and Derain, who grafted the aesthetic values invested in painting onto the sites that came to be visited by tourists. And with the aid of that particular version of the aesthetic formulated by the Fauves in Saint-Tropez and Collioure, touring could—and still can—be made to appear not just as high-minded as art but also as unaffected as nature itself.

The fellow in the snapshot from Saint-Tropez is not only a tourist: he also happens to be an art historian. The discipline of which he is—that is, I am—a practitioner has, historically, set up relations to its objects of study quite similar to those established between artists and their landscapes. One strain of art-historical writing, more prevalent during the nineteenth century than now, self-consciously figured the art historian as an active and gifted mediator of the ineffable in art. The texts of John Ruskin and Walter Pater exemplify this rhetorical scheme. An alternative strain gained prominence at the end of the nineteenth century when art history emerged as an academic discipline and as a science (*Kunstwissenschaft*), a development roughly synchronous with the invention of the new modes of painting and touring we have been exploring here. Under this regime, scholars deployed analytic methods that aspired to provide direct and objective accounts of the artworks under consideration. Both Panofsky's iconographic project and Wölfflin's formalist antitheses (to name just two of numerous

54. Tourist photograph. 1987.

possible examples) eclipse from view the art historian as an active participant in the formation of truth about art. The principle of disinterested scholarship underwrites the entire enterprise.

This book, written within a matrix of academic and publishing institutions largely derived from the legacy of *Kunstwissenschaft*, cannot help but confer upon its own propositions, at least partially, an aura of scholarly objectivity. I, for one, would certainly not wish to disown entirely the possibility that readers of this book will be persuaded by my arguments to hold solid convictions about certain artistic and political events at the beginning of the twentieth century ("solid conviction" being, I would argue along the lines of Stanley Fish,[55] only a slight recasting of the term "objectivity"). At the same, I am willing to acknowledge my mediating role in the discovery, or rather fabrication, of those same events. I have no more naturally rendered the Fauves and their world in these chapters than did Matisse and Derain naturally render Saint-Tropez and Collioure in their paintings. I will also own up to the benefits that I, like many other interested parties, derive from the seemingly disinterested institutions of art history. I am allowed to spend my time studying paintings, I gain status as an educated person, I can even justify excursions to Saint-Tropez and Collioure—all in the name of scholarship. The apparent triviality of these benefits should not belie their agency; nor, in turn, should the existence of such motivations mask the operation of larger, less personal agendas in my work. I would like to imagine, for instance, that some political as well as intellectual interest might be served by questioning the transcendental character—and thus the seeming immutability—of the aesthetic, and of the many ideological propositions that continue, to this day, to be graced by its sanction.

Art historians of the twentieth century, like certain artists and tourists of the same epoch, may or may not conceal their active role in shaping the objects of their own activities. But we are only engineering a deception if we deny the interests served both by those activities and by that act of concealment.

CHAPTER 4

The Golden Age and the French National Heritage

Sometime during the winter of 1904–05 as Matisse worked in his Parisian studio far from Saint-Tropez, *By the Sea* (fig. 38) took a turn from the vertical to the horizontal and became *Luxe, calme et volupté* (fig. 55). In the broad expanse of space now stretching in front of the clad Amélie, Matisse installed a bevy of nude bathers, nymphs of the Mediterranean shore. *Luxe, calme et volupté*, exhibited at the Salon des Indépendants of 1905, was but the first of a number of canvases by the Fauves in which nudes within the landscape transfigured the classical landscape into the classical pastoral. The inclusion of these mythical figures added new dimensions, temporal and political, to the Mediterranean landscape.

1

In *Luxe, calme et volupté*, Amélie and Pierre, the child at left center wrapped in a bathing towel, designate the periphery of this gathering as contemporary territory. The nudes that constitute the central group, in contrast, emerge as something other, something more than mere tourists. These are creatures of myth, bacchantes feasting or nymphs bathing. In subsequent years, Matisse's evocations of Arcadia were only to become more forthright: shepherds pipe and lovers embrace in *Bonheur de vivre* of 1905–06 (fig. 56), while in *Pastoral* of 1905 (fig. 57) a piper crouches in the pose of a goat-legged satyr.

Matisse was far from alone in taking up this subject matter. At the beginning of this century, numerous artists depicted nudes luxuriating within the southern landscape. Matisse probably adopted the motif directly from his friend the Neo-Impressionist Henri Cross, whom Matisse visited in the south and who, since around the turn of the century, had been producing canvases of nudes beside the Mediterranean shore such as *The Shaded Beach* of 1902 (fig. 58). The Nabis likewise painted Mediterranean pastorals; one of their members, Ker-Xavier Roussel, made his reputation largely through such pictures as *Two Nude Women Seated near the Seashore* of 1903 (fig. 59). The list—Renoir in his late works, Cézanne, Vuillard, Bonnard, Denis, Ménard— could go on. With his pastoral works, Matisse joined with these others in the veritable formation of a new genre of painting: twentieth-century depictions of a Mediterranean golden age, the *age d'or* of the *Côte d'Azur*.

Matisse's nymphs transported the scenes he portrayed into mythical time; which is

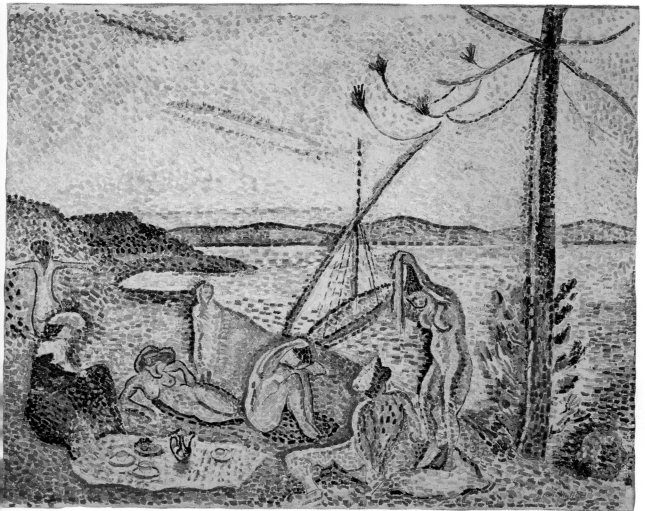

55. Henri Matisse. *Luxe, calme et volupté*. Paris: Musée National d'Art Moderne. 1904–05.

say that, in a certain sense, they escaped time altogether. "The events of myths," argued the sociologist H. Hubert in 1905, "take place, it appears, outside time or—what amounts to the same thing—in the total extension of time . . . However all mythologies have made an effort to situate that eternity along the time line. It has been placed, generally, at the beginning of time, and sometimes at the end. For this reason myths, of whatever sort, are myths of origin or of the end of things." Undoubtedly, Matisse's nymphs and satyrs, evocative of the classical world of Virgil and Ovid, pointed in the direction of origins. These paintings claimed filiation with "the body of myths" that, in Hubert's words, "constitute a prehistory of humanity, of the tribe, or of the nation."[1]

To predate history was necessarily to sidestep the contingencies of civilization since history is, by definition, nothing other than the record of the changes over time of an

always mutable society. Myths of origin thus appeared natural, not social. Matisse made an appropriate choice—an efficacious iconographic decision—when he called forth the world of myth using, almost exclusively, female nudes. At the turn of the century women could be described as natural and therefore, like myths, timeless. Michel Epuy—the writer whom I earlier cited as positing "a very profound analogy" between women and nature[2]—continued his argument:

> Woman, the great flower, the perfect flower, appears from this point of view as the culminating fact of the life of the World, because in Her our rational race (whose true bonds that attached it to Mother Nature have been shattered since the conquest of language) invigorates and rejuvenates itself through contact with the mystical and immaterial global effluvium—origin, end and intermediary of all existence, of all spirit, of all thought, infinite ocean that bathes and penetrates the entire Universe, lives and dies in each creature, and constitutes the vital and primordial essence of the Whole.[3]

56. Henri Matisse. *Bonheur de vivre*. Merion, Penn.: Barnes Foundation. 1905–06. Photograph © 1992 by The Barnes Foundation.

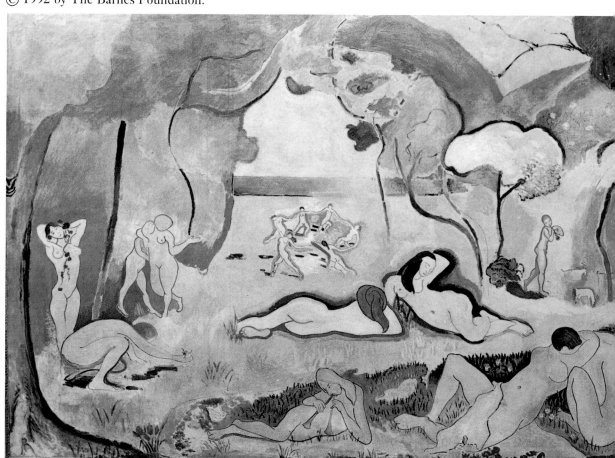

57. Henri Matisse. *Pastoral*. Paris: Musée d'Art Moderne de la Ville de Paris. 1905.

In Epuy's account of woman, as in Hubert's of myth, two temporal scenes intertwine. On one hand, woman returns to "primordial" origins in the prehistorical moment before the "true bonds" to nature were sundered by "the conquest of language," including presumably the language of pictorial representation (woman as the teleological "culmination" is but a variation of this same stance). On the other hand, woman basks in the effluvium that radiates across the "origin, end and intermediary of all existence," an eternity positioned not before the beginning of time but, in Hubert's phrase, "in the total extension of time." The mythical female nudes in Matisse's paintings, with their doubled affinity to nature, usher in both types of eternity: the distant, prehistorical past and unending stasis. Within Matisse's world of bacchantes and female bathers the unconditional plunge into nature and transport into mythical timelessness are complementary and interdependent gestures.

Yet even as they open time out into the temporal expanse of natural myth, Matisse's pastoral paintings also made reference to the contemporary moment, specifically to the new practices of tourism developing in the south. The landscape setting for *Luxe, calme et volupté* (fig. 55) repeats that of *View of Saint-Tropez* (fig. 35) and of *By the Sea* (fig.

58. Henri Cross. *The
Shaded Beach*. Private
collection. 1902.

38), and the modern tourist Amélie Matisse from *By the Sea* survived Henri's revisions
during the winter of 1904–05 to appear again in the large pastoral. Clever viewers
could probably also have made the connection between Matisse's later idyllic canvases
Bonheur de vivre (fig. 56) and *Pastoral* (fig. 57), both based on landscape studies of
Collioure, and the various paintings exhibited by Matisse and Derain at the Salon
d'Automne of 1905 and the Salon des Indépendants of 1906 depicting that fishing port
and its surrounds. Even the nudes in Matisse's pastorals could be seen as epitomizing
the new tourist sensibility of the south. These figures are, quite literally, stripped of the
multiple *toilettes* of the Trouville crowd and of the urban refinement that such clothing
implied. They, like the adventuresome bather Mme Léonide Votez and the sunbathing
readers of Dr. Monteuuis's treatise whom we encountered earlier,[4] expose themselves
to the natural elements of water and sun. Matisse's nudes, perhaps having dipped in
the warm waters of the Mediterranean and now basking beneath a hot southern sun,
indulge in the type of revitalizing hedonism that the new generation of tourists in the
south, ostensibly immersed in nature, made their habit.

Matisse's paintings—this is the point—never force a choice between the eternal and
the contemporary. More than that, they actively blur the line of demarcation between
the two temporal realms. If, on one hand, the clad Amélie in *Luxe, calme et volupté*
serves as a foil that marks the nudes as eternal, on the other hand she bridges the gap
between the world of myth and the contemporary artist and viewer. While somewhat
distanced from the nudes, Amélie nevertheless shares the same pictorial space with
them: forming a semicircle around the tea setting, Matisse's wife and the nymphs seem
to partake in the same picnic, and the white puff of Amélie's hat bears some
resemblance to the headdress—or is it simply a shock of sunlit hair?—of the foremost
nude. All the devices that integrated Amélie into her natural setting in *By the Sea*—the
parallel of her body's contours with the shoreline and her substitution for the village of
Saint-Tropez—continue to operate within the mythical scene in *Luxe, calme et volupté*.

59. Ker-Xavier Roussel. *Two Nude Women Seated near the Seashore*. Paris: Bernheim-Jeune. 1903.

60. Gaston La Touche. *Goodness of Spirit*. Location unknown. 1907.

61. Edouard Manet. *Le Déjeuner sur l'herbe*. Paris: Musée d'Orsay. 1863.

The assimilation, assuredly, is reciprocal: just as Amélie approaches the mythical as a result of her proximity to the nudes, the nudes assume a certain savor of tourism owing to their association with her.

Ultimately it makes little sense to demand whether *Luxe, calme et volupté* and Matisse's subsequent pastorals portray the timelessness of myth or the present practices of Mediterranean travelers, since the premise of these paintings is that the two are one and the same. Over and again, Matisse stitched together the same basic elements as did Gaston La Touche in *Goodness of Spirit* of 1907 (fig. 60), where a very modern young woman, arriving by automobile and equipped with a first-aid kit, ministers to a wounded satyr. La Touche, however, left the joint between present and past, between modern and myth, ludicrously conspicuous; Matisse hid the seams.

The compellingly obvious image against which to measure *Luxe, calme et volupté*—then as now owing to its recent exhibition at the Exposition Universelle in 1900—was Manet's *Déjeuner sur l'herbe* of 1863 (fig. 61), for in both paintings a mixed crowd of clothed and nude figures gather within a bucolic landscape. Yet Manet postulated antiphonies where Matisse described harmonies. In *Le Déjeuner sur l'herbe* fully dressed men, identifiable through their clothes as rakishly modern students, jar against an inexplicably stripped female companion. More important, Manet evoked the pastoral—the reference assured by overt compositional allusions to the river gods of Raphael and the bacchantes of Giorgione[5]—only to allow modernity to declare its complete triumph over, and difference from, the past. The nude in *Le Déjeuner sur l'herbe* is hardly a mythical figure for she has the face of the prostitute from *Olympia* (fig. 25)—Manet's model was the same—and a collection of contemporary clothes piled up before her. Nudity becomes nakedness, the nymph becomes a wanton woman. Manet's *Déjeuner sur l'herbe* probed the multiform disjunctions between modern life and the mythical landscape; Matisse's *Luxe, calme et volupté*, when imagined in contrast to its renowned antecedent, must have emerged that much more an image of their reconciliation.

Luxe, calme et volupté even enlisted Baudelaire, one of the great supporters of Manet's modernist project, to the task of consolidating mythical eternity and the modern age. Matisse extracted the title of his painting from the following lines of Baudelaire's poem *L'invitation au voyage* from the *Fleurs du mal* cycle:

> Tout y parlerait
> A l'âme en secret
> Sa douce langue natale.
>
> Là, tout n'est qu'ordre et beauté,
> Luxe, calme et volupté.
>
> Everything there would speak
> secretly to the soul
> In its gentle mother tongue.
>
> There, everything is order and beauty,
> Luxury, calm and voluptuousness.

At the turn of the century, Baudelaire certainly retained his notorious reputation as a poet of the momentary, of the decadent modern age.[6] Yet Matisse selected a poetic passage that had the effect of recasting the poet of modern life into the bard of Arcadia. Matisse was joined in this recuperation of Baudelaire by a number of literary critics and essayists of the time. Gaston Syffert wrote of Baudelaire in 1909: "His lucid intelligence permitted him to perceive, through ugliness and artifice, beside the evil that reigned imperiously in society, nostalgias for the ideal, the thirst to dream, the desperate and vain efforts striving toward happiness."[7] Seen in this light Baudelaire could be both a modern observer and a poet whose roots, in Roger Allard's words of 1918, "plunge under the 'profound and rich bedrock' of the classical tradition."[8] The producer of *Luxe, calme et volupté*, by association, seemingly did the same.

All this coupling of the present moment and eternal myth in the southern landscape was greatly facilitated, certainly, by the new tourist sensibility—and by the aesthetic from which it was derived—that had always claimed the experience of the Mediterranean landscape to be natural. To draw the connection between southern tourism and mythical time overtly as Matisse did when he transformed *By the Sea* into *Luxe, calme et volupté* or his landscape studies of Collioure into *Bonheur de vivre* and *Pastoral* was to make explicit the expansive temporal dimension already implicit in the recent tourist leap into nature. The "primitive mentality" that Albert Dauzat had recommended tourists seek out in the south was, after all, a close relative to Epuy's "primordial essence" embodied by woman, nature and—by extension—myth. Travel accounts written by tourists in the south described, with a frequency verging on cliché, the voyage as a trip to Eden—that is, to a place existing before the advent of civilization and its history.[9] Matisse's pastorals thus bring to the fore the final self-legitimating implication of the pretense toward naturalism maintained by both the new aesthetic and the new tourist sensibility exercised in the south: that which was actually of remarkably recent historical vintage made itself appear eternally valid. If paintings such as Matisse's and Derain's depictions of Saint-Tropez and Collioure expedited the development of a new mode of touring in the south, *Luxe, calme et volupté* and other Fauve pastoral paintings treated that seemingly natural manner of traveling as eternal by conflating the modern tourist experience with the myth of the classical idyll.

2

And yet, it might be objected, the entire mythical cast of nymphs and fauns, bacchantes and demigods form an odd crew to signal the rejection of civilization and the return to timeless nature. Was not this *dramatis personae* itself passed down from generation to generation, through history, as part of the Western cultural tradition? Matisse's paintings of the idyll inevitably called forth the classical tradition of verse and image extending from ancient times through the Italian Renaissance and into the French *grande tradition*, that same lineage of painters that, we have seen, embodied the aesthetic of the classical landscape.[10] *Luxe, calme et volupté* reiterates quite closely the theme and pictorial organization of Poussin's *Andrians* of around 1631–33 (fig. 62), exhibited at the time in the Louvre; in fact, the pose of Matisse's foremost nude in this picture may have been lifted directly from the similarly positioned male figure in Poussin's canvas.[11] The circle of dancers in the background of *Bonheur de vivre* (fig. 56) would similarly have evoked such classicized precedents as the central group in Ingres's *Golden Age* of 1862 (fig. 63). Matisse, it would seem, made himself part of a specific cultural, and therefore historical, heritage of established masters.

In many contemporary eyes, however, artists of the *grande tradition* were not limited by historical time. Painters joined the pantheon of transcendent artists, the argument ran, precisely by demonstrating a purity of vision that resisted temporal bounds. Poussin, for whom critical and historical interest in the form of monographic books and articles surged enormously in the first decade of the twentieth century, embodied most completely this principle of the *grande tradition*.[12] He was described as a timeless artist in precisely the same double sense—distant past and ongoing eternity—used to characterize the manner by which myth, woman and nature escaped the confines of historical determination. Georges Dralin, writing in 1904, felt that Poussin jumped out of his century to provide a veristic rendition of the harmony between humanity and nature at the beginning of time: "His bacchanals . . . in their disorder, composed with a perfect equilibrium, give the lively and purified impression of that which must have been among the ancients the pagan intoxication with nature."[13] In 1911 Paul Jamot posited similarly direct ties between Poussin and the ancients: "From Plato and Virgil to Poussin is a kinship so tight that one thinks of it as a unique case of

62. Nicolas Poussin. *The Andrians*. Paris: Musée du Louvre. c. 1631–33.

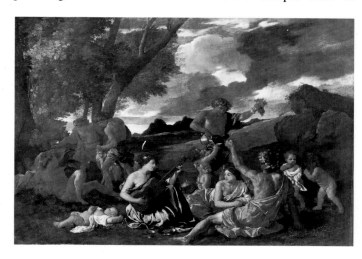

63. Jean-Auguste-Dominique Ingres. *The Golden Age.* Cambridge: Fogg Art Museum, Harvard University. 1862.

metempsychosis."[14] Simultaneously, however, Adrien Mithouard could in 1901 proclaim the temporal extension of the same great artist: "Poussin underlines with the continuity of man the perpetuity of the world."[15] And the editors of *La Rénovation esthétique* in their inaugural manifesto of 1905 could typify the *grande tradition* as "*eternal* and yet always *young*."[16] By such accounts, Poussin and other artists of the *grande tradition* suffered not the restraints of time: they were as eternal as the themes of myth and nature they portrayed in their pastorals.

Freed of temporal restrictions, these artists liberated themselves as well from the limits of civilization. Unlike the legions of nineteenth-century academic artists who critics feared were trapped in the habits of routinized and learned technique and thus mere creatures of their cultural moment, artists of the *grande tradition* painted with a freshness and vitality of vision that circumvented such deadening *poncif*. "It is . . . a complete mistake," wrote Emile Michel in 1906 about Poussin, "to have tried to deprecate this art with the name *academic*, as if Poussin had to be responsible for that which, after him, vulgar imitators have intended for us to accept as the continuation of his style and of his doctrines."[17] The seventeenth-century master may have been the source from which Charles Le Brun derived a codified academic technique, yet simply by dint of being that source Poussin himself appeared free of the sort of cultural determination that damned his unthinking academic emulators. Jean Tarbel, probably a pseudonym for the novelist J. Delorme-Jules-Simon, concluded her study of the artist in 1907 with the claim that his paintings existed "above all times and all schools."[18]

Yet to writers at the turn of the century Poussin's style, though manifestly his own, never appeared idiosyncratic. It no more indexed the personality of a capricious individual than it repeated the formulas of a culturally specific *poncif*. Jamot, the same writer who described a metempsychotic union between Poussin and the ancients, proclaimed that Poussin expressed his ideas in "a language without obscurity or weakness."[19] In 1907 the art historian Raymond Bouyer voiced a similar sentiment in the form of a paradox: "The creator of these grand landscapes here reveals himself, invisible and present. This nature is his thought."[20] Poussin's artistic procedure did

not distort nature since his ideas, and his language, were themselves natural. Hence the artist was both "invisible and present" in paintings created during what Paul Desjardins in 1904 termed "those transparent moments when one is taken neither by the things [depicted] nor by one's own conceptions [of them], but when one seizes them by comprehending them [*comprenant*: both 'incorporating' and 'under-standing']."[21] These commentators all attributed to Poussin a manner of painting quite similar to the directness of experience described by Epuy in the primordial era before "true bonds" to nature were severed by "the conquest of language," or by Baudelaire in an idyllic world where everyone speaks in the "gentle mother tongue." By the manner in which they painted, the argument maintained, Poussin and other true members of the *grande tradition* rediscovered—each time anew—a naturalness of vision and representation; they employed a transparent visual language.

In which camp did Matisse, as he engaged the *grande tradition* thematically, belong: with the true artists or with the practitioners of derivative *poncif*? The answer de-pended on whom one asked. By Symbolist standards, Matisse's pastorals were merely the product of rote method. Maurice Denis complained in 1905: "*Luxe, calme et volupté* is the diagram of a theory"; and in 1906 he wrote about *Bonheur de vivre*: "Matisse . . . hardly does anything . . . but translate theorems of paintings into diagrams."[22] Alter-natively, however, these paintings were exemplary neo-naturalist pictures. We have already seen how *Luxe, calme et volupté* repudiated precisely those aspects of Neo-Impressionism—optical mixing and simultaneous contrast—that spoke of an applied artistic system.[23] More significant, *Bonheur de vivre* (fig. 56) and *Pastoral* (fig. 57) teem with all those devices—exposed priming, minimal layering of paints, bold colors, tactile rhyming, and the avoidance of an autographic style through the mixture of techniques—that served in Fauve landscapes to efface the interventions of idiosyn-cratic individuality and stress instead an unmediated connection between depicted object and painted surface.[24] According to this neo-naturalist interpretation, Matisse's pastorals represented not *poncif* but an escape from it.

The masters of the *grande tradition*, with their "transparent moments" when things portrayed, artistic imagination and visual language became one, constituted natural painters precisely in the way in which the Fauves stood as neo-natural ones. Matisse, by presenting technique as freshly natural even as he evoked the *grande tradition*, fashioned himself—intentionally or not—the latest true artist in an ongoing classical heritage. *Luxe, calme et volupté* and *Bonheur de vivre* appeared to give new life to the *grande tradition* just as other Fauve paintings rejuvenated the flagging Impressionist heritage. And, in return, the *grande tradition* promised to liberate the Fauves from the specificity of their own age and culture by endowing their neo-natural technique with the imprimatur of mythical timelessness.

To revive the tradition of Poussin was to do more than simply lay claim to a natural and eternal style and theme. In the eyes of many commentators on the arts around 1905, Poussin also stood as the most French of all artists. Tarbel proclaimed Poussin "the most characteristic painter of our race . . . our great national painter"[25]; there were many who echoed such words. Renewed interest in Poussin was part of a campaign to discover the national essence of French art.

At first, Poussin might seem an unlikely artist to embody French painting since he had spent virtually his entire professional life in Rome, often working for Italian

patrons. Yet paradoxically it was precisely these connections to Italy that made Poussin such an attractive candidate to be the exemplar of French artistic values. Rome offered the riches of Latin civilization, a heritage stretching back through the Renaissance to imperial Rome and beyond to classical Greece.[26] Steeped in this heritage, the French-born Poussin, as imagined by his chroniclers at the beginning of the twentieth century, could adopt it as his own. And once Le Brun had codified Poussin's practices into the the standards of the French Academy at the end of the seventeenth century, the Latin heritage had effectively been transferred to France. Poussin, the essential link between the Latin past and the modern French nation, served as the means by which the cultural origins of the Latin heritage could be pirated from Rome to Paris. "His France, his real France, he [Poussin] found it in Rome," declared the nationalist Charles Maurras in an open letter of 1902 devoted to the subject of Poussin and addressed to his comrade in arms Adrien Mithouard; "Italy . . . appears vanquished by the firm French line."[27] Mithouard replied in-kind in 1903: "What it is important to recognize, Monsieur, is the continuity of the Occidental tradition, of the most ancient Occidental tradition. . . . Antiquity, henceforth, is us."[28] By such accounts, Poussin embodied French art because he gave the national culture a past, and a past not in the temporally bound seventeenth century but in the timeless recesses of antiquity. He was the keystone of the span between timeless antiquity and modern France.

At the heart of the reverence for Poussin thus lay two paired propositions. Bouyer labeled Poussin's works "echoes of a primitive Greece, seen through a morose Virgil," and yet on the same page declared the artist's independence from *poncif* to be "entirely French."[29] These are claims completely isotropic with Tarbel's doubled argument that Poussin was both "above all times and all schools" and "our great national painter." Primordially natural and temperamentally national at the same moment, this Poussin described by the commentators of the first decade of the twentieth century may seem to our eyes hopelessly mired in contradiction. The contemporary function of this figure and the Latin heritage which he personified, however, was to transcend, or rather to dissimulate, that apparent antithesis. Through the institution of the Latin heritage and the figure of Poussin, the French at the turn of the century could both extend a venerable tradition into the present and, more importantly, legitimate the culture of the French nation by giving it an origin at the beginning of time, free from the contingencies of history.

If Poussin personified the perpetuation of the Latin heritage into modern France, that cultural continuity also had a specific geographical locus: the Mediterranean south. France shared the Mediterranean with Italy and Greece and thus its southern littoral regions could be made to appear directly linked to the nation's illustrious cultural predecessors. Paul Brousse, mentioning the inhabitants of the region of Provence by name but clearly referring to all natives along the French Mediterranean, wrote in 1906: "Rumanians and Provençals are of the same race; they are the sons, the direct descendants, along with the Italians and the Spaniards, of the celebrated Romans, conquerors of the world. Disseminated all along the Mediterranean as far as the distant frontiers of Dacia [ancient Rumania], all these *Latins* have preserved their own nationality and their language."[30]

Authors of tourist guidebooks could play on the same geographical lineage: Paul Bourget pointed out a resemblance between France's Mediterranean coast and that of

Greece, and the geographer Onésime Reclus, in describing his descent from the mountains to the sea near Collioure in 1903, extolled "the great cerulean waters of the Hellenes and the Latins" that stretched before him.[31] The touring Casimir Stryieuski, writing in French for a French audience in 1907 about his voyage to Menton along the Riviera, negotiated the leap from southern tourism to the idyll of classical antiquity as smoothly as Matisse had moved from *By the Sea* to *Luxe, calme et volupté*:

> Certain sunny mornings there, you see as if in a land of dreams, and, if you distance yourself a bit from the city, seeking refuge under the olive trees with light foliage, you can believe yourself really transported into some sort of Virgilian atmosphere. You look for the statue of Pan, garlanded with flowers; you hear the flute of Thyrsis; you think you see Clytie offering herself to Helios: an entire living mythology animates the solitude.[32]

Despite the fact that many isolated sections of the southern coast had had virtually no contact with the mainstream of French society and culture before artists and tourists began to venture into them around the turn of the century,[33] these lands, owing simply to their Mediterranean location, could be made to seem inherently part of the Latin heritage, and therefore, by extension in two temporal directions, inherently both primordially natural and nationalistically French.

Matisse's landscapes and pastorals addressed and reauthorized both of these bridges—Poussin and the Mediterranean south—between the Latin past and the French present. *Luxe, calme et volupté* and *Bonheur de vivre*, when regarded as neo-naturalist paintings, made Poussin's *grande tradition* appear "always young," even as France entered the twentieth century. And because of such paintings, French tourists could view the southern landscape not only through the lens of the classical landscape but also through that of the Latin pastoral, adding temporal and nationalistic depth to their conceptual claims over the land. Fauve painting consequently participated in a double rejuvenation of the French nation: just as the new generation of tourists, through their physical activity, seemed to reinvigorate the body of the French "race,"[34] Matisse and his fellow artists revived and extended an artistic heritage closely linked to the French nation. In Matisse's pastorals, the mythical past validated the latest exploits of modern artists and tourists while reciprocally those exploits brought the eternal into the present—all under the aegis of a Latinate French culture.

3

The Latin heritage was obviously an impressive tool of legitimation, and the Fauves were hardly the only people of their day to exploit its powers. What better way to glorify the French nation than to claim that its cultural roots lay in a mythical and natural past? Such, in fact, was the nationalist project of a certain cadre of reactionary intellectuals, few in number but highly influential, headed by Charles Maurras, the editor of the newspaper *Action française* and founder of the political group of the same name.[35] Since the Latin heritage was in the same years both a major component in the artistic endeavors of the Fauves and a centerpiece in the political program of Maurras and his compatriots, these two movements inevitably collaborated and competed with each other over the meanings and implications of that heritage.

Maurras continuously lauded the virtues of the traditions France had inherited from Italy and Greece. He declared in 1903: "It is essential that there exists a Latin civilization, a Latin spirit, vehicle and complement to Hellenism, interpreter of Athenian reason and beauty, lasting monument to the force of Rome."[36] It was upon the foundations of this classical tradition that the nationalists wished to rebuild French culture, and therefore artists worthy of the name obeyed the dictates of that heritage. A plethora of journals—*La Renaissance latine, La Rénovation esthétique,* Mithouard's *L'Occident,* as well as Maurras's *Action française*—emerged during these years, all devoted to resuscitating French culture by rediscovering and strengthening its roots in the Latin past. Maurras saw Poussin as one link uniting France to its Latin ancestors; we have already heard him expound on the antique origins of the French master of the seventeenth century. And for him the south of France, specifically his native region of Provence, served as a principal Latin connection for the French nation. "For me," he wrote in 1903, "it as a Provençal that I feel myself a Frenchman. I cannot conceive of my Provence without a France."[37] Accordingly, Maurras championed Provençal artists, such as Frédéric Mistral and the other Félibrige poets, as the true practitioners of French culture.

Maurras argued that Provence had more to offer France than simply a lineage of painters and poets; entire political doctrines could accompany that cultural heritage through the nation's Mediterranean gateway. He wrote in 1902: "The empire of the Sun, as Mistral put it . . . , this luminous empire is the country of order, which is to say of authority, of hierarchy, of inequalities and of liberties naturally composed."[38] Similarly, in his article on Poussin Maurras argued: "It is this Rome that taught the French law, [civic] administration, theology, politics, and the discipline of war."[39] Maurras's inventory of political virtues here already indicates a rather reactionary disposition; we can be quite sure that by "liberties naturally composed" Maurras did not have the revolutionary slogan "liberty, equality, fraternity" in mind. Maurras, in fact, was an ardent royalist. Individual Frenchmen, according to him, should willingly subordinate themselves to the "inequalities" and "hierarchies" of the crown much as artists should subordinate their individualities to tradition.

Maurras advocated the reestablishment of an absolute monarchy not simply because he perceived it as the traditional and therefore "natural" form of political rule in France but also because he believed the survival of France depended on it. He insisted in 1900:

If you have resolved to be a patriot, you will necessarily be a royalist. . . .

It is for the peoples to choose: yet, if they want to live, the choice is imposed. They are not free and they must either submit themselves to eternal conditions or relinquish all will to endure.

One can elude and mask these profound conditions of natural politics. One can neither abolish them in their own right nor hide them from the calm and penetrating eye . . .

The Monarchy would reconstitute France and without the Monarchy France will perish.[40]

Genuine culture, according to Maurras in 1908, could only flourish under a king: "It is not by accident that the old France had its style, and that the new France is still in

search of its own. It needs to have a State nourished and supported by strong traditions, a civilization, a society where heredity has its place, [where there are] cultivated ministers [and] gentlemen-Kings."[41] It may have been possible to glean a democratic tradition out of the Mediterranean past, highlighting such regimes as democratic Athens or the various republics of Rome. Such, however, was not the strategy of Maurras. This royalist found in the Latin heritage the precedent of Imperial Rome, a historical justification for the reign of absolutism in France.

If from Maurras's perspective an absolute monarchy was France's birthright as a Latin nation, any other form of government and above all the current French republic—"democracy is evil, democracy is death"[42]—was a perverse deviation from the nation's natural course. "We strive to be opposed to the destruction of the heritage of the past," declared Maurras's follower Léon de Montesquiou in 1905; "we endeavor to suppress the permanent cause of that destruction through the suppression of the current regime and through the restoration of the monarchy."[43] The actual presence of republicans and other destructive types in the country need not indict France itself since Maurras and other royalists could dismiss their dangerous programs as the products of pernicious foreign influences, specifically non-Latin ones. Thus Maurras, in from what our perspective must seem a remarkable deformation of the historical record, asserted in 1902: "Not in France, nor in Spain, nor in Italy, nor moreover in Greece, are anarchy and revolution indigenous."[44] Cosmopolites from the Germanic north—resident aliens, Germans, Protestants, Free Masons all had their place on Maurras's roll call of demons but Jews headed his list—stood as the enemies of the French nation, responsible for the importation of revolution and republic. Maurras thus whitewashed away all conflict within the nation—as long as it was understood that by nation he meant the true France purged of all divisive foreign influences. Maurras strove to contain all of France within the cultural category of the collective Latin heritage.

Not all contemporary thinkers involved in the revival of the Latin heritage were strict monarchists; Maurras represents an extreme. Nevertheless, the amalgam of Latin traditions and reactionary politics that Maurras forged was acknowledged even by his political adversaries. When in 1902 the Marxist Albert Maybon asked the rhetorical question: "Do not the writers of the *Action française*, desirous to ground their miserable and purely political doctrine philosophically, consider ideas of race and tradition as the *substratum* of nationalism and monarchism?", the implied answer was resoundingly in the affirmative.[45] More often than not Maurras's republican opponents accepted his fundamental equation: they disputed his monarchist position not by claiming the Latin heritage as their own but rather by condemning the legacy from Rome and by positing alternative cultural and political roots for the French nation. Although the republican Gaston Sauvebois strove to adapt some principles of classicism to his own political cause, he had to admit in 1911 that "the literary renaissance" of the Félibrige poets and other such regionalists "was very close to finding its counterpart in a political movement—that could only be reactionary."[46] Thus even though Maurras ranted away at the extreme right end of the political spectrum, he managed to specify the axioms and set out the agenda for much of the political dialogue in France during the decade and a half before the First World War. The battle over French nationalism would be fought largely over the issue of the benefits and dangers of the Latin tradition. As

the reactionary Henri Clouard stated in 1913: "One can say that contemporary philosophers and political theoreticians group together or oppose each other according to how they utilize or disregard the lessons of the classical culture of the Occident."[47]

Less explicitly indebted to a specific cultural heritage, republicans could occasionally insist on maintaining some distance between art and politics. In 1905 the critic Camille Mauclair, a staunch republican and a long time defender of the Impressionist movement, lamented "the detestable interference of political nationalism in the question of art." Nevertheless, republicans often did associate their political doctrine with cultural movements, and when they did so republicans tended to reject the Latin heritage outright. Mauclair continued: "When speaking of origins, one must clearly distinguish the 'Latin' side and the 'French' side."[48] In painting, as we have seen, Mauclair considered the eighteenth century rather than the seventeenth the era of true French style.[49] He posited an entire French heritage culminating in Impressionism that, while including some artists also claimed by the Latin nationalists, categorically rejected anything tainted by Rome. If there is such a thing as nationalism in art, argued Mauclair, "that nationalism is the French direction in art opposed to the Italians, which is to say the contrary to that which the nationalists maintain. Nationalism, or classicism, for French artists, is anti-Roman art, the struggle against Rome."[50]

Concomitant with the dismissal of the Latin cultural heritage came the repudiation of its political institutions. Latin authoritarianism, in its insistence on all-encompassing unity and the subordination of individuality, precluded healthy contention of the type that the republican Léon Bazalgette envisaged when he wrote in 1898: "For inevitable and productive conflicts, it is necessary to create antagonists."[51] Hence the suppression of the Latin heritage appeared as imperative to the republicans as its preservation did to the nationalists. As Bazalgette warned in 1903: "It is necessary that all we owe to our Roman origins be extirpated from our flesh and from our consciousness, and that we live a different existence purified of all that which, until now, corrupts us. We must *delatinize*—or die."[52]

Since neither side disputed the terms of the debate—for the most part the legacy of Rome belonged to the reactionaries—the Latin heritage had become from virtually all perspectives overlaid with definite political implications. Yet the fundamental opposition inscribed in the Latin dispute for and against—an authoritarian state and a fear of Jewish cosmopolitanism on one hand, and the republic and the rights of individuals on the other—was hardly new in France at the turn of the century. These were precisely the issues contested in one of the greatest political controversies in the history of France, the Dreyfus Affair, dating from the 1890s. Both sides acknowledged the patrimony of the Affair in the current dispute over the Latin heritage. Maurras stated in 1915: "The Dreyfus Affair, understood as the painful expression of an excess of laxity and of liberty, had played . . . an essential role in [prompting] the reaction of the classical spirit and of national feeling."; while the republican Sauvebois wrote in 1911: "Neo-royalism that was still latent, or among many in a paradoxical state, declared itself officially following the Affair."[53] Of course the repositioning of the issues of the Dreyfus Affair into the conflict over Latinism was enormously advantageous to the reactionary anti-Dreyfusards: rather than basing their argument on the negative grounds of attacking a maligned Jewish army officer whose guilt—in a strictly legalistic sense—became increasingly difficult to maintain, they could adopt the posi-

tive stance of extolling a cultural tradition with a rich pedigree. In any case, the Dreyfus case had involved much more than simply the issue of the guilt or innocence of a single man or even than a referendum on the Third Republic: entire philosophical systems and fundamental patterns of reasoning were pitted against one another. And these basic antagonisms played themselves out again in the subsequent conflict over the Latin heritage.

One of these philosophical issues, whether humans can construct their own reality or must accept it as given by nature, had special relevance to debates over the politics of art. From the nationalist perspective, the correct form of government was dictated by—to use Léon Montesquiou's phrase from a polemic published by Maurras's *Action française* in 1911—"external reality." Montesquiou continued: "We no longer speak of making a constitution since we recognize that the constitution is already made, that it already exists, necessitated as it is by nature. Thus we intend simply to seek out the necessary constitution, simply to determine that which nature imposes on us."[54] Monarchy in France, claimed Montesquiou in 1905, enjoyed the legitimacy of "the natural laws on which depend the order and the progress of societies."[55]

Of course the trick was to know what those "natural laws" were, what "external reality" dictated. For the nationalists this posed no problem: reality was intuitively obvious. Louis Rouart, whom Maurras claimed as his friend,[56] argued in 1904 that the truth could be known by "geniuses of intuition, capable of placing themselves directly in contact with reality and of accomplishing spontaneously, without theories and without discussions henceforth superfluous, the acts indispensable for the public welfare." Rouart's "geniuses," however, needed not be a select group. He continued by condemning his republican opponents:

> By presenting morality to [the people] not as a living tradition handed down by our ancestors and improved by successive generations, not as a practical ideal of good-ness, of generosity and of sacrifice, but as a cold necessity of Reason, you will—except in very rare and exceptional circumstances—only end up perverting the people, taking away their precious good judgment, distorting their naïve and direct vision of things, [and] making them loose—in a word—all their magnificent intui-tive qualities.[57]

Even the common people, freed from republican interference, could perceive the necessity of the monarchy, a form of government to be found in the natural traditions of the nation.

Republicans, in contrast, advocated a conscious and rational building of the nation. Paul Deschanel, Vice-President of the Chamber of Deputies and later to become President of the Third Republic, may have been voicing a republican platitude, but his choice of words in 1896 reveals a great deal: "We want . . . to forge a powerful instrument of progress and reforms, and to help to secure for the the Republic a government, in the highest and most noble sense of the word, in order to organize the democracy, to renovate France and to rectify its misfortunes,"[58] To "forge . . . progress and reforms"; nothing could be further from the nationalist position of accepting the established truths of tradition. Such a program required foresight and perhaps even the strong leadership of an enlightened few. Bazalgette, writing in 1903, went so far as to propose draconian measures to purge the "poison" of Latinism from France:

I want to say that salvation will not arise from the collective will because it is precisely the will that is the most affected faculty among [the Latin peoples]. . . .

The operation should be attempted by intelligence, intelligence pure and simple. An all-powerful intelligence, that of a man or a committee, it doesn't matter. But it would require a type of dictatorship of intelligence. . . .

This dictatorship of intelligence would be the struggle of the conscious brain against fate, of will against destiny. It would require much frankness and no sentimentalism at all.[59]

One camp asserted that no mediating barriers need intervene between the people of France and their comprehension of their Latin destiny. The other claimed that a cadre of individuals could rationally determine the optimal course for the country and benevolently lead French citizens toward the realization of its ideals. The debate between nationalists and republicans thus involved more than a contest between king and parliament or between Latinate and delatinized culture; equally at issue was whether one found the French nation or made it.

4

Matisse's canvases such as *Luxe, calme et volupté* (fig. 55) and *Bonheur de vivre* (fig. 56) could not have remained above the political fray raging over the Latin heritage. These paintings depict themes that, for the most part, corresponded to the nationalist program of discovering a cultural definition of the French nation: idyllic reveries evoking Poussin and the *grande tradition*, Mediterranean settings suggestive of the nation's Latin orientation. Since monarchists claimed the Latin heritage as their own and republicans more or less conceded it to them whole, the subjects of Matisse's paintings when viewed in the first decade of the twentieth century could not have helped but carry a heavy tinge of nationalist politics.

It would, however, be hasty to equate the Fauve artistic project to the nationalistic political one. When advocates of the Latin heritage did discuss contemporary art, they praised artists of a different ilk than the Fauves. The painter who garnered most of their praise was Maurice Denis. We have already encountered Denis in the guise of a Symbolist critic, yet Denis's position was to shift somewhat during the course of the first decade of the twentieth century in the direction indicated by the subtitle of his collected essays: *From Symbolism and Gauguin Toward a New Classical Order*. While maintaining a constant belief in the capacity of privileged artists to perceive eternal truths, Denis began to contend that those truths could best be divined from the "experience of the past." As early as 1905, he insisted that "the recourse to tradition is our best safeguard against the giddiness of reasoning, against the excess of theories."[60] By 1909, while not disavowing Gauguin and Van Gogh, he demoted them to the "destructive and negating" role of clearing ground for a subsequent rebirth of "tradition, measure and order"; by then too he had kind words for the "logic of facts" of the monarchists of the Action Française.[61] Even without this gradual evolution in his critical stance, Denis as a painter produced many idyllic canvases such as *The Beach* of 1906 (fig. 64) throughout the decade. Both Rouart and Mithouard, the two nationalist writers whom Maurras was later to name as his compatriots in the cause of resuscitat-

64. Maurice Denis. *The Beach*. Location unknown. 1906.

ing Poussin,[62] lauded the artist; in Mithouard's words from 1907, "[Denis] knew how to incorporate . . . the paganism of our classical masters into the Christian and Occidental tradition."[63] Mauclair, writing from the republican perspective, devoted more words to Denis than any other artist when in 1905 he discussed painters he felt imprudently embodied the nationalist reaction in art.[64]

A second artist active at the beginning of the twentieth century who expressed the values of the nationalist movement in paint was René Ménard; *Antique Scene* of 1908 (fig. 65) is a typical canvas. In 1913 the aesthetician Frédéric Paulhan described Ménard's qualities that would have appealed to the nationalists: "M. René Ménard evokes . . . the memory of Poussin. He also has a feeling for grandeur, for austere simplicity, for rational and strong serenity, with high aspirations. And he took pleasure in antique temples. Yet his landscapes are of a different spirit, less rough and less fixed; they are in some sense the 'dreams of a mystic pagan.'"[65]

The paintings by Denis and Ménard differ from Matisse's pastorals markedly on stylistic grounds, and objections to Fauve paintings from within the nationalist camp would have almost certainly have addressed the issue of technique. Strong drawing was of crucial importance to the nationalists; Maurras himself had claimed that the Italian artistic legacy had been conquered by the "firm French line." A clearly delineated canvas was a well-ordered one, and the metaphorical equation of such a picture to a well-ordered society was always implicit. Tancrède de Visan, writing in 1905 in response to Mauclair, found a nationalist "evolution" in art a healthy means of reestablishing the priority of line over color: "In painting, the theoreticians of color have definitively won all approbations, thanks to the Impressionists. Currently, what is at stake is to come to terms with *line* and, at the same time, to put an *idea* in a painting."[66] The sharply articulated figures in Denis's *Beach* and Ménard's *Antique Scene*, each limb precisely posed and modeled, would have satisfied the nationalist artistic doctrine. Rouart, writing in 1904, found in Denis's paintings "the line of Italy,

which is to say simple, precise and always noble forms that unfold in delicious, transparent light."[67]

The drawing of figures in Matisse's *Luxe, calme et volupté* (fig. 55) would have proven entirely unacceptable to the critics such as Rouart. It is not that the picture is completely devoid of delineation. Traces of Matisse's preliminary outlines—thin, black and sketchy—appear throughout the canvas, especially among the foreground figures; they are clearly visible around the teacups and the left ankle and arm of the figure borrowed from Poussin. Yet these lines are overwhelmed by great swarms of brightly colored dabs, pointillist dots grown mutantly large. These dabs constantly trespass across the boundaries laid out by the preliminary sketched lines: color triumphs over drawing. There is no modeling here, and no sharp delineation of form. Denis's comments on the painting, while recognizing the promise offered by Matisse's choice of theme, fret over the application of "theory," a thinly veiled reference to the artist's modified Neo-Impressionist color technique. "It is in reality that [Matisse] will best develop his very rare gifts for painting," advised Denis in 1905 just as "reality" in his writings was shifting in emphasis from Symbolist idea to nationalist fact. "He will rediscover, in the French tradition, the feeling for the possible."[68] Denis offered Matisse prescription and warning, both laden with obvious political overtones: accept the reality of tradition and be saved, or be damned in the trap of arbitrarily imposed color theory.

Bonheur de vivre (fig. 56), exhibited the following year at the Salon des Indépendants, appears a step in Denis's direction for in it Matisse abjured the modified pointillism of his earlier canvas. And yet here too color rides rough-shod over line. Gauguinesque patches of pure, semi-translucent color extend over large areas of canvas irrespective of the preliminary outlines still partially visible beneath them: the boundary between aqua grass and orange earth in the left foreground, for instance, lies substantially to the right of the thin charcoal-colored line demarcating Matisse's placement of the division during the *ébauche*. Throughout the picture one color patch merges into another without the benefit of any linear articulation as, for example, when the sea in the background modulates left to right from blue to pink. At best, in the thick outlines sur-

65. René Ménard. *Antique Scene*. Paris: Petit Palais. 1908.

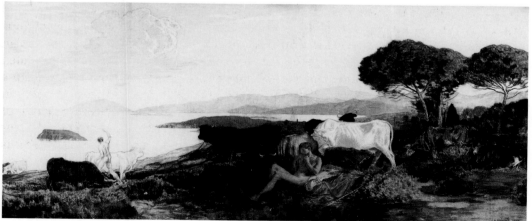

rounding the central reclining figures, line becomes the equal of color; it becomes, in fact, equated with it. Here unctuous pigment performs the roles of delineating human form and establishing background color simultaneously. Yet even in these passages the rules of chroma seem to override those of linear articulation: when the thick border reaches the bright orange hair of the more horizontal of the two nudes it changes hue to complementary light blue, interrupting the linear flow of the strong orange and red halo which otherwise nearly encompasses the two figures. All in all, Denis was no more pleased with Matisse's effort in 1906 than he was in 1905, for Matisse had not heeded his advice:

> The absence of all traditional technique, of all learned craft [*métier*], corresponds, among the young painters, to a type of anarchic virtuosity that destroys, by wanting to exaggerate it, the freshness of individual expression. . . .
>
> Matisse, whom we know to be marvelously talented for perceiving and simply rendering the beauties of nature, hardly does anything anymore but translate theorems of paintings into diagrams.[69]

Drawing, *dessin* in French, concerns more than just the articulation of individual figures; it also refers to the correct arrangement, the "design" of the overall composition. On this level, Matisse's pastorals would have satisfied nationalist criteria of drawing only marginally more than they did on the smaller scale. Ménard and Denis may once again set the standard. In Ménard's *Antique Scene* (fig. 65), the sweep of a shore line, offset by a crop of trees serving as a *repoussoir*, defines a logical progression into space exemplary of the compositional practices of the *grande tradition*. Individual pictorial elements are well anchored within that space: the overlapping of cattle and the contours of the intervening landscape, for example, adequately account for the recession from the piping shepherd at right center to his companion further to the left. Similarly in Denis's *Beach* (fig. 64) few figures venture far from the various outcroppings of rock that define relative distance from foreground left to distant Greek temple.

Matisse, of course, did not violate all traditional rules of composition: both *Luxe, calme et volupté* and *Bonheur de vivre*, as well as many of the landscapes studies of Saint-Tropez and Collioure on which they are based, adopt the general pictorial principles of the *grande tradition* as their own. Yet spatial discrepancies, all but lacking in works by Ménard and Denis, quickly emerge in Matisse's large canvases. Perhaps the strongest line in *Luxe, calme et volupté* is the long curve beginning with the back of the center-most bather, passing along the diagonal lateen yard of the moored sailing boat and various tree branches to finish up in the upper right corner of the canvas. This arc cuts across both near and distant shores of the bay, but unlike those coastlines it fails to recede: from foreground nude to middleground sailboat, it snaps forward again to foreground tree. The lateen yard is especially ambiguous since it is impossible to distinguish how much of its diagonal to attribute to spatial recession and how much to the actual functional obliqueness of the spar. Moreover, the crucial point where yard intersects mast becomes hopelessly enmeshed in the tangle of lines and paint spots that define both rigging and the various contours of the distant hills and shore line. Similarly at the right side of the picture, Matisse's dabbed technique fuses the blue of mountains in the deep background to the aura of complementary color along the left

edge of the prominent foreground tree. Over and again, these devices work against the fiction of pictorial depth carved out by the compositional conventions of the *grande tradition*, telescoping the distance between near and far.

While *Bonheur de vivre* relies on no such linear tricks, its space is no less ambiguous. Figural groups in this work, isolated against swatches of pure color, float adrift in undefinable depth. How much distance should be assigned, for instance, between the central reclining figures and the circle of dancers above them? How much distance between the dancers and the sea? Surrounding foliage offers little help since its large areas of chromatic uniformity suggest the shallowness of theatrical flats more than naturalistic graduated recession.

Matisse had no need to invent such devices of spatial uncertainty from scratch since he could inherit many of them from Impressionist and Symbolist artists. Overlapping lines that flatten near and far crop up frequently in Cézanne's Provençal landscapes, and figures suspended in ill-defined space people both the works of the Impressionists—especially early Monet and Degas's ballet scenes, complete with theatrical flats—and Gauguin's canvases. Similarly, for his drawing-defying techniques at the level of the brush stroke—modified pointillist technique, wide bands of unctuous pigments, flat areas of color—Matisse relied heavily on the lessons of the past few generations of painters. And here, from the perspective of the most ardent nationalists, lay the crux of the problem with Matisse. Any artistic precedent of such recent vintage was inherently suspect.

The proscription on recent styles was in part overtly political in origin. Those wishing to see France return to monarchy, or simply to a form of government conducive to continuity, had to ignore outright the political heritage of republicanism marked out by the nation since 1789. As the republican Etienne Antonelli, implicitly addressing the nationalists, phrased it in 1909: "Let us grant [for a moment], however, that the French Revolution was simply an error, an accident. One must [still] recognize that for 120 years the idea of revolution has lived, has unfolded. That is an undeniable *fact*. By what right can the traditionalists disregard that *fact*."[70] But this "fact" was precisely that which the nationalists had to deny. In order for prerevolutionary government to be the self-evident political order in France, the revolution had to appear a complete aberration; the "natural" course of history had somehow to skip over a difficult century of change.

The leap, indeed, needed to be greater than just 120 years because even the eighteenth century appeared to many nationalists as dangerously far down the road of decadence toward revolution. Only the seventeenth century, the age of that most absolute of monarchs Louis XIV, captured the essence of the nation's natural past. The traditionalist Raoul Narsy, writing in 1905, polemically contrasted the two centuries:

Here . . . order, equilibrium, serene force, in the absolute accord of certitude; there feverish agitations, gropings. . . .

The seventeenth century, our classical age, . . . taken as a whole assumes the most universal and most national character. . . .

In contrast, the eighteenth century, entirely given over to fantasies, to individual endeavors, consumed by multiple interests, devoted to revolutionizing customs and institutions, divided over doctrines, grievances and remedies, is a febrile period.[71]

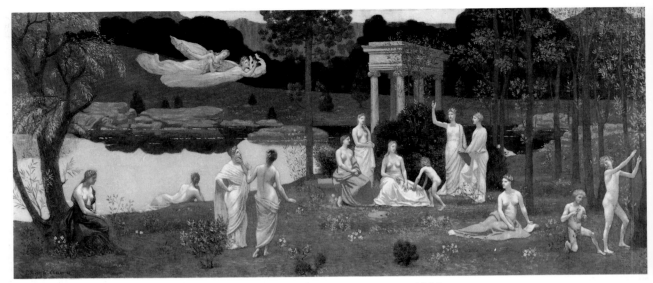

66. Pierre Puvis de Chavannes. *The Sacred Grove*. Chicago: Art Institute. 1884.

From the nationalist perspective, nothing in the years since France's classic age could assume the guise of an alternative political heritage without throwing into question the inevitability of tradition dictating a return to forms of government inherited from the era of absolutism.

Given the cultural foundations of the nationalist project, alternative artistic traditions born since the seventeenth century could have no more validity than political ones. Impressionism, fatally implicated by the age in which it emerged, consisted of artists pathologically flawed by the myriad evils of the nineteenth century: rampant individuality, scientistic theorizing, and ignorance of tradition. In a contribution to the Latinate *Renaissance esthétique* in 1906, Emile Bernard, a painter in the style of Denis, decried recent trends in painting:

> From where could have come—and from where still comes—incitement for this monstrous deformation of art engendered by the cult of personality? As I reflect about it, I would say: from Science. I have already demonstrated that that which today is called Science (with a capital "S") has produced, in the realm of color, the Impressionist catastrophe, weakening the noble characters of artists meant for higher work.[72]

Writing in the same pages in 1905, Bernard further condemned artists in the modern age (presumably exempting himself and his close colleagues): "In comparison to Poussin and Le Brun, our epoch is characterized by the most complete ignorance of art."[73]

To create acceptable painting, artists born in what the royalist Léon Daudet labeled "the stupid nineteenth century"[74] had to lift themselves out of their own diseased epoch to become self-styled anachronists emulating styles indigenous to an earlier and healthier era. The eighteenth century was as flawed in art as it was in politics. As Maurras was still arguing in 1927: "An art that only suited the strong, the powerful, the art of the seventeenth century, first seduced, then defied and disheartened, and finally withered the weak poetic vein of the following century."[75] The Renoir of

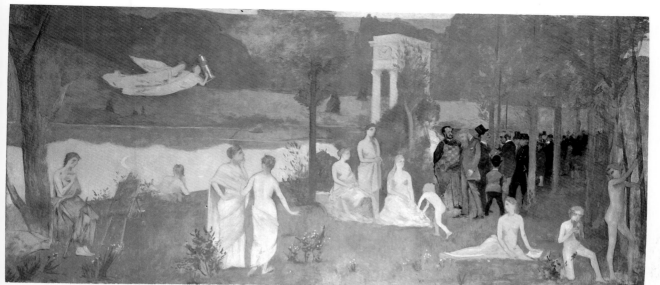

67. Henri de Toulouse-Lautrec. *"The Sacred Grove," Parody of a Painting by Puvis de Chavannes at the Salon of 1884.* Princeton University: The Art Museum. Lent by the Henry and Rose Pearlman Foundation.

Luncheon of the Boating Party (fig. 2), evocative of the eighteenth-century masters Watteau and Boucher, may have been headed in the right direction temporally but he had not gone far enough.[76] Perhaps one of the few artists of the Impressionist generation fully acceptable to the nationalist cause was Puvis de Chavannes.[77] The author of such overtly classicizing images as *The Sacred Grove* of 1884 (fig. 66) received the hard-earned approbation of Maurras himself. "Puvis de Chavannes," Maurras declared in 1895, "is from the family of Poussins and Racines."[78]

Artistic style from the nationalist perspective thus had to be more than just inherited from the past: it had to flow from the lost past of a distant age. Nationalist painting, like nationalist politics, had to convey that tinge of nostalgia that signaled an idealization of former times and distinguished them from the corrupt present. The essential temporal gap was visually manifest, and could be parodied. In Henri de Toulouse-Lautrec's send-up of Puvis's *Sacred Grove* of 1884 (fig. 67) the rogues and freaks—the dwarf-artist himself is part of the crowd—that wander onto Puvis's idyllic stage irrevocably lay bare the radical disjunction between Puvis's perfected classical figurines and a none-too-perfect contemporary society. Introduced into Denis's or Ménard's canvases, Lautrec's motley crowd would have had much the same effect. That which Lautrec lampooned was precisely that which the nationalists held dear: the quarantine of traditional values and institutions from the republican infection of the present.

From a nationalist perspective, Matisse's pastorals failed completely to isolate the classical past from the modern age. In *Luxe, calme et volupté* and *Bonheur de vivre*, Matisse violated the "firm French line" of *dessin* using stylistic tools derived from the Impressionists and Symbolist legacy that ardent nationalists would undoubtedly have condemned as the late-nineteenth century incarnate. Despite the idyllic theme of these paintings, Matisse's brightly colored and loosely painted dabs, planes and unctuous lines would have impinged on the nationalist's version of the distant, lost golden age no less than did Lautrec's band of rascals.

If Matisse's two pastorals would have left nationalist critics cold, to that audience Derain's paintings of nudes within the landscape might well have proved more objec-

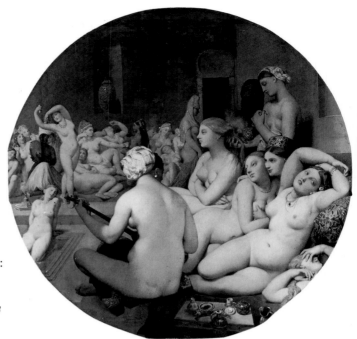

68. Jean-Auguste-Dominique Ingres. *The Turkish Bath*. Paris: Musée du Louvre. 1862.

69. André Derain. *The Golden Age*. Tehran: Museum of Modern Art. 1905.

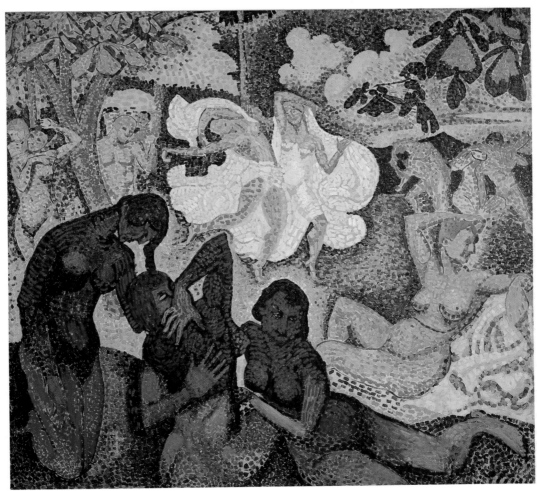

tionable still. In all likelihood Derain produced *The Golden Age* of 1905 (fig. 69) shortly after encountering *Luxe, calme et volupté*, and painted *The Dance* of 1906 (fig. 71) in the wake of *Bonheur de vivre*. These two monumentally large pictures, the first executed with large pointillist dabs and the second with a Fauve mixture of styles, disregard both senses of classical *dessin* much as did Matisse's pastorals. Moreover, in their evocations of previous artists Derain's paintings, like Matisse's, would have exuded a strong sense of the nineteenth century. The reference to Ingres's *Turkish Bath* of 1862 (fig. 68) made by the seated nude at the right edge of *The Golden Age* might have sat well enough with most nationalists. Even the obvious debt of *The Dance* to Gauguin may have proved somewhat acceptable to their more moderate members from a Symbolist background such as Denis, even if the stridently bold colors would certainly have been too much for the champions of Ménard. The pointillist mosaic in *The Golden Age*, however, would have spoken to all of rigid theory, artificial construction, and the evils of the post-revolutionary century. And *The Dance* would have evoked two notorious paintings by artists irrevocably associated with the nineteenth century. Derain based the dancing woman at the right edge of the picture on the similarly positioned black slave in Eugène Delacroix's *Women of Algiers* of 1834 (fig. 70), and viewers who had looked attentively at Manet's *Déjeuner sur l'herbe* (fig. 61) at the Exposition Universelle in 1900 would have discovered that Derain's painting, too, contained a bird along the upper edge and a toad in the lower left corner. Certainly there was no nostalgia for the absolutist seventeenth century in these works.

But it was Derain's treatment of the pastoral theme that perhaps would have most raised the hackles of the ardent nationalists. Both *The Golden Age* and *The Dance* conform to the basic iconographic program of the pastoral: nudes or semi-nudes posed before a generalized landscape setting. There is enough here to establish the timeless, mythical dimension of the subject. Yet unlike Denis, Ménard or even Matisse, Derain failed to situate Arcadia within the Latin world. These paintings do not depict the gentle Mediterranean shore, let alone Greek temples on the hill tops. Odd flowing robes and bizarre flora and fauna indicate places more exotic, and the stylistic reliance of *The Dance* on Gauguin suggests the islands of Oceania as the site of Derain's pastorals. As contemporary critical discussions of Gauguin convey, such distant lands were decidedly not part of Mediterranean world and its classical heritage. "He brought back [to Tahiti] a hatred of Europe," commented the critic Marius-Ary Leblond about Gauguin's paintings from Oceania in 1904; "he did not go only to seek nature, but also to flee civilization."[79] Even Denis, who had studied with Gauguin and revered him as a master, in 1903 called Gauguin "a type of Poussin without classical culture."[80] Derain's *Golden Age* and *Dance* would undoubtedly have elicited even harsher condemnation for abandoning the classical heritage of the West. Only these paintings' derivation from Matisse's well-known pastoral canvases would have preserved somewhat of an association between these canvases and the Latin *grande tradition*.

Worse: in Derain's pictures the golden age degenerates from Apollonian composure into Dionysian ecstasy. Between the calm Ingresesque nudes at the left and right edges of *The Golden Age* revelers break out in fevered gyrations. And in *The Dance* the classically posed nude bather in the background cedes center stage to what appears to be some form of animistic ritual in the foreground. Seen in the light of Derain's canvases, even Matisse's pastorals seem to take on a certain Dionysian flavor: the kiss in the foreground of *Bonheur de vivre* becomes that much more impassioned, and the

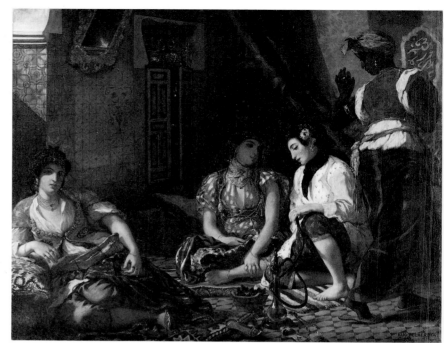

70. Eugène Delacroix.
Women of Algiers. Paris:
Musée du Louvre. 1834.

71. André Derain. *The Dance*.
London: Fridart Foundation.
1906.

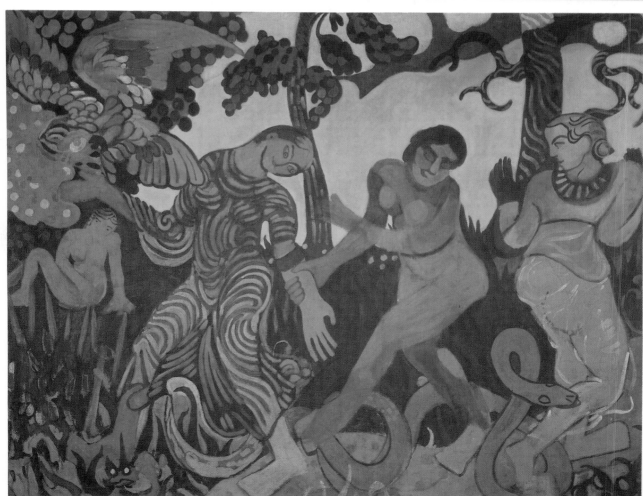

dancers further back appear to increase their cadence. All these transgressions of the pastoral genre are measured, to be sure: the Fauves included composed figures along with their inebriates, and even Poussin had depicted bacchanals in works such as *The Andrians* (fig. 62). To aficionados of Denis and Ménard, however, Derain's canvases would have challenged the idea that the mythical past offered a model of classical order to which the decadent present should return. From this perspective Derain, even more than Matisse, had violated the promise of calm and hierarchical Latin past in favor of the pleasures of exotic intoxication.

<p style="text-align:center">5</p>

"It has been placed, generally, at the beginning of time, and sometimes at the end," Hubert had written of eternity; "for this reason myths, of whatever sort, are myths of origin or of the end of things." If Matisse's and Derain's pictures failed to represent a leap backward into the well-ordered past, did their paintings perhaps point in the opposite temporal direction? Despite the near consensus during the first decade of the twentieth century that the heritage of the Latin south belonged to the reactionary nationalists, the Mediterranean shore had once been used—quite recently, in fact, though before the years of Dreyfus—as the site for a representation of a golden age at the end of time.

If polemical anarchist illustrations such as Kupka's *How Long Until the Allotment of Air Space?* (fig. 19) claimed to document the injustices of the present, Paul Signac's painting *In the Time of Harmony* of 1894 (fig. 72) promised the paradise that the

72. Paul Signac. *In the Time of Harmony*. Montreuil-sous-Bois: Mairie. 1894.

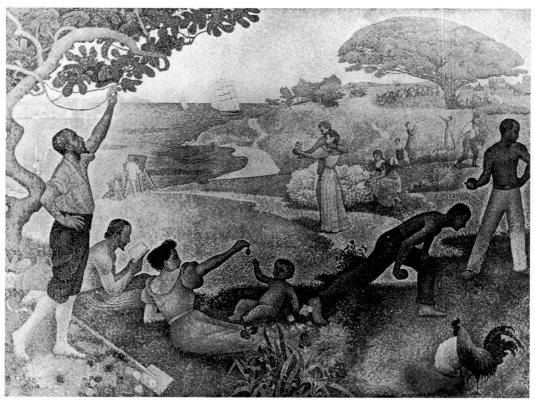

downtrodden could expect in the future following the anarchist transformation of society. Signac, a frequent traveler to the Mediterranean, found his model for utopia along the French Riviera. The calm blue sea with visible distant shore and the parasol pine in *In the Time of Harmony* are typical of the landscape around Saint-Tropez. The people portrayed by Signac have the time and open space to enjoy the pleasures of life: a good book, playing with a child, a dance, painting a picture, a plunge in the bay, a game of *boules*. Yet labor has not disappeared from this paradise. In addition to the shovel in the foreground and a man sowing the fields and women folding linen in the middleground, a steam tractor chugs along in the distance. In the anarchist utopia, work freely chosen and performed for one's own benefit is a pleasure rather than an exploitative burden, and the gesture of Signac's sower echoes that of the player of *boules*. As the anarchist theorist and journalist Jean Grave explained in his own fictional utopia *Terre libre* of 1908: "Work, far from being a punishment as the Christian religion contends and as capitalist society has organized it, is to the contrary attractive and necessary when it is performed willingly, without constraint and by inclination."[81]

The inclusion of such modern inventions as the steam tractor in *In the Time of Harmony* speaks against the placement of Signac's utopia in the mists of the past. More important, the scientist pointillist dots with which Signac painted the work indicate that this utopia lies in the future, waiting to be constructed with the rational theories and methods recently developed by modern society. Signac's technique implied the careful fabrication of the world it depicted: the dots of paint laid on the canvas by Signac in the present accumulate to produce an image of a future paradise. This temporal bifurcation between technical means and depicted result serves as the pictorial representation of the process of transformation required to attain the anarchist golden age. Signac wanted to take no chance that the temporal location of his picture could be misinterpreted: in 1893 he expressed his wish that the phrase coined by the anarchist Charles Malato, "the golden age is not in the past, it is in the future," be inscribed on the title plate of the picture.[82]

The polemicist André Girard, writing in the pages of Grave's *Temps nouveaux* in 1906, declared the revolutionary necessity for such artistic prognosticators of the anarchist future: "This marvelous picture [*tableau*] that he had just finished imagining, this magic vision that his poet's soul has evoked, why could it not become reality? . . . Hope is the great source of energy; it is happiness. Anyone who thinks that the secret of happiness can be found in the short term is blind."[83] The lurid exposition of existing social abuses by printed image and word may have fueled revolutionary fervor, but without artistic visionaries to pilot the way to paradise the anarchist cause lacked direction.

The anarchist artist not only portrayed the ends of anarchist revolution, he also embodied its means. We have already heard Jean Grave champion the artist, "his own and sole master," as the prototype for the type of unfettered work that awaited all in the anarchist future.[84] The contemporary painter entered the ideal world, for a moment, in the process of creating his image. Indeed, while most of the characters in *In the Time of Harmony* exist only in the "no place" of utopia, the depicted painter, whose back to us echoes the position that Signac himself must have adopted to paint this large canvas, forms a bridge between that world and this. In anarchist theory and in Signac's practice, the artist assumed the responsibility of—to use Grave's phrase

from 1897—"thinking and acting in a new manner, thus facilitating the passage from yesterday to tomorrow."[85] That activity of the vanguard, argued Frédéric Stackelberg in a book published by *Les Temps nouveaux* in 1899, constituted a revolutionary role: "It is up to the self-conscious revolutionaries to clear away the poisonous excrescences of the past in order to adapt the edifice of the future, which much protect the destinies of the new humanity, to the demands of its rapid and increasingly self-conscious evolution."[86]

The charge levied by the traditionalists at the republic that it tried to manufacture a political future out of abstract principles would readily have been accepted by the anarchists, for they themselves saw this to be their revolutionary mission. *In the Time of Harmony* constituted one such gesture toward constructing a new world. Executed in a rational style rationally chosen as appropriate for the coming age, the painting declares Signac a revolutionary for today and a model worker of tomorrow.

Denis had explicitly rejected *Luxe, calme et volupté* and *Bonheur de vivre* for their application of cold theory to painting; from his perspective the Fauve pastorals, especially pseudo-pointillist works such as *Luxe, calme et volupté* and Derain's *The Golden Age*, may well have appeared compatible with Signac's anarchist artistic program of the 1890s. Yet Fauve paintings no more represented a gap between the present state of injustice and a future paradise than they did between a lost world of monarchs and a corrupt republican present. Iconographically the Fauves did not include in their idyllic paintings the signs of technological progress: work clothes, steam tractors and such. More important, style in Fauve painting, unlike that in Signac's *In the Time of Harmony*, never gives pictorial form to the process of revolutionary transformation. Matisse's and Derain's large paint dabs in their earlier pastorals undercut the systematic aspect of Neo-Impressionism intended to wrest a new, libertarian society from a corrupt present, while their later canvases *Bonheur de vivre* and *The Dance* abandon completely any reference to the chosen method of anarchist art. Fauve paintings, interpreted as neo-natural paintings, do not make utopia; they find it at Saint-Tropez and Collioure as those sites exist in the present.

Even to the extent to which Fauve style indexed the painter's individuality, that personality never broke free from the here and now to leap forward into a not-yet-realized utopia. As in Vlaminck's depictions of Chatou, as in Matisse's and Derain's landscapes of the tourist south, the Fauve pastorals associate their authors closely with the Mediterranean sites and scenes they depict. The Fauve artistic persona, seemingly a product of native soil, actually subscribed closer to Maurras's dictum "it is as a Provençal that I feel myself a Frenchman" than to Grave's insistence from 1895 that the revolutionary painter "will be able to give free reign to his imagination, to the caprices of his fantasy, [and] execute the work of art as his will have conceived it."[87] It should thus come as little surprise that when Amédée Catonné reviewed the Salon des Indépendants of 1905—which included *Luxe, calme et volupté*—for the anarchist *Temps nouveaux*, he pointedly did not classify Matisse among the Neo-Impressionists: "Our social conditions compel toward easel painting—painting destined for the salon or for the museum—talents that, one can imagine, would do marvelously at architectural decoration. I am thinking of Charles Guérin, Maurice Denis, Henri Matisse, and a large number of others."[88] If the traditionalist Denis considered Matisse a Neo-Impressionist who constructed his paintings with theory, the anarchist press could label

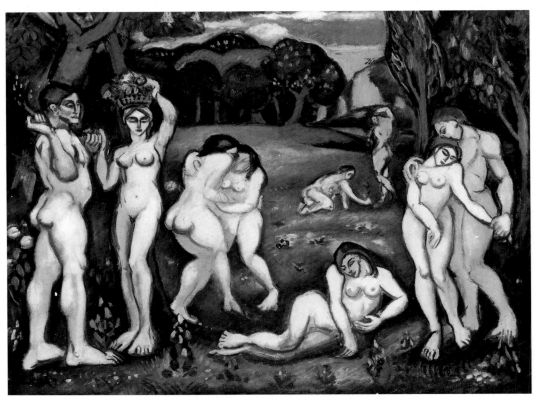

73. Othon Friesz. *Spring*. Paris: Musée d'Art Moderne de la Ville de Paris. 1908.

him a traditionalist in the mold of Denis who found his art in the conventional practice of painting with oil on canvas.

Matisse's and Derain's pastorals were thus caught between the newly emerging nationalist notion of a lost Latin past and the anarchist concept, somewhat dated since Dreyfus, of an unattained future in the Mediterranean south. The Fauves, in essence, collapsed the difference. Neither locked in the recesses of time nor held forth as a carrot to motivate revolutionary change, the Fauve pastorals link the golden age to the present. Matisse's pastorals, after all, identified mythical eternity with the ostensibly natural tourist practices just taking hold in the Mediterranean south. No modern figure could, in the manner of Lautrec's intrusive crew, disrupt the classical idyll in *Luxe, calme et volupté* since Amélie is already a part of the scene. Painting techniques evocative of the turn of the century would not seem out of place in *Bonheur de vivre* or *The Dance* since they are already there, integrated harmonically into pastoral themes suitable for the *grande tradition*. The golden age of the Fauves was neither origin nor end, neither *genesis* nor *telos*, but rather the conflation of the two within the current age.

Ultimately, Matisse and Derain were to have much company in forging this temporal compromise. As the political fortunes of anarchism waned in the new century[89] and Signac and his followers lost political control of the meaning of the Mediterranean south to the nationalists, these artists were gradually to empty their utopian pictures of the signs of revolutionary change. A painting such as Cross's *Shaded Beach* (fig. 58), a

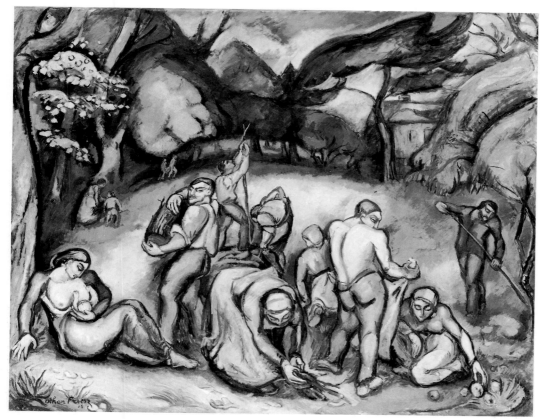

74. Othon Friesz. *Autumn Work*. Oslo: Nasjonalgalleriet. 1907–08.

depiction of bathers ambiguously either contemporary or mythical that is rendered in large dabs of colored pigment, charts the same trajectory away from early Neo-Impressionism as did Matisse's *Luxe, calme et volupté*. By 1907 even Denis, while maintaining some reservations about the technique, had kind words for Cross's pictures of bathers and nymphs: "Ah, how I love this painting by Cross that represents a nude man beneath the sky of Provence! . . . The faithful respect he has for nature, the sincerity of his vision subsists . . . , as with the classics, beneath this work of decorative construction."[90] In many respects Cross's *Shaded Beach* and similar pictures by Signac from the same decade are closer in spirit to Roussel's *Two Nude Women Seated near the Seashore* (fig. 59) or Denis's *Beach* (fig. 64) than they are to Signac's pre-Dreyfus *In the Time of Harmony* (fig. 72). Conversely, Roussel's and Denis's canvases, if scrutinized for traces of styles from the nineteenth century, could appear less firmly embedded in the pre-revolutionary past than the works of, say, Ménard or Puvis.

A painting cycle pursued by Othon Friesz in 1907–08 and clearly conceived with Matisse's influential *Bonheur de vivre* in mind perhaps most clearly lay out the temporal implications of Matisse's and Derain's pastoral canvases. *Spring* (fig. 73), filled with cavorting nudes freed from the burdens of work, presents an idyll not unrelated to pictures by the likes of Ménard. *Autumn Work* (fig. 74), on the other hand, depicts clothed laborers working the land in a blissful state similar to the scene in Signac's *In the Time of Harmony*. Yet Friesz could imagine these two pictures as a set, and although the

artist developed only *Autumn Work* into a mural-sized painting, similarities between the two paintings still outweigh their differences. Composition matches composition, and the two pictures are executed in like coloration and technique. Friesz's paintings simply refuse to acknowledge the existence of the temporal distance between past and future, between nationalists and anarchists. Friesz, like Matisse and Derain before him, posited utopia not in the spring at the dawn of civilization nor in the autumn of its culmination, but in the eternal summer of the present moment.

Politically the present implied, of course, the Third Republic. Yet undoubtedly the Fauve vision of the golden age would have proven no more satisfactory to Latinophobic republicans than it did to hard-line nationalists and anarchists. Not only did these pictures embrace the Mediterranean south, they also suggested that the nation's cultural identity was to be naturally found rather than consciously made. Old-school republican thinkers had their own artistic heros: the writer who insisted on a vanguard "dictatorship of intelligence" to lead "the struggle of the conscious brain against fate, of will against destiny" was, after all, the same Léon Bazalgette who championed Monet as a pantheist priest.[91] Bazalgette could see in Monet's late canvases the signs—all those skillfully labored layers of paint—of an artistic will to construct the world. He was not alone: as we have seen, late Impressionism had become by the beginning of the twentieth century an art movement closely associated with the social and political powers of the Third Republic.[92]

The Fauve pastorals formulated an alternative cultural justification for the Third Republic. Even as they adapted a traditionalist vocabulary of direct, natural apprehension, even as they took upon themselves the enormous cultural weight of the Latin heritage, Matisse and Derain refused the temporal rift of nostalgia so central to the nationalist program. In such works the present moment, not the absolutist seventeenth century, seemed the inevitable product of the cultural and political heritage flowing from Athens and Rome to Paris. The Latin heritage, according to these paintings, belonged to modern France; or rather, the tradition and the current-day nation were one and the same. And that "fact" was to be found, not fabricated. Nationalist tools were brought to bear on a cause other than nostalgic regret: the ratification of the republican status quo.

It was a rare argument to make in 1906, this justification of the existing republican state of affairs using the cultural artifact of the Latin heritage. Indeed, perhaps the case enjoyed clearer articulation in the realm of painting, owing to the Fauves, than in overtly political discourse. However in subsequent years, as Kenneth E. Silver has shown, the concept was to gain increasing popularity.[93] When France stood on the threshold of the First World War less than a decade after the Fauves had painted their pastoral canvases, the idea that modern France, republic and all, was the natural spiritual progeny of the Latin heritage had become a truism accepted unquestioningly by the vast majority of French citizens. As French soldiers marched into battle against Germany, the nation stood united, party-political differences absorbed in the all-encompassing *union sacrée*. French men and women rallied behind the image of a naturally Latinate France pitted against Germanic barbarity of the north. The republic, in other words, had accepted the lion's share of the nationalist agenda as their own. Maurras, writing in 1916, claimed: "Since [1905], the republican politicians have considered it ingenious—having seen our popularity—to have as their program this

same national restoration from which they have taken off the monarchy. It was (almost acknowledged at times by certain indiscreet persons) the program, one could say, 'of the *Action française* without the king.' "[94] He continued by quoting a letter the Action Française had received in January 1916 from a soldier at the front partisan to the organization's cause:

"Today . . . it's been achieved. That which appeared impossible has been accomplished slowly under our eyes: the ideas of the *Action française* are everywhere, events have given them the most dazzling consecration possible. Not one of our forecasts that has not come true, not one of our criticisms that was not justified, not one of our solutions that did not not prove to be correct. The evidence has been so striking that official thinking itself has been moved by it.

"This point appears crucial to me. The *Action française* has during the war truly set the tone for the government of the Republic. Ministers and highly placed people have borrowed from us, down to our vocabulary."[95]

The extremist Maurras was less than satisfied: for him it was monarchy or nothing. He condemned the very idea of "*Action française* without the king" as "a great error, a capital error. One does not aspire to a goal by foregoing the only means [of attaining it]."[96] Despite Maurras's reservations, however, the sea-change had occurred; even the extreme right had to acknowledge that the republic had taken on a new form. The belief that France even in the modern age was united as a nation and naturally Latin, a belief pioneered in painting by the Fauve pastoral canvases a decade earlier, had by 1914 become the image of French civilization all but universally accepted by the nation at war.

CHAPTER 5

Woman, Cézanne and Africa

"That which interests me most is neither still life nor landscape, but the human figure,"[1] wrote Matisse in "Notes d'un peintre," his first major theoretical statement, published in 1908. Five of the six canvases that Matisse chose to illustrate the "Notes d'un peintre" depict single female figures at close range; three of them are nudes. After his extended foray into landscape and pastoral, Matisse had by 1908 returned to a subject that he had more or less neglected since his studies of studio models in 1903–05: the female nude.

Actually, the return to the theme predates Matisse's "Notes d'un peintre" by more than a year, and Matisse did not embark alone on the venture. At the Salon des Indépendants of 1907 Matisse and Derain, as if in concert, presented to public scrutiny a pair of new canvases depicting nude figures. Above the title *Tableau no. III*—suggesting a programmatic advancement from the implied paintings *I* and *II*, *Luxe, calme et volupté* and *Bonheur de vivre*, shown at the previous two Indépendants—Matisse offered *Blue Nude (Souvenir of Biskra)* (fig. 75), while Derain's principal contribution was *Bathers* (fig. 76). This simultaneous thematic turn by the two acknowledged leaders of the Fauves must have seemed the proclamation of a Fauve revival of the unclothed female figure viewed close on, a return to the theme of Matisse's studio nudes of around 1904.[2]

More than a recapitulation of Matisse's earlier figure studies, Fauve pictures from 1907 onward—above all those by Matisse—broadened the temporal and spatial implications of the nude. The body itself came to fill more than the mere moment granted it earlier by Matisse's neo-naturalist rendition in the studio pictures.[3] At the same time, later Fauve canvases of the nude pushed back the cultural horizons of Matisse's pastoral vision to encompass not only France's Mediterranean coast but parts of Africa as well. The politics of time, already activated in works such as *Luxe, calme et volupté* and *Bonheur de vivre*, became intricately entwined in that politics of space that goes by the name of colonialism.

1

Where does Matisse's *Blue Nude* (fig. 75) position itself in time? In one respect, the picture, as a reworked study of the right-most of the two central nudes in *Bonheur de vivre* (fig. 56), assumes the same temporality as that earlier idyll. The palm fronds in

75. Henri Matisse. *Blue Nude (Souvenir of Biskra)*. Baltimore: Museum of Art. 1907.

the background of *Blue Nude* (I will discuss the geographic implications of this detail later) may reinforce the pastoral air by establishing a natural setting. I have argued that the Fauve idyllic landscape located the eternal paradise of classical myth in the present age, all the while maintaining the pretense of simply finding it there.[4] *Blue Nude*, by extension, might likewise be seen to conflate, naturally, the timeless and the contemporary.

Yet the iconographic signs of the idyll have weakened substantially since the days of *Bonheur de vivre*. *Blue Nude* lacks the piping shepherds, amorous couples, and—above all else—the site along the Mediterranean shore that in *Bonheur de vivre* and like canvases spoke so strongly of classical myth. Derain's *Bathers* (fig. 76) further prunes away the thematic devices of the mythical pastoral: the artist provided no more suggestion of a landscape than a rudimentary tree whose outlines only roughly and ambiguously articulate the division between blue water and green land. Many of Matisse's figure studies from these years such as *Standing Nude* of 1906–07 (fig. 77), which Matisse selected as an illustration for "Notes d'un peintre," remove even these minimal traces of the pastoral. A vague set of architectural planes provisionally places the female in the artist's studio, far from a natural setting indicative of temporal expanse.

Late Fauve painting presented the female body more or less on its own, but that body itself could suggest a temporal locus. Earlier, we have seen how the "very profound analogy" between women and nature posited by Michel Epuy ostensibly placed woman in contact with the "vital and primordial essence of the Whole," an

76. André Derain. *Bathers*. New York: Museum of Modern Art. 1907.

entity unquestionably transcending the historical moment.[5] The female body, especially when nude, could denote the seemingly natural continuity of humanity from the origin of the species onward, and countless contemporary texts and pictures—including the Fauve pastorals—marshaled this understanding of the figure of woman in their construction of images of mythical eternity. Around the turn of the century, as we have seen, the resulting concept of found origins had conservative, generally anti-republican political connotations.[6]

Such, however, was not the only possible meaning of the female nude at the turn of the century. Alternatively, women could be cast as the paragons of advanced civilization, the conservators of genteel values in the face of nature's baseness. Pericles Grimanelli, in his book *La Femme et le positivisme*, expressed the idea in 1905: "All real progress in the life of woman presupposes a succession of victories over violence, over beastliness, over pride, over ignorance and over folly. . . . Occidental woman of the twentieth century is so much above that which one can know about primitive woman in her soul and in her body, even in her beauty, that one could have said without paradox that she is a product of humanity."[7] The argument took blatant visual form in the frontispiece by A. Segaud to the book by Edmond Perrier and René Verneau entitled *La Femme dans la nature, dans les mœurs, dans la légende, dans la société* of 1908 (fig. 78).[8] An idealized Occidental nude floating amongst the clouds appears spiritual and refined as a result of her juxtaposition to a brutish, earthbound troglodyte at the bottom of the

image. By such accounts, Western woman, and the civilization she embodied, had no special rapport with primitive natural forces: she rose above them.

The political implications of this second conception of womanhood are obvious enough. To insist on the difference between females of the past and ladies of the present reinforced the republican case that the history of humanity consisted of progress from vulgarity and vice toward enlightenment and virtue.[9] The theories of Darwin and their offshoot of social Darwinism, recently popularized in France, added enormous weight to the case.[10] Segaud's illustration, which even bears the caption "The Physical Evolution of Woman,"[11] displays an unmistakable Darwinian tenor. In such descriptions of progress, current civilization was made by men and preserved by women, not found in nature. The essential trope of the picture is the positing of a fundamental difference between the world that once was and the world that is today.

Thus if the classical pastoral had but one operative valence in the politics of time during first decade of the twentieth century, the female nude had (at least) two. The battle between reactionaries and republicans, between champions of the Latin heritage and defenders of northern cosmopolitanism, between eternal sameness and evolutionary difference, between finding the nation and making it, was also fought over the figure of the woman's body.

Thematically, the late nudes by the Fauves committed themselves to neither of these two politically charged descriptions of woman. The exposition of difference between

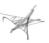

77. Henri Matisse. *Standing Nude.* London: Tate Gallery. 1906–07.

78. A. Segaud. *The Physical Evolution of Woman.* Drawing. Published in Edmond Perrier & Le Dr Verneau, *La Femme dans la nature, dans les mœurs, dans la légende, dans la société* (Paris, [1908]), frontispiece.

L'ÉVOLUTION PHYSIQUE DE LA FEMME

Frontispice dessiné par A. Segaud

elevated modern woman and her lowly pre-historic counterpart no more appears in these works than does a forging of ties between woman and eternal myth. Subject matter alone fails to represent the expanse back in time required to construct either case, one built on the sameness of past and present, the other on their difference.

As the portrayal of temporal extension evaporated in theme, however, it resurfaced in painting technique. Earlier Matisse and Derain had painted in an ostensibly immediate, neo-naturalist manner that seemed to collapse painting into its subject and thus the time of artistic production into the moment portrayed; the landscapes at Collioure are exemplary.[12] Matisse's *Blue Nude* and Derain's *Bathers*, in contrast, bear the mark of time-consuming artistic labor. Abandoning those devices that over the recently preceding years had authorized a neo-naturalist reading of Fauve painting, the two chief Fauve painters were by the beginning of 1907 in the process of introducing into their works the visible signs of pondered and sustained artistic intervention. Through these stylistic means, time and origins reemerged in the Fauves' late canvases.

Blue Nude (fig. 75), it is true, shares with many of Matisse's paintings from the years 1905 and 1906 the extensive display of untouched surface: large areas of an off-white priming define the tone of much of the nude's flesh. Previously, such exposed primed canvas had served as the reassuring ground on which Matisse's technique declared itself simple and quick, the antithesis of skilled artistic mediation. Not so in the *Blue Nude*. Here layers of paint surrounding untouched priming build one upon another to form passages of increasing technical complexity. Simple dark outlines of a muddy violet cast, similar to the figural outlines in *Bonheur de vivre* (fig. 56), define the basic configuration of the *Blue Nude*. Yet whereas flat patches of monochromatic pigment filled in these outlines in the earlier painting, in *Blue Nude* a two-toned chiaroscuro of bright white highlights and blue shadows carve out sculptural space, albeit somewhat crudely, for the figure. At points—the upper thigh, the left breast, the right shoulder, and above all the face—blue and white brush strokes pile up in areas of multi-layered density unseen in Matisse's previous Fauve work. This paint, far from appearing hastily laid on the canvas, looks carefully and consciously worked. Seen in conjunction with such passages of thick and layered paint, exposed priming in *Blue Nude* serves not as the accomplice to technique but as its foil, highlighting through contrast the effort and time expended by the artist in constructing areas of heavily encrusted surface.

Blue Nude has not just been worked, it has been reworked. To the side of the nude's supporting upper arm and rising above her left breast, traces of light blue paint demarcate that which appears as Matisse's initial conception of the figure's placement. Similarly, a halo of dark paint encircling her left buttock suggests a significant altera-tion of the location of this haunch. These markings are all surface phenomena visible at the time of the canvas's completion, not *pentimenti* that have only recently re-appeared after covering layers of pigment have become semitransparent over time. Matisse, far from disguising his revisions, gave them patent visual form. The painting presents not the unity of the picture and its object in the flash of the neo-naturalist moment but the alterity of sustained procedural revision. While the presence of what are ostensibly the artist's first traces suggests that Matisse may have derived the initial composition spontaneously without aid of preliminary sketches, his subsequent addi-tion of pigment signals the pondered reconsideration of any such impulsive beginnings. The chasm between apparent initial conception and final realization measures, indeed

serves as the representation of, the distance traversed by stylistic mediation during the extended period of the picture's realization.

Sustained artistic intervention is as evident in Derain's *Bathers* (fig. 76) as in Matisse's *Blue Nude*. This too is a picture that has been extensively worked. In terms simply of the quantity of paint on the canvas it is hard to imagine that less than two years earlier the same artist had produced *Port of Collioure, the White Horse* (fig. 41). While *Bathers*—whose surface is entirely covered by pigment—lacks the contrast between priming and labored passages operating in Matisse's *Blue Nude*, here unctuous paint accumulates yet thicker still. Heavy Cézannesque faceting, reminiscent of Matisse's *Carmelina* (fig. 23), ponderously models Derain's three figures. Simultaneously, thick dark lines stake out their principal contours. Often facets of color and delimiting lines seem directed at cross purposes. At the lower abdomen of the central figure, for instance, patches of pigment cover over sections of the linear "V" articulating the junction with the legs, and in the middle of the back of the nude to the right a stark bar of dark paint interrupts the relatively subtle surrounding modeling in orange and peach. It is as if color and line in *Bathers* alternate in firing volleys back and forth, the one heaping yet another layer of paint on the canvas to correct the excesses of the other. To acknowledge this dynamic is to recognize a seemingly self-sufficient logic of style driving the picture over time away from its putative motif toward the realm of artistic interpretation. The painterly traces of repeated revision signal a lasting intervention by the artist between the subject and the completed canvas, the two entities that in Derain's earlier paintings had appeared all but completely unified in a moment of spontaneous mutual identification.

Of course, the amount of time consumed by simple artistic procedure, the duration of revisions implied by the ghosts of previous poses in Matisse's *Blue Nude* and by the similarly thick encrustations in Derain's *Bathers*, was trivial, a few months at most. On its own this span was nothing compared to that posited thematically by the conflation of the present and mythical eternity in the pastoral canvases. Once the representation of the painter's intervention had opened the door to artistic interpretation, however, the leap into eternity seemed an inevitable consequence. In "Notes d'un peintre," Matisse himself described the process. Shortly after introducing into his paintings palpable signs of his own artistic mediation, Matisse, in a move unprecedented in the career of the then 39-year-old artist, intervened in the forum of contemporary art criticism with a manifesto directed at controlling the interpretation of his most recent work. "I will condense the meaning of this body by seeking its essential lines," wrote Matisse about painting the female nude; "one can search for a truer, more essential character, which the artist will seize so that he may give to reality a more lasting interpretation."[13] The mediating artist, now manifest in the canvas in the form of pondered style, allowed the transformation of mere momentary reality—the woman posing before the artist—into the temporal expanse of essences.

All this should sound familiar. For Matisse to claim the mysterious capacity for capturing the eternal was to cast himself in a role similar to that granted to such painters as Van Gogh, Gauguin and Monet of the late period by Symbolist critics: a pantheist priest distilling essences for the rest of humanity to contemplate.[14] The Fauves' heavily reworked surfaces beginning in 1907 could, for viewers with a Symbolist bent, easily embody the technical means toward that spiritual end, much as had

the complex layers of paint in Monet's late canvases. If earlier Fauve paintings permitted both Symbolist and neo-naturalist readings, the stylistic shift of 1907 and Matisse's programmatic statement of 1908 tipped the balance decidedly toward the former doctrine. Indeed, Symbolist interpretations of Matisse's "Notes d'un peintre" and of Fauve painting have since become frequent in the art-historical literature.[15] "That which I seek, above all," wrote Matisse in a strongly Symbolist passage from the "Notes d'un peintre" often cited in such accounts, "is expression."[16]

Art historians, in fact, have often relied on the Symbolist aspects of Matisse's "Notes d'un peintre" to characterize the entirety of Fauve painting as a Symbolist project. Such an approach incorrectly assumes that the artist's written statements control the meaning of his works; but even should we grant Matisse's word final authority, he himself insisted in "Notes d'un peintre" on the marked difference between his recent and earlier paintings.

> Often, when I start to work, I record fresh and superficial sensations during the first session. A few years ago, I was sometimes satisfied with that result. If today I were satisfied with this, now that I think I see further, there would remain a vagueness in my picture: I would have recorded the fugitive sensations of a moment that would not completely define me and that I would barely recognize the next day.
>
> I want to reach that state of condensation of sensations that makes a painting. I might be satisfied with a work done in the first attempt, but I would soon tire of it; therefore, I prefer to rework it so that later I can recognize it as representative of my state of mind. There was a time when I did not leave my canvases hanging on the wall because they reminded me of moments of over-excitement and I did not like to see them again when I was calm. Today, I try to put calmness in them, and I rework them as long as I have not succeeded.[17]

Matisse's Symbolist claims in "Notes d'un peintre" can be imposed, at most, only on his paintings dating since his stylistic shift revealed at the Salon des Indépendants of 1907.

The artistic predecessor explicitly evoked by Matisse's and Derain's manner of painting beginning in 1907, in any case, was neither Van Gogh nor Gauguin—the darlings of many a Symbolist critic—nor even Monet; the painting technique in canvases such as *Blue Nude* and Derain's *Bathers* instead summon forth Paul Cézanne. By 1907 Matisse and Derain, no longer eclectic borrowers, adopted their pondered, reworked method for the most part from that one artist alone. Both *Blue Nude* and *Bathers*, especially in their backgrounds, have moved away from the bright palette of earlier Fauve landscapes toward the darker tones of Cézanne's paintings. In *Bathers*, Derain modeled his figures by juxtaposing facets of color in the manner of Cézanne. The figural arrangement of Derain's three figures, moreover, recalls numerous bathing scenes by Cézanne, such as *Five Bathers* of 1885–87 (fig. 79), a reproduction of which hung on Derain's studio wall.[18]

Matisse's *Blue Nude* also displays some Cézannesque faceting, for instance, in the five distinct planes of blues and whites that define the upper breast. And in this work Matisse reproduced the figural awkwardness and technical incompletion of Cézanne's painting. The bulbous haunch and overly muscular shoulders of the *Blue Nude* are not far removed from the severe anatomical distortions, often androgynizing in effect, that

79. Paul Cézanne. *Five Bathers*.
Basel: Kunstmuseum. 1885–87.

characterize many of Cézanne's figural groups. The contrast between untouched
priming and heavily reworked passages across the flesh of Matisse's nude similarly
echo the startlingly neglected patches of canvas within many of Cézanne's nudes.
Cézanne's notorious *nonfinito* survived the artist's own death in the visible yet seem-
ingly incomplete revisions of Matisse.[19]

The affinity between the Fauves and Cézanne did not go unnoticed. As early as the
spring of 1907 Vauxcelles, commenting on the Salon des Indépendants at which
Matisse's *Blue Nude* and Derain's *Bathers* were on display, characterized the grow-
ing worship of Cézanne with the remark: "A chapel has been founded where two
imperious priests officiate, MM. Derain and Matisse."[20]

Coincidentally in these very years, Symbolist criticism as lead by the influential
Denis assumed a new tenor, largely under the sign of Cézanne.[21] The critical
reputation of Cézanne, whose paintings were virtually unseen in Paris until 1895, was
for the most part a product of the first decade of the new century. Denis could thus
describe his own conversion as a Symbolist critic "from Gauguin and Van Gogh to
classicism" through the figure of this artist unburdened by a critical legacy formulated
in the late-nineteenth century before the resurgence of interest in the classical.
"Without the destructive and negating anarchism of Gauguin and Van Gogh," wrote
Denis in 1909, "the example of Cézanne, with all the tradition, measure and order it
involves, would not have been understood."[22] In his review of the massive posthumous
retrospective of Cézanne at the Salon d'Automne of 1907, Denis maintained that a
"consensus" shared this perception: "It is understood that Cézanne is a kind of classic
and that the younger generation considers him a representative of classicism."[23]

Cézanne, according to Denis, owed his status as a classic in large part to the
fact that he sunk his roots into genuine Latin soil. "An independent, a recluse,"
who abandoned the artistic—and, metaphorically, the political—vicissitudes of the
cosmopolitan capital in favor of the simple life of the Provençal countryside, Cézanne
manifested "a Latin instinct." He remained untainted by the Parisian practices of
academic *poncif*, and thus a "natural taste" shaped his artistic production.[24] Awkward-

ness (*gaucherie*) served Denis and other commentators as the guarantee that Cézanne painted in a sincere manner, original not in the sense of the idiosyncratic but rather in that of avoiding the recipes of learned technique. As Richard Shiff has argued: "To [Cézanne's] contemporaries his strange and awkward style indicated that he had succeeded in attaining a genuine primitiveness, no mere affectation or imitation of the primitiveness of others, but rather a primordial originality. He seemed to escape convention and imitation to an extent that few, if any, knowledgeable moderns had done."[25]

And yet Cézanne's procedural primitiveness hardly placed him outside the tradition of Western painting. Cézanne, the argument ran, shared his natural ability to return to primordial originality with the great masters of the *grande tradition*, whom—as we have already seen—were considered to have attained such a condition owing specifically to their reputed purity of vision and technique cleansed of any historically bound *poncif*.[26] The great classics, including that chief personification of the *grande tradition* Poussin, were in this sense also primitives. Hence to praise Cézanne's for his awkwardness was to christen the artist a member of the *grande tradition*, a brother of Poussin. Indeed, contemporary critics made this link between the two great artists directly. As Shiff points out: "By this time (1905) the association of Cézanne with Poussin seems to have become a commonplace."[27] The very critics instrumental in the resuscitation of the *grande tradition*, most notably Maurice Denis and Emile Bernard, were those most active in forging the link between Poussin and Cézanne.

Cézannean style in the first decade of the twentieth century thus on its own implied a certain orientation in time. The *grande tradition*, in which Cézanne assumed his place, spoke clearly of classical origins, of primal myth. As an artist only recently deceased, Cézanne stood as an affirmation that the ostensibly timeless cultural heritage of the Latin *grande tradition* extended into the modern age. "He is at the same time the culmination of the classical tradition and the result of the great crisis of liberty and light that has rejuvenated modern art," wrote Denis of Cézanne in 1907; "he is the Poussin of Impressionism."[28] Cézanne as the personification of the primitive classic served the vital function of eliding the difference between primordial origins and contemporary painting.

Such was precisely the temporal configuration that, I have argued, characterized the Fauve's pastorals such as Matisse's *Bonheur de vivre* dating from 1905 and 1906: a grounding of the French present in the classical past, and a pulling of the classical past into the French present. Matisse's and Derain's reliance on Cézanne may thus constitute new means to an established end. Matisse himself wanted his audience to see the continuities between new and old works despite his shift in technique: "I feel very strongly the tie between my most recent canvases and those I painted in the past. . . . I always head toward the same goal but I calculate my route for getting there differently."[29] Many of the stylistic devices Matisse and Derain adopted from Cézanne—anatomical distortions, faceting, crude geometrizations; in sum, everything that constituted Cézanne's awkwardness—were precisely those that critics pointed to as signs of Cézanne's status as a primitive classic. Through Cézannean style, Matisse in *Blue Nude* and Derain in *Bathers* inscribed both past and present into the female bodies they depicted, just as they had conflated past and present in their pastorals through a combination of theme and style. These nudes from 1907 appear distant

indeed from the temporal logic of Segaud's frontispiece (fig. 78), which cast modern woman as the product of human culture, the culmination of centuries of evolution away from barbarous origins.

Of course, to emulate the technical procedures of a master of the *grande tradition*, even an awkward one, was to flirt dangerously with paradox. Cézanne appeared the primitive classic because his awkwardness signaled his refusal to copy others; how then could Matisse and Derain hope to copy this refusal to copy? It was a contradiction, however, that the critics were willing to overlook. Once the concept of origins in the modern age had been grafted onto Cézanne's particular manner of painting, the association survived the transference to the hands of other artists; the route between Cézanne and *Cézannisme* proved remarkably easy to negotiate. At the end of 1907, for example, Michel Puy could deny that Matisse blindly copied Cézanne while still crediting him with capturing the master's essence: "He did not discover Cézanne, whose reputation was growing daily, but he revealed to [his own followers] the foundation of [Cézanne's] style, its essence, and he helped orient their efforts." Puy concluded his study of the Fauves, the first extended essay devoted exclusively to the movement, with the optimistic prediction that these artists, following in the wake of the nineteenth century when all tradition had been destroyed, might well provide a "foundation for the constitution of a new tradition."[30]

Even Denis, that established Symbolist critic and recent convert to the *grande tradition* who had earlier dismissed Matisse's Fauve canvases for their excesses of theory and personality, found words of praise for Matisse following the artist's stylistic transformation. Argued Denis in 1909:

Young people, those who are headed toward classicism... are less theoretical; they believe more in the power of instinct. Nothing is more characteristic in this regard than the article published in the *Grande Revue* in December 1908 by M. H. Matisse...

They, like us, need truths that are not rudimentary or negative, but rather positive and constructive. Philosophical individualism, the cult of the self, was only able to give intellectual stimulation to men of our generation; [the younger generation] have felt a necessity for a firmer rule for living and, after having wandered in the clouds of pure reason, have resumed contact with solid realities and collective ideals.[31]

The new Matisse, it would seem, had renounced his earlier unacceptable ways to join Denis's pantheon of classical artists. Matisse's Cézannesque canvases openly invited the likes of Denis to interpret them as expressions of essences and of classical eternity. Still, by the end of the decade, Matisse was not alone in altering his stance: the Symbolist critic met the Fauve artist halfway. That which Denis now sought in painting was mediation not by the idiosyncratic individual—Van Gogh, say—but by the "collective ideal" of classical tradition—exemplified, even personified, by Cézanne. To the extent that "natural taste" characterized artists of that tradition, Symbolism in Denis's hands had curiously transmogrified into a form of naturalism: classical paintings rendered timeless truths not contingent on individual artistic personalities. Denis and Matisse—like Poussin and Cézanne, like the past and the present, even like Symbolism and naturalism—could embrace on the grounds of the collective and eternal French *grande tradition*.

80. Henri Matisse. *Fruit and Bronze*. Moscow: Pushkin Museum of Fine Arts. 1910.

2

If, beginning in 1907, Matisse and Derain stamped their paintings with the well-established temporal coordinates of the *grande tradition*, spatially these works ventured into less familiar terrain. The female figures rendered through a Cézannesque technique, at once primitive and classical, in Matisse's *Blue Nude* and Derain's *Bathers* were not necessarily Latin, nor even European, bodies. Signs of Africa mark these ostensibly classical nudes. Signs of two Africas, in fact: the region north of the Sahara considered part of the Orient, and the more southern expanse of black Africa. At the turn of the century, images of ethnic women promised knowledge about more than simply the female form. Amédée Vignola, introducing his two-volume collection of nude photographs of *Toutes les Femmes*, "all the women" of the world, declared in 1901: "If we here give special treatment to woman, it is . . . because a complete study of the world of woman provides the most certain account of the physical and moral life of the peoples of the world."[32] Activating this same synecdoche, Fauve works that revealed African women ostensibly divulged much about African society as well.

And yet, the knowledge about either Africa supplied by these canvases remained uncertain, partial, and confused. The subtitle of Matisse's *Blue Nude*, "Souvenir of

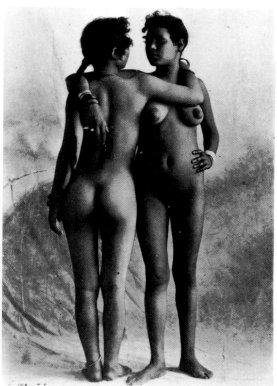

81. Henri Matisse. *Two Negresses*. Bronze. Baltimore: Museum of Art. 1908.

82. *Two Tuareg Girls*. Photograph. Published in *L'Humanité féminine*, no. 6 (5 January 1907), 40.

Biskra," indicates a precise location for the scene portrayed: the military outpost and emerging tourist oasis in the Algerian interior, which Matisse had visited during his trip to northern Africa in the spring of 1906. Since, however, the work was exhibited in 1907 with the simple title *Tableau no. III*, visitors to the Salon des Indépendants would have gained only a vague sense of a northern African location from the clumps of exotic palms in the background.

Other "souvenirs of Biskra"—pottery, utensils and carpets purchased by Matisse during his brief African sojourn in 1906 and on subsequent visits—crop up with regularity in the artist's still lifes over the next several years. An Oriental rug, for instance, serves as a backdrop for a collection of *objets d'art* and pieces of fruit in *Fruit and Bronze* of 1910 (fig. 80).[33] Matisse's articles from Algeria, metonyms for the peoples who produced them, could seem to embody the cultures of northern Africa much in the manner of the ethnic female nude. In *Fruit and Bronze*, however, the female nude does not suggest Africa north of the Sahara. At the left of the still-life grouping stands Matisse's own bronze sculpture of two woman from 1908 that currently goes by the rather pejorative title *Two Negresses* (fig. 81). In *Fruit and Bronze*, the Orient must share space with black Africa.

As he had with *Blue Nude*, Matisse exhibited *Two Negresses*—this time at the Salon d'Automne of 1908—under a geographically reticent title: it appeared as *Groupe de deux jeunes filles*. Nevertheless, the formal characteristics of this sculpture, and of many other table-top bronzes that Matisse produced toward the end of the decade, could well on their own have evoked black Africa in the contemporary French mind. As

Jack Flam has shown, Matisse's bronze nudes often possess the same short-cropped coiffures, bulbous breasts, elongated torsos, and "shelf" of the buttocks typical of the wooden figurines produced by the Baule and Fang peoples. Matisse's "young girls," moreover, assume stiff frontal poses similarly reminiscent of rigidly symmetrical Baule and Fang prototypes. Both of these types of African sculpture, Flam points out, were widely available in Paris at the time.[34] Even for those viewers unaware of the growing number of sub-Saharan figurines in Paris on public display and in private collections, the exaggerated posteriors of Matisse's sculpted nudes may have called to mind contemporaneous ethnographic accounts that proposed steatopygia as a defining characteristic of Hottentot women.[35] Undoubtedly Matisse and most of his contemporaries would have associated his bronzes—themselves dark in color—less with the "white world" of Europe than with the "black world" of Africa.[36]

While the figure titled *Reclining Nude I* of 1907 (fig. 83) strikes a distinctly Occidental pose and sports a European chignon, Matisse's rendition of breasts and buttocks makes reference, much as it did in *Two Negresses*, to sub-Saharan sculptural models[37] or to standard contemporaneous ethnographic descriptions of African physical types. *Reclining Nude I* in turn served as a model for Matisse's *Blue Nude* (fig. 75), which was painted from the clay sculptural original rather than from a living woman. Traces of what Europeans considered a distant black-African source, passed through imported African figurines and Matisse's sculpture before reaching the canvas, continue to mark the body in *Blue Nude*: the short black hair, the bulbous haunch. Even the skin color—such a strong sign, then as now, of racial difference—suggested an exotic woman from the depths of Africa. "In the Sudan," wrote René Verneau, conservator at the Musée d'Ethnographie, in 1908 in his survey of different ethnic types of women, "one encounters women whose skin is frankly black, and even gives off bluish reflections" (the term *Soudan* referred at the time to the entire sub-Saharan region stretching from what is now Senegal to the Red Sea).[38] Blue passed beyond mere tonal variation of a basic Caucasian flesh tone by which taxonomists of the day classified the incremental differences between lighter and darker Europeans, and even North Africans; a different hue implied a fundamentally different kind of being.

Yet the "bluish reflections" in *Blue Nude* serve to highlight white flesh, not black. Signs of ethnicity, in the end, simply do not add up in Matisse's painting. Anatomy that to French viewers suggested black Africa is set in a European pose; skin tone connotes both the blackest of Africans and the fairest of Europeans. And Matisse depicted all in an oasis of northern Africa using a style that spoke of the Latin *grande tradition*. *Blue Nude* points beyond the Latin world, but in many directions at once, and back toward Europe as well. Its collection of geographic attributes, mere fragments, seem as eclectic and randomly juxtaposed as the tableau of exotic *objets d'art* assembled in *Fruit and Bronze*.

Such an intercontinental admixture could prompt similarly disparate criticism. Maurice Denis's reaction to Derain's *Bathers* of 1908 (fig. 90), a painting explicitly Cézannean in theme and composition that includes three Africanized heads along the upper edge of the canvas,[39] provides a fine case in point. Derain and several other like artists, claimed Denis in his review of the Salon d'Automne of 1908 at which *Bathers* of 1908 was Derain's only figural canvas,

obviously have little regard for nature, and abhor Greco-Latin beauty. . . . Gauguin

and his Tahitians are somewhat responsible for this uglification of forms, for these quadrangular paws with four notches. Yet Gauguin's exoticism had such a strong odor of nature! Here, that brutal perfume has disappeared. Does M. Derain, who has a talent for decoration, know that even the Oceanians and the savages of all latitudes disdain neither nature nor the substance [*matière*] of the work of art? If he searches for the nourishment of his art outside our Occidental tradition, I advise him to see the admirable sculptures of Benin at the British Museum. . . . If he only has a taste for abstract syntheses, I entreat him him to consider the decorative motifs of the Hindus or the Javanese. . . . Even outside every idea of nature, in the domain of the pure ornament, there are laws and necessities, and it is not only sensibility but also reason that is lacking here.[40]

Denis grasped that Derain looked beyond European culture, but that insight led the critic nowhere; or rather, it led him everywhere. Denis's prose takes us on a quick trip around the world. We embark, along with Derain, away from a Europe represented by "Greco-Latin beauty." After a quick stop with Gauguin and the Tahitians,[41] we look in on "savages" of many climes: Oceania, Benin, India, Java. These cultures direct us back toward the "laws" of a now universalized aesthetic standard; by following their dictates, Denis is convinced, Derain can return to a type of art acceptable to the critic's Occidental eyes. Confronted with Derain's cultural composite, Denis was caught both

83. Henri Matisse. *Reclining Nude I*. Bronze. Baltimore: Museum of Art. 1907.

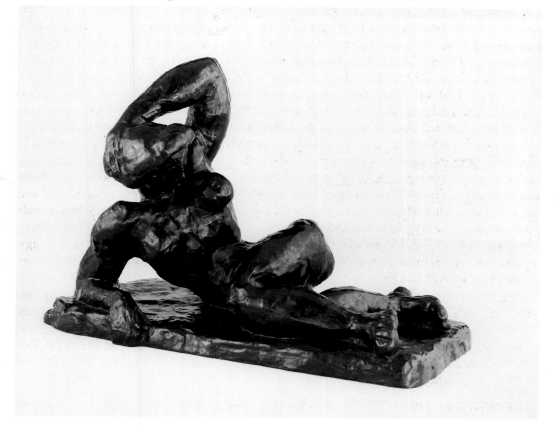

leaving and returning to the West, simultaneously identifying "beauty" exclusively with the classical heritage while locating artistic necessity among all peoples of the world.[42]

Fauve paintings and the critical response they elicited may well have lacked the coherence provided by geographic fixity, yet the African peoples and sites to which these paintings and sculptures made fragmentary reference were themselves hardly geographically fixed in the contemporary French mind. Consider the source photograph for Matisse's *Two Negresses* (fig. 81), clipped by the artist in 1907 from the pages of a periodical entitled *L'Humanité féminine* which presented nude photographs of women from many races under the guise of ethnographic investigation (fig. 82).[43] The dark skin of the two women portrayed would seem incontrovertible proof of their sub-Saharan origins, and art historians ever since have accepted that, in the words of Albert E. Elsen, "the title of the sculpture of the *Two Negresses . . .* is true to its source."[44] Yet the photograph appeared over the caption "Two Tuareg Girls" in an issue of *L'Humanité féminine* devoted to South Algeria and Tunisia. The Tuareg, reported contemporary reference books, were a nomadic people extending southward across the Sahara from southern Algeria to the Niger river. As Berbers they were classified under the "white world" in various racial taxonomies, although *La Grande Encyclopédie* of 1886 claimed that certain of their number "have interbred [*métissés*] with [the negroes]."[45] As a race, the Tuareg were the perfect sign of the lack of boundaries between the Orient and black Africa, and thus of the impossibility of any ethnographic project of producing a clear-cut taxonomy of humanity.

Amédée Vignola, editor and writer of *L'Humanité féminine* would hardly have fussed with such details. This was a periodical that did not burden itself with the duties of systematic presentation, and hardly even bothered with the pretense of accuracy. The photograph of Tuareg models, for example, appeared in neither the issue devoted to "Negresses" nor the number on "Bedouins and Berbers"; the surrounding text in the issue on "South Algeria and Tunisia" concerned the Jews.[46] For the caption "Deux filles targui," Vignola used the incorrect adjectival form—the singular *targui* rather than the invariable plural *touareg*—and elsewhere misidentified an Arab culture as Berber.[47] *L'Humanité féminine* lacked ethnographic rigor; it only pretended to ethnography, perhaps, for the sake of dissimulating its prurient plates behind the veil of scientific disinterest. We cannot even be sure that the two women shown in the photograph from its pages were Tuareg; practically any ethnic body would do in this scene undoubtedly posed in a European photographer's studio.[48] While ostensibly resolving a dispute over ethnicity—"This here, this is a Tuareg," the image seems to say—the photograph, and Vignola's lax presentation of it, only compound the geographic ambiguity lurking in Matisse's sculptural group.

The site of Biskra, evoked by *Blue Nude* (fig. 75) and by countless still lifes by Matisse, raised similar, if more complex difficulties. On the edge of the Sahara, Biskra occupied the borderlands—and not only in a geographic sense. Virtually all contemporary French accounts highlighted one attraction of the outpost over all others: the 'Uled-Nayls, women who, the writers maintained, guilelessly flocked to the pleasure quarter of Biskra to earn their dowries through prostitution. René Fage scribed a typical commentary in 1906:

> There is a huge crowd . . . in the quarter of the 'Uled-Nayls where the Arabs love to stroll. Biskra without the 'Uled-Nayls would no longer be Biskra. For so many

years they have come from afar to offer their youth to passersby, and this corporeal abandon is such a general practice in their tribe and so little a dishonor that the natives cultivate and pamper them like the extraordinary flowers that decorate their gardens. Europeans themselves look on the 'Uled-Nayls without repulsion, surprised only by the bizarreness of these customs that permit them to sell themselves without self-degradation. Moreover, the streets where they live are not streets of pariahs; there are hardly any more frequented in the new city.[49]

Biskra was preeminently the city of female spectacle and sex without shame; it blurred the frontier, ostensibly well articulated back home in Europe, between prostitution and morality.

How to locate such a place within a European scheme of virtue? On the one hand, the behavior of the 'Uled-Nayls at Biskra undoubtedly reinforced a European belief that northern Africans lived beyond the bounds of civilized decency. "How they amuse themselves," generalized the essayist Louis Bertrand in 1910 about inhabitants of the Orient, "[the] joy [of the Oriental] is the brutal and grave expression of an instinct satisfying itself. It seldom elevates itself above the simple pleasures of love and drink."[50] On the other hand, the hedonistic pleasures unburdened by guilt in Biskra suggested a sensuous golden age, miraculously reborn in the modern era. "One enters into Biskra," wrote Fage, "as if into an earthly paradise."[51]

On this note the contemporary image of the Orient circled back to the classical pastoral, and Matisse's *Blue Nude* rejoined his *Bonheur de vivre* (fig. 56), perhaps the artist's most forceful rendition of the idyllic theme. In Biskra, French tourists found displayed before their eyes—for surely the spectacle of the 'Uled-Nayls was hardly performed exclusively for sake of the indigenous population—a hint of their own innocent origins in a lost golden age. "This, " expounded the Comte d'Adhémar in his book *Mirages algériens* of 1900, "is undoubtedly why we Occidentals . . . turn back with such passion toward the routes of antiquity," by which he meant toward the Orient.[52]

Topographically, in short, the sexualized body of the Oriental woman belonged both outside and inside the Occident. Hedonism in the Orient, as in the pastoral, demarcated that in which modern Europe did not indulge on moral grounds, but also that which it supposedly had once enjoyed and hoped, in fantasy, to regain. Europe's representations, Michel de Certeau has argued,

> turn[] the primitive society into a festive body and an object of pleasure. . . .
>
> The primitive man represents an economy other than work. He reintroduces the other economy into the general picture. By way of hypothesis we can state that in an esthetic and erotic fashion, his is the return of what the economy of production had to repress in order to be founded as such. In the text he is situated in effect at the juncture of a prohibition and a pleasure.[53]

Biskra and the 'Uled-Nayls there ineluctably embodied, for French chroniclers and their readers back home, that juncture between the moral condemnation and the return—in this case, welcomed by the West—of the repressed. More generally, all evocations of the erotic African body, including those by the Fauves, rode this frontier line of Western ethics.

The tension between whether or not Europe contained Africa within its system of values and beliefs played itself out not only in what was portrayed, but also in how it

was represented. Europe mobilized a number of epistemic technologies to describe and understand Africa, but at the turn of the century two predominated: aesthetics and ethnography. These two representational practices established somewhat different relations between the European subject and the African object of knowledge.

In Jean-Léon Gérôme's *The Carpet Merchant* of around 1887 (fig. 84), the Orient, carpets and all, submits to the dictates of Occidental pictorial organization. Gérôme's precise, almost hyperrealist style catalogues the minute details of architecture, weavings, costumes and physiognomies. Through such canvases Occidental painters took over the business of representing the Orient, and did so on their own artistic terms.[54] Edward Said argues that that representation "is always governed by some version of the truism that if the Orient could represent itself, it would; since it cannot, the representation does the job, for the West, and *faute de mieux*, for the poor Orient."[55] Through *orientaliste* painting, the aesthetic of Occidental art claimed the Orient as part of its rightful representational realm.

Yet even as *The Carpet Merchant* asserted the viability of European aesthetics in northern Africa, the painting posited observing and observed cultures as united in the shared appreciation of objects of fine art. The depicted Oriental purchasers of the carpet and Occidental viewers of Gérôme's canvas alike are invited to admire the beauty of the giant tapestry draped over the balcony in the background. European and African taste seem to match; in effect, Gérôme's imposed Western aesthetic becomes universal. Countless *orientaliste* paintings that obsess over the intricate details of the finely crafted artifacts of northern Africa proclaim this same congruence of aesthetic standards spanning the Mediterranean.

Under the aegis of science, ethnographers collected their own set of details, capturing and cataloguing great quantities of information about the lives and mores of indigenous Africans. A photograph published in 1906 in the massive report of the Mission scientifique du Bourg du Bozas entitled *De la Mer Rouge à l'Atlantique à travers l'Afrique tropicale* (fig. 85) illustrates the surrounding text describing the habits of the Turkana people. The photograph also documents the act of documentation; it bears the caption: "The doctor gathers evidence concerning the culinary hygiene of the Turkana."[56] Here the depicted viewer within the picture, unlike those in Gérôme's painting, is himself a European. The black woman simply cooks; only white Westerners—the doctor in the picture, the picture's implied viewers—take an interest in "hygiene" (the term itself exudes scientific detachment). The ethnographer shares no aspect of his mode of viewing with the objects under study; the ethnographic project of "gathering information" (*se documenter*, a reflexive verb that circles action back toward the subject of the phrase) implicitly elevates the European observer above the African observed. The spatial relation between races in this photograph, in fact, resembles quite closely the dynamic in Segaud's frontispiece (fig. 78). While the photograph refrains from the overt disparagement performed by the print, both images assert a fundamental difference between the seemingly civilized and the ostensibly primitive: the doctor with his Western knowledge hovers above the cook like the idealized nude with her beauty floats above the troglodyte. Segaud's image of the earthbound creature, with her dark skin, may even have relied for its meaning on stereotypes installed in contemporary European minds by ethnographic photographs and verbal descriptions of black Africans.

84. Jean-Léon Gérôme. *The Carpet Merchant*. Minneapolis: Institute of Arts. c. 1887.

Le docteur se documente sur l'hygiène culinaire des Tourkouana.

85. *The Doctor Gathers Evidence Concerning the Culinary Hygiene of the Turkana.* Photograph. Published in Mission scientifique du [Robert] Bourg de Bozas, *De la Mer Rouge à l'Atlantique à travers l'Afrique tropicale* (Paris, 1906), 334.

If oil painting provided the primary vehicle for the aesthetic view of Africa, photography was the ethnographer's visual medium of choice. Painting implied a transference of aesthetic valuation from representation to depicted object: the canvas conferred the status of art on the carpet. Photography, a medium at the beginning of the century not yet heavily endowed with an aesthetic sanction of its own, posited only difference between its own technical complexity and the ostensibly simple lives it documented. The medium, like the vantage point, belonged exclusively to the West. Indeed, ethnographic photographs such as the numerous physiognomic studies that fill the Bourg de Bozas report (fig. 86) often bear an uncanny resemblance to photographs that back home in Europe served to survey and regulate populations likewise dispossessed of the social mechanisms of knowledge and representation.[57]

In a general sense, the aesthetic approach held greater sway in the Orient while ethnography reigned in the black region to the south. France had decades ago completed the simple discovery of unknown peoples in northern Africa, where it had maintained a colonial presence since 1830. This was, in the words of Bertrand, "an Orient already conquered and transformed by Europe."[58] Over the decades of European presence in northern Africa, *orientaliste* painting had proliferated fantastically; the *orientalistes* even held a Salon of their own in Paris beginning in 1893. The greater assimilation of northern Africa within the French colonial system undoubtedly

Petenmoï, indigène iguiai ou lango.

86. *Petenmoï, Iguiai or Lango Native*. Photograph. Published in Mission scientifique du [Robert] Bourg de Bozas, *De la Mer Rouge à l'Atlantique à travers l'Afrique tropicale* (Paris, 1906), 349.

facilitated the aesthetic supposition of sameness. Algeria had actually been incorporated into France in the form of three new *départements*; "thus," concluded Augustin Bernard in 1913, "the home country will recognize in the new France her own image."[59]

No *noiristes* were simultaneously sending canvases from south of the Sahara back to Europe. The French presence was much less pronounced in sub-Saharan Africa, and vast sections of the region had yet to be submitted to exploration of the most basic sort.[60] This was the land, seemingly, of pure difference from Europe. In 1908 Edouard Foà, an archetypal explorer and big-game hunter of the pith-helmet variety, characterized the fundamental opposition he perceived between European white and the African black, despite the superficial accoutrements provided by recent colonial inroads. It is an ugly quotation, but captures well the violent condescension directed against black Africa by many Europeans: "Besides our physical constitution, superior in terms of intelligence, we have behind us fifteen centuries of civilization, gradually accumulated, while the black, today dressed as a gentleman, was yesterday a cannibal, his teeth sharpened into points, his head decorated with feathers, [who] strangled little children to offer to fetishes."[61] Peoples attributed with such absolute and irredeemable alterity from the West were peoples considered suitable for ethnographic intervention.

Yet these geographic predilections of aesthetics and ethnography hardly held fast. Ethnographers still catalogued and photographed the peoples of northern Africa, and Gérôme's *Carpet Merchant* (fig. 84) depends as much on fascination with the non-Occidental exoticness of the Orient as it does on the assertion of shared taste across cultures. Conversely, collections of black-African artifacts underwritten by aesthetic rather than ethnographic principles began to emerge during the first decade of the twentieth century; Denis's attempt to find aesthetic "laws" in the sculpture of Benin indicates the trend. In the end, the practices of aesthetics and ethnography were not kept distinct in the contemporary French mind. Rather, they overlapped and interpenetrated in the larger European project of knowing Africa.[62]

Interpenetration of two epistemic practices, textual imprecisions and outright mistakes, fluidity between the regions north and south of the Sahara, even an uncertain

imbrication of Europe and the large continent to its south: if Fauve painting crossed its signals about Africa, it was not alone. In bringing the Orient and black Africa together through the practice of European painting, Matisse's and Derain's canvases cannot be said to have made categorical mistakes, since the categories themselves were in flux. At the turn of the century no coherent standard of what constituted Africa—or either of its two halves—existed in Western Europe by which to measure the extent of the Fauve confusions. Whether Matisse's *Blue Nude* constituted an ethnographic bit of *deux filles targui* [*sic*] or a Cézannean nude firmly embedded within the Western *grande tradition*, even what distinguished the one from the other, remained at the beginning of this century gaping questions, unanswered and unanswerable.

<p style="text-align:center">3</p>

Confusion, incoherence: these are figures of the failure of the European undertaking to understand Africa. Yet Europeans engineered their own epistemic incapacity; it was not the result of, say, the inherent intractability of Africa (though it could easily be figured as that). The failure of knowledge, moreover, could be highly productive in its own right. Not only did the shortcoming not impede the colonial expansion of one continent over another, it facilitated it.[63]

Homi K. Bhabha formulates a compelling description of the process. Colonialism, according to Bhabha, turns on the figure of mimicry. "Colonial mimicry is the desire for a reformed, recognizable Other, as *a subject of a difference that is almost the same, but not quite*. Which is to say, that the discourse of mimicry is constructed around an *ambivalence*."[64] The colonial presence induces the colonized subject (the non-European) to emulate certain European behaviors, or alternatively provokes the colonizing subject (the resident European) to imagine such similarities. Yet that emulation or similarity can never succeed in remaking the Asian or African into a European. "To be Anglicized," points out Bhabha, "is *emphatically* not to be English."[65] The colonizer thus sees in the colonized both a likeness ("almost the same") and an ineradicable difference ("but not quite").

This inability to classify indigenous populations along the European/non-European axis generates a profound disturbance within the colonial system. The ambiguity demands address, thereby justifying the intervention of the colonial system. Bhabha writes: "It is as if the very emergence of the 'colonial' is dependent for its representation upon some strategic limitation or prohibition *within* the authoritative discourse itself. The success of colonial appropriation depends on a proliferation of inappropriate objects that ensure its strategic failure, so that mimicry is at once resemblance and menace."[66] Seemingly endangered by its own inadequacies, the colonial system declares its emergency powers: it imposes an authoritarian regime within the colony that violates the principles of post-Enlightenment civility ostensibly practiced at home. The colonial system permits itself quite uncivilized acts for the exigency of normalizing the ambivalent status of colonized people within the Western imagination. The colonizer can have it both ways, unleashing barbarisms in the name of civilization. In Bhabha's words, colonial authority becomes "civility's supplement and democracy's despotic double."[67]

The epistemic crisis at the heart of colonialism thus provided both the *raison d'être*

for the European overseas adventure—its quest for knowledge—and legitimation for its extraordinary means. The Colonial Question could brook no answer since anything resembling resolution would have rendered the institutions of colonialism, indeed the European presence itself, superfluous. The crisis functioned, precisely, by never reaching its end. As de Certeau has written of European mechanisms for understanding ostensibly primitive peoples: "The savage becomes a senseless speech ravishing Western discourse, but one which, because of that very fact, generates a productive science of meaning and objects that endlessly writes."[68]

At the turn of the century, the multifaceted incoherence of Africa as it existed in French accounts sanctioned a massive incursion of colonial institutions and personnel—the military, government, ethnographic expeditions, tourists, *orientaliste* painters—across the Mediterranean. The epistemic crisis demanded an investigation of how various types of Africans—the carpet merchant, the hedonistic 'Uled-Nayl, the "black dressed as a gentleman," and the female Turkana cook—resembled Europeans, and how they did not. It also required France to intervene in that great expanse of land to the south in an attempt to draw a conceptual frontier, and maintain an administrative border, between the Orient and black Africa, between *Algérie* and *Afrique-Occidentale française*. And the French had to decide where on the African continent aesthetics, the science of shared sensibilities, gave way to ethnography, the science of racial difference. These enterprises were doomed to fail, but to do so for the benefit of Europe.

Fauve paintings that made reference to Africa were very much part of colonialism's epistemic project. Although these canvases could no more resolve the confusions of Africa than could other colonial texts and images, they could manage them to great profit. Matisse's paintings, in particular, engaged, indeed produced, Western ambiguities about Africa in such a way that these pictures constituted a call for the regulation by the European artistic tradition of African cultural resources.

Matisse's canvases often mix together signs of the Orient and of black Africa, yet the artist quite consistently treated the artifacts from the two regions in different manners. The still lifes, such as *Fruit and Bronze* (fig. 80), are filled with Matisse's souvenirs of his excursions to northern Africa: carpets and textiles, teapots and vases. These objects appear next to Matisse's reworkings of sub-Saharan sculptures; actual artifacts from black Africa are notably absent. Only once, in *Still Life with African Sculpture* of 1906–07 (fig. 87), did Matisse attempt to include an actual sub-Saharan figurine within a still-life setting. It was a canvas the artist left unfinished.

Before appearing in Matisse's canvases, black Africa passed first through the filter of Matisse's sculptures. *Two Negresses* (fig. 81) and other figurines depicted in Matisse's paintings had already incorporated aspects of sub-Saharan art into an inherently Occidental artistic practice. These sculptures, far from being African, are heavily Westernized versions of a select number of African attributes. In his paintings, Matisse construed affinities between Oriental items and these European reworkings of black-African figurines rather than with actual sub-Saharan artifacts. *Reclining Nude I* (fig. 83) depicted in *Sculpture and Persian Vase* of 1908 (fig. 88) echoes an Oriental teapot, looped arm and extended arm reflecting handle and spout.

Black Africa required aestheticization by Europe, argued Matisse's paintings; the Orient did not since it appeared already suitably aesthetic. The distinction im-

87. Henri Matisse. *Still Life with African Sculpture*. Private collection. 1906–07.

plemented in these canvases articulated a division not only between Africa north and south of the Sahara but also between the appropriate territory of the aesthetic and that of ethnography. By performing the aestheticization of black Africa himself, Matisse could not help but imply that before his own sculptural intervention the investigation of the sub-Saharan region belonged to those who studied difference. *Two Negresses* belonged in *Fruit and Bronze*, after all, while its excluded photographic source (fig. 82) had been clipped from the pages of a magazine with ethnographic pretensions.

To assimilate black Africa first into sculpture rather than directly into painting was to match like to like: the overwhelming majority of sub-Saharan artifacts known to Europeans were three-dimensional, and many were monochromatic. In contrast, Oriental art of the type that Matisse included in his canvases tended, despite the occasional teapot or vase, toward flatness. Carpets and textiles were two-dimensional, and the pottery chosen by Matisse often featured colorful decorated surfaces. Within Matisse's world, each region of Africa was characterized by its own distinctive dimensional state.

The difference marked out, from the perspective of Europe, certain inadequacies in each African mode of artistic production. A purely decorative surface of the Oriental variety could not hope to capture the corporeality of material objects, while the African monochromatic sculpture could hardly render the surface patterns of chroma. In other words, neither artistic mode attributed by Europe to Africa possessed the means to represent the other, and failing that, to represent their difference. European painting, on the other hand, prided itself on its facility in both dimensional registers. A flat surface, it nonetheless could convey three-dimensional weight through chiaroscuro modeling, which was self-consciously seen as an invention of modern Occidental

artists.[69] From the European vantage, only European painting could combine black Africa and the Orient, objects and surfaces, within the same representation, namely, the illusionistic pictorial space of the painted surface.

The negotiation of such dimensional differences, fully resonant with issues of African race, constitutes a principal activity of Matisse's still lifes from the period. In *Fruit and Bronze*, a crude chiaroscuro of colored highlights and the segmentation of body parts grant the depicted sculptural group, at the left side, a strong sense of material substance. Moreover, the base of the sculpture marks the precise location where its weight presses down on the background carpet, abruptly bending the rug into the third dimension. The Oriental vase to the right, in contrast, lacks virtually any tonal variation across its upper half to denote roundness; the blue decorations on its surface appear to push up flatly against the surface of Matisse's canvas.[70] This vessel seems to float in the air since the carpet curves gradually beneath, its pattern and border never foreshortened. Even the prominent lemon near the base of the sculpture appears rounded owing to its glistening highlight, while those further right often meld into the flat decoration of the tapestry. Scanning the canvas back and forth, the viewer witnesses Matisse's virtuoso manipulation of the capacities of Western painting, generating space out of flatness and flattening the volume out of space.[71] *Fruit and Bronze*, and numerous other Matisse still lifes from the period that play two dimensions off three, declares the superiority of European painting over that which it represents. The Occident alone can contain both black Africa and the Orient.

Only within the space of the West, consequently, can African differences be understood, codified, placed in a hierarchy. The female body of black Africa embodied by Matisse's sculptures takes its place within a setting consisting of the artifacts of the Orient; yet Matisse posed all within his European artist's studio. Just as the sculpted figurines and the collected souvenirs are metonyms for the peoples of Africa, the studio represents the territory of Africa itself. "Whereas the model is a figure of the

88. Henri Matisse.
Sculpture and Persian Vase.
Oslo: Nasjonalgalleriet.
1908.

symbolic appropriation of the body," Sarah Graham-Brown has written, "the studio is a figure of the symbolic appropriation of space."[72]

A figurine against a floral carpet; a figure within the natural landscape: working within his European studio, Matisse, in essence, recast the disjunctions between Africa north and south of the Sahara as the harmony of the pastoral. Just as the pastoral depended on the integration of the human body and nature, Matisse's manipulations of two and three dimensions forge common ground for figurine and backdrop within the illusionistic space of Western painting. And the Africanized figurines, like the nudes in the pastoral paintings, are almost exclusively female. In the end, *Fruit and Bronze* uncannily echoes *Bonheur de vivre*; both act out an idyllic theme of the *grande tradition*. *Blue Nude* (fig. 75) serves as the perfect middle term of this equation since it can be read as either an Africanized bacchante lifted from *Bonheur de vivre* and posed before actual palms or as a figurine by Matisse positioned against a decorated Oriental tapestry. Africa—in the guise of the artist's studio—resembles the Mediterranean shore.

To equate Africa, via the studio, with the classical pastoral not only Europeanized African space, it also brought Africa under the regime of European time. Africa had no history in European eyes, and thus constituted some sort of origin. James Clifford writes: "In Western taxonomy and memory the various non-Western 'ethnographic presents' are actually pasts. They represent culturally distinct times ('tradition') always about to undergo the impact of disruptive changes associated with the influence of trade, media, missionaries, commodities, ethnographers, tourists, the exotic art market, the 'world system,' etc."[73] As we have seen, Europe located the African past in several Western temporal schemas: Africa as the first link along the evolutionary chain, Africa as the eternal earthly paradise. The European intervention that allowed such acts of classification, however, risked destroying "authentic" Africa, that Africa which existed always outside time. "Progress, the great trifler," rhapsodized the photographer of the Orient Adrien Bonfils around the turn of the century, "will have swiftly brought about the destruction of what time itself has respected . . . before progress has completely done its destructive job, before this present which is still the past has forever disappeared, we have tried to fix and immobilize it in a series of views."[74]

In *Fruit and Bronze*, Matisse's souvenirs and figurines attempt to "fix and immobilize" the uncorrupted Africa in just this manner. Matisse depicted not the Africa across which Europe was in these years busily inscribing the multifarious marks of its presence; he presented instead a tableau of African or Africanized objects that exude authenticity. The Oriental items, collected not created by Matisse, were the products of indigenous industries ostensibly unaffected by the Occidental invasion. Matisse, of course, made the figurines, yet when they are portrayed within a Cézannesque still life their anatomical distortions emerge as the sculptural equivalents of Cézanne's painterly awkwardness. Such awkwardness spoke strongly of an authenticity unbesmirched by modern Europe; for Matisse to emulate it in clay enhanced, rather than adulterated, the seeming primal purity of his prototypes from black Africa.

Nevertheless, these ostensibly authentic African artifacts are arranged in *Fruit and Bronze* in such a manner as to replicate the Occidental theme of the pastoral. The rhyming of African exaggerations of the body to Cézannesque technique, moreover, renders the primitive origins of Africa reassuringly indistinguishable from the primi-

tive classic of the Latin heritage. Even those parts of Africa untouched by modern European influence, it would seem, conform to the temporal order of the French *grande tradition*. According to *Fruit and Bronze*, the African past is the European past, and neither—owing to the continuity of the classic—need be alienated from the modern age.

In creating and then addressing certain ambiguities of Africa, Matisse's paintings thus offered a set of regulating propositions: dimensions could account for the division across the Sahara, the aesthetic of the Latin classic encompassed both the space and the time of Africa. These solutions, however, depended entirely on the metonymic substitution of still-life objects and female figures for African cultures. Matisse differentiated and harmonized souvenirs and figurines, not regions of Africa; Africa reenacted the space and time of the Occidental pastoral only to the extent that the artist's studio proved an adequate stage.

Undoubtedly, these acts of substitution held great currency—then as now. Such, after all, was the enabling logic of the souvenir, and Matisse would hardly have bothered to collect portable objects during his visits to northern Africa if they did not speak in some way of their geographic and cultural origins. Clifford, summarizing Susan Stewart's analysis of modern museums, describes a similar process:

> Museums . . . create the illusion of adequate representation of a world by first cutting objects out of specific contexts (whether cultural, historical, or intersubjective) and making them "stand for" abstract wholes—a "Bambara mask," for example, becoming an ethnographic metonym for Bambara culture. . . . Paralleling Marx's account of the fantastic objectification of commodities, Stewart argues that in the modern Western museum "an illusion of a relation between things takes the place of a social relation."[75]

Matisse represented Africa metonymically not in the public space of the museum but in the privacy of his studio. He domesticated Africa (the verb is wonderfully ambiguous): bringing the foreign home to France, recreating Africa within his personal interior.

Metonymic substitution, however, was not identity. To locate the Orient in a carpet or the sub-Saharan region in a figurine was simultaneously to open the possibility that Africa exceeded the object, and thereby escaped the European aesthetic. That excess could lie at one remove in the domain of the ethnographic—the Turkana cook, for example—or at a double remove, seemingly beyond the reach of all European representations. The carpet in European hands could not help but hint at the purportedly inscrutable Oriental, the Africanized bronze at the unexplored sub-Saharan hinterlands.

In a word, Matisse's African artifacts functioned as fetishes—not, in this case, for the Africans who produced them but for the Europeans who collected them and rendered them in representations of their own. Bhabha, cultivating a Freudian analogy rather than the Marxian one proposed by Stewart and Clifford, describes the role of the colonial fetish:

> Fetishism is always a "play" or vacillation between the archaic affirmation of wholeness/similarity—in Freud's terms: "All men have penises"; in ours "All

men have the same skin/race/culture"—and the anxiety associated with lack and difference—again, for Freud "Some do not have penises"; for us "Some do not have the same skin/race/culture.". . . The fetish . . . gives access to an "identity" which is predicated as much on mastery and pleasure as it is on anxiety and defence, for it is a form of multiple and contradictory belief in its recognition and its disavowal of it.[76]

Allow me to paraphrase. In Freud's scenario, the young boy, confronted with the sight of a woman without a male sex organ immediately substitutes some other object to compensate for that lack: the high-heel of a shoe, a foot, whatever. Woman plus fetish, from the boy's perspective, together regain an illusory wholeness, modeled on the boy's own body, the division of which the boy cannot comfortably imagine. The wholeness is always illusory, however, and to a certain extent the boy knows it to be so, for he constantly confronts visual proof, in the form of the fetish itself, that an act of substitution has taken place. The fetish thus does double work, both compensating for the difference between male and female, *and* representing that difference. For Bhabha the indigenous mimic—the Anglicized Asian, say, or the Frenchified African—serves the colonizer as a fetish since the mimic both affirms the similarity of all humans *and* represents the seemingly ineradicable differences of race and culture. The colonial fetish embodies a contradiction in that it both disavows and marks out the difference between colonizer and colonized.

Matisse's studio tableaux play out this same game of similarity and difference. Here the fetishes are nothing other than the objects from Africa, or derived from Africa, put on display. On the one hand, Matisse's still lifes, by making Africa (in the form of its artifacts) appear the perfect reiteration of the European pastoral, disavow difference to affirm the sameness—on Western terms—of all people. On the other, these studio scenes depicting nothing more than small, portable samplings of Africa implicitly recognize that shattering difference that lay beyond the frame—the frame of the picture and the frame of the Occident.

This intolerable "contradictory belief" invested in the fetish justified the regulating intervention, on the part of Matisse's paintings and on the part of Western art, in the artifactual affairs of Africa. The lack of resolution inherent in the fetish, far from disqualifying Matisse's efforts to impose an always contingent order, redoubled their necessity. And Matisse's paintings beginning in 1907 are replete with the visible signs of those efforts. Matisse, declare his canvases, worked hard: he carefully arranged and mounted his still-life tableaux and then struggled over time to render them using his Cézannesque encrustations. Nothing could be further from the neo-naturalist Fauve landscapes of the preceding years, ostensibly unmodified by the artist in theme and seemingly captured in a spontaneous flash. Matisse's shift in style and his turning toward African themes, both beginning in 1907, were intimately related: the anxiety of colonial logic, the epistemic crisis of European expansion, underwrote Matisse's labors to make out of Africa that which he had previously found along the Mediterranean shore.

How fitting, finally, that Matisse's stylistic transformation and shift in geographic focus played themselves out largely through the body of woman, perhaps—in psychoanalytic terms—the ultimate fetish. In particular black Africa, from the French per-

spective the more distant and foreign part of the continent, virtually always manifested itself in Matisse's paintings in the female form. A long chain of fetishizations results, whereby acts of recognition and disavowal recognize and disavow earlier acts of recognition and disavowal. In *Blue Nude*, Biskra encompasses black Africa, the body of woman becomes a cipher for the resulting pair, a Westernized sculpted figurine stands in for the body of woman, and an oil painting in the primitive classic legacy of Cézanne represents the figurine. At each step, the figure of woman (in psychoanalytic terms both phallic presence and its lack) insists on the fetishistic nature of the substitution, for woman connoted both barbaric troglodyte and idyllic nymph, both natural origin and evolved civilization, and—as my earlier analysis of Matisse's nudes in the studio can now suggest—both physical being and illusionistic representation. And at each step, the similarities and differences of the two terms demanded negotiation.

Matisse's paintings of the nude from 1903–05, I have argued, assigned the role of subject to artist and viewer figured as male, a position of power activated by the painted representation and exercised over the female object. In Fauve canvases depicting the female figure beginning in 1907, that masculinized subject explicitly asserted itself in the seemingly imperative but always vain attempt to make order out of the abundance of ambiguities embodied in the ethnic nude. Engaging the gendered technology of vision and driven by anxieties about similarity and difference, the subject of Matisse's paintings actively managed the continuing expansion of the European representational realm, an agent in the colonial quest—the interminable quest—for knowledge.

CONCLUSION
Figures of Innovation and Tradition

I have described, in the preceding pages, an artistic movement that often disowned the creative autonomy of its artists. Seen as neo-naturalist pictures, Fauve paintings from before 1907 appeared to be purged of the painter's interpretive intervention, as if the object or site portrayed impressed itself physically into the surface of the canvas. After 1907 signs of artistic mediation, in the form of Cézannesque technique, filled the pictures of Matisse and Derain, but in these works the agency of the artist subsumed itself to the larger entity of the *grande tradition*: the Fauves rendered the female nude and explored Africa in the name of the Latinate Occident. The propositions formulated by these two phases of Fauvism—the natural control by male subjects over female objects and by tourists over the land, the essentially Latin character of France, the need to penetrate Africa for the sake of furthering knowledge—retained their cultural currency, and political efficacy, for years and even decades to come.

As the embodiment of innovative painting, however, Fauvism served a remarkably short tenure. A common art historical narrative—one whose origins and history I will briefly trace here—would have it that a single individual, seemingly a free agent, brought Fauvism to its abrupt end. Onto the stage of French high art (so the story goes) entered the Spaniard Picasso, and sometime between 1907 and 1909, as if overnight, his genius superseded the accomplishments of his French peers. Picasso emerged against the background of established painting, challenging the hegemony of French national art, to become within the French cultural sphere the personification of innovative painting unfettered by a naturalist aesthetic or a national cultural tradition.

Paris could have ignored Picasso; the history of art is strewn with many contraventions, often quite ingenious, of established pictorial orders that have done little to stir the waters, and undoubtedly countless more have gone unremarked altogether. Yet Picasso made a tremendous splash. If Picasso took on the French art world, the French art world, beginning with the Fauves themselves, returned the favor by taking on Picasso. In the end, the disturbance named Picasso proved of great use: the admission and integration of the invader into the realm of French painting authorized the public articulation of the idea that the Fauves were archetypal French national artists.

During a period when painted image and written word constantly sought out the solid foundations of Latinism, the Spanish persona of Picasso presented a paradox. The Iberian peninsula faced on the French "Latin sea" of the Mediterranean, and ardent nationalists such as Maurras explicitly included the country within the compass of the Latin world.[1] The cultural Maginot line of French nationalism ran along the

89. Pablo Picasso. *Les Demoiselles d'Avignon*. New York: Museum of Modern Art. 1907.

Rhine, not along the Pyrenees. Yet Spain lay far distant from the ever-westward trajectory traced by the classic as it passed in relay from Athens to Rome to Paris. By this criterion Spain was at best a backwater, at worst the land of the Moors. The native son Picasso could appear as Janus-faced as his land of origin; as Guillaume Apollinaire remarked in 1905 during Picasso's earliest years in Paris "He saw himself morally as more Latin, rhythmically as more Arab."[2]

The figure of Picasso, ambiguously the outsider inside the Latin heritage, had the potential to blur the frontier lines of the cultural realm of the French nation. Beginning in 1907, his paintings realized that potential—spectacularly so. *Les Demoiselles d'Avignon* of 1907 (fig. 89), spoke a pidgin, intermingling and hopelessly conflating terms from both the Latin and non-Latin lexicons. In the process, the painting cast the *grande tradition* not as the foundation of art to be discovered anew by modern painters but rather as simply one resource among many to be manipulated by an ambitious artist pursuing his own ends.

Signs of the *grande tradition* abound in *Les Demoiselles d'Avignon*. Nudes packed tightly into a hothouse interior would have brought to mind Ingres's *Turkish Bath* (fig. 68), a work by an artist firmly positioned within the classical heritage. And the poses of Picasso's five women bear a close resemblance to a number of Cézanne's bathing scenes, including *Five Bathers* (fig. 79); in both paintings women enter from the left and right and the central nude raises her elbow above her head. Even Picasso's crude geometrizations and awkward scumbles of paint might well have evoked Cézanne in the minds of contemporaries on the lookout for technical awkwardness and the sincerity it implied.

The *grande tradition*, however, must share space with other cultures in this picture: the facial features of the three peripheral nudes clearly derive from the carved masks of black Africa.[3] These strange countenances are disturbingly different from the remainder of the canvas. Their colors—whether dark tan and olive at the left, highly saturated orange and blue at the lower right, or striations of red, green, white and black at the upper right—have little relation to those of the bodies to which they are attached. Similarly the jagged crudeness of the features and the radical anatomical distortions performed in the two faces to the right irrevocably distinguish these three patches of canvas from the surrounding expanse. Even psychological accessibility varies within the picture between the Africanized and the non-Africanized. While the direct gazes of the two central figures suggest reciprocal attention between viewer and depicted women, the impermeability of the mask-like heads at the edges close off all regular channels of human address.

Unlike Matisse's *Fruit and Bronze* (fig. 80), Picasso's *Demoiselles d'Avignon* makes no claim that the aesthetic of European painting could encompass the artifacts of sub-Saharan Africa. Here the Occidental aesthetic does not even attempt to manage ethnic difference; instead it allows that difference to disrupt the pictorial unity of the canvas. In this respect, the non-aestheticized signs of Africa that Picasso admitted into his canvas resembled the dissimilar alien of ethnography more than, say, the assimilated alien of artistic Orientalism. Like the frontispiece by Segaud (fig. 78) or the photograph of the Turkana cook taken by the Bourg de Bozas expedition (fig. 85), Picasso's *Demoiselles d'Avignon* posits a fundamental disparity between European and non-European cultures.

In the ethnographic images, "advanced" European civilization and the African "primitive" were inscribed into two unquestionably distinct bodies: goddess versus troglodyte, doctor versus native. These representations mitigated the threat of difference by placing it at a distance: the "primitive" belonged far away both spatially—south of the Sahara—and temporally—in prehistoric times before the evolutionary development of the human race. *Les Demoiselles d'Avignon* no more exiled difference in this manner than it aestheticized it away. Picasso grafted African physiognomies onto European bodies, bringing the two into the closest of physical proximities. Temporal remoteness vanishes as well when masks and bodies combine to form a nasty alchemic surprise: the contemporary prostitute. Eternal Cézannean nudes become women for sale and the Arcadian backdrop for these five "bathers" transmogrifies into the claustrophobic interior of a modern brothel. In Picasso's large canvas, the essential female from the past—whether primitive or classical or both—becomes indistinguishable from the most marginalized of women in the present.[4]

Picasso, like Matisse, produced confusions out of the materials of Africa and the Latin heritage, but confusions of a much more severe and conspicuous variety. *Les Demoiselles d'Avignon* confounded the categories of geography, of time, and even of sexual morality in such a way as to foreclose the regulatory activity either of the Occidental aesthetic or of ethnography. Where Matisse and the Fauves offered hope that the art of Europe could manage such issues of difference and sameness, Picasso did not.

From this disjointed admixture of cultural fragments a new breed of agent was born. *Les Demoiselles d'Avignon* seemed the booty of multiple quick pillages into differing

90. André Derain. *Bathers*. Prague: Národní Galerie. 1908.

territories of art and artifact, and—since ostensibly no single culture could encompass them all—the pillager appeared to be none other than Picasso himself. In Matisse's pictures, the *grande tradition* could appear the subject working through the artist to incorporate Africa into its domains. In Picasso's canvas, the artist assumed the role of the subject who chose and manipulated objects from Africa and the *grande tradition* alike, two artistic heritages that served the individual painter as exploitable resources. Matisse's painting, it would seem, found itself to be part of the French *grande tradition*, while Picasso ostensibly made his own style. Just as the Spanish persona of Picasso cast him as something other than a natural agent of French art, his eclectic manner of painting and diverse thematic references proclaimed the painter's autonomy from the dictates of any such national tradition.

The image of Picasso as an artist outside tradition and in control of his own artistic production was quickly to become a standard critical line on the Spanish painter. Guillaume Apollinaire's *Méditations esthétiques: Les Peintres cubistes*, published in 1913 but assembled largely from fragments of criticism written between 1905 and 1912, formulated the idea in particularly explicit and—as it was to turn out—influential terms. "Modern art," wrote Apollinaire about a movement he saw more or less completely personified by Picasso,[5] "spurns, generally, most of the means to please

91. Pablo Picasso. *Factory at Horta de Ebro*. Leningrad: Hermitage Museum. 1909.

employed by the great artists of the past."[6] This liberated painter, revealer of truths he made rather than found, was no more constrained by his subject matter than by the weight of tradition: "Resemblance no longer has any importance, since everything is sacrificed by the artist to the truths, to the necessities of a higher nature that he establishes for himself without discovering it. Subject matter no longer counts, or hardly does so."[7] The Promethean figure of the abstract artist free to paint as he chooses—such a crucial player in the drama of art and art criticism ever since—has its modern origins here, in Apollinaire's heroization of Picasso unbound.[8]

Les Demoiselles d'Avignon remained in Picasso's studio until 1922, only leaving for public exhibition briefly in 1916. However, a number of members of the Parisian art world, the Fauves among them, were brought in for a look. Their purported declarations of outrage upon confronting the large canvas have made their way into the art-historical literature.[9] More important, the Fauves responded in paint, leaving a record of how this group of artists attempted, in the face of the challenge posed by *Les Demoiselles d'Avignon*, to reassert the unity and agency of the *grande tradition*.

Beyond a doubt, *Les Demoiselles d'Avignon* prompted Derain to paint his large *Bathers* of 1908 (fig. 90), a work that, like Picasso's picture, implants three mask-like faces within a scene of five Cézannesque bathers. While Picasso's and Derain's pictures share a common debt to Cézanne's *Five Bathers* (fig. 79), Derain rearranged his figures away from the model of Cézanne to match that of Picasso almost exactly: standing woman to the left, two central figures, squatter and three-quarter profile to the right. Once on Picasso's turf, Derain worked to deny, one by one, the Spaniard's myriad fragmentations and disjunctions. The heads in Derain's *Bathers* of 1908, devoid of striations and bold colors, are much less Africanized than were Picasso's. Derain simultaneously modified his Cézannean means of rendering the bodies as if to meet the heads halfway in style, further smoothing Picasso's rough transition from heads to

92. Georges Braque. *Houses at L'Estaque.*
Bern: Kunstmuseum. 1908.

bodies. *Bathers*, moreover, takes place in no brothel. The blue of water and sky, the white of clouds, the gentle curves of tree trunk and hill side all announce the release of Picasso's five fallen women into the open spaces of nature. The female nude returns to the morally blameless pastoral, to the fold of the *grande tradition*. Derain's *Bathers* of 1908 reasserts the potential of Occidental painting to encompass all, in spite of the incursions of Picasso.

One Fauve painter more than the rest took on the task of responding to Picasso, and he practically made an artistic career of it: Georges Braque. The story can be told—and has been, with often excruciating rigor[10]—of how Braque's figural studies and landscapes beginning in 1907 rebut Picasso's manipulations of Cézanne, and how Picasso retorted in kind to Braque. Partners in an increasingly intimate dialogue, Braque and Picasso soon found themselves saying much the same thing. Already by 1909, when Picasso painted *Factory at Horta de Ebro* (fig. 91) after seeing Braque's *Houses at L'Estaque* (fig. 92) and other depictions of L'Estaque from 1908, the two artists were both practicing that manner of painting, soon christened Cubism, that paradoxically fragmented pictorial space while also promising a new visual synthesis, a new aesthetic order. Picasso and Braque, in a remarkable collaboration marked by feisty internal competition, were to tussle over the unity and disunity of this new aesthetic for nearly a decade to come.

In time, the Fauves were to derive enormous benefits from having pitted themselves against Picasso. With the attributes of innovation and capricious agency displaced onto this foreign invader, the Fauves could in contrast appear committed to the eternal verities of the French national tradition. By the years between the wars, critical debate ranged not over whether the Fauves and their various heirs constituted a new French tradition—on that there was something close to general agreement—but over which Fauve artist best embodied the heritage of French painting.[11] And the case was

virtually always made by juxtaposing each "French" artist, paragon of consistency, against the always mutable and "foreign" Picasso. Maurice Raynal in his *Anthologie de la peinture française de 1906 à nos jours* of 1927 formulated his description of "living art" around the two poles of a constant "naturalism," of which Vlaminck was exemplary, and an ever-changing "idealism," for which the Cubist Picasso served as the defining case.[12] In the hands of André Salmon writing in 1920, Derain, "who . . . submitted to no influences other than those of the eternal masters," became the "Regulator" to the "Animator" Picasso.[13] Even Braque, despite his proximity to Picasso during the years of Analytic Cubism, could fill the role of the protector of French constancy. In a special issue of *Les Cahiers d'art* devoted to Braque in 1933 Christian Zervos wrote: "Braque joins the great line of classical painters. . . . While Picasso was driving art toward its total liberation, Braque was causing it to rediscover the *grande tradition*."[14]

The most frequent and most powerful juxtaposition, however, was that of Matisse and Picasso. "Matisse," argued Waldemar George in 1931, "places in opposition to the dynamic but too often sterile principle that governs the art of Pablo Picasso the immanent principle of French perfection."[15] Pierre Courthion expanded on the idea in 1934:

> The painting of Henri Matisse evolves toward more intimacy and profundity; it knows its limits, and in its climate it will flourish with a surprising unity. Picasso will follow the opposing tendency, spreading himself out in all directions, Proteus, breaking as if wantonly and with an infernal malice all that could give to his personality a continuity without surprises and without shocks. The nomad Pablo Picasso, explorer of forms and of civilizations, will face off in this manner against the painter Henri Matisse, priest of Mediterranean light.[16]

Matisse appeared unchanging precisely because Picasso changed. Matisse appeared a man of his race precisely because Picasso appeared an autonomous individual. And Matisse was French—in 1939, for instance, Jean Cassou declared Matisse the "accomplished representative of audacious and lucid French genius"[17]—precisely because Picasso was not.[18]

It did not matter how one sliced the pie of Parisian art into French and foreign portions: naturalism versus idealism, regulation versus animation, the Fauve Matisse versus the Cubist Picasso, or within Cubism, Braque versus Picasso. And it did not matter what sort of foreigner Picasso was supposed to be—René Huyghe, art historian and future member of the Académie Française, could even label him an "Israelite without ties" in 1935, a frightening era when the Germans were hardly alone in blaming much on the Jews.[19] The sheer critical bustle devoted to addressing such issues obscured the grounding assumption that national character was a meaningful category by which to evaluate contemporary painting. It was taken for granted that one could demand of art produced in Paris whether or not it was French, and conclude that some of it indeed was.

If Fauve painting from the period 1905–07 extended itself by means of classic themes and seemingly natural techniques toward the French *grande tradition*, the Fauves only received open critical acclaim as embodiments of the national heritage once Picasso emerged as their foreign foil. Denis's acceptance of Matisse in 1909, for instance, occurred only as Picasso was assuming within the drama of French painting

the role of autonomous innovator. Much as the figure of Picasso was predicated on the existence of Fauvism to exemplify the tradition against which revolt was possible, the standing of the Fauves as the latest practitioners of the French *grande tradition* depended on artistic audaciousness being displaced onto the figure of Picasso. Picasso did not bring Fauvism to an end; ironically, his resistance converted Fauvism into a national tradition. Or—to reverse the attribution of agency—tradition required such a transgressor as Picasso in order to project an image of its own necessity and stability.[20]

With the widespread acceptance of this perceived contrast between Picasso and the Fauves, in any case, the dialectic of tradition and innovation—once positioned across the divide between academic and modern art—now played itself out entirely within the realm of the modern. The figure of Picasso would continue to embody foreign audaciousness until after World War Two, when New York assumed that role in the face of a seemingly stable European tradition of modernism based in Paris. Only then did members of the French art establishment embrace Picasso as one of their own.[21]

Picasso's emergence as a major figure in the Parisian art world did more than solidify modern painting around the two complementary poles of tradition and innovation. It also led to a new description of the dynamics of cultural change. Apollinaire's *Méditations esthétiques*, once again, provides the formulation that would soon become commonplace. Near the beginning of his text, Apollinaire indulged in the following digression that, in a strikingly traditional gesture, sinks the roots of his own account of artistic development into the legitimating soil of classical Greece:

> We know the story of Apelles and Protogenes that is in Pliny. . . .
>
> One day, Apelles arrived on the island of Rhodes to see the works of Protogenes, who lived there. The latter was absent from his studio when Apelles called. An old woman was there who was watching over a large canvas fully prepared to be painted. Apelles, instead of leaving his name, drew on the canvas a line so refined that one could not imagine anything better to follow.
>
> Upon returning, Protogenes, seeing the trace, recognized the hand of Apelles, and drew over the line a yet more subtle line of a different color, and, as a result, there appeared to be three lines on the canvas.
>
> Apelles came back the next day without encountering the man he sought, and the subtlety of the line that he drew that day disheartened Protogenes. For a long time, this canvas elicited the admiration of connoisseurs who beheld it with as much pleasure as if, instead of presenting almost invisible lines, someone had depicted gods and goddesses on it.[22]

The story is an allegory for all artistic creation. Progress in painting results from individuals in personal competition, each trying to better the other. Protogenes rises to Apelles's challenge, and Apelles responds in-kind. Picasso counters Matisse—or Braque, or Derain, or whomever—and the Fauve counters Picasso.

Though based on a traditional artistic myth, Apollinaire's account pretends that neither tradition nor subject matter carry any weight in painting: the story begins with a blank canvas. Simply through their formal innovations, Apollinaire suggested, creative artists already have the status of Greek myth; they need not attain it through adherence to the *grande tradition* or the depiction of the golden age. Most important, artistic advancement occurs with complete indifference to historical constraints. The essential

painterly strokes are not the product of a given culture or epoch: they depict no contemporary event, they do not record the skilled training of a particular academic regime, they express no intrinsic national character. Rather, they spring pure from the interaction between two autonomous personalities, two masters as much at home in the pages of Pliny as in the studios of twentieth-century Paris.

Individual versus individual, then, not individual versus tradition. The myriad dialogues of art pare down to this single, isolated exchange. Apollinaire described not political painting but pure painting; not a national audience but a timeless audience of those disciples capable of sensing the divine. But, of course, the role of culture in defining national character had hardly come to an end: as we have seen that special amalgam of the eternal Latin and the contemporary republic forged by the Fauves was to become within a decade the rallying cry for a nation at war. Even Picasso's Cubist paintings served the national cause when patriots in need of villains as well as heros condemned such paintings as *boche*.[23] Likewise, modern painting continued its engagements in the politics of gender and colonialism for decades to come. For initiates of the doctrine of modernist formalism, however, Apollinaire's legend from Pliny and the critical legacy it engendered disguised the existence of such political impulses and uses of painting: the Fauve artists seemingly painted as they did because they were responding to Picasso, just as Picasso responded to the Fauves. If timeless genius gave birth to art, painting could not be tainted by mere national interest or political struggle. Apollinaire's, then, was the ultimate dissimulation: the version of the *grande tradition* that defined the French nation, as well as the assertions of power over women and over Africa formulated in modern painting, appeared the fruit of agents outside history talking to each other. Contemporary political doctrine in the arts adopted the mantle of eternal truth.

We still perform this dissimulation ourselves. The direct descendants of Apollinaire, many scholars to this day continue to see the development of painting as the result of the struggle between autonomous artists, a battle of Titans. Obviously, Picasso and certain of the Fauves did at times look carefully at each other's paintings and develop strategies of pictorial refutation. To select out and focus upon this particular inter-personal phenomenon and treat it as the cause of artistic creation, however, pre-determines the ends toward which painting appears to be directed. On its own, this avenue of investigation can only lead to a modernist teleology in which art exists for the purpose of revealing to us the minds of its creators. Consider, for instance, the well-known recent debate between William Rubin and Leo Steinberg over whether Braque or Picasso invented Cubism between 1907 and 1909. By jointly framing the issue as a contest over who first took the great Cubist plunge—Rubin concludes "I believe that Braque would have created early Cubism had Picasso never existed"[24] while Steinberg finishes "The creator of Cubism—whom I shall continue to call Picasso—knew what he needed and when to resist"[25]—these scholars locate both the origin and the destination of art outside history, within the psychological and technical realm of artistic genius.

Rubin and Steinberg, moreover, replicate the very dynamic they seek to describe. Rubin gives his final rebuttal to Steinberg the title "Pablo and Georges and Leo and Bill." Art history marches forward because Bill has something to say to Leo, just as painting marches forward because Georges has something to say to Pablo.

My own study hardly escapes from taking part in the give-and-take of this exchange. Rhetorically, I have produced this book for a set of audiences, both professional and lay, that impose on me the institutional expectation that I stake out my own position in relation to previous scholarship on Fauvism. And sociologically I am a member of the same museo-academic world of art history inhabited by Rubin and Steinberg. To see scholarship as only this dialogic regime of statement and response, however, dissimulates the discipline's political engagements and purposes, much as Apollinaire's criticism obfuscated the political functions of painting. A significant proportion of the academic community continues to believe that intramural exchanges among colleagues, above all else, drive scholarship forward as it strives to reveal an objective truth. If we thus imagine scholars—or demand of them—to act autonomously from politics and in a manner unmotivated by the extra-academic forces of history, we only ascribe to scholarship the same mantle of disinterestedness earlier claimed for art by the likes of Apollinaire. In the end, nothing could be more interested—and more political—than this notion of the impartial and objective scholar.

An account of painting and criticism in France in the first decade of the twentieth century necessitates an interrogation, rather than simply a reiteration through scholarship, of the ostensible disinterest of the modernist aesthetic. We must recognize that there is more to the transition from Fauvism to Cubism than a battle of geniuses, more than formalist exchanges between the Fauves and Picasso-*cum*-Apollinaire. At the same time we cannot ignore that dynamic and instead focus exclusively on the way in which paintings participated overtly in the political struggles—over gender, over land, over colonial expansion, over national identity—of their day. For the former process inflects the latter: the transposition of political issues into the aesthetic realm of painting, and into the seemingly dispassionate realm of scholarship, was, and still is, itself a political act of dissimulation embedded in and constitutive of history.

NOTES

All translations, unless otherwise noted, are by me.

NOTES TO THE INTRODUCTION

1. "La révolution ne peut être utile et bonne qu'en se combinant avec la tradition, comme tout le monde en convient maintenant, et la difficulté est de trouver les éléments et les proportions de cette combinaison." Fr[édéric] Paulhan, *L'Esthétique du paysage* (Paris, 1913), 158.

2. Louis Vauxcelles, "Salon d'Automne," *Gil Blas*, 17 October 1905.

3. "Le *Salon d'Automne* a entrepris de démontrer, par ces expositions rétrospectives, la légitimité constante de l'effort révolutionnaire pour rejoindre la tradition. La tradition d'un peuple consiste à faire germer dans l'intimité de sa nature le fruit de ses découvertes nouvelles sur le terrain des acquisitions qui constituent son patrimoine héréditaire. . . . Comme Puvis l'année passée, Ingres et Manet vont nous affirmer doucement que le révolutionnaire d'aujourd'hui est le classique de demain." Elie Faure, "Préface," in Société de Salon d'Automne, *Catalogue de peinture, dessin, sculpture, gravure, architecture et art décoratif* (Paris, 1905), 19.

4. Théodore Duret, *Histoire des peintres impressionnistes* (Paris, 1906); and Camille Mauclair, *L'Impressionnisme: Son histoire, son esthétique, ses maîtres* (Paris, 1904).

5. See Robert Gordon & Charles F. Stuckey, "Blossoms and Blunders: Monet and the State," *Art in America* 67 (January–February 1979): 104–05. The critic André Michel lent early support to the idea: "Si j'étais millionnaire—ou ministre des Beaux-Arts,—je demanderais à M. Claude Monet de me décorer quelque immense galerie des fêtes dans un Palais du peuple." André Michel, *Exposition Universelle de 1900: Les beaux-arts et les arts décoratifs* (Paris, [1901]), 307. Gordon's and Stuckey's translation of this passage ("some vast festive hall in a public place") fails to capture the civic connotations of the term "Palais du peuple."

6. "Les tableaux anarchistes de ma jeunesse sont devenus des tableaux *centre-gauche*." Henry Cochin, "A propos de quelques tableaux impressionnists," *Gazette des beaux-arts*, 3rd period, 32 (1 August 1904): 106.

7. This pairing of finding and making, which will emerge as something of a *leitmotif* through this book, I did not make myself; I found it. Richard Shiff has stood for me as the founder of the concept, and in many informal conversations over the years we have both enjoyed making frequent reference to it. Analyses of finding and making appear, in various guises, throughout Shiff's published work, perhaps most visibly in the conclusion entitled "Making a Find" to Shiff's book *Cézanne and the End of Impressionism: A Study of the Theory, Technique, and Critical Evaluation of Modern Art* (Chicago, 1984).

8. Louis A. Montrose, "Professing the Renaissance: The Poetics and Politics of Culture," in *The New Historicism*, ed. H. Aram Veeser (New York & London, 1989), 15.

9. Montrose, "Professing the Renaissance," 20.

10. Dominick LaCapra, *History, Politics, and the Novel* (Ithaca, 1987), 10, 9.

11. To bring into discussion my own position of articulation, as I have in these last two paragraphs and will continue to do on occasion throughout this book, will not, I hope, be taken as a sign of authorial hubris. I feel it would be disingenuous of me to insist on the historical contingency of the artifacts under study and then fail to acknowledge the contingent meaning, and location in history, of this text. This is especially true since, as I will argue later, my standing as a academic art historian at the end of the twentieth century is in part derived from the very historical and historiographic developments from earlier in this century that I examine. In the end I believe the more presumptuous course would have been for me to omit a consideration of my own position of writing and thereby implicitly claim for myself an authorial voice of dispassionate objectivity outside of history.

12. Such a selective approach is, of course, entirely dependent on previous scholars having defined the oeuvres and established the chronologies of the various Fauve artists. Recent studies that have been especially helpful in this regard, even though I often take issue with the authors' various interpretations, include the books on Fauvism by John Elderfield, *The "Wild Beasts": Fauvism and Its Affinities* (New York, 1976); Judi Freeman, ed., *The Fauve Landscape* (Los Angeles & New York, 1990); Marcel Giry, *Fauvism: Origins and Development*, trans. Helga Harrison (New York, 1982 [French ed. 1981]); and Ellen C. Oppler, *Fauvism Reexamined* (New York, 1976); and more specifically those on Matisse by Jack Flam, *Henri Matisse: The*

Man and His Art, 1869–1918 (Ithaca, 1986); and Pierre Schneider, *Matisse*, trans. Michael Taylor & Bridget Strevens Romer (New York, 1984 [French ed. 1984]). I have reviewed Flam's and Schneider's books in James D. Herbert, "Matisse Without History" (review article), *Art History* 11 (June 1988): 297–302.

NOTES TO CHAPTER 1

1. Monet and Renoir's canvases from 1869 of La Grenouillère in Bougival, none of which had been seen in Paris since 1889, were certainly much less known in 1905 than Renoir's later pictures of Chatou, and these earlier paintings received little or no attention in critical and historical accounts of the day.

2. There are several ways in which the relation between generations of artists can be described. Harold Bloom in *The Anxiety of Influence: A Theory of Poetry* (New York, 1973) offers what has become an especially influential model—one that I would like to disown without delay. "Strong poets make . . . history by misreading one another, so as to clear imaginative space for themselves," Bloom writes; "my concern is only with strong poets, major figures with the persistence to wrestle with their strong precursors, even to the death" (5). This Freudian drama of fathers and sons tells the story entirely from the perspective of the artists. I am more concerned with the reception than the production of paintings, the meanings—often multiple—that these works came to hold for people other than the artists themselves. Thus any "anxiety" the Fauves may have felt about important painters who preceeded them is more or less irrelevant to my account.

3. Derain's pictures of London and Vlaminck's of Chatou themselves attracted little critical attention. Since Vollard withheld Derain's paintings of London from the art market as a speculation on their future monetary appreciation, only a single painting from the series was exhibited during the Fauve years—*Big Ben* (Troyes: Musée d'Art Moderne), shown as *Westminster, Londres* at the Salon d'Automne of 1906—and it was noticed only by a critic or two. Vlaminck's paintings of the suburbs, while exhibited at all the Salons des Indépendants and the Salons d'Automne during the period, also garnered little critical commentary. Despite this paucity of criticism, Derain's and Vlaminck's paintings, I will contend, were still capable of generating meanings as they entered an arena of reception shaped but not determined by art critics. It will be one of my tasks here to construct what those meanings could have been.

4. Desmond Fitzgerald, "Claude Monet: Master of Impressionism," *Brush & Pencil* 15 (March 1905): 187; cited in Steven Z. Levine, *Monet and His Critics* (New York, 1976), 288; and in Grace Seiberling, *Monet's Series* (New

York, 1981), 200. Both Levine's and Seiberling's monographs provide extensive surveys of the criticism written about Monet.

5. Even many of Monet's early works, as Robert L. Herbert and John House have shown, were technically quite sophisticated, requiring multiple sessions to paint. Such technique, however, presented itself as quick and simple. See Robert L. Herbert, "Method and Meaning in Monet," *Art in America* 67 (September 1979): 90–108; and John House, *Monet: Nature into Art* (New Haven & London, 1986).

6. "Avec cette intense faculté de synthèse, la nature, simplifiée dans le détail et contemplée dans ses grandes lignes, devient véritablement un rêve vivant. . . . La vision de la nature par Claude Monet est une opération psychologique, une transposition absolue, une synthèse." Camille Mauclair, *L'Impressionnisme: Son histoire, son esthétique, ses maîtres* (Paris, 1904), 79, 81.

7. "Sans qu'aucun épisode vienne distraire le spectateur des féeries qu[e la lumière] joue avec ses partenaires, les brouillards et les fumées." Gustave Kahn, "L'Exposition Claude Monet," *Gazette des beaux-arts*, 3rd period, 32 (1 July 1904): 83.

8. See, among others, Théodore Duret, *Histoire des peintres impressionnistes* (Paris, 1906), 92–93; Joseph Guérin, "Les Arts: Galeries Durand Ruel, Exposition de Claude Monet," *L'Ermitage* 15.2 (June 1904): 152; and Charles Saunier, "Petite Gazette d'art: Claude Monet," *Revue Blanche* 23 (15 December 1900): 624.

9. "Abandonnent définitivement la méthode de strictement juxtaposer des menues taches qui faisait vraiment trop transparaître le procédé." Félicien Fagus, "Gazette d'art: Exposition Pissarro," *Revue blanche* 24 (1 February 1901): 222.

10. "Sens *cosmique* des pierres"; "sens *biblique* des pierres." Léon Bazalgette, "Les Deux Cathédrals," in *L'Esprit nouveau dans la vie artistique, sociale et religieuse* (Paris, 1898), 378, 387. See also Robert de la Sizeranne, "Le Bilan de l'impressionnisme," in *Les Questions esthétiques contemporaines* (Paris, 1904), 56: "[L'impressionnisme] s'alliait par d'obscures affinités aux tendances analytiques de l'esprit contemporain et répondait fort exactement, quoique inconsciemment, aux nouvelles conceptions panthéistes." Robert L. Herbert thoroughly discusses Bazalgette and other critics treating Monet as an alternative priest in "The Decorative and the Natural in Monet's Cathedrals," in *Aspects of Monet*, ed. John Rewald & Frances Weitzenhoffer (New York, 1984). Herbert summarizes the critics' position: "By restoring life to the cathedral, Monet transfers the inner essence of the medieval era from the outmoded priesthood to the artist. The artist's creativity is now the locus of true spirituality, that is, of non-material poetic and imagina-

tive thought" (170).

11. "Il est inouï que le travail analytique d'un impressionniste traduise ainsi, dans l'imitation des plus superficielles apparences et des plus fugitives, le caractère permanent et général des choses. Claude Monet a poussé si loin son intense observation des détails qu'il a rencontré la vérité profonde en laquelle ils se combinent." Guérin, "Les Arts: Exposition de Claude Monet," 152.

12. "C'est une synthèse de l'existence universelle"; "au plus profond du mystère de la substance"; "beauté d'un jour et de toujours." Gustave Geffroy, "La Tamise de Claude Monet: Exposition rue Laffitte," *L'Humanité*, 4 June 1904; reprinted in Gustave Geffroy, *Claude Monet: Sa vie, son œuvre*, 2 vols. (Paris, 1926), 2:129, 131, 133. My thanks to Joanne Paradise for locating the original version of this article.

13. For a summary of these identities, occasionally disputed, see M. Carey, *Pierre-Auguste Renoir, The Luncheon of the Boating Party* (Washington, 1981); John House, "Luncheon of the Boating Party" [catalogue entry], in *Renoir*, ed. Anne Distel, John House, & John Walsh, Jr. (London, 1985), 222–23; and Robert L. Herbert *Impressionism: Art, Leisure, and Parisian Society* (New Haven & London, 1988), 248.

14. R. Herbert identifies the type of cap in R. Herbert, *Impressionism*, 248.

15. I derive this formulation from Lévi-Strauss's description of kinship communities, and mean to imply that Renoir, much like the structural anthropologist years later, took it for granted that men were the subjects and women the objects of exchange. Claude Lévi-Strauss, *The Elementary Structures of Kinship*, rev. ed., trans. James Harle Bell, John Richard von Sturmer, & Rodney Needham (Boston, 1969 [French ed. 1949]).

16. "Des employés ou des trottins." Georges Lecomte, "L'Œuvre de Renoir," *L'Art et les Artistes* 5 (April–September 1907): 244.

17. See T. J. Clark, *The Painting of Modern Life: Paris in the Art of Manet and His Followers* (New York, 1985), chapter 3; R. Herbert *Impressionism*, chapter 6; and Paul Hayes Tucker, *Monet at Argenteuil* (New Haven & London, 1982).

18. "Renoir semble...le continuateur moderniste des maîtres français du XVIIIe siècle.... Représentant des canotiers avec leurs belles amies sur les terrases des guinguettes à travers les arceaux desquelles on découvre la Seine embrasée,...il apparaît comme le peintre de ‹Fêtes galantes› modernes et populaires." Lecomte, "L'Œuvre de Renoir," 244.

19. Thomas E. Crow has rediscovered quite a bit of social contestation taking place in Watteau's pictures at the beginning of the eighteenth century. That reading, however, was completely lost at the beginning of the twentieth century when Watteau's paintings were universally accepted as un-problematic renditions of carefree *fêtes galantes*. See Thomas E. Crow, *Painters and Public Life in Eighteenth-Century Paris* (New Haven & London, 1985), chapter 2.

20. "C'est par la magnificence de la couleur, par la richesse de la pâte, par la maîtrise de l'exécution, par le charme pictural que la scène moderniste s'élève au rang de la grande peinture.... On n'a rien peint de plus libre, de plus naturel, de plus français!" Mauclair, *L'Impressionnisme*, 134. See also Camille Mauclair, "De Fragonard à Renoir (Une Leçon de nationalisme picturale)," *Revue bleue*, 5th series, 2 (9 July 1904): 45–49; Duret, *Histoire des peintres impressionnistes*, 153; and Thadée Natanson, "De M. Renoir et de la beauté," *Revue blanche* 21 (1 March 1900): 373.

21. Virtually none of Vlaminck's canvases from the Fauve period are dated, and the artist's relative stylistic consistency from his integration into the circle of Fauve artists exhibiting at the Salon des Indépendants and the Salon d'Automne in 1905 until the major transformation of his style around 1907–08 makes the dating of paintings from this period rather arbitrary. Since my argument will not posit a chronological progression for these pictures and since I choose not to enter into art-historical debates about the proper dating for specific paintings, I will for convenience assign the date "c. 1906," by which I mean to indicate the period from 1905 through 1907, to all of Vlaminck's paintings of the suburbs that I discuss in this chapter.

22. Derain traveled to London twice, once in 1905 and again in 1906, and it is uncertain which paintings he executed during each stay. Again, I wish to avoid entering into disputes over the dating of individual works, and will assign the date "1905–06" to all of Derain's canvases from London.

23. "Avec la décadence [actuelle] apparaissent l'art affadi, mièvre, l'ingéniosité puérile, les subtilités, les couleurs affaiblies diluées, l'anémie des teintes et demi-teintes, la sourde langueur des nuances effacées." J.-C. Holl, *Après l'impressionnisme* (Paris, 1910), 42.

24. "Manie de la facture et...les virtuosités de la brosse"; "art de décadence." Ch[arles] Moreau-Vauthier, *La Peinture* (Paris, 1913), 78.

25. "C'est de la peinture extrêmement civilisée, très décadente, très *fin de race*." Georges Lanoë, *Histoire de l'école française de paysage depuis Chintreuil jusqu'à 1900* (Nantes, 1905), 290.

26. "S'aventurer parmi l'effervescence des jeunes"; "Les tons violents, la sensibilité vierge des pures couleurs apparaissent, comme si les artistes tenaient à se régénérer au contact des sensations primitives. Chez ces derniers la décadence fut la source d'une révolté généreuse de leur jeunesse

contre un art qu'ils devinaient mortel." Holl, *Après l'impressionnisme*, 42.

27. "Ceux-là ont prétendu se montrer naïfs et gauches. Ce goût de la fausse naïveté, nous vaut, depuis quelques années, des manières de peindre qui défient toutes les factures. La gaucherie appliquée y triomphe avec une feinte candeur." Moreau-Vauthier, *La Peinture*, 79.

28. "Science délicate"; "salle archi-claire, des oseurs, des outranciers"; "effarouch[ants] et virulent[s]." Louis Vauxcelles, "Salon d'Automne," *Gil Blas*, 17 October 1905.

29. My argument here about how the Fauves represented artlessness is greatly influenced by Richard Shiff's discussion of how Impressionist artists developed technical devices for representing originality. See Richard Shiff, "The End of Impressionism: A Study in Theories of Artistic Expression," *Art Quarterly*, new series, 1 (Autumn 1978): 338–78. Revised versions of this argument appear in the early chapters of Richard Shiff, *Cézanne and the End of Impressionism: A Study of the Theory, Technique, and Critical Evaluation of Modern Art* (Chicago, 1984) and in Richard Shiff, "The End of Impressionism," in *The New Painting: Impressionism 1874–1886*, ed. Charles S. Moffett (San Francisco, 1986).

30. Art historians often include painters such as Gustave Moreau, Odilon Redon and the Nabis under the rubric of Symbolism. I will be using the term only in reference to Van Gogh and Gauguin.

31. Stylistic passages reminiscent of Cézanne also appear occasionally in Derain's canvases from London; the faceted sky in *Charing Cross Bridge* (fig. 5), for instance, owes something to the earlier artist. The relationship between Fauvism and Cézanne is extremely complex and I will delay exploring the issue until chapter 5, section 1 where it will be a principal theme. In the London series, in any case, Derain relied much more on Van Gogh and Gauguin than he did on Cézanne.

32. Undoubtedly the example of Van Gogh was itself at least partially responsible for the shift by the Neo-Impressionists away from pointillism towards larger dabs of paint beginning around the turn of the century. I will remark further on the connections between Fauvism and late Neo-Impressionism in chapter 3, section 1 and chapter 4, section 5.

33. "M. de Vlaminck est un virulent imagier qui met en fureur et en déroute les spectateurs bourgeois; singulier tempérament qui rappelle Van Gogh, avec un moindre accent sans doute." Louis Vauxcelles, "Salon des 'Indépendants,'" *Gil Blas*, 20 March 1907.

34. For an extensive survey of critical reactions to Van Gogh, see Carol M. Zemel, *The Formation of a Legend: Van Gogh Criticism, 1890–* *1920* (Ann Arbor, 1980), especially chapter 4, "Van Gogh Criticism in France, 1890–1900," and chapter 5, "Van Gogh Criticism in France, 1900–1920."

35. "Ce sont uniquement des gens du peuple qu'il s'est plu à représenter.... On ne découvre dans son œuvre aucun personnage appartenant aux classes supérieures." Théodore Duret, *Vincent van Gogh* (Paris, 1916), 16.

36. François Monod, "Les Expositions: Le 21e Salon des Indépendants," *Art & Décoration* 17 (May 1905): supplement, 1. The list of adjectives are culled from Monod, "Les Expositions: Le 21e Salon des Indépendants," 1; François Monod, "Chronique," *Art & Décoration* 23 (February 1908): supplement, 2; Ad. van Bever, "Les Aînés: Un Peintre maudit, Vincent van Gogh (1853–1890)," parts 1, 2, *La Plume*, nos. 373, 374 (1 June, 15 June 1905): 536, 609; Emile Bernard [Francis Lepeseur, pseud.], "L'Anarchie artistique: Les Indépendants," *La Rénovation* [title changed July 1905 to *La Rénovation esthétique*] 1 (June 1905): 94; Mauclair, *L'Impressionnisme*, 193; and Charles Morice, "Le XXIe Salon des Indépendants," *Mercure de France*, modern series, 54 (15 April 1905): 540.

37. Adjectives from J.-C. Holl, "Salon d'Automne," *Les Cahiers d'art et de littérature*, no. 5 (October 1906): 72; Paul Jamot, "Le Salon d'Automne," *Gazette des beaux-arts*, 3rd period, 36 (1 December 1906): 468, Mauclair, *L'Impressionnisme*, 193; Maurice Denis [P.-L. Maud, pseud.], "L'Influence de Paul Gauguin," *L'Occident* 4 (October 1903): 164; reprinted in Maurice Denis, *Théories 1890–1910: Du symbolisme et de Gauguin vers un nouvel ordre classique*, 2nd ed. (Paris, 1912 [1st ed. 1912]), 166; Charles Morice, "Gauguin," in Société du Salon d'Automne, *Catalogue des ouvrages de peinture, sculpture, dessin, gravure, architecture et art décoratif* (Paris, 1906), 186; and Léon Werth, "Le Mois de peinture," *La Phalange* 5 (20 June 1910): 727.

38. "Selon Gauguin, tout ce qui est européen—dévié, étriqué, anémique, chétivement calculé,—est inférieur à ce qui est sauvage, aux manifestations spontanées et inconscientes de l'instinct indigène. L'art même, la dernière chose que ses adversaires ou ses réfractaires contestent à la civilisation, l'art européen n'est que domestication, empoisonnement, castration de nos instincts les plus naturels, primordiaux: il n'est plus ‹direct›." Marius-Ary Leblond, "La Vie tahitienne de Paul Gauguin," *Revue bleue*, 5th series, 1 (14 May 1904): 636.

39. "Vomissait toute civilisation." Louis Vauxcelles, "Le Salon d'Automne," *Gil Blas*, 5 October 1906. Today it could certainly be argued that Oceanic and Breton cultures were themselves "civilizations" and that therefore Gauguin had not eliminated from his paintings all signs of civiliza-

tion but rather had simply replaced the artistic signs of one culture with those of another. Most French contemporaries, however, would never have considered Oceania and Brittany as human civilizations in their own right. Henri Chervet, for instance, maintained that the "macaques" among whom Gauguin lived "ne nous intéressaient, ne pouvaient nous intéresser qu'à titre de curiosité zoologique." Henri Chervet, "Le IVe Salon d'Automne," *La Nouvelle Revue*, new series, 43 (1 November 1906): 99.

40. The passage on Van Gogh appears in [Maurice] Vlaminck, *Tournant dangereux: Souvenirs de ma vie* (Paris, 1929), 229, while declarations of independence from previous artists and styles crop up with regularity throughout both Vlaminck, *Tournant dangereux* and Maurice Vlaminck, *Portrait avant décès* (Paris, 1943).

41. Shiff makes this point about the late works of Monet in the three versions of "The End of Impressionism."

42. "Il est très conscient de la matière, de son importance et de sa beauté, mais, aussi, le plus souvent, cette enchanteresse matière, il ne la considère que comme une sorte de merveilleux langage destiné à traduire l'Idée. C'est, presque toujours, un symboliste.... un symboliste sentant la continuelle nécessité de revêtir ses idées de formes précises, pondérables, tangibles, d'enveloppes intensément charnelles et matérielles. Dans presque toutes ses toiles, sous cette enveloppe morphique, sous cette chair très chair, sous cette matière très matière, vît, pour l'esprit qui sait l'y voir, une pensée, une Idée, et cette Idée, essentiel substratum de l'œuvre, en est, en même temps, la cause efficiente et finale. Quant aux brillantes et éclatantes symphonies de couleurs et de lignes, quelle que soit leur importance pour le peintre, elles ne sont dans son travail que de simples *moyens* expressifs, que de simples *procédés* de symbolisation." G.-Albert Aurier, "Les Isolés: Vincent van Gogh," *Mercure de France*, modern series, 1 (January 1890): 27; reprinted in and translation from Ronald Pickvance, *Van Gogh in Saint-Rémy and Auvers* (New York, 1986), 312–13.

43. "L'inouï Van Gogh... arracha [la couleur], lui, toute saignante, à toute la nature, à la lumière, au soleil même, s'en pétrit une langue inconnue pour exprimer la vie universelle et identique." [Félicien] Fagus, "Gazette d'art: L'Art de demain," *Revue blanche* 29 (1 December 1902): 544.

44. "Amour et Beauté, condensation de la vie, harmonie des lignes, des couleurs et des valeurs, qu'il signifie l'expression des faits et des idées. C'est parce que Paul Gauguin fut symbolique que l'école de Pont-Aven gardera son influence." Armand Seguin, "Paul Gauguin," part 2, *L'Occident* 3 (April 1903): 232.

45. In regard to art criticism written about the Fauves before 1907, I have chosen to focus on the Symbolist position, especially as it was articulated by Maurice Denis, and on the ideas of a handful of dissenters such as Vauxcelles. For a more extensive assessment of Fauve criticism, see Roger Benjamin's *Matisse's "Notes of a Painter": Criticism, Theory, and Context, 1891–1908* (Ann Arbor, 1987), especially chapter 4, "Major Critics"; and Roger Benjamin, "Fauves in the Landscape of Criticism," in *The Fauve Landscape*, ed. Judi Freeman (Los Angeles & New York, 1990). My account of Denis's stance actually embraces that of many other critics as well since, as Benjamin points out, Denis's "arguments were in themselves so strong, so coherent and meshed so well with Matisse's known penchant for theorizing, that they were adopted by the majority of serious critics writing on Matisse for the next few years." Benjamin, *Matisse's "Notes of a Painter"*, 95.

46. "C'est [une] recherche absolue de l'intellectualité pure... L'idée de cette conception doit être, encore qu'un peu confuse, élevée et intéressante... Le poème symboliste ou le livre de métaphysique semblaient tout indiqués." "Foski," "Carnet de Paris: Anx Indépendants," part 2, *La Nouvelle Revue*, new series, 39 (15 April 1906): 561.

47. "[Gauguin] devait... trouver insuffisant le procédé qui consiste à se subordonner aux aspects fugitifs de la nature... Pour exprimer sur la toiles ses interprétations décoratives, il lui fallut se donner une manière doublement personnelle en ce qu'elle émanait en grande partie de lui seul et traduisait en outre les conceptions d'une personnalité très particulière." Joseph Guérin, "Les Arts: Paul Gauguin," *L'Ermitage* 14.3 (November 1903): 233.

48. Monod, for example, argued: "Ce qui fait un artiste ou un mystique, l'exagération de la sensibilité dans telle direction spéciale et déterminée, ne diffère pas essentiellement de ce qui fait un fou. Par la couleur et par le dessin, Van Gogh donnait issue à une exaltation contenue et concentrée, violent et sourde, qui s'acheva dans la folie." Monod, "Les Expositions: Le 21e Salon des Indépendants," supplement, 1.

49. "Dès l'entrée de la salle qui lui [l'école de Matisse] est consacrée,... on se sent en plein dans le domaine de l'abstraction. Sans doute, comme dans les plus ardentes divagations de Van Gogh, quelque chose subsiste de l'émotion initiale de nature. Mais ce qu'on trouve surtout, en particulier chez Matisse, c'est de l'artificiel;... c'est la peinture hors de toute contingence, la peinture en soi, l'acte pur de peindre. Toutes les qualités du tableau autres que celles du contraste des tons et des lignes, tout ce que la raison du peintre n'a pas déterminé, tout ce qui vient de notre instinct et de la nature, enfin toutes les qualités de représentation et de sensibilité sont exclues de l'œuvre d'art." Maurice Denis, "La

Peinture," *L'Ermitage* 16.2 (15 November 1905): 317; reprinted as "De Gauguin, de Whistler et de l'excès des théories," in Denis, *Théories*, 200.

50. "C'est proprement la recherche de l'absolu. Et cependant, étrange contradiction, cet absolu est limité par ce qu'il y a au monde de plus relatif: l'émotion individuelle." Denis, "La Peinture" (15 November 1905): 317; reprinted as "De Gauguin, de Whistler et de l'excès des théories," in Denis, *Théories*, 200.

51. "Vous n'êtes satisfait que lorsque tous les éléments de votre œuvre vous sont intelligibles. . . . Il faut s'y résigner: tout n'est pas intelligible. Il faut renoncer à reconstruire un art tout neuf avec notre seule raison. Il faut se fier davantage à la sensibilité, à l'instinct . . ." Denis, "La Peinture" (15 November 1905): 317–18; reprinted as "De Gauguin, de Whistler et de l'excès des théories," in Denis, *Théories*, 201. The passage, crucially, continues: ". . . et accepter, sans trop de scrupules, beaucoup de l'expérience du passé. Le recours à la tradition est notre meilleure sauvegarde contre les vertiges du raisonnement, contre l'excès de théories." This elision of the difference between individual sensibility and tradition captures, in a nutshell, Denis's evolution from Symbolism to classicism. I will discuss this development further in chapter 4, section 4 and chapter 5, section 1. Benjamin is especially effective in tracing the dissemination throughout the art critical community of Denis's charge that "too much ratiocination or calculation was at the root of Matisse's excesses." Benjamin, *Matisse's "Notes of a Painter"*, 94–95.

52. "Tout s'y peut déduire, expliquer; l'intuition n'y a que faire. . . . Combien loin de la lyrique outrance d'un van Gogh!" André Gide, "Promenade au Salon d'Automne," *Gazette des beaux-arts*, 3rd period, 34 (1 December 1905): 483–84.

53. "C'est l'abus des théories, le souci par trop exclusif des moyens d'expression." Charles Morice, "Le XXIIe Salon des Indépendants," *Mercure de France*, modern series, 60 (15 April 1906): 536.

54. See Mikhail Bakhtin, *Problems of Dostoevsky's Poetics*, ed. & trans. Caryl Emerson (Minneapolis, 1984 [1st Russian ed. 1929, rev. Russian ed. 1963]), 185. Mieke Bal and Norman Bryson have recently discussed precisely this dynamic of reception: "Surrounding those forms [of looking by actually documented viewers] are other, submerged series of procedures that have addressed other needs, procedures whose traces can be discerned from the forcefulness of the attempts to repress them." Mieke Bal & Norman Bryson, "Semiotics and Art History," *The Art Bulletin* 72 (June 1991): 186.

55. F. de Bernhardt, *Londres et la Vie à Londres* (Paris, 1906), 36; and W[illiam] H.

Dumont & Ed[ward] Suger, *Londres et les Anglais* (Paris, 1908), 42. Dumont and Suger were actually Englishmen, but in their book they hid their anglophone given names by using only initials, adopted the guise of Frenchmen (*e.g.* "chez nous") and clearly assumed a set a French presuppositions about England on the part of their French-language readers.

56. "Ce que je voulais peindre, c'était l'objet lui-même, avec son poids, sa densité, comme si je l'avais représenté avec la matière même dont il était formé." Vlaminck, *Portrait avant décès*, 136.

57. "Des rapports de volumes peuvent exprimer une lumière ou la coïncidence de la lumière avec telle ou telle forme." André Derain, *Lettres à Vlaminck* (Paris, 1955), 197.

58. "Le goût, le toucher et l'odorat sont des *sens de contact* . . . ; l'œil et l'oreille sont adaptés pour percevoir *à distance*"; "viscérales"; "notre régime mental." Lucien Bray, *Du Beau: Essai sur l'origine et l'évolution du sentiment esthétique* (Paris, 1902), 32, 50. Margaret Olin traces the antithesis of the visual and the tactile, and the greater degrees of "immediacy" and "reality" attributed to the latter, through the aesthetic theories of the nineteenth and early twentieth centuries. Margaret Olin, "Validation by Touch in Kandinsky's Early Abstract Art," *Critical Inquiry* 16 (Autumn 1989): 144–72.

59. "La brutalité barbare [de M. Vlaminck] sait condenser les traits essentiels d'un paysage; ses *Bateaux* creusent dans la Seine des remous qui s'agitent et se tordent avec une puissance surprenante de vérité." André Pératé, "Le Salon d'Automne," *Gazette des beaux-arts*, 3rd period, 38 (1 November 1907): 402.

60. "Soucieux avant tout d'exactitude matérielle, ils semblent se défier de la pensée et du sentiment." Paul Gsell, "Les Salons de 1909: L'Orientation de l'art contemporain," *La Revue* 80 (1 June 1909): 343.

61. "Il est l'intermédiaire, que Socrate appelait plus franchement l'entremetteur, des esprits . . . Assimilant et recomposant tout la série des idées et des émotions qui ont amené la création d'une œuvre, il les convertit en formules accessibles et claires dont le public pourra se nourir. De qui tient-il son mandate? De sa conviction, de sa sympathie, de son altruisme, comme le prêtre expliquant Dieu à ses frères en humanité. . . . La critique est une vocation idéologique, et un art, elle aussi, mais surtout un apostalat. . . . On sentira qu'il ne sert ni plus ni moins que l'artiste lui-même." Camille Mauclair, "La Critique d'art: Sa mission, son état actuel," *Revue bleue*, 5th series, 10 (28 November 1908): 681–82.

62. Again, Bal and Bryson: "We should . . . shift the terms of analysis from the actually docu-

mented viewers to the way [their] discourses produce their own exclusivity." Bal & Bryson, "Semiotics and Art History," 186.

63. "Des êtres, nés d'une femme comme lui, déguenillées et sales." Edouard Deiss, *Un Eté à Londres: Souvenirs d'un passant* (Paris, [1900]), 18.

64. "La terre anglaise est le pays béni des oppositions heurtées. La foule grouillant dans la ‹cité› possède, au plus haut point, ce caractère de dualité. Peu de classes de gens: les riches ou ceux qui paraissent l'être et les gueux, aux vêtements sordides.... Le spectacle est unique. Londres présente cette opposition des choses, inconnue à Paris et dans la plupart de nos villes françaises: le spectacle des plus grandes richesses et des plus grandes misères." Deiss, *Un Eté à Londres*, 17, 19.

65. "On recontre dans cette rue tous les types londoniens, depuis le petit voyou débraillé jusqu'à la grande dame en costume opulent." Dumont & Suger, *Londres et les Anglais*, 12.

66. "Je ne serais pas éloigné de croire l'Anglais doué d'un sixième sens lui permettant de ne pas voir les choses susceptibles de chagriner son esprit." Deiss, *Un Eté à Londres*, 22.

67. See, for example, Dumont & Suger, *Londres et les Anglais*, 201; Charles Huard, *Londres comme je l'ai vu* (Paris, 1908), 167, 189; and D. Pasquet, *Londres* (Melun, 1909), 5.

68. "Je vois ces immenses trains de larges bateaux, de chalands pleins jusqu'aux bords et jusqu'aux bords aussi enfoncés dans l'eau. En voici un qu'un homme seul néanmoins fait manœuvrer. Voici aussi les vapeurs qui en remorquent d'autres trop encombrés. Et cela se croise en tous sens sans se heurter. Les bateaux de plaisance se pavanent au milieu de tout cela. Bateaux particuliers, bateaux de service régulier pour Kew." Louis Bourgouin-Malchante, *John Bull et sa Capitale* (Laval, 1909), 118.

69. The word "dirigeants" is from Deiss, *Un Eté à Londres*, 18.

70. This painting has not always been considered part of the London series: under the title *Péniches sur la Seine* it has been considered a Parisian view. The stylistic compatibility of this painting with others in the London series, the type of boat depicted which is prevelant in many contemporaneous photographs of London and in none of Paris, and finally the likely reflection of Victoria Tower at the upper edge of the picture should together dispel any ambiguity about the portrayed location.

71. "Centre du commerce de luxe de Londres." Bernhardt, *Londres et la Vie à Londres*, 183. See also Dumont & Suger, *Londres et les Anglais*, 12.

72. "La Tamise avec ses docks et ses navires, c'est la première image qu'on a de Londres, et c'est la plus vraie"; "C'est bien la Tamise qui est le trait principal du paysage de Londres et de sa beauté. C'est de la Tamise et de ses ponts qu'il faut voir Londres." Joseph Aynard, *Londres, Hampton Court et Windsor* (Paris, 1912), 1, 5.

73. Bourgouin-Malchante, *John Bull et sa Capitale*, 96; Karl Baedeker, *Londres et ses environs*, 11th ed. (Leipzig, 1907), 104–10.

74. "Qu'est-ce que la carte postale illustrée? c'est l'infini kaléidoscope, où peuvent se refléter autant d'aspects qu'en présentent, qu'en présentèrent, qu'en présenteront la Nature et l'Humanité." "La Carte postale illustrée," *Le Figaro illustré*, special issue (October 1904): [unpaginated].

75. "Pour y arriver, il faut pénètrer dans des cours, saturées de gaz empoisonnés et nauséabonds qui se dégagent des tas d'ordures et des eaux croupissantes. Jamais un rayon de soleil ne pénètre dans ces cours, où jamais, non plus, n'entre une bouffée d'air frais. On monte un escalier pourri qui menace de céder à chaque pas; que dis-je? en certains endroits le mal est fait, et l'étranger qui s'aventure dans ces parages, recontre des solutions de continuité où il risque cent fois de se rompre le cou. On traverse ensuite des corridors sombres et sales où fourmille la vermine. Alors, si l'on n'a pas été repoussé par les puanteurs épouvantables que remplissent l'atmosphère, on pénètre dans ces taudis où des milliers d'êtres humains sont entassés les uns sur les autres." Bernhardt, *Londres et la Vie à Londres*, 226. Bernhardt's book is actually something of a hybrid account of London, interspersing reformist passages such as this with the less probing observations of a tourist.

76. Allow me to leave, for the moment, the relationship between Fauve painting and tourism in this state of unstable equivalence. I will return to the subject, exploring how each shaped the practices of the other, in chapter 3.

77. These conflicts are extensively examined by T. Clark, *The Painting of Modern Life*, chapter 3; R. Herbert, *Impressionism*, chapter 6; and Tucker, *Monet at Argenteuil*.

78. Discussed by T. Clark, *The Painting of Modern Life*, 201.

79. "Le canotage est beaucoup moins florissant qu'autrefois sur le fleuve." Octave Beauchamp, *L'Ile de France* (Clichy, [1910]), 133. "Site autrefois fameux et très fréquenté des peintres et des canotiers." *De Paris à Versailles, Saint-Germain, Marly* (Paris, [1912]), 32. The Baedeker guide in 1907 still described Bougival as "fréquenté par les amateurs de canotage," but this was itself a bit of a demotion: sometime between 1889 and 1900 the writers had dropped the adverb "très" from the phrase. Karl Baedeker, *Paris et ses environs*, 16th ed. (Leipzig, 1907), 387.

80. Georges Poisson, *Evocation du Grand*

Paris, 3 vols. (Paris, 1956–61), vol. 2: *La Banlieue nord-ouest* (1960), 215.

81. Ardouin-Dumazet, *Voyage en France*, 70 vols. (Paris & Nancy, 1893–1922), vol. 46: *Region parisienne V: Nord-Ouest, la Seine de Paris à la mer* (1907), 101–02.

82. Ardouin-Dumazet, *Voyage en France*, 46:99–100.

83. Georges P. Thierry, *A travers un siècle de notre yachting de course à voile* (Paris, 1948), 219. Thierry neither names the specific period the illustration is meant to portray nor provides the exact date of the club's move to Meulan.

84. While the literature on anarchism is extensive, two standard texts on the history of the movement are James Joll, *The Anarchists*, 2nd ed. (Cambridge, Mass., 1980 [1st ed. 1964]); and Jean Maitron, *Le Mouvement anarchiste en France*, 2 vols. (Paris, 1975).

85. For anarchist statements on the need for free land and on the importance of the countryside, see Jean Grave, *Réformes, Révolution* (Paris, 1910), 341; and G. Lechartier, *L'Anarchie* (Paris, [1900]), 9, 42.

86. "Propriété privée"; "Terrain appartenant à l'état"; "Peche [sic] gardée."

87. See Ardouin-Dumazet, *Voyage en France*, 46:69; Ardouin-Dumazet, *Voyage en France*, vol. 47: *Region parisienne VI: Ouest, l'Yveline et le Mantois* (1907), 286–87; Gustave Coquiot, *Dimanches d'été* (Paris, [1897]), 61; Gustave Coquiot, *En suivant la Seine*... [elipsis in the title in the original] (Paris, 1926 [text dated 1893–94]), 61–62; Poisson, *Evocation du Grand Paris*, 2:96, 130; and Marius Tranchant, *L'Habitation du Parisien en banlieue* (Paris, 1908).

88. Ardouin-Dumazet, *Voyage en France*, 47:305–06.

89. "L'art libre, tel que nous l'entendons, rendra l'artiste son propre et seul maître. Il pourra donner cours à toute son imagination, aux caprices de sa fantaisie, exécuter l'œuvre telle qu'il l'aura conçue, l'animer de son souffle, la faire vivre de son enthousiasme.... Ainsi que l'a dit un détraqué qui, en cela, pensait juste: *L'art, cette suprême manifestation de l'individualisme*, contribuera à la jouissance et à l'extension de l'individu." Jean Grave, *La Société future*, 8th ed. (Paris, 1903 [1st ed. 1895]), 367–68. The assignation of these two differing political roles to art—documenting current conditions and exemplifying advanced consciousness—has been well rehersed throughout the twentieth century, most famously in the debate between Georg Lukács and Theodor Adorno. It would be a mistake to reduce anarchist artistic policy at the turn of the century to either the either position since, in essence, the anarchists wished to activate both strategies for their cause. For a more complete discussion of anarchism and art, see Robert L. [Herbert] & Eugenia W. Herbert,

"Artists and Anarchism: Unpublished Letters of Pissarro, Signac and Others," parts 1, 2, *The Burlington Magazine* 102 (November, December 1960): 473–82, 517–22; and Eugenia W. Herbert, *The Artist and Social Reform: France and Belgium, 1885–1898* (New Haven, 1961).

90. Maurice de Wlaminck [sic], "L'Entente," *Le Libertaire*, 16–23 December 1900; and Maurice de Wlaminck [sic], "Le Chemin," *Le Libertaire*, 13–20 July 1901.

91. "Mon ardeur me permettait toutes les audaces, toute les impudeurs pour négliger les conventions du métier de peintre. Je voulais faire naître une révolution dans les mœurs, dans la vie courante, montrer la nature en liberté, la libérer des anciennes théories du classicisme dont je détestais l'autorité autant que celle du général ou du colonel. Je n'avais ni jalousie ni haine, mais une rage de recréer un monde nouveau, le monde que mes yeux voyaient, un monde pour moi seul." Vlaminck, *Tournant dangereux*, 93–94.

92. See, for example, Ellen C. Oppler, *Fauvism Reexamined* (New York, 1976), 192. Marcel Giry voices the same argument (appropriating Oppler's words and phrasing without citation), in *Fauvism: Origins and Development*, trans. Helga Harrison (New York, 1982 [French ed. 1981]), 13–14.

93. I will discuss Signac's efforts to fulfill the second part of the anarchist program through his pointillist technique and his utopian vision in chapter 4, section 5.

94. "Et je n'avais d'autre exigence que de découvrir à l'aide de moyens neufs les attaches profondes qui me reliaient à la terre même." Vlaminck, *Tourant dangereux*, 94.

95. "Cette liberté idéale, c'est précisément ce que la bourgeoisie demande à l'artiste—mais à l'artiste seul—de représenter. Il s'en faut d'ailleurs que cette superposition de la pratique libertaire de l'art en tant qu'épanouissement parfaite *de tout individu*, et la conception libérale de l'art comme activité symbolique *réservée à certains individus* ait abusé tous les anarchistes." Michel Melot, "La Pratique d'un artiste: Pissarro graveur en 1880," *Histoire et Critique des arts* 2 (June 1977): 25. Melot here insists that not all anarchist critics were deceived by this superimposition in 1880; I use his analysis to stress instead that the concept of artistic individuality could serve more than one political cause.

96. "Août, les blés sont mûrs....Je m'arrête. Une équipe de faucheurs met en gerbes. Le soleil tape dur, les gens sont en sueur. Les femmes ont la tête recouverte de madras et les hommes ont les manches de leur chemise retroussées jusqu'aux épaules. Je suis mal à l'aise. Les faucheurs, comme je m'arrête, me font un: ‹Bonjour, monsieur›, respectueux. Vis-à-vis d'eux, j'ai honte de moi-même. Ma boîte, ma toile

à la main, ils ont du respect pour le monsieur que je représente. Je suis honteux de ne pas travailler, de ne pas faire pousser le blé que je mange. . . . Je tâche de m'excuser, de trouver des raisons valables. Je ne peux opposer que des mensonges hypocrites. Le fait est là; l'art, la peinture me semblent être des trucs . . . Je suis devant eux un malhonnête homme . . . Ce n'est pas la première fois . . ." Vlaminck, *Tournant dangereux*, 223–24, final three ellipses in the original.

97. "Un sentier dans la forêt, la route, le bord d'une rivière, un reflet de maison dans l'eau, un profil de bateau, un ciel avec des nuages noirs, un ciel avec des nuages roses. On a beau disposer d'une palette riche, on ne peut toucher profondément les choses en regardant un paysage par la portière d'une automobile, en touriste, ou en passant ses vacances dans un coin de campagne. On ne flirte pas avec la nature, on la possède." Vlaminck, *Tournant dangereux*, 227.

98. In subsequent chapters I will examine further the connections between women and landscape posited by texts and images, including Fauve paintings, during the first decade of the twentieth century. For more on the sexual euphemism of possession, see the introduction to chapter 2.

NOTES TO CHAPTER 2

1. "On ne flirte pas avec la nature, on la possède." [Maurice] Vlaminck, *Tournant dangereux: Souvenirs de ma vie* (Paris, 1929), 227. I have discussed this passage in chapter 1, section 5.

2. Of course, the trope itself can be turned on its head: "possession," as a metaphor (itself a cliché) for copulation, figured sexual congress as proprietorship. The circularity, far from disabling the cultural logic, strengthened it: gender relations and property relations reinforced each other through mutual affirmation.

3. Carol Duncan, in the only feminist discussion of *Carmelina* that I have discovered, remarks on such a confrontation: "a powerfully built model coolly stares [Matisse] down." Duncan concludes that Matisse "transpose[s] the sexual conflict onto the 'higher' plane of art." Carol Duncan, "Virility and Domination in Early 20th-Century Vanguard Painting," *Artforum* 12 (December 1973): 33.

4. Jane Gallop, *Reading Lacan* (Ithaca, 1985), 38.

5. Many feminists have persuasively argued, on differing grounds, that Lacan's mirror stage offers little hope in the formation of female subjectivity. Luce Irigaray contends that the mirror stage, an anticipation of the later Oedipal crisis, produces a self based on alienation from the Other and thus a subjectivity already male; she advocates a form of female identity based on nearness and touch rather

than distance and sight. Luce Irigaray, *This Sex Which Is Not One*, trans. Catherine Porter (Ithaca, 1985 [French ed. 1977]). Mary Ann Doane, in contrast, indicts the lack of distance between self and image implied by the mirror stage and suggests that women are better served by strategies of distantiation that allow their entry into the Symbolic. Mary Ann Doane, "Film and the Masquerade: Theorising the Female Spectator," *Screen* 23 (September-October 1982): 74–88; Mary Ann Doane, *The Desire to Desire* (Bloomington, 1987); and Mary Ann Doane, "Masquerade Reconsidered: Further Thoughts on the Female Spectator," *Discourse* 11 (Fall–Winter 1988–89): 43–54. Such arguments would seriously undercut my analysis of *Carmelina* were I maintaing that the painting, in the end, produces a viable female subjectivity; but I am not. Rather, as will become evident very shortly, I contend *Carmelina* sets up the straw figure of female subjectivity only to knock it down.

6. Consider, for example, the resistance encountered by Dr. Adolphe Monteuuis (whom we will encounter again in chapter 3, section 2) when he tried to encourage French women, for the sake of their health, to sunbathe nude: "La délicatesse de la française, son goût raffiné et fatalement artificiel du beau font que, faute d'habitude, elle éprouve à prendre un bain d'air une répulsion qui n'existe pas chez l'étranger." Dr [Adolphe] Monteuuis, *L'Usage chez soi des bains d'air, de lumière et de soleil: Leur Valeur pratique dans le traitement des maladies et dans l'hygiène journalière* (Nice, Paris & Brussels, 1911), 58.

7. Jack Flam claims that this painting is "antithetical to narrative." Jack Flam, *Matisse: The Man and His Art* (Ithaca, 1986), 24. For an analysis of Flam's argument on this point, and more generally of his book, see James D. Herbert, "Matisse Without History" (review article), *Art History* 11 (June 1988): 297–302.

8. Laura Mulvey, in her path-breaking article "Visual Pleasure and Narrative Cinema," writes: "[Active scopophila] implies a separation of the erotic identity of the subject from the object of the screen." Laura Mulvey, "Visual Pleasure and Narrative Cinema," *Screen* 16 (Autumn 1975): 10.

9. "Ne nous semble-t-elle pas en définitive comme le hochet de notre vanité, de notre représentation, de notre égoïsme et de notre libertinage?" Octave Uzanne, *Nos Contemporaines: La Femme à Paris, notes sucessives sur les Parisiennes de ce temps dans leurs divers milieux, états et conditions* (Paris, 1894), 12.

10. Mulvey, "Visual Pleasure and Narrative Cinema," 12. Mulvey, I should note, utilizes the concept of the mirror stage in a different manner than I do, using it to underwrite the identification of the viewer with the male screen hero.

11. As Harold Bloom would phrase it, Matisse "wrestle[s] with [his] strong predecessor[]."

Harold Bloom, *The Anxiety of Influence: A Theory of Poetry* (New York, 1973), 5. Undoubtedly for Bloom, this Oedipal drama is the only story worth telling about art. See chapter 1, note 2.

12. Teresa de Lauretis, *Alice Doesn't: Feminism, Semiotics, Cinema* (Bloomington, 1984), 121.

13. de Lauretis, *Alice Doesn't*, 121.

14. Doane writes about classic Hollywood cinema: "The female spectator has basically two modes of entry: a narcissistic identification with the female figure as spectacle and a 'transvestite' identification with the active male hero in his mastery." Doane, *The Desire to Desire*, 19. See also Laura Mulvey, "Afterthoughts on 'Visual Pleasure and Narrative Cinema' Inspired by *Duel in the Sun*," *Framework*, nos. 15, 16, 17 (1981): 12–15.

15. "The male subject 'proves' his symbolic potency through the repeated demonstration of the female subject's symbolic impotence," writes Kaja Silverman; displacements such as this "have as their final goal the articulation of a coherent male subject." Kaja Silverman, *The Acoustic Mirror: The Female Voice in Psychoanalysis and Cinema* (Bloomington, 1988), 24, 10. See also E. Deidre Pribram, "Introduction," in *Female Spectators: Looking at Film and Television*, ed. E. Deidre Pribram (London, 1988), 3: "[Through] the concept of sexual difference, which describes a binary structure of subject/object, . . . object function produces subject validation."

16. "Permet à l'artiste d'affirmer sa personnalité. Chaque peintre peut ainsi accuser son originalité, sa compréhension particulière d'un modèle et, par les moyens qui lui sont propres, traduire l'émotion artistique qu'il en a ressentie. . . . Chaque artiste imprime à son œuvre un signe distinctif, par lequel se marque le génie qu'il a de voir et de peindre les êtres et les choses." Auguste Germain, *Le Nu au Salon: Année 1908* (Paris, 1908), 16.

17. The coherence of the male spectatorial position fabricated by *Carmelina* should never be confused with the coherence of its actual male viewers. Those viewers are, like their female counterparts, undoubtedly torn by competing demands placed on them by innumerable contradictory cultural artifacts. In reading this picture in the 1990s, for example, my subjective position is necessarily rendered inconsistent in gendered terms by my unavoidable socialization as male and the very real and legitimate political imperative today for all analysts of culture, male as well as female, to consider issues of female spectatorship. For me to speculate on female spectatorship is no less of a "'transvestite' indentification" than is Doane's female viewer's alignment with the male hero in Hollywood cinema; the sheer abundance of my references to female feminist theorists in this chapter should testify to my desire to "dress up" my own gendered position while simultaneously ceding authority, symbolically, to members of the opposite sex. Ultimately, I would argue, rifts in this or other forms fracture the consistency of all male viewers. Thus *Carmelina*, rather than reflecting actual male coherence, produces it as an ideological resource, which historical actors—for the most part men—marshal in a variety of gender-political initiatives.

18. The towel draped across the model's pubic region violates the principle of visual accessibility, but it may be the exception that proves the rule. To uncover the pubic triangle would only expose to sight an anatomy that hides from sight as much as reveals. Countless painters and photographers of the day addressed this difficultly by painting a smooth surface across hairless pudenda, paradoxically obfuscating the female sex so as it make it appear completely visible. For discussions of this pictorial tactic, see T. J. Clark, *The Painting of Modern Life: Paris in the Art of Manet and His Followers* (New York, 1984), 135; and Peter Brooks, "Storied Bodies, or Nana at Last Unveil'd," *Critical Inquiry* 16 (Autumn 1989): 19–22.

19. "L'effigie d'un homme, en effet, est toujours *sociale* . . . Mais on peint une femme pour elle-même. . . . Il y a . . . dans la 'représentation d'une femme quelque chose de passif, un élément stable. Le portrait d'homme semble venir au spectateur, lui imposer une volonté: le portrait d'une femme attend qu'on vienne à elle. C'est une forme impersonnelle, le but d'un désir, un motif de lignes, de tonalités, de décors. . . . L'artiste n'y a pas poursuivi la recherche d'une pensée, mais celle des secrets de la forme." Camille Mauclair, *Trois Crises de l'art actuel* (Paris, 1906), 200–01.

20. T. Clark, *The Painting of Modern Life*, 79.

21. T. Clark, *The Painting of Modern Life*, 109.

22. T. Clark, *The Painting of Modern Life*, 79–80. Clark extends his analysis to suggest that this position of subject becomes as unviable as that of the object: "Like any other picture, *Olympia* provided various places from which the viewer might appropriate its main fiction, but those placed ended up by being precisely too various; I shall argue that they were contradictory and largely uninhabitable" (80). If anything, Clark suggests, the painting turns the tables by attributing subjectivity to the implied social being, Olympia: "[Olympia's look] appears to be blatant and particular, but it is also unreadable, perhaps deliberately so. It is candid but guarded, posed between address and resistance—so precisely, so deliberately, that it comes to be read as a production of the depicted person herself; there is an inevitable conflation of the qualities of precision and contrivance in the way the image is painted and those qualities as belonging to the fictive subject; it

is *her* look, her action up us, her compostion of herself" (133).

23. Ultimately, Clark does not see this confoundation of established gender relations as disruptive to the "social order" since "this very negation is pictured as something produced in the social order, happening as part of an ordinary exchange of goods and services." T. Clark, *The Painting of Modern Life*, 80.

24. "Sous ce nom, les ateliers possèdent deux types, le modèle professionnel qui nous vient généralemment de l'Italie, fit escale à la place Pigalle et attend du hasard l'engagement et le pain quotidiens.... Il y a enfin les modèles choisis par le cœur, et ce ne sont pas toujours les moins parfaits." Victor Nadal, *Le Nu au Salon*, 2 vols. (Paris, 1905), vol. 1, [unpaginated].

25. Consider, for example, Weilug's cartoon *Bourgeois Behavior* (fig. 33), which I discuss later in this chapter. Rosemary Betterton generalizes about Bohemian Paris in the late-nineteenth and early twentieth centuries: "In the artist-model relationship there seems to be a 'natural' elision of the sexual with the artistic: the male artist was both lover and creator, the female model both his mistress and his muse." Rosemary Betterton, "How Do Women Look?: The Female Nude in the Work of Suzanne Valadon," in *Looking On: Images of Femininity in the Visual Arts and Media*, ed. Rosemary Betterton (London, 1987), 224.

26. "Diable! . . . diable! . . . un monsieur très bien, trop bien. J'aimerais mieux, je préférerais tout à fait que ce fût un pauvre hère, un modèle de métier, un individu quelconque: gens que l'on paie, dont on dispose sans gêne réciproque ni surtout conséquences avouées." Jules Laurens, *La Légende des ateliers: Fragments et notes d'un artiste peintre (de 1818 à 1900)* (Carpentras, 1901), 407–08, ellipses in the original.

27. "Rien de plus naturel et de plus gracieux que cette svelte adolescente qui, en attendant l'artiste qui doit l'immortaliser, regarde son miroir pour s'assurer qu'elle est bien de charmer qui lui conviendra ou de figurer au prochain Salon. Sous l'égide de Morisset, elle y figure avec éclat, car le petit modèle s'est transformé en petit chef-d'œuvre." Nadal, *Le Nu au Salon*, vol. 1, [unpaginated].

28. [Immanuel Kant], *Kant's Critique of Judgement*, 2nd ed., rev., trans. J. H. Bernard (London, 1931 [German ed. 1790]), 55. I will make greater use of this and other Kantian concepts in chapter 3, sections 3 and 4.

29. The most famous formulation of this pair of terms is by Kenneth Clark: "To be naked is to be deprived of our clothes, and the word implies some of the embarrassment most of us feel in that condition. The word 'nude,' on the other hand, carries, in educated usage, no uncomfortable overtone. The vague image it projects into the mind is

not of a huddled and defenseless body, but of a balanced, prosperous and confident body: the body re-formed." Kenneth Clark, *The Nude: A Study in Ideal Form* (Princeton, 1956), 3. Clark does not explore the political meaning of this reformation of the body by art.

30. "Quel homme a jamais senti s'éveiller en lui des idées obscènes à la vue des statues antiques, si vraies et si humaines pourtant? C'est que dans ces représentations, suprêmes efforts de l'art, la réalité est sanctifiée et, pour ainsi dire, consacrée par la beauté." C. Klary, *La Photographie du nu* (Paris, 1902), 42.

31. "Il se passa alors une chose incroyable. Nos modèles qui tout à l'heure causaient et riaient impudiques devinrent muets, soudain. Un sentiment de grandeur et d'inconnu les troubla tout à coup et, de femmes qu'elles étaient en arrivant devinrent des nymphes, nous ne reconnaissions plus nos aimables faubouriennes, à nos yeux elles s'étaient magnifiées! Singulière métamorphose que celle-là et quelle parfaite leçon de la Nature s'imposant à ses créatures et leur dictant une pudeur en dehors de celle des humains!" Emile Bayard, *Le Nu esthétique*, 5 vols. (Paris, 1902–07), vol. 4 (1905–06), 46.

32. "Une différence entre l'instinct vulgaire et l'entière pureté de la contemplation esthétique." Edouard Daelen, *Le Moralité du nu* (Paris, [1905]), 2–7.

33. "Pour le représenter, il faut non seulement une maîtrise complète; mais un caractère exempt de toute bassesse, un caractère sans tache et noble. D'un mot, la condition essentielle de la morale artistique de nu, c'est ‹la vision élevée›." Daelen, *Le Moralité du nu*, 88.

34. Klary, *La Photographie du nu*, 7; Daelen, *Le Moralité du nu*; Bruno Meyer, *La Grâce féminine* (Paris, 1904–05). Although published in Paris, Meyer's book (and perhaps Daelen's) appeared originally in Germany and only subsequently was translated into French. The Germanic origins of the author, however, make the text no less relevant to a study of attitudes in France. Someone decided that there was a French market for such a publication, and French readers presumably purchased and read the book.

35. "Le beau s'impose à tout œil artiste en dehors de toute notion de morale ou de pudeur par l'heureux accord des lignes, du milieu et des valeurs, et plus cet harmonieux ensemble se rapproche de l'idéale perfection, plus disparaît toute idée d'animalité sensuelle." Paul Bergon & René Le Bégue, *Le Nu et le Drapé en plein air* (Paris, [1898]), 11.

36. "Considérées uniquement au point de vue formel en tant que formes." Meyer, *La Grâce féminine*, 66.

37. His *Origin of the World* of 1866 (Paris: private collection), which depicts nothing much

more than a woman's unveiled pudendum, stands as the most notorious case. To this day Courbet's painting stretches to the limit the capacity of the aesthetic to encompass the nude. During Linda Nochlin's presentation entitled "Courbet's *L'Origine du monde*: The Origin without an Orignal" at the annual meeting of the College Art Association in New York in 1985, the peals of laughter that swept the audience can only partially be attributed to Nochlin's witty text. Many of the attending art historians, trained to view images "aesthetically," felt some discomfort as they struggled to regard the painting with professional detachment. Nochlin's presentation has been published as Linda Nochlin, "Courbet's *L'Origine du monde*: The Origin without an Orignal," *October* 37 (Summer 1986): 77–86.

38. Michael Fried, "Representing Representation: On the Central Group in Courbet's *Studio*," *Art in America* 69 (September 1981): 170–71. Fried uses these observations to address questions about the painting much different than the ones I pose.

39. I believe the female figure in *The Painter's Studio* lays out the trajectory taken by the rest of the canvas and, roughly, by Courbet's career: having forsaken the extreme and problematic realism of *The Burial at Ornans* of 1849–50 (Paris: Musée d'Orsay), Courbet by 1855 was seeking the allegorical in the actual.

40. Robert L. Herbert suggested to me the similarities between Seurat's *Models* and the Zeuxis myth.

41. "Un corps de femme... domine la scène qu'elle réchauffe comme un rayon de soleil. Mais autour d'elle, et comme pour rendre hommage á ses victorieux attraits, trois artistes brodent un thème musical qui l'absorbe.... Une femme sert le thé á ces amateurs de musique de chambre et au fervent de fine peinture qui n'écoute que les accords d'un sublime pinceau." Nadal, *Le Nu au Salon*, vol. 1, [unpaginated].

42. "Le confrère dont l'artiste nous reproduit l'élégant atelier ne s'occupe pas des charmes étalés si prés de lui. Tout entier á son œuvre, il se demande si sa main a bien rendu sa pensée. Que lui importent le corps radieux, le buste divin, les jambes superbes de son modèle. Il veut avoir un succès au Salon, et l'ambition l'emporte sur le plaisir." Nadal, *Le Nu au Salon*, vol. 2, [unpaginated].

43. "—Et à part ça, t'es peintre?" *L'Assiette au buerre*, 8 May 1909, 947.

44. "Truc bourgeois."

45. "Se rappeler qu'un tableau—avant d'être un cheval de bataille, une femme nue, ou une quelconque anecdote—est essentiellement une surface plane recouverte de couleurs en un certain ordre assemblées." Maurice Denis, *Art et Critique*, 23 and 30 August 1890; reprinted in Maurice Denis, *Théories 1890–1910: Du symbolisme et de Gauguin vers un nouvel ordre classique*, 2th ed. (Paris, 1912 [1st ed. 1912]), 1.

46. I am here, of course, reversing Meyer Schapiro's famous interpretation of Cézanne's apples as metaphoric representations of human breasts. Meyer Schapiro, "The Apples of Cézanne: An Essay on the Meaning of Still-Life" (1968), in *Modern Art, 19th & 20th Centuries: Selected Papers* (New York, 1978).

47. "Son *faire* franc et large, ses appositions de noir et de blanc... un réalisme que fort heureusement elle n'a pas. *L'Olympia* est avant tout une œuvre de maître peintre, les parties en sont nourries de pâte à longues séances, et comme caressées avec amour.... Manet, de par son vouloir, faisait abstraction du modelé pour ne garder qu'une large opposition de clairs et de foncés successivement colorés." "*L'Olympia* de Manet au Louvre," *La Rénovation esthétique* 5 (May 1907): 56.

48. T. Clark suggests that the genre of the nude was in crisis in the 1860s since sex "kept appearing directly in the flesh, unintended, as something which spoilt what was meant to be a pure formality." *Olympia*, he argues "insist[ed] on that embarrassment and g[a]ve it visual form." T. Clark, *The Painting of Modern Life*, 130, 131. While I might dispute the gravity of the genre's condition in Manet's day, my argument here is that in the long run *Olympia* and its Impressionist and Post-Impressionist progeny surmounted whatever crisis of the nude existed in the 1860s by leading to the development of extremely powerful mechanisms for formalist dissimulation. By 1900 the genre of the nude was not "disintegrating" (128); it had been given new life, and would go on to become perhaps the dominant pictorial theme of European painting in the twentieth century.

49. Questions about the authorship of this painting have been raised by John Elderfield and other scholars and commentators; the Musée National d'Art Moderne, which owns the canvas, has listed the work ambiguously as "attribué à Matisse." John Elderfield, *The "Wild Beasts": Fauvism and Its Affinities* (New York, 1976), 151n*70*. I will spare the reader a detailed presentation and refutation of the various arguments involved and simply state that I see little reason to doubt Matisse's authorship. In any case, the analysis that follows does not depend on Matisse having painted this canvas; the name of the artist who produced the work does not change the manner in which the painting operates.

50. I discuss this and the following passage in chapter 1, section 2.

51. "C'est de la connaissance des lois de son art que le photographe artiste obtient les combinaisons de clair obscur, les contrastes des formes ou des mouvements, et tous les autres moyens

d'expression. Mais toute son habileté disparaîtra, si au moment de l'exécution il ne parvient pas à réveiller dans ses modèles le sentiment de la situation et du sujet, en vue desquels il s'est livré à tant de calculs. . . . Si l'artiste n'est pas maître absolu de son modèle, s'il ne le possède pas, c'est qu'il manque de la théorie ou de la pratique de son art. C'est à lui à suggérer au moment voulu les idées que doivent lui donner l'expression qu'il a observée et choisie." Klary, *La Photographie du nu*, 43.

52. "Le schéma d'une théorie." Maurice Denis, "La Peinture," *L'Ermitage* 16.1 (15 May 1905): 319; reprinted as "La Réaction nationaliste," in Denis, *Théories*, 190. I explore the relation between *Luxe, calme et volupté* and Neo-Impressionism further in chapter 3, section 1 and chapter 4, section 5.

53. Carol M. Armstrong argues that the nude "as the master genre of the offical French salons of the nineteenth century" matched touch to sight and "metaphorize[d] tactile response through facture and formal rhymings." She champions Degas's nudes since "they problematize . . . [the] apprehension [of the female nude] through form and facture" and place "vision and touch . . . at odds." Carol M. Armstrong, "Edgar Degas and the Representation of the Female Body," in *The Female Body in Western Culture: Contemporary Perspectives*, ed. Susan Rubin Suleiman (Cambridge, Mass., 1986), 223, 225, 235. I am contending here that Matisse's *Nude in the Studio*, far from being "deconstructive" (241) in the manner Armstrong attributes to Degas's pictures, reauthorizes the tactile metaphor between the female body and the painted surface.

54. For my earlier and more complete account of the neo-naturalist reading of Fauve painting, see chapter 1, section 3.

55. Kaja Silverman, *The Subject of Semiotics* (New York & Oxford, 1983), chapter 5. While other writers earlier adapted the psychoanalytic term for use in film theory, I cite Silverman on suture since she applies the concept directly to the relation between the male subject and female object.

56. This contrasts with the cinema, where the suture occludes the "process" of making a film—that is, the camera and other devices that constitute the cinematic apparatus—from view. Silverman writes: "The level of enunciation remains veiled from the viewing subject's scrutiny, which is entirely absorbed within the level of the fiction; . . . the gaze which directs our looks seems to belong to a fictional character rather than to the camera." Silverman, *The Subject of Semiotics*, 202. While the "Matisse" implied by *Carmelina* may be no less fictional than the hero of the film, to him is ascribed the means of producing the image denied his filmic counterpart.

57. Louis Althusser, *For Marx*, trans. Ben

Brewster (New York, 1969 [French ed. 1965]), 144; cited in Silverman, *The Subject of Semiotics*, 217.

NOTES TO CHAPTER 3

1. Even viewers not privy to the actual identity of the sitters would probably have assumed the pair to be the family of the artist. To paint members of one's family within a natural setting was standard artistic practice by the turn of the century—Claude Monet, to name just one well-known predecessor, had been doing it for years. Viewers, familiar with such earlier pictures, would almost certainly have taken the touring woman and child lounging along the shore in *By the Sea* to be related to Matisse.

2. "Les villageois, les paysans, ceux qui ne viennent pas aux champs en villégiature, mais qui y vivent leur vie, travaillent le sol, font en quelque sorte partie de la nature." Fr[édéric] Paulhan, *L'Esthétique du paysage* (Paris, 1913), 8. See also Michel Epuy, *Le Sentiment de la nature* (Paris, 1907), 99: "Nous parlons des campagnards, laboureurs, paysans . . . ceux-là mêmes qui vivent dans la Nature, qui ont le privilège non pareil d'être ses plus proches voisins, de la connaître tout au moins par ses aspects généraux, de l'ensemencer, d'en recueillir les fruits bénis."

3. The Neo-Impressionists' application of Rood's theories to painting has been widely discussed in the literature on the movement. For a particularly precise and succinct synopsis of the issue, see Alan Lee, "Seurat and Science," *Art History* 10 (June 1987): 203–23.

4. I will return to *Luxe, calme et volupté*, examining closely its treatment of nudes within the southern landscape, in chapter 4.

5. In reproductions of the painting this procedure seems most pronounced around the rigging of the sailboat, but the photographic image is deceptive. This passage has actually been significantly reworked, probably painted once, covered over in white, then painted again. The presence of such extensively altered areas, however, reveals more than would their complete absence, for they indicate Matisse's desire to obtain the effect of simplicity even when he failed to paint in a simple manner on the first go at the canvas.

6. See chapter 1, section 2.

7. For my earlier and more complete account of the neo-naturalist reading of Fauve painting, see chapter 1, section 3.

8. "Si le sauvage, si le paysan préfèrent les couleurs vives, c'est que leur optique ne s'affine pas suffisamment. Dans un bal villageois les toilettes vertes, rouges, les chapeaux cruellement bleus, les cols de guipure blanche abondent." Paul Adam, *La Morale des sports* (Paris, 1907), 273–74. See also C. R. C. Herckenrath, *Problèmes*

d'esthétique et de morale (Paris, 1898), 3–4: "Pour ce qui concerne le sens de la vue, on observe qu'au début le goût des couleurs voyantes est surtout prononcé.... Le goût du peuple ressemble à celui des enfants.... Le goût des tons discrets et des demi-teintes, c'est-à-dire des couleurs très composées, ne veint que plus tard."

9. See chapter 1, section 1.

10. "Le golfe est une merveille de grâce par ses contours arrondis, les collines boisées de pins-parasols, les hauts fûts des palmiers,... le vieux et pittoresque quartier des pêcheurs." Ardouin-Dumazet, *Voyage en France*, 70 vols. (Paris & Nancy, 1893–1922), vol. 13: *La Provence maritime* (1898), 264.

11. "Dans un pli de la côte, à l'issue d'un vallon, pittoresquement éparpillée entre les forts, les jardins et les criques,... voici le gentille cité de Collioure. L'apparition est charmante." Ardouin-Dumazet, *Voyage en France*, vol. 37: *Le Golfe de Lion* (1904), 288.

12. "La société"; "une simplicité adorable"; "à chacun... de rechercher tels endroits paisibles bien ensoleillés où il pourra goûter à son aise aux mille trésors de la nature, au milieu d'un mélange infini de plaisirs sans cesse renouvelés et bien fait pour récréer." Georges Fontaines, *La Côte d'Azur en l'an 1897: Nice, Cannes, Monaco, Menton, Monte-Carlo* (Lyon, 1897), 43.

13. "On se refait ainsi, pour quelque temps, une mentalité primitive, qui, par contraste, nous montre que les besoins créés par la civilisation raffinée sont, somme toute, artificiels et relatifs; on apprend à mieux apprécier des choses qui nous semblent toutes naturelles et auxquelles nous n'avons jamais pris la peine de réfléchir." Albert Dauzat, *Pour qu'on voyage: Essai sur l'art de bien voyager* (Toulouse & Paris, 1911), 121.

14. "Pour connaître le pays et les habitants, il faut prendre contact avec l'indigène et pénétrer le plus possible dans les milieux locaux." Dauzat, *Pour qu'on voyage*, 330.

15. "On ne connaît pas le Midi ou plutôt on le connaît mal. Les snobs—qui sont légion—y vont l'hiver et s'y enrhument.... [L'été,] ils vont s'enrhumer sur les plages de la Manche ou de la mer du Nord. Moi, je déteste m'enrhumer... et je vais dans le Midi quand les cosmopolites en sont partis et qu'il n'y reste que les gens du cru, les Méridionaux." Henri Boland, *En douce France* (Paris, 1910), 196.

16. "Pêcheurs bronzés et grillés. — C'est le bon hâle du vent, du soleil, du grand air salé qui rend les matelots si forts, et donne à leur teint ces tons chauds et ardents." Victor Dujardin, *Voyages aux Pyrénées: Souvenirs du Midi par un homme du Nord; Le Roussillon* (Céret, 1890), 51.

17. "L'action régénératrice du soleil est si profonde qu'elle produit (le mot n'est pas exagéré) de véritables résurrections... Les bains d'air, de

lumière et de soleil ont sur la santé et la vigueur de l'in ividu comme de la race, une influence considérable... Elles sont une condition de l'énergie vitale." Dr [Adolphe] Monteuuis, *L'Usage chez soi des bains d'air, de lumière et de soleil: Leur Valeur pratique dans le traitement des maladies et dans l'hygiène journalière* (Nice, Paris & Brussels, 1911), 42, 47.

18. "En pataugeant dans l'eau, il me vient une idée diabolique, si je prenais un bain?... Le soleil ardent qui me brûle la figure finit par me décider... La première impression est assez désagréable, mais je finis par m'y habituer et bientôt à la sensation de fraîcheur succède un bien être extaordinaire." Mme Léonide Votez, *2400 Kilometres à travers la France* (Paris & Laval, 1907), 190–92.

19. For discussions of this movement, see Richard Holt, *Sport and Society in Modern France* (Hamden, Conn., 1981); Eugen Weber, "Gymnastics and Sports of *Fin-de-Siècle* France: Opium of the Classes?," *American Historical Review* 76 (February 1971): 70–98; and Eugen Weber, "Pierre de Coubertin and the Introduction of Organized Sport in France," *Journal of Contemporary History* 5, no. 2 (1970): 3–26.

20. "Le tourisme... est devenu véritablement une école nationale d'initiative, d'activité, de sang-froid, de bonne volonté, d'ardeur virile, de noble et saine ambition. Il contribue à développer vers le beau et le bien le noble animal humain." E. de Morsier, "Une Conquête moderne: Le Tourisme," *La Revue* 56 (15 May 1905): 219.

21. "Tourisme"; "Du goût des voyages"; "L'Air et le Soleil."

22. "L'art actual... s'attarde toujours aux formes maniérées d'antan; ‹le sens naturel de l'harmonie› que possèdent en effet les sportsmen s'effare des fantaisies inesthétiques de l'art nouveau.... L'art que nous aimerons n'existe pas encore, en effect. Il serait d'un concept très sobre, de ligne harmonieuse avec simplicité; il magnifierait la beauté humaine, la splendeur du nu, l'impérissable joie des chairs saines; il exalterait le bonheur de vivre, la sérénité des forts, la noblesse des plaisirs naturels." Albert Surier, quoted in Georges Casella, *Le Sport et l'Avenir* (Paris, 1910), 331–32.

23. I will discuss this painting in much greater depth in chapter 4.

24. "Fruste et sauvage." Boland, *En douce France*, 209. "effarouch[ants] et virulent[s]." Louis Vauxcelles, "Salon d'Automne," *Gil Blas*, 17 October 1905. I discuss Vauxcelles's phrase in chapter 1, section 1.

25. "C'est Paris transporté pendant deux ou trois mois aux bords de l'océan avec ses qualités, ses ridicules et ses vices." Adolphe Joanne (Guide Diamant), *Normandie* (Paris, 1873), 166. For a more complete description of Trouville and of

Monet's sojourn there in 1870, see Robert L. Herbert, *Impressionism: Art, Leisure, and Parisian Society* (New Haven & London, 1988), 293–99.

26. "C'est le boulevard d'été de Paris." Karl Baedeker, *Le Nord-Ouest de la France*, 8th ed. (Leipzig, 1908), 218.

27. "Fauve[] à la suite." Louis Vauxcelles, "Le Salon des 'Indépendants,'" *Gil Blas*, 20 March 1907.

28. "L'habitude des villégiatures et des voyages, admise seulement dans l'aristocratie opulente il y a un demi-siècle, est maintenant chère à la petite bourgeoisie." Jacques Lux, "Chronique: Plages de France," *Revue bleue*, 5th series, 8 (7 September 1907): 319. See also A[lbert] Dauzat, *Le Sentiment de la nature et son expression artistique* (Paris, 1914), 261: "Aujourd'hui les voyages se démocratisent de plus en plus, grâce à la modicité des prix, à la commodité et à la rapidité des moyens de transport."

29. "Trouville réunit les publics les plus divers, depuis la haute et riche société . . . jusqu'à la clientèle populaire." Paul Gruyer (Guide Joanne), *Bains de mer de Normandie du Tréport au Mont Saint-Michel: Guide pratique des stations balnéaires* (Paris, 1913), 139.

30. For an extended discussion of the sublime in relation to Monet, see Steven Z. Levine, "Seascapes of the Sublime: Vernet, Monet, and the Oceanic Feeling," *New Literary History* 16 (Winter 1985): 377–400.

31. Edmund Burke, *A Philosophical Enquiry into the Origin of Our Ideas of the Sublime and Beautiful*, ed. J. T. Boulton (London, 1958), 57, 51. Other passages leave open the possibility that Burke also positioned the sublime in the mind of the perceiver. For example: "Whatever is fitted in any sort to excite the ideas of pain, and danger, that is to say, whatever is in any sort terrible, or is conversant about terrible objects, or operates in a manner analogous to terror, is a source of the *sublime*; that is, it is productive of the strongest emotion which the mind is capable of feeling" (39). A comment by Burke on the beautiful may clarify the location of the sublime in Burke's aesthetics: "Whatever produces pleasure, positive and original pleasure, is fit to have beauty engrafted on it" (131). Although beauty, and by extension the sublime, may not exist without humans to perceive it, once that perception occurs these properties becomes "engrafted" onto external nature.

32. "Le sublime est la manifestation d'une puissance qui nous surpasse, l'expression de l'activité infinie . . . L'homme peut nous traduire par la littérature ou par la peinture, par la musique aidée de la poésie, les spectacles dans lesquels nous voyons le sublime." L'abbé Gaborit, *Le Beau dans la nature*, 3rd ed. (Nantes, 1893 [1st ed. 1871]), 125–26.

33. See chapter 1, section 1.

34. [Immanuel Kant], *Kant's Critique of Judgement*, 2nd ed., rev., trans. J. H. Bernard (London, 1931 [German ed. 1790]), 103, 117 ["[subject]" bracketed in the translation].

35. *Kant's Critique of Judgement*, 125.

36. Terry Eagleton, "The Ideology of the Aesthetic," *The Times Literary Supplement*, 22–28 January 1988.

37. A rare exception in which fortifications on a hill actually appear is Derain's *Fishing Boats, Collioure* of 1905 (New York: Metropolitan Museum of Art). Yet even here the mundane activities of fishermen along the beach fill most of the canvas, relegating the fort in the background to a mere detail.

38. No single term in English captures this convention as neatly as "the sublime" conveys the convention I discussed earlier. I believe that in France during the Fauve period the term *pittoresque* may have come close. Unfortunately, for many Anglo-American readers "the picturesque," owing to the legacy of English writings on the landscape beginning with William Gilpin and Uvedale Price in the late-eighteenth century, has assumed a set of meanings quite contrary to then ones I wish to evoke; I must therefore forgo the term. Roger Benjamin has done an excellent job of reconstructing the art-historical and critical treatments of this manner of painting in France around the turn of the century, and he identifies a variety of terms—each, of course, with their own nuances—used to refer to it: *paysage historique, paysage décoratif, paysage classique*. Roger Benjamin, "The *Paysage décoratif* and the Arabesque of Observation" (paper presented at the University of Texas at Austin, 18 April 1991). From this list "the classical landscape" best imparts the sense I intend, which should become clear in the pages to come. I will examine the temporal connotations of "the classical landscape," its evocation of antiquity, in chapter 4.

39. "Petit-fils de Claude." Raymond Bouyer, *Le Paysage dans l'art* (Paris, 1894), 6.

40. Although I will discuss one instance of Matisse borrowing directly from Poussin in chapter 4, section 2.

41. The two aesthetics, it should be noted, were not mutually exclusive. Individual artists could, depending on the site portrayed, switch between the two manners of painting. Matisse, for instance, rendered the rugged rock formations of Belle-Ile in a rather sublime fashion when he visited the Breton island in 1896 and 1897 (Monet had earlier produced a series of paintings of these same sublime rocks around 1886). And certain paintings depicting the Mediterranean shore, such as Monet's canvases from his southern travels in the late 1880s or Dufy's pictures of the rock formation known as the Bec de l'Aigle near La Ciotat from 1907, can be considered hybrids of the sublime and the classical landscape.

42. "Pour bien comprendre le paysage, et comme préparation à un voyage dans une contrée à paysages, il serait bon d'en avoir soi-même dessiné ou peint et à défaut, d'avoir regardé avec attention beaucoup de tableaux: les enseignements de la peinture sont meilleurs que ceux de la nature elle-même directement contemplée." Le Comte d'Ussel, "Des Voyages à l'époque actuelle," *Le Correspondant* 228 (10 September 1907): 969. Dauzat offered similar advice: many pages of *Pour qu'on vogage* are devoted to training readers to evaluate the vistas they would encounter as tourists according to the aesthetic categories of landscape painting. The author of this tourist manual, in fact, also wrote a book entitled *Le Sentiment de la nature et son expression artistique.*

43. "Tout cela forme un des tableaux les plus pittoresques, les plus vivants et les plus colorés de cette Méditerranée où les beaux sites abondent." Ardouin-Dumazet, *Voyage en France,* 37:289.

44. "Les cartes postales illustrées sont en ce moment à la mode et l'origine de cette faveur du public n'est pas très ancienne: ce n'est guère que vers 1889 que les premières cartes postales illustrées ont été connues." L. Tranchant, *L'Illustration photographique des cartes postales* (Paris, 1902), 5. See also Aline Ripert & Claude Frère, *La Carte postale: Son histoire, sa fonction sociale* (Lyon, 1983).

45. "Corot . . . disait ‹Moi, je me promène, je vais, et puis quand je trouve un tableau ou un morceau de nature qui *m'empoigne,* je plante mon chevalet et je travaille›. Nous, quand nous verrons un moreau de nature qui nous *empoignera,* nous planterons notre trépied, nous monterons notre chambre noire par-dessus et nous essayerons de le photographier au mieux de nos moyens. Cet acte de lecture de l'ensemble est un acte purement psychologique: il s'appelle la *simultanéité.* Cette simultanéité, nous l'avons absolument aussi bien que les peintres, aussi bien que n'importe quel artiste, désireux de faire une représentation de la nature." Fréderic Dillaye, *Principes et Pratique d'art en photographie: Le Paysage* (Paris, 1899), 33–34.

46. "Voyager, c'est conquérir par les yeux des pays nouveaux, annexer à sa sensibilité des émotions et des images comme un vainqueur ajoute des territoire à sa patrie." Henry Bordeaux, *Paysages romanesques* (Paris, 1906), 229.

47. "J'ai l'intention de faire pour les villes comme pour les faits historiques; c'est-à-dire de me composer une géographie de la France." Maurice Brousse, quoted in "Notre Enquête sur les collections et les collectionneurs," *Revue Illustrée de la carte postale* 6 (25 May 1905): 613.

48. For a thorough discussion of the cultural isolation of much of rural France as late as the early twentieth century, see Eugen Weber, *Peasants into Frenchmen: The Modernization of Rural France, 1870–1914* (Stanford, 1976). The region of Roussillon in which Collioure was situated had only definitively become French territory in 1659, and many a visitor as the turn of the century found the place more Spanish than French.

49. See chapter 2, section 2.

50. "Il importe de s'être débarrassé, autant que faire se peut, des préjugés, partis pris, intérêts, soucis et conventions qui, dans l'ordinaire de la vie s'interposent entre la nature et nous, au point d'en masquer la vue . . . Il faut avoir . . . une sensibilité foncièrement désintéressée." Paul Gaultier, "Le Sentiment de la nature dans les beaux-arts," in *Reflets d'histoire* (Paris, 1909), 125.

51. Ne vous est-il jamais arrivé, au cours d'un voyage, en face d'un paysage marin, forestier ou montagnard, de communiquer votre admiration à un passant de rencontre, pêcheur, laboureur ou bûcheron, et de vous écrier devant lui:

—Quel beau pays!

Mais l'homme ne vous a pas compris, et invariablement vous vous attirez une des réponses suivantes:

—Oui, c'est un beau pays, le blé vient bien, —la pêche est bonne, —le bois de chêne se vend très cher.

Ou plus souvent:

—Oh! non, c'est un mauvais pays, rien ne vient, —on ne prend plus de poisson, —on s'échine à gagner misérablement sa vie.

Mais si vous essayez de vanter à votre interlocuteur la beauté des lignes de la montagne, le coloris de la mer, de la futaie ou des nuages au soleil couchant, le brave homme haussera les épaules avec un sourire de dédain, ne comprenant pas qu'on puisse s'attarder à pareilles balivernes. Inutile d'insister, vous perdriez votre temps et votre éloquence: *il ne sent pas. . . .:*

[Le sentiment de la nature] est favorisé par la culture de l'esprit, le degré de la civilization. . . . Il n'existe pas chez les âmes simples et primitives, chez l'enfant, chez le paysan, qui, l'un et l'autre, apprécient uniquement le monde sensible dans la mesure où il est susceptible de satisfaire leurs plaisirs, leurs besoins, leurs intérêts; le sentiment de la nature suppose, au contraire, une contemplation désintéressée; il est une forme de la jouissance artistique.

Dauzat, *Pour qu'on voyage,* 137–38, 139–40. After the phrase "chez le paysan," Dauzat elaborated with the following footnote: "Encore faut-il distinguer suivant les races. Le Méridional, à cet égard, apprécie mieux la beauté d'un paysage que le paysan du nord de la France."

52. "La femme saisit entre elle-même et la nature une très profonde analogie. . . . Il y a quelque chose de plus souple, de plus aisé, une sorte de compréhension mutuelle plus pénétrante dans

les rapports de ces deux vies: La femme ... aime à se laisser dominer par le monde extérieur, à se donner à quelque chose d'extérieur à elle." Epuy, *Le Sentiment de la nature*, 105–06. Artists were equally apt to equate the natural scenes they painted with women, even with sexually available women. At Belle-Ile Monet referred to the ocean as his *gueuse*, and as Levine points out, the eighteenth-century painter of sublime seascapes Joseph Vernet was quoted as saying: "I too will marry the sea." Claude Monet, letter of 30 October 1886, published in Daniel Wildenstein, *Claude Monet: Biographie et catalogue raisonné*, 4 vols. (Lausanne, 1974–1985) 2:285; Levine, "Seascapes of the Sublime," 390.

53. "Un paysage bien ordonné est comme une âme humaine maîtresse d'elle-même, où les passions sont contenues, où la raison domine, où la force de la vie se traduite, non par l'impétuosité, par l'emportement, mais par le calme et l'équilibre. Les paysages de Poussin ont ainsi un âme noble, fière, grave et sereine dans sa force." Paulhan, *L'Esthétique du paysage*, 98–99.

54. See chapter 2, section 4.

55. "Precisely become I am embedded in conviction, my sense of the rightness of my arguments [in favor of "a speaker-relative concept of ... meaning"] is no less strong ... and is in no way diminished by my ability to give an account of its source." Stanley Fish, *Doing What Comes Naturally: Change, Rhetoric and the Practice of Theory in Literary and Legal Studies* (Durham, N.C., 1989), 2–3.

NOTES TO CHAPTER 4

1. "Les événements des mythes ... se passent, semble-t-il, hors du temps ou, ce qui revient au même, dans l'étendue totale du temps ... Cependant toutes les mythologies ont fait effort pour situer cette éternité dans la série chronologique. On l'a placée, en général, au commencement des temps, quelquefois à la fin. C'est pour cette raison que les mythes, quels qu'ils soient, sont des mythes d'origine ou de la fin des choses ... Le corps des mythes constitue une préhistoire de l'humanité, de la tribu ou de la nation." H. Hubert, *Etude sommaire de la représentation du temps dans la religion et la magie* (Paris, 1905), 3–4.

2. See chapter 3, section 4.

3. "La femme, la grande fleur, la fleur parfaite, apparaît à ce point de vue comme le fait culminant de la vie du Monde, parce qu'en Elle notre race raisonnable (dont les vrais liens qui l'attachaient à la Nature-mère sont brisés depuis la conquête du langage) se retrempe et se rajeunit au contact de la mystique et immatérielle effluve mondiale, origine, fin et intermédiaire de toute existence, de toute âme, de toute pensée, océan infinie qui baigne et pénètre tout l'Univers, vit et meurt en chaque créature, et constitue l'essence vitale et primordiale de Tout." Michel Epuy, *Le Sentiment de la nature* (Paris, 1907), 107–08.

4. See chapter 3, section 2.

5. The pictorial precedents for the *Déjeuner sur l'herbe, Raphael's Judgment of Paris* (known through an engraving by Marcantonio Raimondi) and Titian's *Concert champêtre* (attributed at the time to Giorgione), have been amply documented and discussed in the Manet literature. See, for example, Françoise Cachin, "Le Déjeuner sur l'herbe," in *Manet: 1832–1883*, ed. Françoise Cachin & Charles S. Moffett (Paris, 1983), 165–73.

6. Jacques Rivière, for example, exclaimed of Baudelaire: "quelle dilectation pour la réalité défaillante, incertaine, périssable!" Jacques Rivière, *Etudes*, 17th ed. (Paris, 1944 [1st ed. 1911]), 24.

7. "Son intelligence lucide lui permit d'apercevoir, à travers les laideurs et les artifices, côtoyant le mal qui régnait en maître dans la société, les nostalgies d'idéal, les soifs de rêve, les efforts désespérés et vains tentés vers le bonheur." Gaston Syffert, "Baudelaire," *Portraits d'hier*, no. 7 (15 June 1909): 220–21.

8. "Plongent sous le ‹tuf profond et riche› de la tradition classique." Roger Allard, *Baudelaire et "L'Esprit nouveau"* (Paris, 1918), 16.

9. See, for example, Mme Léonide Votez, *2400 Kilomètres à travers la France* (Paris & Laval, 1907), 110, 125; and Henri Boland, *En douce France* (Paris, 1910), 190–91.

10. See chapter 3, section 4.

11. Jack Flam points out this similarity, and reminds us that Matisse had copied *The Andrians* several years earlier. Jack Flam, *Matisse: The Man and His Art, 1869–1918* (Ithaca, 1986), 118.

12. Only by the end of the first decade of the twentieth century had Cézanne emerged as a major figure rivaling Poussin as the most exemplary painter of the *grande tradition*. I will examine this development, and the Fauves' affinities with Cézanne, in chapter 5, section 1.

13. "Ses bacchanales ... dans leur désordre, composé avec un équilibre parfait, donnent l'impression très vive et purifiée de ce que devait être chez les anciens l'ivresse païenne de la nature." Georges Dralin, "Propos," *L'Occident* 5 (May 1904): 237.

14. "De Platon et de Virgile à Poussin, c'est une parenté si étroite qu'elle fait penser à un cas unique de métempsychose." Paul Jamot, "L'Inspiration du poète par Poussin," *Gazette des beaux-arts*, 4th period, 6 (September 1911): 189–90.

15. "Poussin souligne par la continuité de l'homme la perpétuité du monde." Adrien Mithouard, "Le Classique occidental," *L'Occident* 1 (March 1901): 181.

16. "*Eternelle* et, pourtant, toujours *jeune*."

"Notre But," *La Rénovation* [title changed July 1905 to *La Rénovation esthétique*] 1 (May 1905): 5.

17. "C'est . . . bien à tort qu'on a essayé de déprécier cet art sous le nom d'*académique*, comme si Poussin devait être responsable de ce que, après lui des imitateurs vulgaires ont prétendu nous faire accepter comme la continuation de son style et de ses doctrines." Emile Michel, *Les Maîtres du paysage* (Paris, 1906), 116.

18. "Au-dessus de tous les temps et de toutes les écoles." Jean Tarbel [J. Delorme-Jules-Simon?], "Le Grand Peintre français: Nicolas Poussin," *Le Correspondant* 228 (10 August 1907): 565.

19. "Un langage sans obscurité ni défaillance." Jamot, "*L'Inspiration du poète* par Poussin," 179.

20. "Le créateur de ces grands paysages s'y dévoile invisible et présent. Cette nature est sa pensée." Raymond Bouyer, "Poussin, novateur et paysagiste," *L'Art et les Artistes* 4 (February 1907): 389.

21. "Ces moments transparents où l'on n'est pris ni par les choses, ni par ses propres imaginations, mais où l'on s'en empare en les comprenant." Paul Desjardins, *Poussin* (Paris, [1904]), 115.

22. "*Luxe, Calme et Volupté* est le schéma d'une théorie." Maurice Denis, "La Peinture," *L'Ermitage* 16.1 (15 May 1905): 319; reprinted as "La Réaction nationaliste," in Maurice Denis, *Théories 1890–1910: Du symbolisme et de Gauguin vers un nouvel ordre classique*, 2nd ed. (Paris, 1912 [1st ed. 1912]), 190. "Matisse . . . ne fait . . . guère que traduire en schémas des théorèmes de peinture." Maurice Denis, "La Peinture," *L'Ermitage* 17.1 (15 June 1906): 325; reprinted as "Le Renoncement de Carrière, la superstition du talent," in Denis, *Théories*, 208.

23. See chapter 3, section 1.

24. For my discussion of these "neo-naturalist" devices, see chapter 1, section 3.

25. "Le peintre le plus caractéristique de notre race . . . notre grand peintre national." Tarbel, "Le Grand Peintre français," 544.

26. Today, we would perhaps insist on a greater division between Hellenistic and Latin culture, but the division was easy to elide at the beginning of the twentieth century. As Alban Cabos pontificated in 1911: "N'oublions pas que la civilisation latine est fille de la civilisation grecque . . . *L'Italie est la mère, et la Grèce l'aïeule*, a dit V.-Hugo. Nous pouvons difficilement les séparer. Il nous faut les unir dans le même culte et les étudier avec le même zèle." And this in a graduation address, a forum certainly more appropriate for the repetition of accepted bromides than for the formulation of contestable theses. Alban Cabos, *L'Education classique traditionnelle: Discours prononcé à la distribution des prix du Collège Saint-*

Nicolas de Gimont, le 22 juillet 1911 (Auch, [1911]), 7. Likewise, the nationalist Charles Maurras quipped: "Latin, italien, hellène, il est le même." Charles Maurras, "Barbares et Romans" (1891), *L'Etang de Berre* (Paris, 1915), 358.

27. "Sa France, sa vraie France, il [Poussin] la trouva à Rome"; "l'Italie . . . semble vaincue par la ferme ligne française." Charles Maurras, "Lettre à Adrien Mithouard," *Gazette de France*, 25 December 1902; reprinted as "Poussin et l'Occident" in Charles Maurras, *Quand les Français ne s'aimaient pas*, 2nd ed. (Paris, 1916 [1st ed. 1916]), 352, 354.

28. "Ce qu'il importe en effect, Monsieur, d'apercevoir, c'est la continuité de la tradition occidentale, de la plus ancienne tradition occidentale. . . . L'antiquité, désormais, c'est nous." Adrien Mithouard, "Lettre à Charles Maurras," *L'Occident* 3 (February 1903): 68, 74.

29. "Echoes d'une Grèce primitive, entrevue par un Virgile morose"; "toute française." Bouyer, "Poussin, novateur et paysagiste," 388.

30. "Roumains et Provençaux sont de même race; ils sont les fils, les descendants directs, avec les Italiens et les Espagnols, des fameux Romains, conquérants du monde. Disséminés, le long de la Méditerranée, jusqu'aux ultimes frontières du pays des Daces, tous ces *Latins* ont conservé leur nationalité propre et leur langue." Paul Brousse, "Provençaux et Roumains," *La Nouvelle Revue*, new series, 40 (15 May 1906): 213.

31. Paul Bourget, *La Côte d'Azur* (Paris, [n.d.]), 9. "La grande eau céruléenne des Hellènes et les Latins." Onésime Reclus, *A la France: Sites et Monuments*, 33 vols. (Paris, 1900–06), vol. 18: *Pyrénées Orientales* (1903), 8.

32. "Certains matins de soleil, on vit là comme dans un pays de rêves, et, si l'on s'éloigne un peu de la ville, cherchant au refuge sous les oliviers au léger feuillage, on se croit vraiment transporté dans quelque atmosphère virgilienne. On cherche la statue de Pan, enguirlandée de fleurs, on entend la flûte de Thyrsis, on croit voir Clytie s'offrant à Hélios: toute une mythologie vivante anime la solitude." Casimir Stryienski, "Impressions de la Riviera: Maisons d'artistes," *Revue bleue*, 5th series, 7 (5 January 1907): 31.

33. See Eugen Weber, *Peasants into Frenchmen: The Modernization of Rural France, 1870–1914* (Stanford, 1976).

34. See chapter 3, section 2.

35. For an extended examination of Maurras and the Action Française, see Eugen Weber, *Action Française: Royalism and Reaction in Twentieth-Century France* (Stanford, 1962); and Eugen Weber, *The Nationalist Revival in France, 1905–1914* (Berkeley & Los Angeles, 1959).

36. "L'essentiel est qu'il existe une civilisation latine, un esprit latin, véhicule et complément de l'hellénisme, interprète de la raison et de la

beauté athénienne, durable monument de la force romaine." Charles Maurras, "Les Chansons provençales" (1903), *L'Etang du Berre*, 155.

37. "Pour moi, c'est comme Provençal que je me sens Français. Je ne comprends pas ma Provence sans une France." Maurras, "Les Chansons provençales," *L'Etang du Berre*, 158.

38. "L'empire du Soleil, comme dit... Mistral..., ce lumineux empire est la patrie de l'ordre, c'est-à-dire de l'autorité, de la hiérarchie, des inégalités et des libertés naturellement composées." Charles Maurras, "Une Revue latine" (1902), *Quand les Français ne s'aimaient pas*, 2nd ed., 125.

39. "C'est cette Rome qui apprit aux Français le droit, l'administration, la théologie, la politique et la discipline de guerre." Maurras, "Lettre à Adrien Mithouard"; reprinted as "Poussin et l'Occident" in Maurras, *Quand les Français ne s'aimaient pas*, 2nd ed., 353.

40. "Si vous avez résolu d'être patriote, vous serez obligatoirement royalist.... Aux peuples de choisir: encore, s'ils veulent vivre, le choix est-il dicté. Ils ne sont pas libres et il leur faut ou se soumettre à des conditions éternelles ou se démettre de toute volonté de durer. On peut éluder et masquer ces conditions profondes de politique naturelle. On ne peut les anéantir en elles-mêmes ni les cacher à l'œil calme et pénétrant...La Monarchie reconstituerait une France et sans la Monarchie la France périra." Charles Maurras, *Enquête sur la monarchie* (Versailles, 1928 [first published serially in 1900]), 118–19.

41. "Ce n'est pas accidentellement que la vieille France eut son style, et que la France nouvelle en est encore à chercher le sien. Il y faut un Etat nourri et soutenu des traditions fortes, une civilisation, une société où l'hérédité a sa place, des ministres cultivés, des Rois gentilshommes." Charles Maurras, *Action française*, 26 April 1908; reprinted in Charles Maurras, *Dictionnaire politique et critique*, ed. Pierre Chardon, 5 vols. (Paris, 1932–34), 1:119.

42. "La démocratie c'est le mal, la démocratie c'est la mort." Charles Maurras, *Gazette de France*, 3 September 1905; reprinted as "Liberalisme et Libertés: Démocratie et Peuple," *Action française*, special issue (1906): 10. Maurras is quoting himself here, but does not give the original source.

43. "Nous nous efforçons de nous opposer à la ruine de l'héritage du passé...Nous tentons de supprimer la cause permanente de cette ruine par la suppression du régime actuel et par la restauration de la monarchie." Léon de Montesquiou, *Les Raisons du nationalisme* (Paris, 1905), 218–19.

44. "Ni en France, ni en Espagne, ni en Italie, non plus qu'en Grèce, l'anarchie et la révolution ne sont indigènes." Maurras, "Une Revue latine," *Quand les Français ne s'aimaient pas,* 2nd ed., 124.

45. "Est-que les écrivains de l'*Action Française*, jaloux de fonder philosophiquement leur misérable doctrine purement politique ne regardent pas les idées de race et de tradition comme *substratum* de nationalisme et du monarchisme?" Albert Maybon, "Félibrige et Nationalisme," *Revue blanche* 29 (15 September 1902): 147.

46. "La renaissance littéraire était bien proche de se doubler d'un mouvement politique— qui ne pouvait être que réactionnaire." Gaston Sauvebois, *L'Equivoque du classicisme* (Paris, 1911), 24.

47. "On peut dire que les philosophes et théoriciens politiques contemporains se groupent ou s'opposent dans la mesure où ils utilisent ou négligent les leçons de la culture classique de l'Occident." Henri Clouard, *Les Disciplines: Nécessité littéraire et social d'une renaissance classique* (Paris, 1913), 31.

48. "L'ingérence détestable du nationalisme politique dans la question d'art"; "Des origines, il faut parler en distinguant nettement le côté ‹latin› et le côté ‹français›." Camille Mauclair, "La Réaction nationaliste en art et l'ignorance de l'homme de lettres," *La Revue* 54 (15 January 1905): 162.

49. See chapter 1, section 1.

50. "Ce nationalisme est le sens français de l'art opposé aux Italiens, c'est-à-dire le contraire de ce que les nationalistes prétendent. Le nationalisme, ou le classicisme, pour les artistes français, c'est l'art anti-romain, la lutte contre Rome." Mauclair, "La Réaction nationaliste en art." 157 n*1*. Mauclair provided his listing of true, non-Italianized French artists in Camille Mauclair, *L'Impressionnisme: Son histoire, son esthétique, ses maîtres* (Paris, 1904), 15–16.

51. "Pour les luttes inévitables et fécondes, il faut créer des antagonistes." Léon Bazalgette, *L'Esprit nouveau dans la vie artistique, sociale et religieuse* (Paris, 1898), 13.

52. "Il faut que soit extirpé de notre chair et de notre conscience tout ce que nous devons à nos origines romaines, et que nous vivions une autre existence purifiée de tout ce qui, à l'heure présente, nous corrompt. Il faut nous *délatiniser*— ou mourir." Léon Bazalgette, *Le Problème de l'avenir latin* (Paris, 1903), 151.

53. "L'affaire Dreyfus, conçue comme l'expression douloureuse d'un excès de relâchement et de liberté, avait eu...une part essentielle à la réaction de l'esprit classique et du sentiment national." Charles Maurras, "Après dix ans" (1915), appendix to "De la liberté suisse à l'unité française" (1905), *Quand les Français ne s'aimaient pas*, 2nd ed., 229. "Le néo-royalisme encore latent, ou chez beaucoup à l'état paradoxal, se déclara officiellement à la suite de l'Affaire." Sauvebois,

L'Equivoque du classicisme, 25.

54. "La réalité extérieure"; "Nous ne parlons plus de faire une constitution car nous reconnaissons que la constitution est déjà faite, qu'elle existe déjà, nécessitée qu'elle est par la nature. Simplement donc nous prétendons chercher la constitution nécessaire, simplement déterminer ce que la nature nous impose." Léon de Montesquiou, *De l'anarchie à la monarchie* (Paris, 1911), 5, 15.

55. "Les lois naturelles dont dépendent l'ordre et le progrès des sociétés." de Montesquiou, *Les Raisons du nationalisme*, 225.

56. Charles Maurras, "Après quatorze ans," appendix to "Poussin et l'Occident," *Quand les Français ne s'aimaient pas*, 2nd ed., 357.

57. "Génies intuitifs, capables de se mettre directement en contact avec les réalités et d'accomplir spontanément, sans théories et sans discussions désormais superflues, les actes indispensables au salut public": "En lui [le peuple] présentant la morale non comme une tradition vivante, transmise par les ancêtres et améliorée par les générations successives, non comme un idéal pratique de bonté, de générosité et de sacrifice, mais comme une froide nécessité de la Raison, on n'arrivera, sauf de très rares exceptions, qu'à le pervertir, qu'à lui enlever sa précieuse droiture de jugement, qu'à fausser sa vision naïve et directe des choses, qu'à lui faire perdre en un mot toutes ses magnifiques qualités intuitives." Louis Rouart, "L'Avenir de l'intelligence selon M. Charles Maurras," *L'Occident* 5 (January 1904): 15, 22.

58. "Nous voulons ... forger un puissant instrument de progrès et de réformes, et contribuer à assurer à la République un gouvernement, dans la plus haute et la plus noble acceptation du terme, afin d'organiser la démocratie, de rénover la France et de réparer ses malheurs." Paul Deschanel, "Le Mode d'élection des sénateurs: Discours prononcé à la Chambre des Députés le 17 novembre 1896," in *La République nouvelle* (Paris, 1898), 284.

59. "Le poison"; "Je veux dire que le salut ne surgira pas de la volonté collective puisque c'est précisément la volonté qui est la faculté la plus atteinte chez eux [les peuples latins].... L'opération devrait être tenté par l'intelligence, l'intelligence pure et simple. Une intelligence toute-puissante, celle d'un homme ou d'un comité, peu importe: mais elle exigerait une sorte de dictature de l'intelligence.... Cette dictature de l'intelligence, ce serait la lutte du cerveau conscient contre le *fatum*, de la volonté contre la destinée. Il y faudrait beaucoup de franchise et point de sentimentalisme." Bazalgette, *Le Problème de l'avenir latin*, 146, 147–48, 151.

60. "Il faut ... accepter, sans trop de scrupules, beaucoup de l'expérience du passé. Le recours à la tradition est notre meilleure sauvegarde contre les vertiges du raisonnement, contre l'excès de théories." Maurice Denis, "La Peinture," *L'Ermitage* 16.2 (15 November 1905): 317–18; reprinted as "De Gauguin, de Whistler et de l'excès des théories," in Denis, *Théories*, 201.

61. "Sans l'anarchisme destructeur et négateur de Gauguin et de Van Gogh, l'exemple de Cézanne, avec tout ce qu'il comporte de tradition, de mesure et d'ordre, n'aurait pas été compris.... Depuis ce temps une évolution s'est faite en faveur de l'ordre.... Syndicalistes ou monarchists d'Action Française, également revenus des *nuées* libérales ou libertaires, s'efforcent de rester dans la logique des faits, de raisonner seulement sur des réalités: mais la théorie monarchiste, le nationalisme intégral, a entre autres avantages, celui de tenir compte aussi des expériences *réussies* du passé." Maurice Denis, "De Gauguin et de Van Gogh au classicisme," *L'Occident* 15 (May 1909): 191–92; reprinted in Denis, *Théories*, 258–59. I will discuss the emergence of Cézanne as a figure of tradition in chapter 5, section 1.

62. Maurras, "Après quatorze ans," appendix to "Poussin et l'Occident," *Quand les Français ne s'aimaient pas*, 2nd ed., 357.

63. "Il a su faire rentrer ... dans la tradition chrétienne et occidentale le paganisme de nos maîtres classiques." Adrien Mithouard, "Maurice Denis," *Art et Décoration* 22 (July 1907): 12. See also Adrien Mithouard, "Vers la simplicité," *L'Ermitage* 12.2 (July 1901): 26–39; and L[ouis] R[ouart], "Maurice Denis," *L'Occident* 6 (December 1904): 312–13.

64. Mauclair, "La Réaction nationaliste en art," 157.

65. "M. René Ménard évoque ... le souvenir de Poussin. Lui aussi a le sens de la grandeur, de la simplicité austère, de la sérénité rationnelle et forte, avec de hautes aspirations. Et il s'est plu aux temples antiques. Mais ses paysages sont d'une âme différente, moins rude et moins fixée, ils sont en quelque sorte les ‹rêveries d'un païen mystique›." Fr[édéric] Paulhan, *L'Esthétique du paysage* (Paris, 1913), 174. The editor of *L'Occident* Adrien Mithouard actually had reservations about Ménard; he found his work tinged with "cet artificiel XVIIe siècle, si délibérément méthodique." Mithouard, "Vers la simplicité," 32. Mithouard may have been somewhat more moderate than some of the other nationalists; in their articles on the nationalist reaction in art, in fact, Mauclair and Tancrède de Visan disagreed over whether he was a monarchist. Mithouard's politics, in any case, would have fitted nicely into the moderating trends I will describe at the end of this chapter.

66. "L'évolution"; "en peinture[, l]es théoriciens de la couleur ont définitivement gagné tous les suffrages, grâce aux impressionnistes. A présent il s'agit de s'entendre sur la *ligne* et de

mettre tout de même de l'*idée* dans un tableau." Tancrède de Visan, "La Réaction nationaliste en art: Réponse à M. Camille Mauclair," *La Plume*, nos. 367–68 (1–15 March 1905): 134–35.

67. "La ligne d'Italie, c'est-à-dire les formes simples, précises et toujours nobles qui se déroulent dans la délicieuse lumière transparente." Rouart, "Maurice Denis," 313.

68. "C'est dans la réalité qu'il développera le mieux ses dons, très rares, de peintre. Il retrouvera, dans la tradition française, le sentiment du possible." Denis, "La Peinture" (15 May 1905): 319; reprinted as "La Réaction nationaliste," in Denis, *Théories*, 190.

69. "L'absence de toute technique traditionnelle, de tout métier enseigné, correspond, chez les jeunes peintres, à une sorte de virtuosité anarchique qui détruit, en la voulant exagérer, la fraîcheur de l'expression individuelle.... Matisse, que nous savons merveilleusement doué pour percevoir et rendre simplement les beautés de la nature, ne fait plus guère que traduire en schémas des théorèmes de peinture." Denis, "La Peinture" (15 June 1906): 325; reprinted as "Le Renoncement de Carrière," in Denis, *Théories*, 208.

70. "Admettons, cependant, que la Révolution française ne soit qu'une erreur, un accident. Il faut reconnaître que depuis cent vingt ans l'idée révolutionnaire a vécu, s'est développée. C'est là *un fait* indéniable. De quel droit les traditionalistes peuvent-ils négliger *ce fait*." Etienne Antonelli, "Traditionalisme et Démocratie," *Démocratie sociale*, November 1909; reprinted in Etienne Antonelli, *La* Démocratie sociale *contre l'Action* française: *Décembre 1909–décembre 1910* (Paris, [n.d.]), 88–89.

71. "Ici...l'ordre, l'équilibre, la force sereine, dans l'accord absolu d'une certitude; là les agitations fiévreuses, les tâtonnements.... Le XVII siècle, notre âge classique,... revêt tout ensemble le caractère le plus universel et le plus national.... Au contraire, le XVIII siècle, tout livré aux fantaisies, aux tentatives individuelles, dévoré de curiosités multiples, appliqué à révolutionner les mœurs, les institutions, divisé sur les doctrines, sur les griefs et sur les remèdes est une période fébrile." Raoul Narsy, "M. Salomon Reinach ou le classique cosmopolite," *L'Occident* 8 (October 1905): 157–58.

72. "D'où a pu venir et d'où vient encore l'encouragement à cette monstrueuse déformation de l'art engendré par le culte de la personnalité? Selon ma réflexion, le voici: de la Science. J'ai déjà démontré que ce que l'on nomme aujourd'hui la Science (avec l'S capitale), a produit dans la région de la couleur la catastrophe impressionniste, affaiblissant de nobles tempéraments d'artistes, désignés pour une œuvre supérieure." Emile Bernard [Francis Lepeseur, pseud.], "Du culte de la personnalité," *La Rénovation esthétique* 3 (September 1906): 260–61.

73. "Par rapport à Poussin et Lebrun, notre époque marque la plus entière ignorance de l'art." Emile Bernard, "Les Rénovateurs de l'art," *La Rénovation esthétique* 1 (September 1905): 268.

74. Léon Daudet, *Le Stupide XIXe Siècle: Exposé des insanités meurtrières qui se sont abattués sur la France depuis 130 ans, 1789–1919* (Paris, 1922).

75. "Un art qui ne convenait qu'aux forts, aux puissants, l'art du XVII siècle, séduisit tout d'abord, puis défia, désespéra, ensuite dessécha la faible veine poétique du siècle suivant." Charles Maurras, *Lorsque Hugo eut les cent ans* (1927); reprinted in Maurras, *Dictionnaire politique et critique*, 1:116.

76. Denis, less extreme than Maurras, was willing to accept Renoir as a French national painter. "Etait-il moins nationaliste alors, notre cher grand Renoir, lui qui jamais ne peignit une fille de Montmartre sans synthétiser en elle toute la grâce française, et dont la peinture éclatante et émaillée, issue de la tradition de notre XVIIIe siècle, célébra si parfaitement les joies, les soleils et les femmes de l'Ile-de France?" Denis, "La Peinture" (15 May 1905): 313; reprinted as "La Réaction nationaliste," in Denis, *Théories*, 184–85.

77. During the first decade of the twentieth century Cézanne was also to become acceptable to many nationalist critics. I will examine this development in chapter 5, section 1.

78. "Puvis de Chavannes est de la famille des Poussin et des Jean Racine." Charles Maurras, *Gazette de France*, 28 January 1895; reprinted in Maurras, *Dictionnaire politique et critique*, 4:286.

79. "Il y rapportait la haine de l'Europe.... Il n'est pas seulement allé cherché la nature, mais fuir la civilisation." Marius-Ary Leblond, "La Vie tahitienne de Paul Gauguin," *Revue bleue*, 5th series, 1 (14 May 1904): 636.

80. "Une sorte de Poussin sans culture classique." Maurice Denis [P.-L. Maud, pseud.], "L'Influence de Paul Gauguin," *L'Occident* 4 (October 1903): 164; reprinted in Denis, *Théories*, 166.

81. "Le travail loin d'être un châtiment, comme le soutient la religion chrétienne, et tel que l'a organisé la société capitaliste, est au contraire attrayant et nécessaire lorsqu'il s'accomplit librement, sans contrainte et par goût. "Jean Grave, *Terre libre (Les Pionniers)* (Paris, 1908), 294. See also Jean Grave, *Le Syndicalisme dans l'évolution sociale* (Paris, 1908), 11.

82. "L'age d'or n'est pas dans le passé, il est dans l'avenir." Paul Signac, letter to Henri-Edmond Cross, 1893, cited in Françoise Cachin, *Paul Signac* (Paris, 1971), 65; and in Eugenia W. Herbert, *The Artist and Social Reform: France and Belgium, 1885–1898* (New Haven, 1961), 191.

83. "Ce tableau merveilleux qu'il sort de contempler, cette vision magique que son âme de

poète a évoquée, pourquoi ne pourrait-elle devenir la réalité?... C'est l'espoir la grande source d'énergie; et c'est lui, le bonheur. Aveugle est celui qui pense découvrir le secret du bonheur dans les réalisations immédiates." André Girard, "L'Idéal," *Les Temps nouveaux*, 14 July 1906.

84. See chapter 1, section 5.

85. "Une façon de penser et d'agir nouvelle, facilitant ainsi le passage de hier à demain." Jean Grave, *L'Individu et la Société* (Paris, 1897), 219.

86. "C'est aux révolutionnaires conscients à déblayer des excroissances vénéneuses du passé pour adapter l'édifice de l'avenir, qui doit abriter des destinées de l'humanité nouvelle, aux exigences de son évolution rapide et de plus en plus consciente." Frédéric Stackelberg, *La Mesure du temps* (Paris, 1899), 3.

87. "Il pourra donner cours à toute son imagination, aux caprices de sa fantaisie, exécuter l'œuvre telle qu'il l'aura conçue." Jean Grave, *La Société future*, 8th ed. (Paris, 1903, [1st ed. 1895]), 367. I quote this passage at greater length in chapter 1, section 5.

88. "Les conditions sociales qui sont les nôtres, contraignent à l'unique peinture du chevalet, à cette peinture à destination de salon, de musée, des talents qui feraient merveille, peut-on croire, dans la décoration architecturale. Je songe à Charles Guérin, à Maurice Denis, à Henri Matisse, et à d'autres en grand nombre." Am[édée] C[atonné], "Aux Indépendants," *Les Temps nouveaux*, 15–21 April 1905.

89. In brief: When anarchist acts of "propaganda by the deed" in the form of bomb-throwing and political assassination were attempted in the 1890s, they generated little popular support and eventually were brutally suppressed by the government. This phase of the anarchist movement, which had no other viable means to trigger insurrection, never really recovered from this loss of its engine of revolution. By the early decades of the twentieth century syndicalism, with its weapon of the general strike, had for the most part supplanted earlier forms of anarchism, and anarchist visions of rural utopias gave way to more urban-based visions of an ideal future. I provide here, of course, no more than a thumbnail sketch of the history of anarchism. See James Joll, *The Anarchists*, 2nd ed. (Cambridge. Mass., 1980 [1st ed. 1964]); and Jean Maitron, *Le Mouvement anarchiste en France*, 2 vols. (Paris, 1975).

90. "Ah! que j'aime ce tableau de Cross qui représente un homme nu sous le ciel de Provence!... Le fidèle respect qu'il a de la nature, la sincérité de sa vision subsistent..., comme chez les classiques, au-dessous de ce travail de construction décorative." Maurice Denis, *Henri-Edmond Cross* (Paris, 1907); reprinted as "Quelques Notices: Henri-Edmond Cross," in Denis, *Théories*, 152, 155.

91. See chapter 1, section 1.

92. See the introduction.

93. My brief sketch of these later developments is fully endebted to Silver's extensive discussion of the role of classical culture in uniting France for the First World War. Kenneth E. Silver, *Esprit de Corps: The Art of the Parisian Avant-Garde and the First World War* (Princeton, 1989).

94. "Depuis [1905], les politiques républicains crurent ingénieux, nous voyant populaires, de se donner pour programme cette même restauration nationale dont ils ôtaient la monarchie: ce fut (presque avoué parfois chez certains indiscrets) le programme dit ‹de l'*Action française* sans le roi›." Charles Maurras, "Conclusion" (1916), *Quand les Français ne s'aimaient pas*, new ed. (Paris, 1926), 349. This passage does not appear in the second edition of 1916, but a gaping hole in the typography and an orphaned footnote on page 389 of that edition indicate the passage may have been deleted—by whom or for what reason I cannot speculate—from the first edition of the same year.

95. "‹Aujourd'hui... c'est chose faite: ce qui semblait impossible s'accomplit lentement sous nos yeux: les idées de l'*Action française* sont partout, les faits leur ont donné la consécration la plus éclatante qui soit. Pas une de nos prévisions qui ne se soit réalisée; pas une de nos critiques qui n'ait été justifiée; pas une de nos solutions qui ne se soit révélée comme la vraie. L'évidence a été si saisissante que la pensée officielle elle-même un a été touchée. Ce point me paraît capital. L'*Action française*, pendant la guerre a réellement donné le ton au gouvernement de la République. Des ministres, de hauts personnages, nous ont emprunté jusqu'au vocabulaire›." Maurras, "Conclusion," *Quand les Français ne s'aimaient pas*, 2nd ed., 392.

96. "Grande erreur, erreur capitale. On ne vise pas un but en s'en interdisant le moyen unique." Maurras, "Conclusion." *Quand les Français ne s'aimaient pas*, new ed., 349. See note 94 for a discussion of the possible deletion of this passage from the second edition of 1916.

NOTES TO CHAPTER 5

1. "Ce qui m'intéresse le plus, ce n'est ni la nature morte, ni le paysage, c'est la figure." Henri Matisse, "Notes d'un peintre," *La Grande Revue* 52 (25 December 1908): 741; translation modified from Henri Matisse, "Notes of a Painter," in Jack D. Flam, ed. & trans., *Matisse on Art* (London, 1973), 38.

2. Matisse was already moving away from the landscape and the pastoral by the Salon d'Automne of 1906, where three of his five exhibited works were still lifes. The pairing in the spring of 1907 of *Blue Nude* with *Bathers* by

Derain, a painter previously devoted almost exclusively to landscape, would have accentuated the new importance of the figure to the Fauve artists.

3. See chapter 2, section 4.

4. See chapter 4.

5. See chapter 3, section 4, and chapter 4, section 1.

6. See chapter 4, section 3.

7. "Tout progrès véritable dans la vie féminine suppose une suite de victoires sur la violence, sur la bestialité, sur l'orgueil, sur l'ignorance et sur la sottise.... La femme occidentale du XXe siècle est tellement au-dessus de ce qu'on peut savoir de la femme primitive dans son âme et dans son corps, dans sa beauté même, qu'on a pu dire sans paradoxe qu'elle est un produit de l'humanité." P[ericles] Grimanelli, *La Femme et le positivisme* (Paris, 1905), 9, 15.

8. Edmond Perrier & Le Dr [René] Verneau, *La Femme: Dans la nature, dans les mœurs, dans la légende, dans la société*, 4 vols. (Paris, [1908]), vol. 1.

9. My use of republicanism here refers to the image of the institution propagated before the emergence of the new, conservative defense of the Republic using nationalist terms around the time and partially a result of the Fauve movement, a development I discussed at the end of chapter 4.

10. For the history of the reception of Darwin in France, see Yvette Conry, *L'Introduction du Darwinisme en France au XIXe siècle* (Paris, 1974); Robert E. Stebbins, "France," in *The Comparitive Reception of Darwinsim*, ed. Thomas F. Glick (Austin, 1974); and Linda L. Clark, *Social Darwinism in France* (University, Ala., 1984).

11. "L'Evolution physique de la femme."

12. I discuss this technical aspect of the Collioure landscapes in chapter 3, secion 1, but my most thorough discussion of neo-naturalism in Fauve paintings appears in chapter 1, section 3.

13. "Je vais condenser la signification de ce corps, en recherchant ses lignes essentielles.... On peut rechercher un caractère plus vrai, plus essentiel, auquel l'artiste s'attachera pour donner de la réalité une interprétation plus durable." Matisse, "Notes d'un peintre," 735–36; translation from Flam, *Matisse on Art*, 36–37.

14. See chapter 1, sections 1 and 2.

15. For three recent examples, see Roger Benjamin, *Matisse's "Notes of a Painter": Criticism, Theory, and Context, 1891–1908* (Ann Arbor, 1987), 43–44; Jack D. Flam's introduction to the "Notes d'un peintre" in Flam, *Matisse on Art*, 32–35; and Richard Shiff, *Cézanne and the End of Impressionism: A Study of Theory, Technique and Critical Evaluation of Modern Art* (Chicago, 1984), 56–66. None of these authors simplistically reduces "Notes d'un peintre" to a Symbolist program, but all find strong Symbolist resonances in Matisse's words.

16. "Ce que je poursuis par-dessus tout, c'est l'expression." Matisse, "Notes d'un peintre," 733.

17. "Souvent, quand je me mets au travail, dans une première séance je note des sensations fraîches et superficielles. Il y a quelques années, ce résultat parfois me suffisait. Si je m'en contentais aujourd'hui, alors que je pense voir plus loin, il resterait un vague dans mon tableau: j'aurais enregistré les sensations fugitives d'un moment qui ne me définiraient pas entièrement, et que je reconnaîtrais à peine le lendemain. Je veux arriver à cet état de condensation des sensations qui fait le tableau. Je pourrais me contenter d'une œuvre de premier jet, mais elle me lasserait de suite, et je préfère la retoucher pour pouvoir la reconnaître plus tard comme une représentation de mon esprit. A une autre époque, je ne laissais pas mes toiles accrochées au mur, parce qu'elles me rappelaient des moments de surexcitations, et je n'aimais pas à les revoir étant calme. Aujourd'hui, j'essaie d'y mettre du calme et je les reprends tant que je n'ai pas abouti." Matisse, "Notes d'un peintre," 735; translation modified from Flam, *Matisse on Art*, 36.

18. A photograph of Derain sitting in his studio in front of the framed reproduction was first published in Gelett Burgess, "The Wild Men of Paris," *Architectural Record* 27 (May 1910): 414.

19. An indication of Cézanne's importance to Matisse appears in "Notes d'un peintre" where Cézanne, as well as being one of several artists Matisse quoted on the need to copy nature (742), also emerges as the artist whose canvases best embody compositional order and clarity (739).

20. "Une chapelle s'est constituée où officient deux prêtres impérieux, MM. Derain et Matisse." Louis Vauxcelles, "Le Salon des 'Indépendants,'" *Gil Blas*, 20 March 1907. Vauxcelles is punning here: "une chapelle" can also refer to a tight artistic or literary circle.

21. Shiff in *Cézanne and the End of Impressionism*, especially chapters 9, 12 and 13, has already provided a meticulous description of the formation of a critical consensus emerging in the first decade of the twentieth century casting Cézanne in the role of the "primitive classic." My analysis on this point is heavily indebted to his, and the thoroughness of his examination allows me the luxury of providing an abbreviated account here. See also Benjamin, *Matisse's "Notes of a Painter"*, 178–84.

22. "Sans l'anarchisme destructeur et négateur de Gauguin et de Van Gogh, l'exemple de Cézanne, avec tout ce qu'il comporte de tradition, de mesure et d'ordre, n'aurait pas été compris." Maurice Denis, "De Gauguin et de Van Gogh au classicisme," *L'Occident* 15 (May 1909): 191; reprinted in Maurice Denis, *Théories 1890–1910: Du symbolisme et de Gauguin vers un nouvel ordre classique*, 2nd ed. (Paris, 1912 [1st ed. 1912]), 258.

I also discuss this passage in chapter 4, section 4.

23. "L'opinion moyenne"; "il est entendu que Cézanne est une sorte de classique et que la jeunesse le tient pour un représentant du classicisme." Maurice Denis, "Cézanne," *L'Occident* 12 (September 1907): 119; reprinted in Denis, *Théories*, 238.

24. "Un indépendant, un solitaire"; "un instinct de latin"; "goût naturel." Denis, "Cézanne," 118–19, 123; reprinted in Denis, *Théories*, 237, 242.

25. Shiff, *Cézanne and the End of Impressionism*, 182. To support his claim that "the Cézanne legend repeatedly refers to the primitive qualities of his painting" (166), Shiff cites the following wide variety of critics: Emile Bernard (1891), Gustave Geffroy (1894–95), Georges Lecomte (1891), Camille Mauclair (1904), Georges Lanoë (1905) and Charles Morice (1907).

26. See chapter 4, section 2.

27. Shiff, *Cézanne and the End of Impressionism*, 181. See also Benjamin, *Matisse's "Notes of a Painter"*, 67; and Theodore Reff, "Cézanne and Poussin," *Journal of the Warburg and Courtauld Institutes* 23 (1960): 150–74.

28. "Il est à la fois l'aboutissement de la tradition classique et le résultat de la grande crise de liberté et de lumière qui a rajeuni l'art moderne. C'est le Poussin de l'impressionnisme." Denis, "Cézanne," 132; reprinted in Denis, *Théories*, 252.

29. "Je sens très fortement le lien qui unit mes toiles les plus récentes à celles que j'ai peintes autrefois... Je tends toujours vers le même but, mais je calcule différemment ma route pour y aboutir." Matisse, "Notes d'un peintre," 733; translation modified from Flam, *Matisse on Art*, 35.

30. "Il n'inventa pas Cézanne, dont la réputation grandissait de jour en jour, mais il éclaira pour eux le fond même de sa manière, dans ce qu'elle avait d'absolu et les aida à donner une orientation à leurs efforts"; "base à la constitution d'une nouvelle tradition." Michel Puy, "Les Fauves," *La Phalange* 2 (15 November 1907): 454, 459.

31. "Les jeunes gens, ceux qui vont au classicisme,... sont moins théoriciens, ils croient davantage au pouvoir de l'instinct. Rien n'est à ce propos plus caractéristique que l'article publié dans la *Grande Revue* en décembre 1908 par M. H. Matisse... Ils ont besoin comme nous de vérités non pas rudimentaires ou négatives, mais positives, constructives. L'individualisme philosophique, le culte du moi n'a pu donner qu'un excitant intellectuel aux hommes de notre génération: ils ont senti la nécessité d'une règle de vie plus ferme et, après avoir erré à travers les nuées de la raison pure, ils reprennent maintenant contact avec des réalités solides, et des idéals collectifs." Denis, "De Gauguin et de Van Gogh au classicisme," 196; reprinted in Denis, *Théories*, 263. Benjamin

discusses Denis's "remarkable recantation" in *Matisse's "Notes of a Painter"*, 98.

32. "Si nous y traitons spécialement de la femme, c'est... parce qu'une étude complète du monde féminin est le plus sûr exposé de la vie physique et morale des peuples de la terre." Amédée Vignola, *Toutes les femmes: Etudes*, 2 vols. (Paris, 1901), 1:ix–x.

33. Once again, Cézanne is not far away: his *Still Life with Plaster Cupid* of c.1895 (London: Courtauld Institute Galleries), complete with fruit and figurine, stands as an obvious precedent for Matisse's picture.

34. Jack Flam, "Matisse and the Fauves," in *"Primitivism" in 20th Century Art: Affinity of the Tribal and the Modern*, ed. William Rubin, 2 vols. (New York, 1984), 1:224–26. On the accessiblity of Baule and Fang sculpture in Paris, Flam cites J. B. Donne, "African Art and Paris Studios, 1905–1920," in *Art and Society: Studies in Style, Culture, and Aesthetics*, ed. Michael Greenhalgh & Vincent Megaw (New York, 1978), 106–20.

35. See, for example, Le Docteur [René] Verneau, "Les Caractères physiques de la femme dans les principaux groupes humains," in Perrier & Verneau, *La Femme*, 1:412: "Les *Koranas* constituent une tribue hottentote dans laquelle se sont infiltrés beaucoup d'éléments étrangers. Néanmoins, la femme a conservé la plupart des caractères physiques de la Hottentote, notamment la stéatopygie. Dans sa jeunesse, la masse graisseuse accentue simplement son ensellure lombaire; mais, lorsqu'elle avance en âge, elle devient absolument difforme, l'envahissement des membres inférieurs par le tissu adipeux en arrivant à former d'énormes bourrelets qui retombent sur les pieds."

36. "La Femme dans le monde blanc" and "La Femme dans le monde noir" served Verneau as chapter headings. Verneau, "Les Caractères physiques de la femme," 1:403, 486.

37. Flam, "Matisse and the Fauves," 1:225.

38. "Dans le Soudan, on recontre des femmes dont la peau est franchment noire et présente même des reflets bleuâtres." Verneau, "Les Caractères physiques de la femme," 1:416.

39. Flam writes: "In this 1908 *Bathers*... the three upper heads bear at least some relation to African masks, while the interaction between the figures and the background, as well as some of the poses, is clearly Cézannesque." Flam, "Matisse and the Fauves," 1:220. Susan L. Ball has summarized the possible African sources for this and other paintings by Derain in "The Early Figural Paintings of André Derain, 1905–1910: A Re-Evaluation," *Zeitschrift für Kunstgeschichte* 43 (1980): 79–96. Compositionally, Derain's *Bathers* of 1908 virtually echoes Cézanne's *Five Bathers* (fig. 79) figure for figure. I will discuss the relation of this painting to Picasso's *Demoiselles d'Avignon* (fig. 89) in the conclusion.

40. "M. Braque, M. Van Dongen, M. Czobel, M. Derain ont évidemment peu de souci de la nature, et horreur de la beauté gréco-latine... Gauguin et ses Taïtiennes sont un peu responsables de cet enlaidissement des formes, de ces pieds quadrangulaires à quatre encoches. Mais l'exotisme de Gauguin avait une si forte odeur de nature! Ce brutal parfum est ici évanoui. M. Derain, qui a des dons de décoration, sait-il que même les Océaniens et les sauvages de toutes les latitudes ne méprisent ni la nature, ni la matière de l'œuvre d'art? Que s'il cherche en dehors de notre tradition occidentale l'aliment de son art, je lui conseille de voir au *British Museum* les admirables sculptures du Bénin... S'il ne goûte que les synthèses abstraites, je le prie de considérer les motifs de décoration des Indous ou des javanais... Même en dehors de toute idée de nature, dans le domaine de l'ornement pur, il y a des lois, des nécessités, et ce n'est pas seulement la sensibilité, mais la raison, qui est ici en défaut." Maurice Denis, "Sur l'Exposition des Indépendants," *La Grande Revue* 48 (10 April 1908): 552–53; reprinted as "Liberté épuisante et stérile," in Denis, *Théories*, 224–25.

41. Only later in 1909 did Denis reassess Gauguin in such a way as to bring him closer to the European tradition, casting him as an intermediate figure between Van Gogh's "déformation subjective" and Cézanne's "reconstruction d'art." Denis, "De Gauguin and de Van Gogh au classicisme," 193, 195; reprinted in Denis, *Théories*, 260, 262.

42. My account of Denis's trajectory resembles, and is somewhat modeled on, Michel de Certeau's schematic description of the cycle of departure and return within ethnographic writing. Michel de Certeau, *The Writing of History*, trans. Tom Conley (New York, 1988 [French ed. 1975]), 218–21.

43. *L'Humanité féminine*, no. 6 (5 January 1907): 40. Albert E. Elsen identifies this image as "a photograph from a French ethnographic periodical showing 'Jeunes filles targui,'" to which Flam responds: "Although this photograph is said to have come from an ethnographic magazine, the two women look like professional models posed against an artifical backdrop in a studio." Albert E. Elsen, *The Sculpture of Henri Matisse* (New York, [1972]), 83; Jack Flam, *Matisse: The Man and His Art* (Ithaca, 1986), 494n49. Since both authors know the image from the clipping found in Matisse's personal papers, they appear unaware of the name and hybrid character of the actual source periodical.

44. Elsen, *The Sculpture of Henri Matisse*, 83. Flam, in his discussion of the relation between *Two Negresses* and the photograph, remarks on the "negritude" of Matisse's piece. Flam, *Matisse*, 494n49.

45. "Ils ont enlevé l'oasis aux nègres et se sont métissés avec eux." *La Grande Encyclopédie: Inventaire raisonné des sciences, des lettres et des arts*, 31 vols. (Paris, [1886–1902]), 31:202. The taxonomies include Charles Letourneau, *La Condition de la femme dans les diverses races et civilisations* (Paris, 1903), 301–02; and Verneau, "Les Caractères physiques de la femme," 1:501–02.

46. A[médée] Vignola, "Sud-Algérie & Tunisie," *L'Humanité féminine*, no. 6 (5 January 1907), 40.

47. Vignola wrote of "la tribu berbère des Ouled-Naïls," whereas all other writers identified this group as Arab. A[médée] Vignola, "Bédouines et Berbères," *L'Humanité féminine*, no. 3 (15 December 1906), 19. The *Nouveau Larousse illustré* expounded: "OULED ou OULAD: mot arabe signif. ‹fils› et qui commence le nom d'une foule de tribus d'origine arabe de l'Afrique du Nord... alors que le mot BENI est réservé le plus souvent aux tribus d'origine berbère." *Nouveau Larousse illustré: Dictionnaire universel encyclopédique*, 8 vols. (Paris, [c.1900]), 6:579. Under "TOUAREG," the dictionary prescribes: "*Un* TARGUI. *Une* TARGUIE. —Adjectiv.: *Targui, ie*, et au pl. *touareg* (invar.)." *Nouveau Larousse illustré*, 7:1064.

48. Malek Alloula documents a case in which a single Algerian model, always dressed in the same costume, posed for three different post-card photographs all taken by the same photographer but variously labeled "Jeune Bédouine," "Jeune fille du Sud," and "Jeune fille kabyle." Malek Alloula, *The Colonial Harem*, trans. Myrna Godzich & Wlad Godzich (Minneapolis, 1986 [French ed. 1981]), 62–65.

49. "Il y a du monde... dans le quartier des Ouled-Naïls où les Arabes aiment à flâner. Biskra sans les Ouled-Naïls ne serait plus Biskra. Elles viennent de si loin et depuis tant d'années pour offrir leur jeunesse aux gens qui passent, et cet abandon de leur corps est une règle si générale dans leur tribu et si peu déshonorante que les indigènes les cultivent et les choyent comme les fleurs étranges qui décorent leurs jardins. Les Européens eux-mêmes les regardent sans répulsion, étonnés seulement de la bizarrerie de ces mœurs qui leur permettent de se vendre sans s'avilir. Aussi les rues qu'elles habitent ne sont pas des rues de parias; il n'y en a guère de mieux fréquentées dans la nouvelle ville." René Fage, *Vers les steppes et les oasis: Algérie-Tunisie* (Paris, 1906), 183. The association was reciprocal: if travelers' descriptions of Biskra almost invariably mentioned the 'Uled-Nayls, the definition of the "OULED-NAIL" from *Nouveau Larousse illustré* located "ces sirènes" "dans certaines villes, à Biskra notamment." *Nouveau Larousse illustré*, 6:579.

50. "Comment ils s'amusent... Sa joie, c'est l'expression brutale et grave de l'instinct qui se satisfait. Il ne s'élève guère au-dessus des simples plaisirs de l'amour et de la boisson." Louis

Bertrand, *Le Mirage oriental* (Paris, 1910), 145.

51. "On entre à Biskra comme dans un paradise terrestre." Fage, *Vers les steppes et les oasis*, 173.

52. "Voilà pourquoi sans doute, nous Occidentaux ... nous nous retournons avec tant de passion vers les chemins antiques." Cte V. d'Adhémar, *Mirages algériens* [and] *Le Voyage pratique* (Toulouse, 1990), 64.

53. de Certeau, *The Writing of History*, 228.

54. Linda Nochlin builds a similar argument about Gérôme in Linda Nochlin, "The Imaginary Orient," *Art in America* 71 (May 1983): 119–31, 186–91.

55. Edward W. Said, *Orientalism* (New York, 1978), 21. See also Roger Benjamin, "Matisse in Morocco: A Colonizing Esthetic?," *Art in America* 78 (November 1990): 158: "In the colonialist situation, it is almost always the West that retains the power to represent, to produce for Western consumption images of a colonized people whose own perspective remains unexplored."

56. "Le docteur se documente sur l'hygiène culinaire des Tourkouana."

57. For discussions of the repressive technology of the photographic police archive, Allan Sekula, "The Body and the Archive," *October* 39 (Winter 1986): 3–64; and John Tagg, *The Burden of Representation: Essays on Photographies and Histories* (Amherst, 1988).

58. "Un Orient déjà conquis et transformé par l'Europe." Bertrand, *Le Mirage oriental*, 30.

59. "Ainsi la métropole reconnaîtra dans la France nouvelle sa propre image." Augustin Bernard, in Augustin Bernard, J. Ladreit de Lacharrière, Camille Guy, André Tardieu, & René Pinon, *L'Afrique du nord* (Paris, 1913), 33.

60. For statements on the limited nature of the colonial penetration of the sub-Saharan region, see Gaston Dujarrie, "Préface," in Félix Chapiseau, *Au pays de l'esclavage: Mœurs et coutumes de l'Afrique centrale* (Paris, 1900), 2; and Abel Lahille, *Mes Impressions sur l'Afrique-Occidentale française*, 3rd ed. (Paris, [c.1910]), 197.

61. "Outre notre constitution physique, supérieure au point de vue d'intelligence, nous avons derrière nous quinze siècles de civilisation graduellement accumulés, tandis que le noir, lui, habillé aujourd'hui en gentleman, était hier encore anthropophage, avait les dents taillées en pointe, la tête coiffée de plumes, et égorgeait des petits enfants pour les offrir aux fétiches." Edouard Foà, *Résultats scientifiques des voyages en Afrique d'Edouard Foa* (Paris, 1908), 95.

62. The extended exchange in the pages of *Artforum* between the critic Thomas McEvilley and William Rubin, chief curator of the exhibition entitled *"Primitivism" in 20th Century Art* at the Museum of Modern Art in New York in 1984, provides a fine example in our own day of how much aesthetics and ethnography still share, not despite but because of their differences. McEvilley complains about the exhibition: "The museum's decision to give us virtually no information about the tribal objects on display, to wrench them out of context, calling them to heel in defense of formalist Modernism, reflects the exclusion of the anthropological point of view.... No attempt is made to recover an emic, or inside, sense of what primitive esthetics really were or are." Thomas McEvilley, "Doctor, Lawyer, Indian Chief: *"Primitivism" in 20th Century Art* at the Museum of Modern Art," *Artforum* 23 (November 1984): 57. This formulation conflates the ethnographic account with the "inside" truth about non-Western artifacts by pitting the pair against a "Modernist" interpretation, condemned by McEvilley as historically contigent. Rubin responds by elevating the concept of "art" to a universal aesthetic standard: "Many of the meanings attributed to [tribal objects] by previous generations of anthropologists are being dismissed left and right.... McEvilley *never accepts tribal sculptures as art* ... By denying the manifest genius of tribal artists, McEvilley excludes whole peoples from this cultural commonality." William Rubin, "On 'Doctor, Lawyer, Indian Chief: *"Primitivism" in 20th Century Art* at the Museum of - Modern Art,'" *Artforum* 23 (February 1985): 44–45. Clearly each system of representation—McEvilley's anthropology and Rubin's aesthetics—depends on projecting Eurocentrist relativism onto the other in order to promote its own capacity to reveal essential truths about alien cultures. To anticipate my argument in the following section: it could also be argued that the lack of resolution in the Rubin/McEvilley debate about the "real" character of non-Western artifacts justifies further intervention by Western scholars to address the uncertainties generated by their own disagreements. Aesthetics and ethnography together thereby receive a new mandate.

63. Said could be faulted on this account: By using the term "Orientalism" to refer, often ambiguously, both to an academic discipline and to a colonial system as a whole, Said treats the former as always the perfect synecdochal representation of the latter. I am suggesting here that the failure of the part may enhance the success of the whole. For cogent critiques of Said on this and other grounds, see Homi K. Bhabha, "The Other Question: The Stereotype and Colonial Discourse," *Screen* 24 (November–December 1983): 23–25; and James Clifford, "On *Orientalism*," in *The Predicament of Culture: Twentieth-Century Ethnography, Literature, and Art* (Cambridge, Mass., 1988).

64. Homi Bhabha, "Of Mimicry and Man: The Ambivalence of Colonial Discourse," *October* 28 (Spring 1984): 126.

65. Bhabha, "Of Mimicry and Man," 128.

66. Bhabha, "Of Mimicry and Man," 127.

67. Homi K. Bhabha, "Sly Civility," *October* 34 (Fall 1985): 75.

68. de Certeau, *The Writing of History*, 236. See also Christopher Miller, *Blank Darkness: Africanist Discourse in French* (Chicago, 1985), 16, 248: "Africanist writing projects out from itself an object that refuses to conform to the demands placed upon it.... Africa fills a need in the European novel, a need for something outside itself on which to form its discourse, a need for raw materials to be fashioned and reworked."

69. See Charles Blanc, *Grammaire des arts du dessin: Architecture, sculpture, peinture*, 5th ed. (Paris, 1883 [1st ed. 1867]), 548: "D'après le peu que nous savons de la peinture antique, et le peu qui nous en reste, il est permis de croire que le clair-obscur n'est devenu un moyen d'expression que dans les temps modernes."

70. Flam identifies this vase as a "Chinese porcelain." Flam, *Matisse*, 279. As the term "Orient" implies in both English and French, the Far East had more in common with the Near East from the European perspective than either did with black Africa. Certainly Oriental cultures near and far were attributed with aesthetic sensibilities, and the artifacts from both were praised for their masterful surface decoration.

71. Using some of this same visual evidence, Pierre Schneider argues that Matisse was on the road to complete "surrender" to Oriental decorative flatness: *Interior with Eggplants* of 1911 (Grenoble: Musée de Peinture et de Sculpture) is flatter still, and by the 1920s, maintains Schneider, many of the artist's canvases were pure two-dimensional decoration. Pierre Schneider, *Matisse*, trans. Michael Taylor & Bridget Strevens Romer (New York, 1984 [French ed. 1984]), 176. As an account of the earlier paintings, this interpretation risks the fallacy of teleology; it also ignores the many canvases from the 1920s, often with Oriental themes, that do not collapse into flatness.

72. Sarah Graham-Brown, *Images of Women: The Portrayal of Women in Photography of the Middle East 1860–1950* (New York, 1988), 21.

73. James Clifford, "The Others: Beyond the 'Salvage' Paradigm," *Third Text* 6 (Spring 1989): 73–74.

74. Cited in Graham-Brown, *Images of Women*, 45.

75. James Clifford, "On Collecting Art and Culture," in *The Predicament of Culture*, 220. He refers to Susan Stewart, *On Longing: Narratives of the Miniature, the Gigantic, the Souvenir, the Collection* (Baltimore, 1984).

76. Bhabha, "The Other Question," 27.

NOTES TO THE CONCLUSION

1. See chapter 4, section 3.

2. "Il s'est vu plus latin moralement, plus arabe rhymiquement." Guillaume Apollinaire, "Les Jeunes: Picasso, peintre," *La Plume*, no. 372 (15 May 1905): 483; reprinted in Guillaume Apollinaire, *Chroniques d'art: 1902–1918*, ed. L.-C. Breunig (Paris, 1980), 39.

3. William Rubin thoroughly summarizes the black-African sources and "affinities" for these three faces. William Rubin, "Picasso," in *"Primitivism" in 20th Century Art: Affinity of the Tribal and the Modern*, ed. William Rubin, 2 vols. (New York, 1984), 1:255–66. Rubin suggests Oceanic as well as African prototypes for *Les Demoiselles d'Avignon*. Since contemporaries would have made little distinction between the two and probably would have regarded them as equally alien, I will not trouble to distinguish the one from the other in my text.

4. The comparison here with Manet's *Olympia* (fig. 25) is pressing enough to require comment. Certainly Manet, like Picasso, evoked idealized nudes from the past in his depiction of a modern prostitute. However, the earlier artist did so (if I may simplify) largely for the sake of declaring the priority of representations of the contemporary, the painting of modern life, over those of the past. Picasso's *Demoiselles d'Avignon*, on the other hand, neither subsumes past into present nor present into past.

5. "Les œuvres les plus importantes et les plus audacieuses qu'elle [la nouvelle école] produisit aussitôt furent celles d'un grand artiste que l'on doit aussi considérer come un fondateur: Pablo Picasso"; "La grande révolution des arts ... il a accompli presque seul." Guillaume Apollinaire, *Méditations esthétiques: Les Peintres cubistes* (Paris, 1980 [1st ed. 1913]), 66, 79.

6. "L'art moderne repousse, généralement, la plupart des moyens de plaire mis en œuvre par les grands artistes des temps passés." Apollinaire, *Méditations esthétiques*, 58.

7. "La vraisemblance n'a plus aucune importance, car tout est sacrifié par l'artiste aux vérités, aux nécessités d'une nature supérieure qu'il suppose sans la découvrir. Le sujet ne compte plus ou s'il compte c'est à peine." Apollinaire, *Méditations esthétiques*, 58. In 1907, Apollinaire had once auditioned Matisse for the role of the artist without subject matter: "L'éloquence de vos ouvrages vient avant tout de la combinaison des couleurs et des lignes. C'est ce qui constitue l'art de peintre et non comme le croient encore certains esprits superficiels, la simple reproduction de l'objet." Guillaume Apollinaire, "Henri Matisse," *La Phalange* 2 (15 December 1907): 483. This article stresses Matisse's personality as the source of his art, and Apollinaire included several short quotations from the artist to support his case. However, the article on Matisse was an isolated one in Apollinaire's writings; by 1913 at the latest

Picasso had clearly replaced Matisse completely as Apollinaire's exemplar of purely formal art.

8. Apollinaire is also the source of the still distressingly frequent formulation that pre-Cubist paintings are "perceptual" while Cubist paintings and their offspring are "conceptual." "Ce qui différencie le cubisme de l'ancienne peinture, c'est qu'il n'est pas un art d'imitation, mais un art de conception qui tend à s'élever jusqu'à la création"; "Le cubisme est l'art de peindre des ensembles nouveaux avec des éléments empruntés, non à la réalité de vision, mais à la réalité de conception." Apollinaire, *Méditations esthétiques*, 67, 144. By now, at least, the differentiation should seem glaringly suspect: an artist can neither perceive anything without preceding conceptions, nor conceive anything without preceding perceptions. The weakness of the idea should not blind us, however, to its rhetorical function: from *Méditations esthétiques* to its latest reiteration in text and in classroom, the distinction between perception and conception has served as the means of dismissing subject matter in order to concentrate on hermetic formal issues.

9. See, for example, Roland Penrose, *Picasso: His Life and Work*, rev. ed. (New York, 1971 [1st ed. 1958]), 133.

10. See the extended exchange between William Rubin and Leo Steinberg: William Rubin, "Cézannisme and the Beginnings of Cubism," in *Cézanne: The Late Work*, ed. William Rubin (New York, 1977), 151–202; Leo Steinberg, "Resisting Cézanne: Picasso's *Three Women*," *Art in America* 66 (November–December 1978): 114–33; Leo Steinberg, "The Polemical Part," *Art in America* 67 (March–April 1978): 114–27; and William Rubin, "Pablo and Georges and Leo and Bill," *Art in America* 67 (March–April 1978): 128–47. See also William Rubin, "Picasso and Braque: An Introduction," in *Picasso and Braque: Pioneering Cubism* (New York, 1989).

11. My analysis of the interwar decades in this conclusion is a limited one, tracing only the destiny of certain artists and concepts I discuss earlier in the thesis. Three recent studies provide more complete view of the artistic issues of this era: Malcolm Gee, *Dealers, Critics and Collectors of Modern Painting, 1910–1930* (New York, 1981); Christopher Green, *Cubism and Its Enemies: Modern Movements and Reaction in French Art, 1916–1928* (New Haven & London, 1987); and Kenneth E. Silver, *Esprit de Corps: The Art of the Parisian Avant-Garde and the First World War* (Princeton, 1989).

12. "Nous distingerons d'un côté la tendance *naturaliste*, avec les efforts de la pléiade d'artistes que l'on pourrait également ranger sous la rubique *L'Art Vivant*... Dans un camp opposé, nous reconnaîtrions l'*Idéalisme* parmi les efforts des Cubistes et de certains de leurs disciples." Maurice Raynal, *Anthologie de la peinture française de 1906 à nos jours* (Paris, 1927), 10. Christopher Green provides a deeper analysis of this text, including Raynal's introduction of the intermediate category of "L'Eclectisme." Green, *Cubism and Its Enemies*, 124–26.

13. "Si Picasso mérita d'être nommé l'Animateur, André Derain, qui n'a subi d'autres influences que celles des maîtres éternels, vaut d'être aujourd'hui considérée ainsi que le Régulateur." André Salmon, "André Derain," *L'Amour de l'art* 1 (1920): 196.

14. "Braque rejoint la grande lignée des peintres classiques.... Pendant que Picasso conduisait l'art à sa libération totale, Braque lui faisait retrouver la grande tradition." Christian Zervos, "Georges Braque," *Les Cahiers d'art* 8 (January–February 1933): 7.

15. "Matisse oppose au principe dynamique, mais trop souvent stérile qui régit l'art de Pablo Picasso, le principe immanent de perfection française." W[aldemar] G[eorge], "Dualité de Matisse," *Formes*, no. 16 (June 1931): 94.

16. "La peinture d'Henri-Matisse évolue vers plus d'intimité et de profoundeur; elle connaît ses limites et c'est dans son climat qu'elle s'épanouira avec une unité qui surprend. Picasso, lui, suivra la tendance opposée, se répandant dans toutes les directions, Protée, brisant comme à plaisir et avec une malice infernale tout ce qui pourrait donner à sa personnalité une continuité sans surprises et sans heurts. Le nomade Pablo Picasso, explorateur des formes et des civilisations, se dressera alors en face du peintre Henri-Matisse, prêtre de la lumière méditerranéenne." Pierre Courthion, *Henri-Matisse* (Paris, 1934), 19.

17. "Représentant accompli de l'audacieux et lucide génie français." Jean Cassou, *Matisse* (Paris, 1939), [unpaginated].

18. Not surprisingly, one of the very few writers to regard Picasso as at least partially French was the German Wilhelm Uhde. "Picasso, grâce aux rapports de son esprit avec la tradition française, acquit un grand art gothique... Le cubism de Picasso était la seconde grande manifestation du sentiment gothique en terre de France." Wilhelm Uhde, *Picasso et la Tradition française: Notes sur la peinture actuelle* (Paris, 1928), 28. Yet even here Picasso is not classical, and Uhde also makes a point in his text of differentiating Picasso from Matisse and Braque. Around 1925 Jean Cocteau, a close friend of Picasso and a bit of a marginal character himself, also posited a link between the artist and France: "Je n'insiste pas sur l'Espagne. Picasso est de chez nous. Il a mis toutes les forces, toutes les ruses de sa race à l'école et au service de la France." Jean Cocteau, *Picasso* (Paris, [1923]), 28. Nevertheless elsewhere in the article it is clear that for Cocteau Picasso was primarily an autonomous individual, and even in this passage Picasso is not actually described as

French: there is an importance difference between being "chez nous" and being one of "us." A handful of critics set Picasso against himself by contrasting his "French" realist and classical works from the late 1910s and early 1920s to his more innovative Cubist and Surrealist paintings. See, for example, [Roger?] Bissière, "L'Exposition Picasso," *L'Amour de l'art* 2 (1921): 209–12; and Maurice Raynal, "Préface," in Raymond Cognait, *Les Etapes de l'art contemporain V: Les Créateurs du cubisme* (Paris, 1935), [unpaginated]. Such intramural analyses of Picasso's *œuvre* invariably concluded by reading such variation as a sign of Protean individuality unrestrained, for better or worse, by national character; a naturally French painter could produce only the art of his race.

19. "Israélite sans attaches." René Huyghe, "Le Cubisme: Introduction," in *Histoire de l'art contemporain*, ed. René Huyghe (Paris, 1935), 213. Waldemar George also attributed "sang juif" to Picasso in Waldemar George, "Aut César aut nihil: En marge de l'exposition Picasso aux Galeries Georges Petit," *Formes*, no. 25 (May 1932): 270. Two years earlier he had suggested a German tenor to Picasso's paintings: "Le plus souvent le tableau [de Picasso] lui [le spectateur] arrache ce cri du cœur: *Ach, wie interessant!*" Waldemar George, "Grandeur et Décadence de Pablo Picasso," *L'Art vivant* 6 (1930): 594.

20. This formulation owes much to a New-Historical concept derived from Michel Foucault, most often attributed to Stephen Greenblatt, but well articulated by Jonathan Dollimore: "If the very conflicts which the existing order generates from within itself are construed as attempts to subvert it from without (by the 'alien'), that order strengthens itself by simultaneously repressing dissenting elements and eliciting consent for this action: the protection of society from subversion." Jonathan Dollimore, "Shakespeare, Cultural Materialism and the New Historicism," in *Political Shakespeare: New Essays in Cultural Materialism*, ed. Jonathan Dollimore & Allan Sinfield (Ithaca, 1985), 7.

21. I briefly explore this post-war change in Picasso's standing in James D. Herbert, "Matisse without History," *Art History* 11 (June 1988): 298–99.

22. "On connaît l'anecdote d'Apelle et de Protogène qui est dans Pline.... Apelle aborde, un jour, dans l'île de Rhodes pour voir les ouvrages de Protogène, qui y demeurait. Celui-ci était absent de son atelier quand Apelle s'y rendit. Une vieille était là qui gardait un grand tableau tout prêt à être peint. Apelle au lieu de laisser son nom, trace sur le tableau un trait si délié qu'on ne pouvait rien voir de mieux venu. De retour, Protogène apercevant le linéament, reconnut la main d'Apelle, et traça sur le trait un trait d'une autre couleur et plus subtil encore, et, de cette façon, il semblait qu'il y eût trois traits. Apelle revint encore le lendemain sans rencontrer celui qu'il cherchait et la subtilité du trait qu'il traça ce jour-là désespéra Protogène. Ce tableau causa longtemps l'admiration des connaisseurs qui le regardaient avec autant de plaisir que si, au lieu d'y représenter des traits presque invisibles, on y avait figuré des dieux et des déesses." Apollinaire, *Méditations esthétiques*, 59–60.

23. See Silver, *Esprit de Corps*.

24. Rubin, "Cézannisme and the Beginnings of Cubism," 194.

25. Steinberg, "Resisting Cézanne," 131.

BIBLIOGRAPHY OF CITED SOURCES

PRIMARY SOURCES

Adam, Paul. *La Morale des sports*. Paris, 1907.

d'Adhémar, Cte V. *Mirages algériens* [and] *Le Voyage pratique*. Toulouse, 1900.

Allard, Roger. *Baudelaire et "L'Esprit nouveau"*. Paris, 1918.

Antonelli, Etienne. *La* Démocratie sociale *contre l'*Action française: *Décembre 1909– décembre 1910*. Paris, [n.d.].

Apollinaire, Guillaume. *Chroniques d'art: 1902–1918*. Ed. L.-C. Breunig. Paris, 1980.

———. "Henri Matisse." *La Phalange* 2 (15 December 1907): 481–85.

———. "Les Jeunes: Picasso, peintre." *La Plume*, no. 372 (15 May 1905): 478–83.

———. *Méditations esthétiques: Les Peintres cubistes*. Paris, 1980 [1st ed. 1913].

Ardouin-Dumazet. *Voyage en France*. 70 vols. Paris & Nancy, 1893–1922.
- Vol. 13: *La Provence maritime*. 1898.
- Vol. 37: *Le Golfe de Lion*. 1904.
- Vol. 46: *Region parisienne V: Nord-Ouest, la Seine de Paris à la mer*. 1907.
- Vol. 47: *Region parisienne VI: Ouest, l'Yveline et le Mantois*. 1907.

Aurier, G.-Albert. "Les Isolés: Vincent van Gogh." *Mercure de France, modern series*, 1 (January 1890): 24–29.

Aynard, Joseph. *Londres, Hampton Court et Windsor*. Paris, 1912.

Baedeker, Karl. *Londres et ses environs*. 11th ed. Leipzig, 1907.

———. *Le Nord-Ouest de la France*. 8th ed. Leipzig, 1908.

———. *Paris et ses environs*. 16th ed. Leipzig, 1907.

Bayard, Emile. *Le Nu esthétique*. 5 vols. Paris, 1902–07.

Bazalgette, Léon. *L'Esprit nouveau dans la vie artistique, sociale et religieuse*. Paris, 1898.

———. *Le Problème de l'avenir latin*. Paris, 1903.

Beauchamp, Octave. *L'Ile de France*. Clichy, [1910].

Bergon, Paul, & René Le Bègue. *Le Nu et le Drapé en plein air*. Paris, [1898].

Bernard, Augustin, J. Ladreit de Lacharrière, Camille Guy, André Tardieu, & René Pinon. *L'Afrique du nord*. Paris, 1913.

Bernard, Emile [Francis Lepeseur, pseud.]. "L'Anarchie artistique: Les Indépendants." *La Rénovation* [title changed July 1905 to *La Rénovation esthétique*] 1 (June 1905): 91–96.

——— [Francis Lepeseur, pseud.]. "Du culte de la personnalité." *La Rénovation esthétique* 3 (September 1906): 260–64.

———. "Les Rénovateurs de l'art." *La Rénovation esthétique* 1 (September 1905): 267–74.

de Bernhardt, F. *Londres et la Vie à Londres*. Paris, 1906.

Bertrand, Louis. *Le Mirage oriental*. Paris, 1910.

Bissière, [Roger?]. "L'Exposition Picasso." *L'Amour de l'art* 2 (1921): 209–12.

Blanc, Charles. *Grammaire des arts du dessin: Architecture, sculpture, peinture*. 5th ed. Paris, 1883 [1st ed. 1867].

Boland, Henri. *En douce France*. Paris, 1910.

Bordeaux, Henry. *Paysages romanesques*. Paris, 1906.

Bourg de Bozas, Mission scientifique du [Robert]. *De la Mer Rouge à l'Atlantique à travers l'Afrique tropicale.* Paris, 1906.

Bourget, Paul. *La Côte d'Azur.* Paris, [n.d.].

Bourgouin-Malchante, Louis. *John Bull et sa Capitale.* Laval, 1909.

Bouyer, Raymond. *Le Paysage dans l'art.* Paris, 1894.

——. "Poussin, novateur et paysagiste." *L'Art et les Artistes* 4 (February 1907): 385–90.

Bray, Lucien. *Du Beau: Essai sur l'origine et l'évolution du sentiment esthétique.* Paris, 1902.

Brousse, Paul. "Provençaux et Roumains." *La Nouvelle Revue,* new series, 40 (15 May 1906): 213–24.

Burgess, Gelett. "The Wild Men of Paris." *Architectural Record* 27 (May 1910): 401–14.

Burke, Edmund. *A Philosophical Enquiry into the Origin of Our Ideas of the Sublime and Beautiful.* Ed. J. T. Boulton. London, 1958.

Cabos, Alban. *L'Education classique traditionnelle: Discours prononcé à la distribution des prix du Collège Saint-Nicolas de Gimont, le 22 juillet 1911.* Auch, [1911].

"La Carte postale illustrée." *Le Figaro illustré,* special issue (October 1904): [unpaginated].

Casella, Georges. *Le Sport et l'Avenir.* Paris, 1910.

Cassou, Jean. *Matisse.* Paris, 1939.

C[atonné], Am[édée]. "Aux Indépendants." *Les Temps nouveaux,* 15–21 April 1905.

Chervet, Henri. "Le IVe Salon d'Automne." *La Nouvelle Revue,* new series, 43 (1 November 1906): 97–102.

Clouard, Henri. *Les Disciplines: Nécessité littéraire et social d'une renaissance classique.* Paris, 1913.

Cochin, Henry. "A propos de quelques tableaux impressionnists." *Gazette des beaux-arts,* 3rd period, 32 (1 August 1904): 101–12.

Cocteau, Jean. *Picasso.* Paris, [1923].

Coquiot, Gustave. *Dimanches d'été.* Paris, [1897].

——. *En suivant la Seine . . .* [elipsis in the title in the original]. Paris, 1926.

Courthion, Pierre. *Henri-Matisse.* Paris, 1934.

Daelen, Edouard. *Le Moralité du nu.* Paris, [1905].

Daudet, Léon. *Le Stupide XIXe Siècle: Exposé des insanités meurtrières qui se sont abattués sur la France depuis 130 ans, 1789–1919.* Paris, 1922.

Dauzat, Albert. *Pour qu'on voyage: Essai sur l'art de bien voyager.* Toulouse & Paris, 1911.

——. *Le Sentiment de la nature et son expression artistique.* Paris, 1914.

De Paris à Versailles, Saint-Germain, Marly. Paris, [1912].

Deiss, Edouard. *Un Eté à Londres: Souvenirs d'un passant.* Paris, [1900].

Denis, Maurice. "Cézanne." *L'Occident* 12 (September 1907): 118–33.

——. "De Gauguin et de Van Gogh au classicisme." *L'Occident* 15 (May 1909): 187–202.

——. *Henri-Edmond Cross.* Paris, 1907.

—— [P.-L. Maud, pseud.]. "L'Influence de Paul Gauguin." *L'Occident* 4 (October 1903): 160–64.

——. "La Peinture." *L'Ermitage* 16.1 (15 May 1905): 310–20.

——. "La Peinture." *L'Ermitage* 16.2 (15 November 1905): 309–19.

——. "La Peinture." *L'Ermitage* 17.1 (15 June 1906): 321–26.

——. "Sur l'Exposition des Indépendants." *La Grande Revue* 48 (10 April 1908): 545–53.

——. *Théories 1890–1910: Du symbolisme et de Gauguin vers un nouvel ordre classique.* 2nd ed. Paris, 1912 [1st ed. 1912].

Derain, André. *Lettres à Vlaminck.* Paris, 1955.

Deschanel, Paul. *La République nouvelle.* Paris, 1898.

Desjardins, Paul. *Poussin.* Paris, [1904].

Dillaye, Frédéric. *Principes et Pratique d'art en photographie: Le Paysage.* Paris, 1899.

Dralin, Georges. "Propos." *L'Occident* 5 (May 1904): 234–39.

Dujardin, Victor. *Voyages aux Pyrénées: Souvenirs du Midi par un homme du Nord; Le Roussillon.* Céret, 1890.

Dujarrie, Gaston. "Préface." In Félix Chapiseau. *Au pays de l'esclavage: Mœurs et*

coutumes de l'Afrique centrale. Paris, 1900.

Dumont, W[illiam] H., & Ed[ward] Suger. *Londres et les Anglais*. Paris, 1908.

Duret, Théodore. *Histoire des peintres impressionnistes*. Paris, 1906.

——. *Vincent van Gogh*. Paris, 1916.

Epuy, Michel. *Le Sentiment de la nature*. Paris, 1907.

Fage, René. *Vers les steppes et les oasis: Algérie-Tunisie*. Paris, 1906.

Fagus, Félicien. "Gazette d'art: L'Art de demain." *Revue blanche* 29 (1 December 1902): 542–46.

——. "Gazette d'art: Exposition Pissarro." *Revue blanche* 24 (1 February 1901): 222–23.

Fitzgerald, Desmond. "Claude Monet: Master of Impressionism." *Brush & Pencil* 15 (March 1905): 181–95.

Foà, Edouard. *Résultats scientifiques des voyages en Afrique d'Edouard Foa*. Paris, 1908.

Fontaines, Georges. *La Côte d'Azur en l'an 1897: Nice, Cannes, Monaco, Menton, Monte-Carlo*. Lyon, 1897.

"Foski." "Carnet de Paris: Aux Indépendants." Parts 1, 2. *La Nouvelle Revue*, new series, 39 (1 April, 15 April 1906): 417–19, 560–63.

Gaborit, L'abbé. *Le Beau dans la nature*. 3rd ed. Nantes, 1893 [1st ed. 1871].

Gaultier, Paul. *Reflets d'histoire*. Paris, 1909.

Geffroy, Gustave. "La Tamise de Claude Monet: Exposition rue Laffitte." *L'Humanité*, 4 June 1904. Reprinted in Gustave Geffroy. *Claude Monet: Sa vie, son œuvre*. 2 vols. Paris, 1926.

George, Waldemar. "Aut César aut nihil: En marge de l'exposition Picasso aux Galeries Georges Petit." *Formes*, no. 25 (May 1932): 268–71.

——. "Dualité de Matisse." *Formes*, no. 16 (June 1931): 94–95.

——. "Grandeur et Décadence de Pablo Picasso." *L'Art vivant* 6 (1930): 593–97.

Germain, Auguste. *Le Nu au Salon: Année 1908*. Paris, 1908.

Gide, André. "Promenade au Salon d'Automne." *Gazette des beaux-arts*, 3rd period, 34 (1 December 1905): 475–85.

Girard, André. "L'Idéal." *Les Temps nouveaux*, 14 July 1906.

La Grande Encyclopédie: Inventaire raisonné des sciences, des lettres et des arts. 31 vols. Paris, [1886–1902].

Grave, Jean. *L'Individu et la Société*. Paris, 1897.

——. *Réformes, Révolution*. Paris, 1910.

——. *La Société future*. 8th ed. Paris, 1903 [1st ed. 1895].

——. *Le Syndicalisme dans l'évolution sociale*. Paris, 1908.

——. *Terre libre (Les Pionniers)*. Paris, 1908.

Grimanelli, P[ericles]. *La Femme et le positivisme*. Paris, 1905.

Gruyer, Paul (Guide Joanne). *Bains de mer de Normandie du Tréport au Mont Saint-Michel: Guide pratique des stations balnéaires*. Paris, 1913.

Gsell, Paul. "Les Salons de 1909: L'Orientation de l'art contemporain." *La Revue* 80 (1 June 1909): 330–44.

Guérin, Joseph. "Les Arts: Galeries Durand Ruel, Exposition de Claude Monet." *L'Ermitage* 15.2 (June 1904): 152–53.

——. "Les Arts: Paul Gauguin." *L'Ermitage* 14.3 (November 1903): 232–34.

Herckenrath, C. R. C. *Problèmes d'esthétique et de morale*. Paris, 1898.

Holl, J.-C. *Après l'impressionnisme*. Paris, 1910.

——. "Salon d'Automne." *Les Cahiers d'art et de littérature*, no. 5 (October 1906): 67–114.

Huard, Charles. *Londres comme je l'ai vu*. Paris, 1908.

Hubert, H. *Etude sommaire de la représentation du temps dans la religion et la magie*. Paris, 1905.

Huyghe, René. "Le Cubisme: Introduction." In *Histoire de l'art contemporain*, ed. René Huyghe. Paris, 1935.

Jamot, Paul. "*L'Inspiration du poète* par Poussin." *Gazette des beaux-arts*, 4th period, 6 (September 1911): 177–92.

——. "Le Salon d'Automne." *Gazette des beaux-arts*, 3rd period, 36 (1 December 1906): 456–84.

Joanne, Adolphe (Guide Diamant). *Normandie*. Paris, 1873.

Kahn, Gustave. "L'Exposition Claude Monet." *Gazette des beaux-arts*, 3rd period, 32 (1 July 1904): 82–88.

[Kant, Immanuel]. *Kant's Critique of Judgement.* 2nd ed., rev. Trans. J. H. Bernard. London, 1931 [German ed. 1790].

Klary, C. *La Photographie du nu.* Paris, 1902.

Lahille, Abel. *Mes Impressions sur l'Afrique-Occidentale française.* 3rd ed. Paris, [c.1910].

Lanoë, Georges. *Histoire de l'école française de paysage depuis Chintreuil jusqu' à 1900.* Nantes, 1905.

Laurens, Jules. *La Légende des ateliers: Fragments et notes d'un artiste peintre (de 1818 à 1900).* Carpentras, 1901.

Leblond, Marius-Ary. "La Vie tahitienne de Paul Gauguin." *Revue bleue,* 5th series, 1 (14 May 1904): 635–40.

Lechartier, G. *L'Anarchie.* Paris, [1900].

Lecomte, Georges. "L'Œuvre de Renoir." *L'Art et les Artistes* 5 (April–September 1907): 243–53.

Letourneau, Charles. *La Condition de la femme dans les diverses races et civilisations.* Paris, 1903.

Lux, Jacques. "Chronique: Plages de France." *Revue bleue,* 5th series, 8 (7 September 1907): 319–20.

Matisse, Henri. "Notes d'un peintre." *La Grande Revue* 52 (25 December 1908): 731–45.

Mauclair, Camille. "La Critique d'art: Sa mission, son état actuel." *Revue bleue,* 5th series, 10 (28 November 1908): 681–84.

——. "De Fragonard à Renoir (Une Leçon de nationalisme picturale)." *Revue bleue,* 5th series, 2 (9 July 1904): 45–49.

——. *L'Impressionnisme: Son histoire, son esthétique, ses maîtres.* Paris, 1904.

——. "La Réaction nationaliste en art et l'ignorance de l'homme de lettres." *La Revue* 54 (15 January 1905): 151–74.

——. *Trois Crises de l'art actuel.* Paris, 1906.

Maurras, Charles. *Dictionnaire politique et critique.* Ed. Pierre Chardon. 5 vols. Paris, 1932–34.

——. *Enquête sur la monarchie.* Versailles, 1928 [first published serially in 1900].

——. *L'Etang de Berre.* Paris, 1915.

——. "Liberalisme et Libertés: Démocratie et Peuple." *Action française,* special issue (1906).

——. *Quand les Français ne s'aimaient pas.*
• 2nd ed. Paris, 1916 [1st ed. 1916].
• New ed. Paris, 1926.

Maybon, Albert. "Félibrige et Nationalisme." *Revue blanche* 29 (15 September 1902): 139–48.

Meyer, Bruno. *La Grâce féminine.* Paris, 1904–05.

Michel, André. *Exposition Universelle de 1900: Les beaux-arts et les arts décoratifs.* Paris, [1901].

Michel, Emile. *Les Maîtres du paysage.* Paris, 1906.

Mithouard, Adrien. "Le Classique occidental." *L'Occident* 1 (March 1901): 179–87.

——. "Lettre à Charles Maurras." *L'Occident* 3 (February 1903): 67–74.

——. "Maurice Denis." *Art et Décoration* 22 (July 1907): 1–12.

——. "Vers la simplicité." *L'Ermitage* 12.2 (July 1901): 26–39.

Monod, François. "Chronique." *Art & Décoration* 23 (February 1908): supplement, 1–3.

——. "Les Expositions: Le 21e Salon des Indépendants." *Art & Décoration* 17 (May 1905): supplement, 1–3.

de Montesquiou, Léon. *De l'anarchie à la monarchie.* Paris, 1911.

——. *Les Raisons du nationalisme.* Paris, 1905.

Monteuuis, Dr [Adolphe]. *L'Usage chez soi des bains d'air, de lumière et de soleil: Leur Valeur pratique dans le traitement des maladies et dans l'hygiène journalière.* Nice, Paris & Brussels, 1911.

Moreau-Vauthier, Ch[arles]. *La Peinture.* Paris, 1913.

Morice, Charles. "Le XXIe Salon des Indépendants." *Mercure de France,* modern series, 54 (15 April 1905): 536–56.

——. "Le XXIIe Salon des Indépendants." *Mercure de France,* modern series, 60 (15 April 1906): 534–44.

de Morsier, E. "Une Conquête moderne: Le

Tourisme." *La Revue* 56 (15 May 1905): 211–19.

Nadal, Victor. *Le Nu au Salon*. 2 vols. Paris, 1905.

Narsy, Raoul. "M. Salomon Reinach ou le classique cosmopolite." *L'Occident* 8 (October 1905): 155–59.

Natanson, Thadée. "De M. Renoir et de la beauté." *Revue blanche* 21 (1 March 1900): 370–77.

"Notre But." *La Rénovation* [title changed July 1905 to *La Rénovation esthétique*] 1 (May 1905): 3–6.

"Notre Enquête sur les collections et les collectionneurs." *Revue Illustrée de la carte postale* 6 (25 May 1905): 612–13.

Nouveau Larousse illustré: Dictionnaire universel encyclopédique. 8 vols. Paris, [1898–1904].

"L'*Olympia* de Manet au Louvre." *Le Rénovation esthétique* 5 (May 1907): 56.

Pasquet, D. *Londres*. Melun, 1909.

Paulhan, Fr[édéric]. *L'Esthétique du paysage*. Paris, 1913.

Perrier, Edmond, & Le Dr [René] Verneau. *La Femme: Dans la nature, dans les mœurs, dans la légende, dans la société*. 4 vols. Paris, [1908].

Pératé, André. "Le Salon d'Automne." *Gazette des beaux-arts*, 3rd period, 38 (1 November 1907): 385–407.

Puy, Michel. "Les Fauves." *La Phalange* 2 (15 November 1907): 450–59.

Raynal, Maurice. *Anthologie de la peinture française de 1906 à nos jours*. Paris, 1927.

———. "Préface." In Raymond Cognait. *Les Etapes de l'art contemporain V: Les Créateurs du cubisme*. Paris, 1935.

Reclus, Onésime. *A la France: Sites et Monuments*. 33 vols. Paris, 1900–06. Vol. 18: *Pyrénées Orientales*. 1903.

Rivière, Jacques. *Etudes*, 17th ed. Paris, 1944 [1st ed. 1911].

Rouart, Louis. "L'Avenir de l'intelligence selon M. Charles Maurras." *L'Occident* 5 (January 1904): 14–27.

———. "Maurice Denis." *L'Occident* 6 (December 1904): 312–13.

Salmon, André. "André Derain." *L'Amour de l'art* 1 (1920): 196–99.

Saunier, Charles. "Petite Gazette d'art: Claude Monet." *Revue Blanche* 23 (15 December 1900): 624.

Sauvebois, Gaston. *L'Equivoque du classicisme*. Paris, 1911.

Seguin, Armand. "Paul Gauguin." Parts 1, 2, 3. *L'Occident* 3 (March, April, May 1903): 158–67, 230–39, 298–305.

de la Sizeranne, Robert. *Les Questions esthétiques contemporaines*. Paris, 1904.

Société de Salon d'Automne. *Catalogue de peinture, dessin, sculpture, gravure, architecture et art décoratif*. Paris, 1905.

———. *Catalogue des ouvrages de peinture, sculpture, dessin, gravure, architecture et art décoratif*. Paris, 1906.

Stackelberg, Frédéric. *La Mesure du temps*. Paris, 1899.

Stryienski, Casimir. "Impressions de la Riviera: Maisons d'artistes." *Revue bleue*, 5th series, 7 (5 January 1907): 31–32.

Syffert, Gaston. "Baudelaire." *Portraits d'hier*, no. 7 (15 June 1909): 195–223.

Tarbel, Jean [J. Delorme-Jules-Simon?]. "Le Grand Peintre français: Nicolas Poussin." *Le Correspondant* 228 (10 August 1907): 544–65.

Thierry, Georges P. *A travers un siècle de notre yachting de course à voile*. Paris, 1948.

Tranchant, L. *L'Illustration photographique des cartes postales*. Paris, 1902.

Tranchant, Marius. *L'Habitation du Parisien en banlieue*. Paris, 1908.

Uhde, Wilhelm. *Picasso et la Tradition française: Notes sur la peinture actuelle*. Paris, 1928.

d'Ussel, Le Comte. "Des Voyages à l'époque actuelle." *Le Correspondant* 228 (10 September 1907): 955–79.

Uzanne, Octave. *Nos Contemporaines: La Femme à Paris, notes sucessives sur les Parisiennes de ce temps dans leurs divers milieux, états et conditions*. Paris, 1894.

van Bever, Ad. "Les Aînés: Un Peintre maudit, Vincent van Gogh (1853–1890)." Parts 1, 2. *La Plume*, nos. 373, 374 (1 June, 15 June 1905): 532–45, 596–609.

Vauxcelles, Louis. "Salon d'Automne." *Gil Blas*, 17 October 1905.

——. "Le Salon d'Automne." *Gil Blas*, 5 October 1906.

——. "Le Salon des 'Indépendants." *Gil Blas*, 20 March 1907.

Vignola, Amédée. "Bédouines et Berbères." *L'Humanité féminine*, no. 3 (15 December 1906).

——. "Sud-Algérie & Tunisie." *L'Humanité féminine*, no. 6 (5 January 1907).

——. *Toutes les femmes: Etudes*. 2 vols. Paris, 1901.

de Visan, Tancrède. "La Réaction nationaliste en art: Réponse à M. Camille Mauclair." *La Plume*, nos. 367–68 (1–15 March 1905): 131–36.

Vlaminck, Maurice. "Le Chemin." *Le Libertaire*, 13–20 July 1901.

——. "L'Entente." *Le Libertaire*, 16–23 December 1900.

——. *Portrait avant décès*. Paris, 1943.

——. *Tournant dangereux: Souvenirs de ma vie*. Paris, 1929.

Votez, Mme Léonide. *2400 Kilometres à travers la France*. Paris & Laval, 1907.

Werth, Léon. "Le Mois de peinture." *La Phalange* 5 (20 June 1910): 725–32.

Zervos, Christian. "Georges Braque." *Les Cahiers d'art* 8 (January–February 1933): 1–7.

SECONDARY SOURCES

Alloula, Malek. *The Colonial Harem*. Trans. Myrna Godzich & Wlad Godzich. Minneapolis, 1986 [French ed. 1981].

Althusser, Louis. *For Marx*. Trans. Ben Brewster. New York, 1969 [French ed. 1965].

Armstrong, Carol M. "Edgar Degas and the Representation of the Female Body." In *The Female Body in Western Culture: Contemporary Perspectives*, ed. Susan Rubin Suleiman. Cambridge, Mass., 1986.

Bakhtin, Mikhail. *Problems of Dostoevsky's Poetics*. Ed. & trans. Caryl Emerson. Minneapolis, 1984 [1st Russian ed. 1929, rev. Russian ed. 1963].

Bal, Mieke, & Norman Bryson. "Semiotics and Art History." *The Art Bulletin* 72 (June 1991): 174–208.

Ball, Susan L. "The Early Figural Paintings of André Derain, 1905–1910: A Re-Evaluation." *Zeitschrift für Kunstgeschichte* 43 (1980): 79–96.

Benjamin, Roger. "Matisse in Morocco: A Colonizing Esthetic?." *Art in America* 78 (November 1990): 157–64, 211–13.

——. *Matisse's "Notes of a Painter": Criticism, Theory, and Context, 1891–1908*. Ann Arbor, 1987.

——. "The *Paysage décoratif* and the Arabesque of Observation." Paper presented at the University of Texas at Austin, 18 April 1991.

Betterton, Rosemary. "How Do Women Look?: The Female Nude in the Work of Suzanne Valadon." In *Looking On: Images of Femininity in the Visual Arts and Media*, ed. Rosemary Betterton. London, 1987.

Bhabha, Homi K. "Of Mimicry and Man: The Ambivalence of Colonial Discourse." *October* 28 (Spring 1984): 125–33.

——. "The Other Question: The Stereotype and Colonial Discourse." *Screen* 24 (November–December 1983): 18–36.

——. "Sly Civility." *October* 34 (Fall 1985): 71–80.

Bloom, Harold. *The Anxiety of Influence: A Theory of Poetry*. New York, 1973.

Brooks, Peter. "Storied Bodies, or Nana at Last Unveil'd." *Critical Inquiry* 16 (Autumn 1989): 1–32.

Cachin, Françoise. *Paul Signac*. Paris, 1971.

Cachin, Françoise, & Charles S. Moffett, eds. *Manet: 1832–1883*. Paris, 1983.

Carey, M. *Pierre-Auguste Renoir, The Luncheon of the Boating Party*. Washington, 1981.

de Certeau, Michel. *The Writing of History*. Trans. Tom Conley. New York, 1988 [French ed. 1975].

Clark, Kenneth. *The Nude: A Study in Ideal Form*. Princeton, 1956.

Clark, Linda L. *Social Darwinism in France*. University, Ala., 1984.

Clark, T. J. *The Painting of Modern Life: Paris in the Art of Manet and His Followers*. New York, 1985.

Clifford, James. "The Others: Beyond the 'Salvage' Paradigm." *Third Text* 6 (Spring 1989): 73–77.

——. *The Predicament of Culture: Twentieth-Century Ethnography, Literature, and Art.* Cambridge, Mass., 1988.

Conry, Yvette. *L'Introduction du Darwinisme en France au XIXe siècle.* Paris, 1974.

Crow, Thomas E. *Painters and Public Life in Eighteenth-Century Paris.* New Haven & London, 1985.

Distel, Anne, John House, & John Walsh, Jr., eds. *Renoir.* London, 1985.

Doane, Mary Ann. *The Desire to Desire.* Bloomington, 1987.

——. "Film and the Masquerade: Theorising the Female Spectator." *Screen* 23 (September–October 1982): 74–88.

——. "Masquerade Reconsidered: Further Thoughts on the Female Spectator." *Discourse* 11 (Fall–Winter 1988–89): 43–54.

Dollimore, Jonathan. "Shakespeare, Cultural Materialism, and the New Historicism." In *Political Shakespeare: New Essays in Cultural Materialism*, ed. Jonathan Dollimore & Allan Sinfield. Ithaca, 1985.

Donne, J. B. "African Art and Paris Studios, 1905–1920." In *Art and Society: Studies in Style, Culture, and Aesthetics*, ed. Michael Greenhalgh & Vincent Megaw. New York, 1978.

Duncan, Carol. "Virility and Domination in Early 20th-Century Vanguard Painting." *Artforum* 12 (December 1973): 30–39.

Eagleton, Terry. "The Ideology of the Aesthetic." *The Times Literary Supplement*, 22–28 January 1988.

Elderfield, John. *The "Wild Beasts": Fauvism and Its Affinities.* New York, 1976.

Elsen, Albert E. *The Sculpture of Henri Matisse.* New York, [1972].

Fish, Stanley. *Doing What Comes Naturally: Change, Rhetoric and the Practice of Theory in Literary and Legal Studies.* Durham, N.C., 1989.

Flam, Jack. *Henri Matisse: The Man and His Art, 1869–1918.* Ithaca, 1986.

——, ed. & trans. *Matisse on Art.* London, 1973.

Freeman, Judi, ed. *The Fauve Landscape.* Los Angeles & New York, 1990.

Fried, Michael. "Representing Representation: On the Central Group in Courbet's Studio." *Art in America* 69 (September 1981): 168–73.

Gallop, Jane. *Reading Lacan.* Ithaca, 1985.

Gee, Malcolm. *Dealers, Critics and Collectors of Modern Painting, 1910–1930.* New York, 1981.

Giry, Marcel. *Fauvism: Origins and Development.* Trans. Helga Harrison. New York, 1982 [French ed. 1981].

Gordon, Robert & Charles F. Stuckey. "Blossoms and Blunders: Monet and the State." Parts 1, 2. *Art in America* 67 (January–February, September 1979): 102–17, 109–25.

Graham-Brown, Sarah. *Images of Women: The Portrayal of Women in Photography of the Middle East 1860–1950.* New York, 1988.

Green, Christopher. *Cubism and Its Enemies: Modern Movements and Reaction in French Art, 1916–1928.* New Haven & London, 1987.

Herbert, Eugenia W. *The Artist and Social Reform: France and Belgium, 1885–1898.* New Haven, 1961.

Herbert, James D. "Matisse Without History" (review article). *Art History* 11 (June 1988): 297–302.

Herbert, Robert L. "The Decorative and the Natural in Monet's Cathedrals." In *Aspects of Monet*, ed. John Rewald & Frances Weitzenhoffer. New York, 1984.

——. *Impressionism: Art, Leisure, and Parisian Society.* New Haven & London, 1988.

——. "Method and Meaning in Monet." *Art in America* 67 (September 1979): 90–108.

[Herbert,] Robert L., & Eugenia W. Herbert. "Artists and Anarchism: Unpublished Letters of Pissarro, Signac and Others." Parts 1, 2. *The Burlington Magazine* 102 (November, December 1960): 473–82, 517–22.

Holt, Richard. *Sport and Society in Modern France.* Hamden, Conn., 1981.

House, John. *Monet: Nature into Art.* New Haven & London, 1986.

Irigaray, Luce. *This Sex Which Is Not One.*

Trans. Catherine Porter. Ithaca, 1985 [French ed. 1977].

Joll, James. *The Anarchists*. 2nd ed. Cambridge, Mass., 1980 [1st ed. 1964].

LaCapra, Dominick. *History, Politics, and the Novel*. Ithaca, 1987.

de Lauretis, Teresa. *Alice Doesn't: Feminism, Semiotics, Cinema*. Bloomington, 1984.

Lee, Alan. "Seurat and Science." *Art History* 10 (June 1987): 203–23.

Levine, Steven Z. *Monet and His Critics*. New York, 1976.

——. "Seascapes of the Sublime: Vernet, Monet, and the Oceanic Feeling." *New Literary History* 16 (Winter 1985): 377–400.

Lévi-Strauss, Claude. *The Elementary Structures of Kinship*. Rev. ed. Trans. James Harle Bell, John Richard von Sturmer, & Rodney Needham. Boston, 1969 [French ed. 1949].

McEvilley, Thomas. "Doctor, Lawyer, Indian Chief: *"Primitivism" in 20th Century Art* at the Museum of Modern Art." *Artforum* 23 (November 1984): 54–60.

Maitron, Jean. *Le Mouvement anarchiste en France*. 2 vols. Paris, 1975.

Melot, Michel. "La Pratique d'un artiste: Pissarro graveur en 1880." *Histoire et Critique des arts* 2 (June 1977): 14–31.

Miller, Christopher. *Blank Darkness: Africanist Discourse in French*. Chicago, 1985.

Montrose, Louis A. "Professing the Renaissance: The Poetics and Politics of Culture." In *The New Historicism*, ed. H. Aram Veeser. New York & London, 1989.

Mulvey, Laura. "Afterthoughts on 'Visual Pleasure and Narrative Cinema' Inspired by *Duel in the Sun*." *Framework*, nos. 15, 16, 17 (1981): 12–15.

——. "Visual Pleasure and Narrative Cinema." *Screen* 16 (Autumn 1975): 6–18.

Nochlin, Linda. "Courbet's *L'Origine du monde*: The Origin without an Orignal." *October* 37 (Summer 1986): 77–86.

——. "The Imaginary Orient." *Art in America* 71 (May 1983): 119–31, 186–91.

Olin, Margaret. "Validation by Touch in Kandinsky's Early Abstract Art." *Critical Inquiry* 16 (Autumn 1989): 144–72.

Oppler, Ellen C. *Fauvism Reexamined*. New York, 1976.

Penrose, Roland. *Picasso: His Life and Work*. Rev. ed. New York, 1971 [1st ed. 1958].

Pickvance, Ronald. *Van Gogh in Saint-Rémy and Auvers*. New York, 1986.

Poisson, Georges. *Evocation du Grand Paris*. 3 vols. Paris, 1956–61. Vol. 2: *La Banlieue nord-ouest*. 1960.

Pribram, E. Deidre, ed. *Female Spectators: Looking at Film and Television*. London, 1988.

Reff, Theodore. "Cézanne and Poussin." *Journal of the Warburg and Courtauld Institutes* 23 (1960): 150–74.

Ripert, Aline, & Claude Frère. *La Carte postale: Son histoire, sa fonction sociale*. Lyon, 1983.

Rubin, William. "Cézannisme and the Beginnings of Cubism." In *Cézanne: The Late Work*, ed. William Rubin. New York, 1977.

——. "On 'Doctor, Lawyer, Indian Chief: *"Primitivism" in 20th Century Art* at the Museum of Modern Art.'" *Artforum* 23 (February 1985): 42–45.

——. "Pablo and Georges and Leo and Bill." *Art in America* 67 (March–April 1978): 128–47.

——. *Picasso and Braque: Pioneering Cubism*. New York, 1989.

——, ed. *"Primitivism" in 20th Century Art: Affinity of the Tribal and the Modern*. 2 vols. New York, 1984.

Said, Edward W. *Orientalism*. New York, 1978.

Schapiro, Meyer. "The Apples of Cézanne: An Essay on the Meaning of Still-Life." In *Modern Art, 19th & 20th Centuries: Selected Papers*. New York, 1978.

Schneider, Pierre. *Matisse*. Trans. Michael Taylor & Bridget Strevens Romer. New York, 1984 [French ed. 1984].

Seiberling, Grace. *Monet's Series*. New York, 1981.

Sekula, Allan. "The Body and the Archive." *October* 39 (Winter 1986): 3–64.

Shiff, Richard. *Cézanne and the End of Impressionism: A Study of the Theory, Technique, and Critical Evaluation of Modern Art*. Chicago, 1984.

——. "The End of Impressionism." In *The New Painting: Impressionism 1874–1886*, ed. Charles S. Moffett. San Francisco, 1986.

——. "The End of Impressionism: A Study in Theories of Artistic Expression." *Art Quarterly*, new series, 1 (Autumn 1978): 338–78.

Silver, Kenneth E. *Esprit de Corps: The Art of the Parisian Avant-Garde and the First World War*. Princeton, 1989.

Silverman, Kaja. *The Acoustic Mirror: The Female Voice in Psychoanalysis and Cinema*. Bloomington, 1988.

——. *The Subject of Semiotics*. New York & Oxford, 1983.

Stebbins, Robert E. "France." In *The Comparitive Reception of Darwinism*, ed. Thomas F. Glick. Austin, 1974.

Steinberg, Leo. "The Polemical Part." *Art in America* 67 (March–April 1978): 114–27.

——. "Resisting Cézanne: Picasso's *Three Women*." *Art in America* 66 (November–December 1978): 114–33.

Stewart, Susan. *On Longing: Narratives of the Miniature, the Gigantic, the Souvenir, the Collection*. Baltimore, 1984.

Tagg, John. *The Burden of Representation: Essays on Photographies and Histories*. Amherst, 1988.

Tucker, Paul Hayes. *Monet at Argenteuil*. New Haven & London, 1982.

Weber, Eugen. *Action Française: Royalism and Reaction in Twentieth-Century France*. Stanford, 1962.

——. "Gymnastics and Sports of *Fin-de-Siècle* France: Opium of the Classes?" *American Historical Review* 76 (February 1971): 70–98.

——. *The Nationalist Revival in France, 1905–1914*. Berkeley & Los Angeles, 1959.

——. *Peasants into Frenchmen: The Modernization of Rural France, 1870–1914*. Stanford, 1976.

——. "Pierre de Coubertin and the Introduction of Organized Sport in France." *Journal of Contemporary History* 5, no. 2 (1970): 3–26.

Zemel, Carol M. *The Formation of a Legend: Van Gogh Criticism, 1890–1920*. Ann Arbor, 1980.

INDEX

Italicized numbers indicate the page numbers of illustrations

Action française [periodical], 124, 125, 145
Action Française [political group], 124, 129, 145
Adam, Paul, 90
d'Adhémar, Cte V., 161
Aesthetic, the, 11; and Africa, 162, 164–65, 167–68, 176; and disinterest, 65, 73, 74–76, 81, 107–11; in painting, 65, 68–77; in photography, 65–68, 73, 76. *See also* Fauve painting, aesthetic dissimulation in
Africa: ambiguity of, 160–61, 165–67, 176; fetishization of, 171–73; and time, 170–71, 176. *See also* Matisse, Henri, art works with African references
Africa, sub-Saharan, 165
African sculpture, 158, 165, 168, 176. *See also* Fauve sculpture, and African prototypes
Algeria, 165
Allard, Roger, 119
Althusser, Louis, 81
Anarchists and anarchism, 48–52, 139–43
Antonelli, Etienne, 133
Apollinaire, Guillaume, 175, 177–78, 181–82
Ardouin-Dumazet, 47, 49, 92, 106
Art criticism, discipline of, 15, 38
Art history, discipline of, 110–11, 182–83
Aurier, G.-Albert, 28–29
Aynard, Joseph, 44–45

Bacchic Joy [photograph], 65–66, *66*, 68
Baedeker [guidebook], 45, 97
Bakhtin, Mikhail, 33
Baligant, Raoul: *The Repose of the Model*, *72*
Baudelaire, Charles, 119, 122
Bayard, Emile, 66
Bazalgette, Léon, 18, 127, 128–29, 144
Beauchamp, Octave, 47
Bergon, Paul and René Le Bègue, 68
Bernard, Augustin, 165
Bernard, Emile, 134, 154
de Bernhardt, F. 46
Bertrand, Louis, 161, 164
Bhabha, Homi K., 166, 171–72
Biskra, 156, 160–61
Blind Alley in the Slums, Shoreditch [photograph], *44*, 46

Boland, Henri, 93–94, 96
Bonfils, Adrien, 170
Bonnard, Pierre 112
Bordeaux, Henry, 107
Bourget, Paul, 123–24
Bourgouin-Malchante, Louis, 41, 45
Bouyer, Raymond, 104, 121, 123
Braque, Georges, 180, 182; *Houses at L'Estaque*, *179*, 179
Bray, Lucien, 36
Brousse, Paul, 107, 123
Burke, Edmund, 100

Cabanel, Alexandre, 63
Casella, Georges, 94–95
Cassou, Jean, 180
Catonné, Amédée, 141
de Certeau, Michel, 161, 167
Cézanne, Paul, 112, 153–54; *Five Bathers*, 152, *153*, 175, 178. *See also* Fauve painting, relation to Cézanne
Chevalier, Louis, 41
Clark, T. J., 61–62
Classical landscape, the, 104–05, 110. *See also* Fauve painting, and the classical landscape
Claude Lorrain: *Ariadne and Bacchus on Naxos*, *84*, 104–05
Clemenceau, Georges, 9
Clifford, James, 170, 171
Clouard, Henri, 127
Cochin, Henry, 9
Collioure, 82, 92, 103, 107. *See also* Derain, André, Mediterranean landscapes; Matisse, Henri, Mediterranean landscapes
Colonialism, 10, 11, 146, 164–65, 166–67, 172–73
Competition between individuals: as dissimulation, 182–83; as source of creation, 181–83
Corot, Jean-Baptiste Camille, 9, 104, 106; *Papigno, Buildings in the Valley*, *105*, 105
Courbet, Gustave: *The Painter's Studio, A Real Allegory Summing Up Seven Years of My Artistic Life*, *69* [detail], 69–70
Courthion, Pierre, 180
Cross, Henri: *The Shaded Beach*, 112, *116*, 142–43
Cubism, 179, 182

Daelen, Edouard, 65, 67–68
Darwin, and social Darwinism, 149

Daudet, Léon, 134
Dauzat, Albert, 93, 107–08, 119
Deiss, Edouard, 39–40, 41, 45
Delacroix, Eugène: *Women of Algiers*, 137, *138*
Denis, Maurice: definition of painting, 74; on African sculpture, 165; on Cézanne, 153–54; on Cross, 143; on Derain, 158–60; on Gauguin, 129, 137; on Matisse, 78, 122, 131, 132, 141, 155, 180–81; on the "school of Matisse", 31–32, 76–77, 89–90; on Van Gogh, 129; shift in art-critical position, 129, 153, 155; as a painter, 112, 142; *The Beach*, 129–31, *130*, 132, 135, 143
Derain, André, 8, 13, 180; Mediterranean landscapes, 13, 14, 82–92, 96, 103–05, 108–10: paintings of London, 14, 15–16, 22–46, 54–55; paintings of the nude, 146–55; pastoral paintings, 10–11, 14, 135–45; *Bathers* (1907), 146–47, *148*, 150–51, 152–53, 154–56; *Bathers* (1908), 158–60, 166, *177*, 178–79; *Charing Cross Bridge, London*, 22, 22–24, 27–28, 30, 34–35; *Collioure*, 83–84, *84*; *The Dance*, 137–39, *138*, 141–42; *The Golden Age*, 135–39, *136*, 141; *Houses of Parliament, London*, 41, *42*, 45; *Lighthouse at Collioure*, 89–91, *91*, 99; *The Mountains, Collioure*, 35, *36*; *The Pool of London*, 23, 28, 35, 42–44, *45*, 45; *Port of Collioure*, *102*, 103–04; *Port of Collioure, the White Horse*, 88, *89*, 90, 105, 151; *Regent Street*, 23, 33, *34*, 34, 40, 44; *Return of the Fishing Boats*, 86, 86–87, 108; *The Two Barges*, 41–42, *43*, 86; *View of Collioure*, *104*, 105; *Waterloo Bridge*, 22, *23*, 27, 34
Deschanel, Paul, 128
Desjardins, Paul, 122
Dillaye, Frédéric, 106
Doctor Gathers Evidence Concerning the Culinary Hygiene of the Turkana, The [photograph], 162, *164*, 176
Dralin, Georges, 120
Dreyfus Affair, the, 127–28
Dufy, Raoul: *Posters at Trouville*, 97–99, *99*
Dujardin, Victor, 94
Dumont, William, and Edward Suger, 40
Duret, Théodore, 27

Eagleton, Terry, 103
Elsen, Albert E., 160
Epuy, Michel, 108–09, 114–15, 122, 147
Ethnography, discipline of, 162–65, 176

Fage, René, 160–61
Fagus, Félicien, 17, 29
Falize, Pierre: cover for *Le Sport et l'Avenir*, 94–95, *95*
Faure, Elie, 8–9, 10
Fauve painting: aesthetic dissimulation in, 73–77, 80–81, 108–09; artistic persona in, 30–31, 51–53, 80, 141, 174; and the classical landscape, 104–05, 108–09, 112; composition in, 104–05, 132–33; end of, 14, 174, 181; finding in, 10, 13, 141, 144; geography in, 146, 158–60; making in, 10, 11, 172; relation to Cézanne, 14, 74, 133, 151, 152–55, 158, 170, 178; relation to Degas, 133; relation to Gauguin, 27–31, 131, 133, 137, 151, 159; relation to Monet, 22–24, 33, 36, 46, 98, 103–04, 133, 151–52; relation to Neo-Impressionism, 27, 78, 87–88, 122, 131, 137, 141; relation to Renoir, 20–21, 24–25; relation to Van Gogh, 27–31, 151; seen as French national art, 174, 179–81; and the sublime, 103–04; and the Third Republic, 144–45; time in, 112–19, 122, 124, 135–39, 141–44, 146–51, 154–55; two dimensions vs. three dimensions in, 168–70; vs. Picasso, 14, 174, 178–83
Fauve sculpture: and African prototypes, 157–58, 167, 170
Fauve style, 76; bright colors in, 23–24, 90; color and line in, 131–32, 135–37, 151; naturalism and neo-naturalism in, 13, 16, 37–39, 54–56, 79–81, 90–92, 109, 122; reinvigorating force of, 25–27, 96, 122, 124; simplicity of, 10, 23–25, 30, 36–37, 77–78, 87–92, 104, 109; sustained artistic mediation in, 150–53, 172; tactile correspondence in, 13, 33–38, 78–79, 80, 90–91
First World War, the, 144–45
Fish, Stanley, 111
Fitzgerald, Desmond, 16
Flam, Jack, 157–58
Foà, Edouard, 165
Fontaines, Georges, 92–93
"Foski", 29
Fried, Michael, 69–70
Friesz, Othon: *Autumn Work*, *143*, 143–44; *Spring*, *142*, 143–44

Gaborit, L'abbé, 101
Galliac, Louis: *In the Studio*, *71*, 71–73, 79
Gallop, Jane, 58
Gauguin, Paul, 8, 27–30, 129, 137. *See also* Fauve painting, relation to Gauguin
Gaultier, Paul, 107
Geffroy, Gustave, 18
George, Waldemar, 180

Germain, Auguste, 60–61
Gervex, Henri: *Birth of Venus*, *68*, 69
Gérôme, Jean-Léon: *The Carpet Merchant*, 162, *163*, 165
Gide, André, 32
Girard, André, 140
Gogh, Vicent van. *See* Van Gogh, Vincent
Graham-Brown, Sarah, 169–70
Grande tradition, the, 9–10, 14, 104–05, 120–24, 132–33, 154, 175–79. *See also* Corot, Jean-Baptiste Camille; Ingres, Jean-Auguste-Dominique; Poussin, Nicolas
Grave, Jean, 50–51, 52, 140–41
Grévin, Alfred: *In the Fields*, *47*, 47
Grimanelli, Pericles, 148
Gruyer, Paul, 98
Gsell, Paul, 38
Guérin, Charles, 141
Guérin, Joseph, 18, 29–30
Guide Diamant [guidebook], 97
Guide Joanne [guidebook], 98
Guidebooks, 44–45, 92, 123

Hachette [guidebook], 47
Holl, J.-C., 25–26
Houses of Parliament, London [postcard], *43*, 45
Hubert, H., 112–13, 115, 139
Humanité féminine, L' [periodical], 160
Huyghe, René, 180

Impressionism: as an artistic heritage, 9–11, 14, 26–27, 127, 134; associated with the Third Republic, 9, 144; considered insipid, 25–26; early, 37, 133. *See also* Manet, Edouard; Monet, Claude; Renoir, Pierre-Auguste
Ingres, Jean-Auguste-Dominique, 8–10; *The Golden Age*, 120, *121*; *The Turkish Bath*, *136*, 137, 175

Jamot, Paul, 120–21
Jan, H. L. v.: *The Studio*, *67*, 67

Kahn, Gustave, 17
Kant, Immanuel, 65, 100, 102–03, 107
Klary, C., 66, 68, 77
Kupka, František: *How Long Until the Allotment of Air Space?*, *48*, 48–49, 139

La Touche, Gaston: *Goodness of Spirit*, *117*, 118
Lacan, Jacques, 58
LaCapra, Dominick, 12
Lanoë, Georges, 26
Latinism, 9, 13, 123–29, 144–45, 153, 174–75
Laurens, Jules, 63
de Lauretis, Teresa, 60
Le Brun, Charles, 121, 123, 134
Leblond, Marius-Ary, 28, 137
Lecomte, Georges, 19
London: descriptions of, by social reformers, 39–41, 46; tourist descriptions of, 39, 41, 44–46. *See also* Derain, André, paintings of London; Monet, Claude, paintings of London
Lorrain, Claude. *See* Claude Lorrain

Lux, Jacques, 97

Malato, Charles, 140
Manet, Edouard, 8–10, 119; *Bar at the Folies-Bergère*, *59*, 60, 80; *Déjeuner sur l'herbe*, *118*, 118, 137; *Olympia*, 61–63, *62*, 74, 118
Marque, Albert, 8, 26
Marquet, Albert, 76, 78, 97
Matisse, Henri, 8, 12, 13, 180; art works with African references, 10, 11, 13, 14, 156–61, 166–73, 177; Mediterranean landscapes, 13, 14, 82–92, 96, 103–05, 108–10, 124; "Notes d'un peintre," 146, 147, 151–52, 154; paintings of the nude, 9, 11, 13, 14, 56–65, 73–81, 108–09, 146–55, 172–73; pastoral paintings, 10–11, 14, 56, 112–24, 129–47, 154, 161, 170; *Blue Nude (Souvenir of Biskra)*, 146–48, *147*, 150–51, 152–53, 154–57, 158, 160–61, 166, 170, 173; *Bonheur de vivre*, 14, 29, 95, 112, *114*, 116, 120, 122, 124, 129, 131–33, 135, 137, 139, 141–42, 143, 146–47, 150, 154, 161, 170; *By the Sea (Gulf of Saint-Tropez)*, 84–86, *85*, 104–05, 108, 112, 116, 124; *Carmelina*, 56–65, *57*, 67, 73–74, 76, 77, 79–80, 151; *Fruit and Bronze*, 156, 157, 158, 167–70, 176; *Luxe, calme et volupté*, 14, 78, 87–88, 112, *113*, 115–20, 122, 124, 129, 131, 132–33, 135, 137, 141–42, 146; *Nude in the Studio (Marquet Painting in Manguin's Studio)*, *75*, 76–81, 89, 109; *Pastoral*, 112, *115*, 116, 122; *Reclining Nude I*, 158, *159*, 167; *Sculpture and Persian Vase*, 167, *169*; *Standing Nude*, 147, *149*; *Still Life with African Sculpture*, 167, *168*; *Two Negresses*, 157, 157–58, 160, 167–68; *View of Collioure with the Church*, 89–90, *90*; *View of Saint-Tropez*, *83*, 83–86, 87–88, 92, 103, 106, 110, 116
Matisse, Amélie, 86, 112, 116–18, 142
Matisse, Pierre, 86, 112
Mauclair, Camille, 16, 20, 38, 61, 127, 130
Maurras, Charles: affiliations claimed by, 128, 129–30; on art of the seventeenth century, 134; on drawing, 130; on the Dreyfus Affair, 127; during the First World War, 144–45; on Latinism, 9, 124–26, 141, 174; on monarchy, 125–26; on Poussin, 123, 125; on Puvis de Chavannes, 135; on republicanism, 126
Maybon, Albert, 126
Melot, Michel, 52–53
Meyer, Bruno, 67, 68, 73
Ménard, René, 112, 143; *Antique Scene*, 130, *131*, 132, 135
Michel, Emile, 121
Mistral, Frédéric, 125
Mithouard, Adrien, 121, 123, 125, 129–30
Monet, Claude, 14, 28, 144; paintings of the Channel shore, 96–97, 100–03; paintings of Giverny garden, 9, 53–54; paintings of

London, 15–18, 36, 46; paintings of Rouen Cathedral, 17–18, 90; *Charing Cross Bridge (Overcast Day)*, 16, *17*; *Cliffs of Petites Dalles, 100*, 100–01; *Hôtel des Roches Noires, Trouville*, 96, 97, 98; *The Manneporte, Etretat II, 101*, 101–02. *See also* Fauve painting, relation to Monet

Monod, François, 28

de Montesquiou, Léon, 126, 128

Monteuuis, Dr. Aldolphe, 94, 116

Montrose, Louis A., 11

Moreau-Vauthier, Charles, 25–26, 27

Morice, Charles, 32

Morisset, Henri-Georges: *The Model, 64*, 64

de Morsier, E. 94

Mulvey, Laura, 59

Nadal, Victor, 62–63, 64, 72

Narsy, Raoul, 133

Nationalism, reactionary, 9, 11, 124–30, 133–39, 149

Neo-Impressionism, 52, 78, 87–88, 140, 141. *See also* Fauve painting, relation to Neo-Impressionism

Nocturnal Attack by Two Hooligans [drawing], *40*, 40

Nude [painting genre], the, 68–73; narration in, 58–61, 76, 79–80; object of, 61–64, 76; photography and, 65–68; subject for, 56–61, 64, 76. *See also* Derain, André, paintings of the nude; Matisse, Henri, paintings of the nude

L'Occident [periodical], 125

Oriental *objets d'art*, 168, 170

Orientalist painting, 10, 162, 164

Paulhan, Frédéric, 8, 87, 109, 130

Pastoral [painting genre], the. *See* Derain, André, pastoral paintings; Matisse, Henri, pastoral paintings

Perrier, Edmund, and René Verneau, 148

Petenmoï, Iguiai or Lango Native [photograph], 164, *165*

Pératé, André, 38

Photography. *See* Aesthetic, the, in photography; Nude [painting genre], the, photography and

Picasso, Picasso: persona of, 14, 174–75, 176–78; vs. the Fauves, 14, 179–83; *Les Demoiselles d'Avignon, 175*, 175–78; *Factory at Horta de Ebro, 178*, 179

Postcards, 39, 44, 45–46, 92, 106–07, 110

Poussin, Nicolas, 9, 104, 109, 120–24, 125, 154; *The Andrians, 120*, 120, 139·

Puvis de Chavannes, Pierre, 8–9, 143; *The Sacred Grove, 134*, 135

Puy, Michel, 155

Raynal, Maurice, 180

Reclus, Onésime, 124

Regatta in the Basin of Rueil, or the Container and the Contained, The [drawing], *47*, 48

Rejuvenation, physical, 94–95, 116

Renaissance latine, La [periodical], 125

Renoir, Pierre-Auguste, 14, 112; *Luncheon of the Boating Party*, 15, 18–20, *19*, 134–35. *See also* Fauve painting, relation to Renoir

Rénovation esthétique, La [periodical], 125

Republicanism, 9, 11, 126–29, 133, 144–45, 149

Rococo painting, 19–20, 24, 135

Rood, Ogden, 88

Rouart, Louis, 128, 129–31

Roussel, Ker-Xavier: *Two Nude Women Seated near the Seashore*, 112, *117*, 143

Royalism, 125–26, 128, 133–34

Rubin, William, 182–83

Said, Edward W., 162

Saint-Tropez, 82, 92, 103, 107, 140. *See also* Matisse, Henri, Mediterranean landscapes

Saint-Tropez, General View [postcard], 92, *93*, 106

Salmon, André, 180

Salon d'Automne, the, 8–9; the Fauve "cage" at, of 1905, 8, 12, 26, 31–32, 82, 89–90

Salon des Indépendants, the: Matisse and Derain at, of 1907, 146, 153

Sauvebois, Gaston, 126, 127

Segaud, A.: *The Physical Evolution of Woman*, 148–49, *149*, 155, 162–64, 176

Seguin, Armand, 29

Seurat, Georges, 69; *The Models, 70*, 70–71; *A Sunday Afternoon on the Island of La Grande Jatte*, 71

Seventeenth century vs. eighteenth century, legacies of, 133–35

Shiff, Richard, 154

Signac, Paul, 52, 78, 142; *In the Time of Harmony, 139*, 139–41, 143; *Saint-Tropez in the Setting Sun*, 87, 87

Silver, Kenneth E., 144

Silverman, Kaja, 79

Stackelberg, Frédéric, 141

Steinberg, Leo, 182–83

Stewart, Susan, 171

Stryieuski, Casimir, 124

Sublime, the, 100–04, 105.

Suburbs, the Parisian: social conflicts in, 46–49, 54. *See also* Vlaminck, Maurice, in the Parisian suburbs

Surier, Albert, 95

Syffert, Gaston, 119

Symbolist criticism, 10–11, 27–30, 74, 153; of Fauve painting, 29, 31–33,

38, 76–77, 81, 89–90, 122, 151–52. *See also* Art criticism, discipline of

Tarbel, Jean [J. Delorme-Jules-Simon?], 121, 122, 123

Thames Near the Docks, The [photograph], *44*, 45

Thierry, Georges P., 48

Time and timelessness, 112–15, 120. *See also* Africa, and time; Fauve painting, time in; Woman, and time

de Toulouse-Lautrec, Henri: *"The Sacred Grove," Parody of a Painting by Puvis de Chavannes at the Salon of 1884, 135*, 135

Tourism: on the Channel coast, 82, 96–100; on the Mediterranean shore, 14, 82–83, 92–96, 115–16, 119, 123–24, 142; relation to the land, 106–08; relation to painting, 105–08, 109–10, 124

Trouville, 96–100

Trouville, The Boardwalk [postcard], 97, 98

Tuareg, the, 160

Two Tuareg Girls [photograph], *157*, 160, 168

'Uled-Nayl, the, 160–61

Union sacrée, 144

d'Ussel, Le Comte, 106

Uzanne, Octave, 59

Van Gogh, Vincent, 27–30, 129. *See also* Fauve painting, relation to Van Gogh

Vauxcelles, Louis, 8, 10, 12, 26, 27, 28, 96, 153

Verneau, René, 148, 158

Vignola, Amédée, 156, 160

de Visan, Tancrède, 130

Vlaminck, Maurice, 8, 12, 13, 180; in the Parisian suburbs, 14, 15–16, 20–39, 50–55; *Bank of the Seine at Chatou*, 54, *55*; *Boats*, 38; *Chestnut Trees at Chatou, 20*, 20–21, 24, 27, 34, 50; *Luncheon in the Country, 21*, 21, 50; *Regattas at Bougival, 49*, 50; The *"Restaurant de la Machine"* at Bougival, 24, *25*, 27, 30, 34, 52, 54; *The Wheat Farm with the Red House*, 50, *51*

Vollard, Ambroise, 15

Votez, Mme Léonide, 94, 116

Vuillard, Edouard, 112

Watteau, Jean Antoine: *Embarkation for Cythera*, 20

Weilug: *Bourgeois Behavior, 72*, 73

Woman: relation to the land, 108–09; as sign for a society, 156; and time, 114–15, 148–50

Zervos, Christian, 180